COSMOPOLITAN MODERNISMS

D1628636

ANNOTATING ART'S HISTORIES

COSMOPOLITAN MODERNISMS

EDITED BY KOBENA MERCER

Institute of International Visual Arts
(inIVA)

The MIT Press
Cambridge, Massachusetts
London, England

Copublished by the Institute of International
Visual Arts (inIVA) and The MIT Press

© 2005 inIVA
Texts © 2005 the authors
Images © 2005 the artists
(unless stated otherwise)

ISBN 1-899046-41 7 (inIVA)
ISBN 0-262-63321-3 (The MIT Press)

A catalogue record of this book is available from
the British Library

Library of Congress Cataloging-in-Publication Data

Cosmopolitan modernisms / editor, Kobena Mercer.
 p. cm. — (Annotating art's histories)
 Includes bibliographical references.
 ISBN 0-262-63321-3 (pbk. alk. paper)
 1. Art and globalisation—History—20th century.
 2. Multiculturalism in art. 3. Modernism (Art)—Cross-
 cultural studies. I. Mercer, Kobena, 1960- II. Series.

N72.G55C675 2005
306.4'7'0945—dc22
 2005042808

10 9 8 7 6 5 4 3 2 1

Editor: Kobena Mercer
Copyeditor: Linda Schofield
Designed by Untitled
Production coordinated by
Uwe Kraus GmbH
Printed in Germany

Front and back cover:
Romare H. Bearden, *The Prevalence of Ritual:
Conjur Woman,* 1964, collage, $9^1{}_4$ x $7^1{}_4$ inches
© Romare Bearden Foundation/
VAGA, New York/DACS, London 2005
Image © Board of Trustees,
National Gallery of Art, Washington

Supported by The Getty Foundation

To find out more about inIVA publications or to place
an order, please contact:

Institute of International Visual Arts (inIVA)
6–8 Standard Place
Rivington Street
London EC2A 3BE
Tel +44 20 7729 9616
Fax +44 20 7729 9509
Email booksales@iniva.org
www.iniva.org

MIT Press books may be purchased at special quantity
discounts for business or sales promotional use. For
information, please email special_sales@mitpress.mit.edu
or write to Special Sales Department, The MIT Press,
55 Hayward Street, Cambridge, MA 02142.

CONTENTS

COSMOPOLITAN
MODERNISMS

INTRODUCTION
KOBENA MERCER

Artists all over the world responded to the changing conditions of 20th-century life by approaching their work with a questioning attitude. This underlying attitude was one of the defining features of modernism, giving rise to a proliferation of artistic movements, styles and forms. *Cosmopolitan Modernisms* revisits the broad historical period in which modernist attitudes took shape in different national and cultural environments. Travelling through moments of crisis and innovation, it reveals the dynamic interplay between different cultures as a constant thread that weaves in and out of the story of modern art as a whole. Taking different geographical regions and time periods as their chosen focus of enquiry, each contributor comes back to our contemporary moment with questions that address the limitations of our available knowledge about modernism's cross-cultural past.

As the first volume in a new series of art historical studies, *Cosmopolitan Modernisms* offers a fresh approach by showing how a shared history of art and ideas was experienced differently around the globe. Setting the tone for the critical exploration of the interactive relationships that have always been present between the western centre and societies hitherto placed on the periphery, this book introduces the overarching scope of *Annotating Art's Histories* as a series of interventions that sets out to question the depth of our historical understanding of cultural difference in the visual arts.

Over the past two decades there has been a significant growth of interest in the work of artists from non-western countries and from minority backgrounds within the West. Such interest reflects the impact made by recent generations of artists, critics and curators who have brought questions to the visual arts that are critically informed by their culturally diverse identities. Today matters of difference and diversity are a commonplace – in a way that they were not twenty or thirty years ago – and the widespread acknowledgement of multiple identities in public life has enriched our experiences of art and has enlivened the entire setting of contemporary reception and debate.

Take a brief look over the past two decades and one could observe that the shifts brought about by identity politics in the 1980s, and global trends in the 1990s, have affected the art world just as all other areas of cultural and social life have been affected. Standing back from the hurly burly of recent change, one observes that the apparent acceptance of cultural difference as a permanent fact of life in western societies amounts to an immense shift in world-views. Where 'society' can be said to be formed by a general agreement or consensus about what constitutes reality, what comes into focus is a lop-sided shape for the 20th century as such. For the first sixty or seventy years of the last century, reality was agreed upon and thus governed by a monocultural consensus, which has given way, over the last thirty years, to a world in which multiculturalism is increasingly held to be the social norm – even if the post-modern condition of permanent argument and dissensus comes with it as an inevitable corollary.

The sequence of international exhibitions that have marked out the growing interest in non-western and minority artists on the part of the metropolitan art world – *'Primitivism' in 20th Century Art: Affinities of the Tribal and the Modern* (1984) at the Museum of Modern Art, New York; *Magiciennes de la Terre* (1989) at the

Pompidou Centre in Paris; the controversial Whitney Biennial of 1993; and *Documenta XI* (2002) in Germany – gives one a measure of the ways in which multiculturalism and globalisation have become virtually 'normal' in the contemporary visual arts. On closer scrutiny, however, a whole range of unanswered questions also come to light. Why does 'the contemporary' so often take precedence over 'the historical' as the privileged focus for examining matters of difference and identity? Does the heightened 'visibility' of black and minority artists in private galleries and public museums really mean that the historical problem of 'invisibility' is now a problem solved and dealt with? To what extent has the curating of non-western materials in blockbuster exhibitions led to visual culture displays that may actually obscure the fine art traditions of countries that experienced colonialism and imperialism? In a situation where the aspiration to be all-inclusive has become the official watchword of institutional policy, has the very idea of 'inclusion' now become a double-edged sword?

Pursuing such questions, *Cosmopolitan Modernisms* suggests that there is more to the material histories of the visual arts than our contemporary moment seems to imagine. Taking account of the three-fold interaction among non-western artists, minority artists within the West, and western art movements that have engaged with different cultures, the range of perspectives brought together in this book begins to map out the critical pathways between past and present addressed by the series as a whole. While the encounter between post-colonial studies and contemporary art writing has created a distinct field of enquiry into cross-cultural aspects of the visual arts, the resulting state of play has tended to push art history into something of a quandary. On the one hand, traditional methods of research have been challenged by the rise of visual culture as a wider paradigm of critical enquiry, as well as by the range of concerns with cultural difference often grouped together under the heading of post-colonialism. Conversely, the interest in colonial history explored by contemporary artists and theorists alike has generated considerable interdisciplinary insight and yet the prevalent tendency to roam across the cultural sphere at large – taking in literature, film, photography and popular culture – has left the specific realm of the fine arts relatively untouched, especially as regards the lives and works of non-western and minority artists during the broad historical period of modernism between the 1890s and the 1980s.

Annotating Art's Histories sets out to address the gaps in our understanding of 20th-century art by restoring the work of art to the centre of investigation. Rather than seeking to fulfil an ideological programme for a totally 'inclusive' global art history - whatever that might be - the creative ambition for the series is to bring together research and scholarship that foregrounds close attention to individual artists and the institutional contexts in which their ideas and works were forged. Building upon the existing literature in the field, the series examines specific topics of enquiry with newly-commissioned writings whose themes and concepts have been developed in a symposium convened around each subject. In this way, the series raises questions for both the more conservative aspects of art history as a humanities discipline as well as for the theory-driven orientation in contemporary studies that often loses sight of the actual object of experience, even though the insights generated

by the overlap between visual studies and post-colonial studies clearly inform the investigations that each volume undertakes.

This introduction describes the artistic and intellectual context in which the series unfolds. Rather than attempt a definitive survey, it sketches the field of enquiry created since Edward Said's *Orientalism* (1978) inaugurated the post-colonial turn. Casting a critical eye over the key tendencies that have arisen in art history's responses to post-colonial questions, it is a partial and provisional review of how we have arrived at the current state of play with regards to understanding cultural difference, not as an arbitrary irrelevance that detracts from the 'essence' of art, nor as a social problem to be managed by compensatory policies, but as a distinctive feature of modern art and modernity that was always there and which is not going to go away.

Mapping various pathways through the field, as laid out in the bibliography, the starting point lies in a consideration of the language used in naming the general phenomena apprehended by such terms as 'the global', 'the international', 'the cross-cultural' and 'the culturally diverse'. Could 'the cosmopolitan' serve as a conceptual tool capable of cutting through the congested, and often confusing, condition created by these competing vocabularies? How can a case study approach to hitherto 'minor' 20th-century artists be reconciled with the wider insights generated by the critique of modernism associated with post-colonial and post-modern approaches? Can traditional art history genres, such as the survey and the monograph, be adapted to take account of cross-cultural dynamics, or do such concerns call for a wholly different approach to cultural chronology and artistic agency? Whereas 20th-century literature frequently

accepted voices from different cultures into the modernist canon, why did painters and sculptors encounter such a long-standing struggle with canon formation in the visual realm? Indicating some of the ways in which each chapter responds to these topics, this introduction situates *Cosmopolitan Modernisms* as a critical contribution to the field of cross-cultural studies in the history of the visual arts.

Critically Cosmopolitan

Discussing the reception of modernist art in colonial India, Partha Mitter argues that the widespread European fascination with the so-called primitive actually assisted the critical development of a counter-modern discourse that called the authority of western 'progress' into question. Far from the rigid dichotomy of self and other found in the tendency towards historical generalisation in certain strands of post-colonial theory, Mitter's historical enquiry into colonialism and nationalism in Indian art, as it developed from the 1890s to the 1920s, reveals a rather different story in which identities are constantly modifying one another in the very moment of their mutual encounter.

The communications revolution that brought about new forms of transport and travel at the turn of the century enabled individual and collective movement across national boundaries that almost always opened up the possibility of two-way traffic. The Bengali poet Rabindranath Tagore struck a chord with audiences in Europe and Latin America and, for their part, modernists such as Wassily Kandinsky and Paul Klee stimulated widespread interest when their works were exhibited in Calcutta in 1922. In proposing a notion of the 'virtual cosmopolitan' to account

for such cross-cultural patterns, Mitter shows how a historiography of modern art can advance out of the limitations of a Eurocentric world view by examining the unintended consequences of modernisation. The interrelationship between these three terms – modernism, modernity and modernisation – indeed forms one of the key motifs of this book.

While the cosmopolitan evokes the idea of a world-citizen, and suggests an outlook that is open and receptive to what is strange or foreign, the term was thoroughly imbued with pejorative connotations in 19th-century Europe. Often used to identify the mobility of wealthy élites who were seen to exist 'everywhere and nowhere' with little or no loyalty to the nation-state, the term also appeared in *The Communist Manifesto* (trans. 1888), as Paul Overy notes, where Marx and Engels re-accentuated it to describe the international dimensions of a market economy constantly expanding its search for raw materials and new consumers across the world. In the vocabulary of modern politics, 'internationalism' arose as an alternative, where it suggested class solidarity against the global march of industrial capitalism. Overy's study opens up a further aspect to the over-determined relationship between colonialism and modernism: the way 'whiteness' comes to be visible as a problem of identity when it is thrown into crisis. The modernist architecture of the 1927 Weissenhofseidlung model housing project adopted elements from North African and Middle Eastern cultures, but when such features provoked an anti-orientalist backlash in pre-Nazi Germany the volatile conditions of European modernism in the 1930s were revealed to cut across left/right distinctions. At what point did avant-garde confidence in revolutionary

internationalism give way to the institutionalisation of modernism as the International Style?[1] This well-established question receives an altered inflection in light of Overy's account of the 'white walls' of modernist architecture as a complex signifier of the cosmopolitan that arose in a period when the identity of 'Europe' itself was thrown into crisis by fascism and nationalism.

Twentieth-century traumas of global warfare and unfinished revolution are often evoked to explain the mid-century migration of modernism from European cities such as Paris, Vienna and Berlin to the United States and New York after 1945; but one could also observe that the converse journey of artists moving from colonial periphery to western metropolis has received much less art historical attention, even though it further highlights an on-going narrative of two-way traffic. The coexistence of different modernisms, in the plural, comes out as a core feature of the Caribbean milieux addressed by Michael Richardson and Lowery Stokes Sims. Where the cross-cultural fusion of African and European elements in the Caribbean region inspired the Cuban painter Wifredo Lam, and attracted surrealists such as André Masson and André Breton, the contrasting emphases taken in these two chapters highlights a perspectival approach in which the relevance of the past to the present is drawn out in different ways. Lam's refusal to perceive ancestral rituals and modernist painting as mutually exclusive interests made him post-modern *avant la lettre*, according to Sims; whereas Richardson argues that the universalist ethos of the surrealist outlook led to an affinity with the Negritude poets of the 1940s that has, in turn, been rejected by an insular conception of '*créolité*' in recent Francophone debates.

'Cosmopolitanism evokes mixed feelings', writes James Clifford in response to cultural studies debates that have tried to reinflect the term so as to investigate what could be called a 'cosmopolitanism-from-below', in which perspectives on mass migration, exile, asylum, and border-crossing feature prominently. Where cultures and identities are no longer understood as 'essences' fixed by the laws of nature, but are lived and experienced as 'worldly, productive sites of crossing: complex, unfinished paths between local and global attachments', Clifford's notion of a *discrepant cosmopolitanism*, 'gives us a way of perceiving, and valuing, different forms of encounter, negotiation, and multiple affiliation rather than simply different "cultures" or "identities".'[2]

In Ann Gibson's chapter on the abstract painting of Norman Lewis, and my chapter on the collages of Romare Bearden, the conflicted experiences of African American artists in the New York art world of the 1940s and 1950s can be seen to bear out some of the difficulties of 'encounter, negotiation and multiple affiliation' in a social world that was polarised by boundaries of 'race' and ethnicity. Even as the careers of these two black artists complicate the received assumption that minorities were simply excluded from the unfolding development of modernism at large, the story behind the Spiral group – which Lewis, Bearden and Hale Woodruff formed after the 1963 March on Washington led by Martin Luther King – presents a fascinating instance of how the relationship between art and politics was articulated without relying on a notion of an avant-garde. In a situation where artists from minority backgrounds had been seen as culturally 'backward', we find that the notion of historical time as a linear, homogenous chronology (which underpins the 'advance guard' as a combative frontier that pushes towards the future) was implicitly contradicted in the experience of African American artists who addressed the historic freedom struggles of the 1960s that redefined the very meaning of blackness as a significant figure of difference in the modern imagination.

With the first English translation of Ferreira Gullar's 'Theory of the Non-Object', which was highly influential in the Brazilian neoconcrete movement of the late 1950s, Michael Asbury demonstrates another facet to this altered view of historical time. The discrepant time-scale, whereby Gullar's interest in gestalt psychology and phenomenology pre-dated similar concerns on the part of minimalism in North America in the mid-1960s, does not so much reverse the traditional art historical concern with primordiality – who did or said what first – as it interrupts the sequential model of artistic chronology that many modernist art historians have inherited from the past. Indeed, where differences of culture, ethnicity or nationality interrupt the received narrative of 20th-century art, and thus introduce a critical 'differance' in the Derridian sense of delaying the closure of the signifying chain, what we find is not a wholly 'other' object of study that is somehow foreign or strange, but rather different ways of seeing that ask us to look and think again about art that is held to be familiar and taken for granted.

Offering the first explication of the philosophy of art put forward in C.L.R. James' essay on 'Picasso and Jackson Pollock' (1980), which has been overlooked until now by art historians and post-colonial critics alike, David Craven gives us a glimpse of what a truly 'worldly' account of modernism and modernity might look like. As Craven reveals, the subtle contrasts that James

makes in his readings of *Guernica* (1938), on the one hand, and *Autumn Rhythm* (1950), on the other, encapsulate a grasp of 'world culture' that goes far beyond our contemporary clichés of mere inclusion and wrestles instead with the 20th century's core dilemma, as Robert Rauschenberg expressed it in his often-cited statement: 'Painting relates to both art and life. Neither can be made. (I try to act in that gap between the two.)'.[3] In the sense that each of the modernist paradigms brought their questioning attitudes to bear precisely on this gap between art and life – worrying away at the frame that separates the picture plane from its perceptual surroundings, as Gullar puts it – the related historiographical duality between formalist and contextualist approaches is questioned by Craven's evocation of Mikhail Bakhtin's 'dialogical' method of enquiry.[4]

If the formal analysis of Heinrich Wofflin's *Principles of Art History* (1915, trans. 1950) sought to provide the discipline with a scientific basis of objectivity that was then modulated by the liberal humanist iconography of Erwin Panofsky, the social histories of art associated with Arnold Hauser, Frederic Antal and Meyer Schapiro placed the emphasis on the social contexts in which art transforms various materials in the process of producing meaning in different visual languages.[5] Perhaps there is a parallel here with Peter Wollen's writing on the concept of 'two avant-gardes' (which was actually addressed to the history of modernist cinema).[6] The drive to optical purity and the unconditional autonomy of the art object associated with such formalist critics as Roger Fry, Clive Bell and Clement Greenberg was constantly offset by the cut-and-thrust interventionism of constructivism, futurism, dada and surrealism as movements that sought to challenge the given realities of everyday life. Where would cultural difference feature in such a narrative? In the sense that the dialogue between art history and post-colonial studies has entailed a massive critique of the Eurocentric assumptions that were often masked by the supposedly value-free search for 'pure' form as a guarantee of aesthetic value, it might seem that the answer lies firmly in the contextualist axis. This foregrounds the institutional basis of artistic production and reception as material practices that are immanent to the power relations of the societies in which they arise. But, on the other hand, without attention to specific matters of form, would art not be reduced to images that can only illustrate their contingent contexts?

In the sense that contemporary studies in visual culture could trace a genealogy to the so-called New Art History of the 1970s, and to John Berger's *Ways of Seeing* (1972), the 'linguistic turn' brought about by the introduction of methods from semiotics, and subsequently post-structuralist theories of discourse, attempted to cross the binary divide between contextualist and formalist choices. Above all, feminist interventions overturned this either/or dichotomy by questioning the 'additive' model that assumed that artists hitherto excluded on account of gender could be simply added in to a pre-existing narrative without understanding why they were left out in the first place. Such historians as Norma Broude, Whitney Chadwick, Linda Nochlin and Griselda Pollock initiated a major paradigm shift by questioning 'the canon as a discursive strategy in the production and reproduction of sexual difference',[7] and hence a third option was created, which examines the history of art to explore the constitutive role of representation in

the social construction of reality and in the lived experiences of modern subjectivity.

Coming back to our contemporary moment, one might say that each of these critical developments has contributed to a conversation in which matters of cultural difference can now be moved on from the reactive critique of Eurocentrism and brought into a proactive relationship with a range of artistic traditions and lineages that are worthy of study in their own right. Each of the contributors to *Cosmopolitan Modernisms* performs such a move by virtue of the quality of attention given to individual artists, their words and their works, and the specific contexts in which they acted as 'world-citizens' who were curious to explore the creative potential of cultural differences. While 'the cosmopolitan' undergoes a semantic transformation on this critical return journey through 20th-century art, it is important to emphasise that the term is not being proposed as an evaluative or judgemental banner heading (in the sense that it is a good thing if you have it, too bad if you don't). Equally important is to acknowledge the number of regions that are missing from the book's coverage - Africa, the Arab world, China, Japan, Russia and Eastern Europe, First Nations in Australia and Canada, among others. In this respect, while the series aims to facilitate connections and comparisons among established and emerging areas of research (across a range of genre that includes interviews and translations), the premise that the history of art across the entire world should be 'programmed' by inclusion at each and every turn is one that we call into question.

Like the additive model before it, the contemporary ideology now surrounding the notion of 'inclusion' creates a pressure to pursue this goal as an end in itself, as if 'inclusion' was the end of the story. In contrast to the prevalent anthology model in contemporary publishing, which often aspires to be all-inclusive even at the risk of overwhelming the reader with information overload, each incremental step taken in the development of *Annotating Art's Histories* as an ongoing series seeks to overcome the barriers of specialisation (whether disciplinary, geographic, or identity-based) by making a long-range commitment to a consistently critical approach to the cultural history of art.

But what are the needs and expectations that anthologies, like large-scale survey exhibitions, aim to fulfil? Against the backdrop of the previously mentioned sequence of international exhibitions that has marked the institutionalisation of cultural diversity in the world of contemporary art, the next section offers a review of the encounter between the discourses of art writing and the driving concerns of the post-colonial turn.

Art History and Post-colonial Studies

In the twenty-five year period between writing *Orientalism* (1978) and his death in 2003, Edward Said's approach to the study of literature and culture has exerted considerable influence. His particular focus on western perceptions of the Middle East was addressed in *The Question of Palestine* (1983) and *Representing Islam* (1987), and the broad scope of his critically humanist outlook informed *Culture and Imperialism* (1993), but it was *Orientalism* that signalled a decisive turning point in intellectual life. Arguing that,

> without examining Orientalism as a discourse one cannot possibly understand

the enormously systematic discipline by which European culture was able to manage – and even produce – the Orient politically, sociologically, militarily, ideologically, scientifically, and imaginatively during the post-Enlightenment period,

he defined it as a 'network of interests [...] governed not simply by empirical reality but by a battery of desires, repressions, investments, and projections'.[8] By demonstrating that language played a primary and formative role in the discursive construction of 'the Orient' as an object of colonial knowledge, Said's methods issued a break from Marxist theories of ideology and the dependency model of Third World studies, both of which assumed a pre-existing reality that was merely distorted or mystified by hidden political interests. By virtue of employing post-structuralist concepts that attributed a 'world-making' role to representation,[9] this approach not only highlighted the importance of cultural practices in the discursive formation of colonial history, but also encouraged a degree of theoretical transferability to a wide range of world-historical situations.

Hence in the first phase of post-colonial studies, such texts as Tzvetan Todorov's *The Discovery of America: The Question of the Other* (1982), which went back to 1492 to show how European Renaissance identity was shaped by the AmerIndian encounter; Gayatri Spivak's *In Other Worlds* (1985), which examined materials from 19th-century colonial India; and the *"Race", Writing and Difference* (1985) collection edited by Henry Louis Gates Jr, each contributed to a paradigm-shift that displaced previous methods of cross-cultural enquiry in anthropology, the sociology of 'race' and

ethnicity, and the critique of neo-colonialism. While several important art historical studies made use of approaches that pre-dated the post-colonial turn, including Partha Mitter's *Much Maligned Monsters: History of European Reactions to Indian Art* (1977) and Hugh Honour's multi-volume series *The Image of the Black in Western Art* (1989), it may be said that Linda Nochlin's, 'The Imaginary Orient' (1983) marked one of art history's initial responses to Said's distinctive methods of enquiry.

Bringing her analysis of 19th-century realism to bear on orientalist paintings, Nochlin's account of the naturalistic depiction of exotic scenes that served as a screen upon which a mythological 'timelessness' deflected attention from the chaotic upheavals instigated by French military campaigns in North Africa, concurred with Said's approach. Her insights into Delacroix's romanticist orientalism, as seen in *Death of Sardanapalus* (1827–28) with its underlying fantasy of masculine omnipotence in which female bodies, like colonised countries, could be owned or disposed of at will, introduced issues of gender and sexuality that had not been uppermost in Said's account. Further studies in the context of the Arab world, such as Malleck Allouah's *The Colonial Harem* (1985), extended such insights, while others, such as John MacKenzie's *Orientalism: History, Theory and the Arts* (1995), have flatly rejected Said's framework.

Just as Nochlin wrote in response to a 1982 exhibition, Hal Foster's 'The "Primitive" Unconscious of Modern Art, or White Skins, Black Masks' (1985) was one of many responses to William Rubin's 1984 MoMA exhibition. *'Primitivism' in 20th Century Art* proved to be a flashpoint for a range of criticism that galvanised at the point where post-colonial thought met the

cultural politics of various 'identity' movements. In the mid-1980s context, the far-reaching impact of new ways of understanding the legacy of the colonial past cut across any clear disciplinary distinction between art criticism and historical analysis. On the one hand, although Foster's criticism marked the first moment at which post-colonial concerns were taken on board by historians of modernism, it was not until the mid-1990s that in-depth approaches to primitivism were developed. During the first phase of the dialogue between post-colonial studies and art criticism it may be said that the epistemological break triangulated by the post-colonial, the post-modern and post-structuralist theory was in many ways led by artists themselves. In Britain and the United States, the philosophical critique of Eurocentrism was sharpened by criticisms of exclusionary practices in contemporary arts institutions. The artist Rasheed Araeen, for instance, established the journal *Third Text* in 1987 and subsequently curated *The Other Story: Afro-Asian Artists in Post-war Britain* (1989), which was the first historical survey of its kind. In this volatile milieu, in which different constituencies were each coming to terms with the changing attitudes signalled by the ubiquitous prefix 'post', texts such as Homi Bhabha's 'The Other Question – The Stereotype and Colonial Discourse' (1983) were equally influential in providing a new vocabulary for cultural criticism, even though they were not primarily addressed to the visual arts as such. Hence, on the other hand, what arose from the interdisciplinary conversations generated in this period came to be identified as 'visual culture'. Before looking at some of the insights and blind spots of the visual culture paradigm, it is important to take account of the concept of

'otherness' that emerged as the key concept in this major epistemological shift.

Whereas Nochlin followed Said's historical analysis to question the accuracy or veracity of western depictions, it was precisely the model of representation as adequation or correspondence to reality that Homi Bhabha challenged. As collected in *The Location of Culture* (1994), Bhabha's essays introduced deconstructionist methods from Derrida and psychoanalytic theories from Lacan to augment the Foucaldian approach that Said had taken. Drawing on traditions in continental philosophy, this innovative framework helped to establish the examination of the relational positions of self and other in the symbolic realm of language as the defining axis of a new vocabulary in cultural criticism. With richly productive insights into the ambivalent dynamics of fear and fascination surrounding the ego's relationship to the imaginary other; into the way that stereotypes act according to a logic of fetishism in which the ego's dependence on the other is denied and disavowed, even as its illusion of omnipotent control is anxiously maintained; and, above all, with his insights into the importance of the gaze in the looking relations of the colonial scene, Bhabha's contribution was highy influential across several disciplines.

Significantly, the concept of fetishism also animated Foster's critique of MoMA's 1984 *'Primitivism'* exhibition, which proposed that formal and morphological affinities among tribal artefacts and modernist art were evidence of universal patterns in human perception. Suggesting an analogy between the extractive economy of imperialism and the de-contextualisation of non-western objects, mostly not intended to be exhibited for

aesthetic contemplation as art, Foster's contribution sought to reveal the interdependent relationship of modernism and colonialism that was historically disavowed by Eurocentric ideologies that upheld a formalist doctrine of absolute autonomy.

Where notions of fetishism cut across Marxist and Freudian fields of enquiry, and had been further reinflected by feminist art writing, the psychoanalytic orientation in the analysis of 'race' and representation played a doubly important role. On the one hand, such an approach paved the way for the rediscovery of Frantz Fanon's *Black Skins, White Masks* (1952, trans. 1967), which had revealed the complex entanglement of coloniser and colonised as two faces of an inter-subjective structure that in Fanon's view recast the account of mutual recognition storied in Hegel's master/slave dialectic. This approach informed the politics of representation that was acted upon by artists from post-colonial and diaspora backgrounds throughout the 1980s. On the other hand, however, the battery of concepts associated with the post-structuralist focus on self and other had the outcome of elevating the analysis of representation out of any one empirical reference point, such that art, film, photography or literature could all equally serve as 'texts' to be taken as raw material for the overarching contextualist orientation of the visual culture paradigm.

In light of the double meaning of 'representation' as both a practice of depiction and a practice of delegation – both of which pertain to the relationship of art and politics – the tendency that endowed the critical analysis of self and other with a wide degree of theoretical transferability undoubtedly contributed to the breakthrough moment of the late 1980s.

Where Araeen addressed the continuity of a Eurocentric mind-set across the historical crisis of modernism in 'From Primitivism to Ethnic Arts' (1987), the critic Michelle Wallace echoed this wide-ranging purview in her essay on 'Modernism, Post-Modernism and the Problem of the Visual in Afro-American Culture' (1990). The survey of African American, Latino American and Native American artists in *The Decade Show* (1990) was complemented by the New Museum's anthology *Out There: Marginalisation and Contemporary Culture* (1990).

In the European context, the pluralist approach taken by curator Jean-Hubert Martin in *Magiciennes de la Terre* (1989) responded to MoMA's anachronistic view of primitivism by prominently featuring a variety of contemporary non-western materials (even if they were mostly craft objects). While the exhibition's controversial reception generated insightful responses in the writings of critic Thomas MacEvilley in *Art and Otherness* (1992), and Susan Hiller's *Myths of Primitivism* (1991) anthology, *Magiciennes de la Terre* marked the point at which metropolitan arts institutions took the critique of Eurocentrism on board by turning to 'the global' as a programming framework that would both redress the omissions of the past and incorporate the discourse of identity brought into circulation by contemporary art. Whereas the attempt to curate on the basis of identity politics had led to the highly divisive reactions that arose in response to the Whitney Biennial of 1993, to which Homi Bhabha contributed the essay, 'Beyond the Pale: Art in an Age of Multicultural Translation', the global turn characterised by the growth of the international biennale exhibition circuit in such locations as Australia, South Korea, Turkey and South Africa proved to be the more

prevalent institutional means for seeking a resolution to the questions raised by post-colonial concerns. Such developments were the subject of critical analysis in Jean Fisher's edited collection, *Global Visions: Towards a New Internationalism in the Visual Arts* (1994) which featured the views of such practising artists as Jimmie Durham and Everlyn Nicodemus, as well as art historians such as Sarat Maharaj and Judith Wilson.

In this second phase of dialogue, one could observe a complementary relation between visual culture and art history where both sought to re-examine the historical construction of cultural difference in diverse practices of representation. The focus on self and other that provides the principal theme for such studies as Maria Torognovic's *Gone Primitive: Savage Intellects, Modern Lives* (1990) and *Negrophilia: Black Culture and Avant-Garde Paris* (2001) by Petrine Archer-Straw, was matched by the critical study of the gaze in ethnographic photography, as seen in Elizabeth Edwards' anthology on *Anthropology and Photography 1860–1920* (1992). The study of collecting undertaken by James Clifford in *The Predicament of Culture* (1988) was followed by Timothy Mitchell's 'Orientalism and the Exhibitionary Order' (1988); Annie Coombes' study of British institutions in *The Invention of Africa* (1993) and the wide-ranging remit of *Colonialism and the Object* (1998) edited by Tim Barringer and Tom Flynn.

Art history surveys undertaken in light of post-colonial critique, such as Colin Rhodes' *Primitivism and Modern Art* (1994), and texts that revise the curriculum, such as the Open University book on *Primitivism, Cubism and Abstraction* (1993), have revealed that the phenomenon was always more than a style, a school, or a phase, as primitivism was of foundational importance for the very birth of modernism. The innovative study of visual and literary materials in Sieglinde Lempke's *Primitivist Modernism: Black Culture and the Origins of Transatlantic Modernism* (1998) also serves to demonstrate the paradoxical role that primitivism played as a catalyst for artists of colour, an important point often lost sight of when the critique of Eurocentrism is pursued as an end in itself.

Questions for Visual Culture

In the sense that the global turn of the mid-1990s brought about a fusion between the discourses of the international and the multicultural, it may be said that a third phase of *rapprochement* in the dialogue on cultural difference and the visual arts has led to the current consensus on inclusion. Characterised by the blockbuster exhibition genre and the anthology format in arts publishing, the drive to be all-inclusive has, however, been an ambivalent and uneven affair.

At the very moment when post-colonial studies were taken to task in critiques launched by Benita Parry and Aijaz Ahmed, amongst others,[10] prominent art critics such as Lucy Lippard and Robert Hughes took contrary views on the significance of diversity in the arts, which had given rise to the so-called 'culture wars' in which the very language of public debate was thrown into crisis.[11] In the sense that 'inclusion' has come to provide a settlement to these disputes, it is important to underline the choices that are now available in terms of a vocabulary for understanding the changing relationships between art and society in the 20th century.

The detailed account provided in the preceding section has been necessary because without informed choices for a critical vocabulary for dealing with matters of cultural difference, we find that old orthodoxies are merely reproduced with new contents. The comprehensive scope of Edward Lucie-Smith's *Race, Sex and Gender in Contemporary Art: The Rise of Minority Culture* (1994) ratified the growing interest in diversity on the part of public institutions and the international art market. The nomenclature of 'racial minorities' that appeared in Lucie-Smith's subsequent survey of art since 1945, *Art Today* (1999), is, however, somewhat puzzling because it is widely understood that there are no such things as 'races' – the very term is a historical product of the discourses that made monocultural world-views appear to be 'natural' in a bygone era when western hegemony went unquestioned.

Turning to the ways in which teaching and research in art history have taken these questions on board, this introduction draws to a close by considering three tendencies that are symptomatic of unresolved issues in this field of study. The first concerns uneven patterns in the production of knowledge. Where the area-studies model institutionalised the academic study of art in pre-colonial periods for such regions as the Indian sub-continent, imperial China, and pre-Colombian art in the Americas, other cultural regions such as Native North America, Aboriginal Australia and continental Africa have only come into view as fields of study within the past ten to fifteen years. One of the ways in which such disparities have been addressed has been through anthologies that offer a compendium of writings around a geographically defined topic. *Chinese Art at the Crossroads* (2002), edited by Wu Hung, which

questions the traditionalist focus that tends to minimise attention to modern art in China and its diasporas, exemplifies an intellectual response that takes these uneven conditions into account. On the other hand, the very title of *Reading the Contemporary: African Art from Theory to the Marketplace* (1999), a first of its kind anthology edited by curator Okwui Enwezor and artist-cum-historian Olu Oguibe, hints at some of the pressures of supply and demand that inform the choices and decisions frequently made in the name of inclusion.

While the integration of continental Africa into the international art world has been long overdue, and Enwezor's and Oguibe's ground-breaking initiatives have sought to redress this imbalance, the privileged focus that 'the contemporary' enjoys as that which 'talks back' to the colonial discourse of the past has the unwitting outcome of obscuring earlier periods in the first half of the 20th century. Far from being a matter of individual intentions, one finds this pattern – whereby art of very recent provenance is held to counter-balance representations from the colonial era – across the field as a whole. In *The Third Text Reader on Art, Culture and Theory* (2002), an editorial decision was taken to omit monograph-style articles on individual artists and, as a result, attention to modernist history, although present, is overshadowed by the sheer quantity of material that primarily concerns identity issues in contemporary politics.

Secondly, the rise of visual culture has compounded this tendency. While many competing approaches each take a different emphasis, the study of representation that proceeds on the view that medium-specificity has been historically transcended often tends to feature cultural difference in the medium

of photography and film rather than the visual arts per se. *Visual Culture: The Reader* (2002), coedited by Jessica Evans and Stuart Hall, foregrounds photography as the medium for addressing 'race' and ethnicity, while Nicholas Mirzoeff's *The Visual Culture Reader* (1997) features writings on 'visualising race and identity' as a counterpart to 'visual colonialism'. The tendency to interpret the post-colonial as 'talking back' to the discourse of self and other, as defined by the power relations of the colonial scene, even results in situations where actual works of art are shown but not discussed at all – as is the case of Gavin Jantjes' *Untitled* (1989), a painting that quotes a fragment from *Demoiselles D'Avignon*, that appears on the cover of *Colonial Discourse and Post-Colonial Theory* (1993), edited by Patrick Williams and Laura Chrisman, but which received no discussion in the anthology itself.

Thirdly, to what extent do the origins of post-colonial studies in literary criticism precipitate a textualist approach that entails 'scanning' visual culture for predetermined contents? The problem here is that 'reading' visual culture not only tends to conflate the history of art with the treatment of history by contemporary artists, but also that the aesthetic dimension of the work of art is made secondary to the variety of 'meanings' that the interpreter can find in it. Jean Fisher addressed this reductive tendency in 'The Work Between Us' (1997) by questioning the limitations of the linguistic model, but it is significant that Partha Mitter had previously pinpointed the way in which theories of '"colonial discourse" suffer from a sense of pre-destination'. Where Mitter suggests that 'the past... is a form of otherness', and that historians of the arts 'respond

imaginatively to the ineluctable "foreignness" of the past', [12] it may be said that the avoidance of close attention to modernist practices on the part of non-western and minority artists throughout the 20th century as a whole is reinforced by the predominant style of a critique of Eurocentrism that endlessly returns the discussion to western artists and institutions.

Modernism as a Story of Migrations

Building on some of the lines of enquiry reviewed in this introduction, and raising questions for the field of cross-cultural studies along the way, *Cosmopolitan Modernisms* takes a look at some of those missing modernists hitherto squeezed out of the picture. Have we now arrived at a place where comparisons and connections can be made between previously separate areas of research? While the prospect of comparative study is clearly on the agenda of some promising recent developments, [13] the response to this question indicated by the contributions to this book suggests that it may be more valuable to leave the connective dots open to reflection rather than attempt to close up 'world art' in a programme of total inclusion. Nonetheless, four distinct strands weave in and out of this return journey through various moments in 20th-century art.

Migration as a historical feature of modernism: Revealing the earliest known use of the term 'modernismo' in 1888, by Nicaraguan poet Rubén Dario (1867–1916), David Craven has elsewhere demonstrated that the circulation of the term in Guatemala, Peru and Spain predated its appearance in the western European context, where 'the most common

Gavin Jantjes, *Untitled*, 1989

term for modernism in the teens and twenties was simply "the new art" ("el arte nuevo" or "die neue Kunst")'.[14] Without returning to philology, such evidence offers alternative ways of understanding the fluid state in which a variety of modernisms coexisted prior to the institutional narratives of the post-1945 period. Echoing Raymond Williams' view in *The Politics of Modernism* (1989), that it was in, 'a generation of "provincial" immigrants to the great imperial capitals that avant-garde formations and their distanced, "estranged", forms have their matrix',[15] Craven suggests the history of modernism is best viewed as a delta, rather than a homogenous mainstream. Like Mitter and Overy, he finds the definition of modernism put forward by Perry Anderson[16] – in which the break with naturalistic conventions in academic art, the proximity to social revolution, and widespread fascination with technology emerged as key facets of a new attitude to art – as providing a viable starting point for examining historical similarities and overlaps that were obscured by the subsequent institutional equation of modernism with European and American formations. By virtue of being able to conjoin two or more disparate cultural and geographical spaces, a migrant perspective cuts across the nation-state as the primary basis of identification and affiliation and points to the role of both the city and of knowledge-based élites as sociological conditions of access to art education and professional patronage on the part of non-canonical artists.

Primitivism as counter discourse:
Embedded with reference to the 'invented traditions' thesis and the 'imagined communities'

thesis in historical and cultural studies, Mitter's highly productive notion of primitivism as a discourse of the counter-modern resonates with Lowery Sims' insights into a 'second wave' of primitivism on the part of artists in the African diaspora. In contrast to the self and other axis of post-colonial theory, the detailed investigations into the cultural transformation of artistic sources that were made available by the two-way traffic of modernisation casts the question of agency in a different light. Whereas the political discourse of anti-colonial nationalism in India provided one set of conditions for the re-articulation of the primitive in the critique of western 'progress', could it be said that a certain degree of complicity with the discourse of primitivism on the part of the Harlem Renaissance generation of African American artists points to a converse situation in which agency was activated by an appropriation of an imagined 'Africa' marked by such tropes as irony, parody and repetition?

Stylistic choices and contingent contexts:
While visual studies often use literary methods to examine modernist art, the contextualist approach that seeks to tease out recurring stylistic affinities across paintings, poetry and novels has seldom featured in the visual culture paradigm. While my chapter attempts to trace such links between Romare Bearden's collages and Ralph Ellison's writings, the scope of Michael Richardson's chapter and his previous work as editor and translator of *Refusal of the Shadow: Surrealism and the Caribbean* (1996) points to an approach in which the literary and the visual may illuminate one another without being reduced to equivalent expressions of culture or identity. In this respect, attention to

the genealogy of concepts of 'style' may open a critical passageway between art history and cultural studies. Where formalist historians such as Wofflin and Riegl sought to dis-articulate 'style' from the evolutionist framework of the 19th century, where it was saturated with racist and nationalist values, the disciplines of linguistics and anthropology played an important role in Shapiro's anti-hierarchical conception of art as a visual language, which in turn influenced the notion of style as an expression of sub-cultural resistance or dissidence. Ann Gibson's view that the theoretical insights of post-colonial studies can be reconciled with the empirical study of overlooked minority modernists by actually looking at their work for the first time – as her *Abstract Expressionism: Other Politics* (1997) does in detail – articulates a constructive reply to calls for historical revision that remain abstractly rhetorical. In so far as 'style' mediates the contingent contexts of material production, it provides a conceptual bridge to the aesthetic dimension of the art object that cannot be reduced to matters of representation.

Chronotopes of modernity:
The figurative presence of Bakhtin and his dialogical method hovers over many of the exit routes suggested across the book as a whole in terms of finding ways out of the current predicament of cross-cultural approaches to the history of art. Defined in *The Dialogic Imagination* (1975, trans. 1981) as 'an optic for reading texts as x-rays of the forces at work in the culture system from which they spring',[17] the term pertains to Michael Asbury's reflections on neoconcretism in 1950s Brazil, which question the temporal logic of 'deferred action' that Hal Foster evokes

to account for the neo-avant-garde of the North American scene. Although other contributions also express doubts as to notions of historical time as developmental 'progress', and thus question the evaluative claims made for various avant-garde formations, the use of chronotopes to explore the multiple time-scales of diaspora life in Paul Gilroy's study of *The Black Atlantic* (1993) nonetheless resonates with the view of temporal deferral as a characteristic of historical trauma. To what extent might Bakhtin's chronotopes shed light on a world system that was perpetually vulnerable to crisis, according to Enrique Dussell, even though the hegemony of Eurocentrism strained to 'manage' the illusion of unbroken continuity from 1492 to 1945?[18] Because chronotopes are time–space categories to be found in cultural forms themselves, rather than in abstract systems that aspire to objective measurement, how might our understanding of modern art be altered and modified once their presence in individual works of art is taken into account? En route to modernism's cross-cultural past, this is a question that we are only now beginning to ask.

NOTES

1. The Third Manifesto of the De Stijl movement in 1921 placed the emphasis, 'not [on] the spirit of socialism nor that of capitalism, but rather an "International of the spirit which is spiritual".' Hans Belting, 'The Unwelcome Heritage of Modernism: Style and History', in *Art History After Modernism*, Chicago and London: University of Chicago, 2003, 34. See also Paul Overy, *De Stijl*, London and New York: Thames and Hudson, 1991.
2. James Clifford, 'Mixed Feelings', in Pheng Cheah and Bruce Robbins eds, *Cosmopolitics: Thinking and Feeling Beyond the Nation*, Minneapolis: University of Minnesota, 1998, 362 and 365. Other contributions to this debate include Homi Bhabha, 'Unsatisfied Notes on Vernacular Cosmpolitanism', in Peter C. Pfeiffer and Laura Garcia-Moreno eds, *Text and Narration*, Columbia S.C.: Camden House, 1996, and 'Cosmopolitanism', *Public Culture*, vol. 12, no. 13, 2000.
3. Robert Rauschenberg quoted in Lucy R. Lippard, *Pop Art*, London and New York: Thames & Hudson, 1966, 6.
4. Mikhail Bakhtin, *The Dialogic Imagination* [1975], Austin: University of Texas, 1981; see also M. Bahkhtin/P.N. Medvedev, chap. 3, 'The Formal Method in European Art Scholarship', in *The Formal Method in Literary Scholarship*, Cambridge and London: Harvard University Press, 1985.
5. Heinrich Wofflin, *Principles of Art History: The Problem of the Development of Style in Later Art* [1915], New York: Dover, London: Bell & Hyman Ltd, 1950; Erwin Panofsky, *Studies in Iconology: Humanistic Themes in the Art of the Renaissance* [1939], New York: Harper & Row, 1972; Arnold Hauser, *The Philosophy of Art History*, London: Routledge and Kegan Paul, 1959; Frederick Antal, *Essays in Classicism and Romanticism*, London: Routledge and Kegan Paul, 1966; Meyer Schapiro, *Words and Pictures: On the Literal and the Symbolic in the Illustration of a Text*, The Hague: Mouton, 1973.
6. Peter Wollen, 'The Two Avant-Gardes', *Studio International* (November–December 1975), in *Edinburgh '76 Magazine*, 1, London: British Film Institute, 77–85.
7. Griselda Pollock, *Differencing the Canon: Feminist Desire and the Writing of Art's Histories*, London and New York: Routledge, 1999, 26; see also Linda Nochlin, 'Why Have There Been No Great Women Artists?', in Thomas Hess and Elizabeth Baker eds, *Art and Sexual Politics*, London and New York: Collier Macmillan, 1973; Rozsika Parker and Griselda Pollock, *Old Mistresses: Women, Art and Ideology* [1981] London: Pandora, 1986; Norma Broude and Mary D. Garrard, *Feminism and Art History: Questioning the Litany*, New York: Harper & Row, 1982; Whitney Chadwick, *Women, Art, and Society*, London and New York: Thames & Hudson, 1990.
8. Edward Said, *Orientalism*, London and New York: Routledge, 1978, 3 and 8.
9. See Edward Said, *Beginnings: Intention and Method*, New York: Basic Books, 1975 and *The World, the Text and the Critic*, London: Faber, 1983.
10. Benita Parry, 'Problems in Current Theories of Colonial Discourse', *Oxford Literary Review*, 9 (1 & 2), 1987; Aijaz Ahmed, *In Theory: Classes, Nations, Literatures*, London: Verso, 1992; Arif Dirlik, *The Postcolonial Aura: Third World Criticism in the Age of Global Capitalism*, Boulder, CO: Westview Press, 1997.
11. Lucy R. Lippard, *Mixed Blessings: New Art in a Multicultural America*, New York: The New Press, 1990, Robert Hughes, *The Culture of Complaint: The Fraying of America*, New York: Oxford University Press, 1993; see also Brian Wallis, Mariane Weems and Philip Yenawine eds, *Art Matters: How the Culture Wars Changed America*, New York: New York University Press, 1999.
12. Partha Mitter, *Art and Nationalism in Colonial India, 1850–1922,* Cambridge: Cambridge University Press, 1994, 8.
13. In the UK, the Arts and Humanities Research Board has provided support for a major initiative in comparative studies on Art and National Identity in India, Japan and Mexico (1860s to 1940s) coordinated by Orianna Baddeley (Camberwell School of Art), Partha Mitter (University of Sussex) and Toshio Watanabe (Chelsea School of Art). The website created by the project on Globalising Art, Architecture and Design History features information and contacts as well as a keynote speech by Donald Preziosi, 'Grasping the World: Conceptualising Ethics after Aesthetics', www.glaadh.ac.uk.
14. David Craven, 'Modernism', in Maryanne Cline Horowitz ed., *New Dictionary of the History of Ideas*, New York: Scribners & Sons, 2005 (in preparation).
15. Raymond Williams, *The Politics of Modernism*, London: Verso, 1989.
16. Perry Anderson, 'Modernity and Revolution', *New Left Review*, no. 144, 1984.
17. Mikhail Bakhtin, 1981, op. cit. 425–26.
18. Enrique Dussell, 'Beyond Eurocentrism: The World System and the Limits of Modernity', in Fredric Jameson and Masao Miyoshi eds, *The Cultures of Globalization*, Durham N.C. and London: Duke University Press, 1998, 3–25.

REFLECTIONS ON MODERN ART AND NATIONAL IDENTITY IN COLONIAL INDIA: AN INTERVIEW

PARTHA MITTER

Partha Mitter is Research Professor in Art History at the University of Sussex and an internationally acclaimed authority on Indian art. His first book, Much Maligned Monsters: History of European Reactions to Indian Art *(1977) broke new ground in the comparative study of art, and his authoritative survey on* Indian Art *(2001) encapsulates the breadth of his scholarship across ancient and modern periods. Professor Mitter is the recipient of numerous fellowships, including Clare Hall, Cambridge University (1970–74); the Institute of Advanced Study, Princeton University (1981–82) and, most recently, he has been Scholar at the Getty Research Institute (2000–01) and Resident Fellow at the Clark Art Institute, Williamstown (2003–04). The following interview, conducted at his Oxford home in January 2004, touches on the wide range of his research interests, and takes the period examined in his unique and definitive study of* Art and Nationalism in Colonial India, 1850–1922 *(1994) as its principal focus.*

Kobena Mercer: The critique of the 'canon' seems like a good place to begin because this is where the concerns of post-colonial studies come into contact with questions raised by a critical art history. Both are concerned with exposing the limitations on knowledge brought about by underlying ideologies, such as Eurocentrism. Have such critiques affected your approach as an art historian?

Partha Mitter: Well, as far as I can see, my book *Much Maligned Monsters*, published in 1977, laid bare for the first time the cultural preconceptions that informed western representations of other art traditions, thus prefiguring the orientalism debate.[1] I examined how western

misrepresentations contributed to the construction of the history of Indian art. Moreover, ever since the late 18th century, art history has been concerned with classifying artefacts or art objects in terms of their style and morphology, an exercise that came under attack in the 1970s from a wide range of scholars, including myself, who challenged the more conservative aspects of the discipline. The broad historical background is important to bear in mind here because, from the 19th century onwards, art history has claimed to be objective, like the natural sciences, and yet, as I see it, its discourse has been dominated by many unexamined ideas such as the classical canon, the value of naturalism and the norms of taste, and much of this goes back to Vasari's stylistic categories. If I can put it this way, the two major preoccupations of art history have been with stylistic genealogy and teleology, which, taken together, dictated that all art must be placed on a universal scale and ranked within a hierarchical system.

So when you turn to histories of Indian art, which were written initially by Europeans, who had tremendous influence on Indian writers as well, what you immediately encounter is the clash of taste. An example might be the leading authority James Fergusson, the creator of the chronology of Indian art and architectural history in 1876, who claimed to be a great admirer of Indian art. He said that India could never reach the intellectual heights of Greek art, but existed on a lower step of the ladder, even though her arts were rich and original. He claimed that the chief characteristic of Indian art was that it was written in decay. Among other themes, which were even more fundamental, that deeply affected artists in colonial India, was the idea that art is universal, that there are clear rules of

art, and that you know what good art looks like, because the values of naturalism or verisimilitude were held to be universally valid.[2]

KM: So when did modernism make its appearance in India?

PM: As we entered the 20th century, Indian artists faced the great challenge of modernism, from 1922 onwards. I use that precise date because a very important exhibition of Klee, Kandinsky and Bauhaus artists took place in Calcutta that year, at the invitation of the great Indian poet Rabindranath Tagore. Though its immediate impact was unclear, this major event slowly affected the outlook of Indian artists. Here we must remember that reproductions were a very important influence in Indian responses to western art. From the 1920s onwards, as modernist 'technologies' like cubism came into India, and were adopted, we need to examine how art reproductions in books and magazines contributed to the reinterpretations of cubism that was specific to the Indian context. Being far away from the actual metropolitan scene, the main sources used by colonial artists were reproductions as they had little chance of seeing original works of artists like Picasso.

KM: Since modernism repudiates the classical canon, did things improve?

PM: No! Coming back to the canon, by the 1920s, the modernist canon had replaced the earlier classical canon with its own claims to universal validity. The crucial point I'm trying to stress is the claimed universality of all western canons, since the way you judge any artist is dependent on the way in which art history has been written.

Let's take the first major book written on modern Indian art as a case in point. Its author, W.G. Archer, uses the western modernist canon to explain the reception of modernism in India.[3] The concept of a 'canon' is still crucial in terms of how we understand the impact of modernism on Indian artists. Even today, non-European artists are seen as marginal and peripheral, unless they are accepted within the European framework. Anish Kapoor is a wonderful artist, and I do like his work very much, but one of the reasons he's accepted is because he doesn't challenge the canon, and so he becomes part of the canon. Those who do challenge the canon, consciously or unconsciously, have a problem.

KM: How does this view inform your approach to modern art in India, where you set out to show 'the actual transformations of western sources by colonial artists'?

PM: Well, let me start with the question of influence, which is a very important principle used in art history, and has been important in evaluating modern Indian art. The first cubist artist in India was Gaganendranath Tagore, nephew of the poet Tagore. When he studied Gaganendranath's work, Archer was infuriated by the fact that these paintings were semi-narrative in character and yet they had the temerity to try and imitate cubism. He believed, with Clive Bell and Roger Fry, that you had to distinguish between formal purity and the anecdotal subject matter of narrative art. Archer came to the conclusion that Gaganendranath's works lacked vigour, which in some mysterious way was present in Braque and Picasso. So for him, they're weak as art, but then, on the other hand, he also says that these works are un-Indian.

Gaganendranath Tagore,
Cubism, c.1921

Now why does he say that? Well, Archer's judgement basically rested on dominant western historical ideas, which affected representations of non-western art. To put it very simply, in the colonial situation, if you imitate a style perfectly, you are really aping or mimicking a western form. But on the other hand, if you are unable to do that, you become second-rate, an ersatz artist or, let's say, a Picasso *manqué*. You really can't make it either way, and you might say, in Homi Bhabha's phrase, that the modern Indian artist is 'white, not quite'. The key issue here is that the art historical principle of influence is not a neutral and objective concept. In the case of Archer's reaction to modern art in India, the reason why he found Gaganendranath's use of cubism to be a kind of failed cubism was because of the added dimension provided by colonial power. Because cubism was regarded as the product of European civilisation, an Indian artist who engaged with it was immediately locked into the interdependent relationship between the coloniser and the colonised.

KM: But don't you think influence creates dependent relationships?

PM: I thoroughly disagree with this sentiment. 'Influence' has been a fact of world art history or cultural transmission right from ancient times. The Greeks were defeated by the Romans and were held in condescension by them, and yet the Romans greatly admired Greek poetry and art: they emulated Greek art as a cultural ideal. Cultural transmissions and borrowings do not always mean subordination but represent a continuous flow of styles and motifs from one country to another and the crossing of frontiers entails the continuous hybridisation of art forms. Here power relations can be totally absent.

KM: So how should we approach Gaganendranath's cubism?

PM: A more productive way of looking at Gaganendranath's cubism is to identify his 'intentions' and explore how they differed from those of other exponents. Let's take analytical cubism in the period 1909–1910: what Braque and Picasso were doing was simply nothing less than bringing 400 years of naturalism to an end. This is the great revolution of the picture plane brought about by creating conflicting relationships of light and shadow, which breaks up the naturalistic depiction of objects in space. But if you look at the expressionists – Georg Grosz, Franz Marc or Lyonel Feininger, for instance – these artists were not primarily interested in the revolutionary aspects of cubism. What were they interested in? Its decorative possibilities. Grosz was using cubism to tell a story about revolution and his *Homage to Oskar Panizza* (1917–18) is a brilliantly created series of fragmented objects within a canvas; Marc was really using cubism to create decorative designs. But in either case, these artists were not interested in Picasso's central concerns. And there have been a whole range of 'creative' misunderstandings of cubism that could take you all the way to Russia, to early Malevich.

If you take Gaganendranath, he was constantly experimenting within the Indian context. Initially, he used Pan-Asian elements from Japanese and Indian art to construct a new 'oriental' art form. Cubism provided him with another 'technology' to create dazzling patterns, broken-up objects, and multi-faceted planes.

In this way he created a fairy-tale world of imagination through cubism. Now this is something very different from cubism as originally achieved by Picasso and Braque, and proceeds in a way that is very different from the original intentions of Picasso and Braque in the Parisian context. Thinking seriously about how can we study these differences without getting stuck in the colonial problem of the periphery or margin as compared to the metropolitan centre – bearing in mind, of course, that for modernism it is Paris and not London that is actually the centre – there is a another way of addressing the issues.

Recently I have been reading John Clark's *Modernity in Asian Art*, which uses the semiotic theories of Umberto Eco to study the transmission of the discourse of modernism to Asia – when it's transferred to India, it becomes in some ways a different discourse, because it leads to different questions and different aims. The drawback of the close discourse of western avant-garde lies in its failure to accommodate new non-western discourses.[4] This seems to accord with my own view that what we find from the mid-19th century onwards – when we look at the wider cultural aspect of modernity – is that the world is slowly becoming global. It's not necessarily that globalisation happened within a decade or so, but, nonetheless, what is happening in modernism is a kind of archaeology, in which the artist in his studio or the curator in his museum has access to the art of the world. All artists in the West and non-West engage in this sort of archaeologising, but the exercise is valorised differently. Picasso's 'primitivism' is usually dismissed as having very little impact on the basic core of his art. In other words, even if Picasso uses African art this has only a marginal effect on his achievement, or to put it differently, his artistic integrity is not compromised by such borrowings. But as you have seen, poor Gaganendranath's 'hybrid' cubism does not enjoy such luxury. I think we need to consider 'borrowings' differently. As with Picasso, so with Gaganendranath: both use sources taken out of context, but they transform them in the light of their own needs and experiences.

KM: So in the case of cubism, you are suggesting that Gaganendranath's appropriation had more in common with the German expressionists than with the attack on illusionism carried out by the exponents of analytical cubism in France?

PM: Indeed, the German critic Max Osborn, at an exhibition of modern Indian art in Berlin in 1923, quite perceptively spotted an affinity between the Indian artist and the expressionists. But let me take another example: the famous 1922 exhibition in Calcutta, which showcased Bauhaus artists, also involved the eminent Austrian historian of ancient Indian art, Stella Kramrisch, then working in Calcutta. As she pointed out, the art of the Indian nationalist artists – the proponents of the Bengal School in the early 20th century – was very similar in spirit to the art of Kandinsky and the abstract artists. Why? Because European art didn't necessarily mean naturalism, and that the transformation of the forms of nature in the work of art was as common to ancient and modern India as it was to modern Europe. Do you recall what Kandinsky says? 'Our sympathy, our understanding, our inner feeling for the primitives, arose partly because, like us, these pure artists wanted to capture in their works the inner essence of things.' And he then asks – and this is very significant – 'And pray,

who are these primitives?' And he concludes, 'Now one looks at the wisdom of those who are held in condescension by the West and seen as savages, and now being studied by theosophists. A crudely carved column of an Indian temple is as much animated by the same soul as any living modern work.'[5]

So why is Kandinsky saying that? Because – and this is an interesting aspect of primitivism as a global art movement – the discourse gives rise to a 'counter-modern' tendency in which artists in India and Europe see themselves challenging this whole business of progress and teleology. In this period it is not only Kandinsky, but also Malevich, Mondrian, and others who were reading ancient Indian texts such as the *Upanishads* and the *Bhagavad Gita*. For Kandinsky, the anxiety that materialism had turned the world into an evil place meant that humanity could be rescued by art. Theo van Doesburg justifies non-representational art by quoting a story of the Buddha. Malevich doesn't call his work non-objective, but very interestingly, he says that it dissolves objectivity, and that's very similar to Indian Vedantic thought, which he knew.

One interesting point emerges here: the objective of abstract art was to create a flat, two-dimensional effect by emulating primitive and non-western art, which was of course also the aim of the Bengal School artists, who sought to go back to Indian decorative art. The historical experiences of European modernists and Indian nationalist artists were vastly different, I agree, but importantly, all these artists were making a common cause against naturalism.

Now there are two ways of looking at this cross-cultural moment. The Eurocentric position has been recently reiterated by fine writers like John Golding who reject Sixten Ringbom's well-researched view on the importance of eastern ideas on Kandinsky's art, which Golding views as marginal to the trajectory of modernism and merely part of the prevailing cult of the irrational and the occult.[6] Golding says, 'No, we have to go back to the West again to understand their ideas', but I question this. I know that later on their ideas did change, but in their most original periods Kandinsky and Malevich were looking into aspects of eastern philosophy that they couldn't find elsewhere. You only have to think of Malevich between 1905 and 1919, up to the time he was driven into retreat by Stalin, to appreciate the importance of eastern thought in Malevich's approach to abstraction.

Hence, on the other hand, you could look at such borrowings from the point of view of modernity and understand it as an intellectual search for an alternative to western empiricism. In philosophy, from Nietzsche onwards, there has been a radical questioning of western rationality, which challenges ideas of positivism and empiricism. I find this to be an amazingly consistent feature of modern non-positivist philosophy as it always comes back to the crossovers between East and West, say, in Heidegger's existentialism, or in Sartre's use of Buddhism. Above all, eastern philosophy provides an alternative to Cartesian rationality. It was the first serious challenge to the whole rationalist project of the Enlightenment and in these East–West crossovers you find arguments that were later taken up in post-modernism and post-colonial thought. In the light of these global cultural exchanges, why should we assume that the transfer of artistic styles is a one-way process?

These wider cultural issues call for an alternative approach, and I think visual studies

have brought these questions into view, because otherwise art history will always remain confined within the study of objects and the tracing of styles. I'm developing the idea that you have to look at the broader issue of hybridity and cultural crossovers in this crucial period.

KM: Going back to the question of influence and originality, what you've described sounds like a double bind for artists in the colonial period. On the one hand, there's the demand to demonstrate competence in academic art, for which colonial artists are often seen as being slavish imitators of western influences. On the other hand, if they produce an art that has no precedent in the West, it's seen as second-rate modernism that is culturally impure or unauthentic. Do you see this as a predicament facing artists in the colonial period? Is it something specifically modern as well?

PM: Yes, it is very much a colonial predicament and here I'll mention two things. One is that, taken in a wider sense of modernity, which coincides with colonial rule but predates the arrival of modernism in the arts, you could say that the question of imitation goes back to the issue of colonial mimicry in English education under the Raj. For the British, the introduction of English education had both a civilising mission and a practical purpose – to fill the lower end of the imperial bureaucracy. But they sought to maintain strict control over it – 'You must learn English, but you mustn't become too English'. Western dress such as trousers and shirts were introduced for Indian men in the public sphere, but you shouldn't be impeccably dressed, with bespoke tailoring: then you were branded an English lackey. And yet, if you did not participate

at all, as was the case with the so-called tribals, then you were left out of it with an inevitable decline of living conditions. Thus for the élite, one of the most vexing aspects of colonial anxiety has been that of accepting or rejecting hybridity.

At the same time, we must remember the thrill experienced in discovering the whole world of western sciences and literature. The élite in India already had their own literature and culture, but they were deeply affected by the Enlightenment values of freedom and equality. Additionally, the Raj project of westernisation was riddled with glaring contradictions in its ideology, which was predicated on democracy in England and despotism in the empire, and these contradictions were morally difficult for Raj officials to uphold. This made a meeting ground between the rulers and the ruled possible because a number of British individuals like Annie Besant for instance were genuinely interested in fighting alongside Indians in their struggle for equality in the empire. As part of Raj westernisation policy, in the first phase of colonial art (1850s to 1900), you find that academic art was extolled. The central figure here is Raja Ravi Varma, an artist who was greatly prized by the English, by the Indian aristocracy, and by the ordinary people alike. Varma's success owed much to the age of mechanical reproduction, as millions and millions of his oleographs were circulated and his naturalism found a widespread response in popular taste.

KM: How would you describe the transition from this age to the nationalist era?

PM: Varma's history paintings were the first to imagine the nation's past. And yet when the next generation of nationalists, the Bengal School

Ravi Varma,
The Triumph of Indrajit
(*from the epic Ramaya*),
1903

painters, constructed their cultural identity, they rejected Varma's brand of naturalism, which they saw as slavish imitation, ingrained in the colonial psyche and the Victorian taste of colonial India, and that's when they began to try to 'recover' pre-colonial art. Now this was very much a conscious construction, as you can never go back to the past in that way, although the whole neurosis about authenticity was a very nationalist preoccupation all over the world. It is the great nationalist predicament: how do you retain the 'authentic tradition' in our modern age? And you can't: constant intermixture and hybridity are a fact of modernity, even as you have this tremendous dream of authenticity. So in this period, the Bengal School staked its claims to authenticity. Branded as hybrids, academic artists retorted, 'Our subject matter is indigenous, therefore we are nationalists.' Thus the whole issue of authenticity became embroiled in the question of imitation and influence.

Modernism created other problems as well, but let's first go back to the pre-colonial age to see how the predicament facing artists in colonial India was specifically 'modern'.

Naturalism is a fascinating device in representation: everything looks real, but it is not real in the sense that what one sees is realised by conventions and 'tricks' of illusionism. Nonetheless lifelikeness and trompe-l'oeil effects fascinated non-Europeans. Colonial Indians were captivated by Varma's prints, and this included those who were the poorest and had no understanding of western culture. But the Japanese in the 17th century also admired illusionism, and they were not colonised. Let's look at this cross-cultural phenomenon in more detail. The Mughal empire under Akbar in the 16th century was one of the three of the greatest

empires, along with Charles V's Spanish empire and the Chinese empire. (Britain was nowhere at this time, I'm afraid, as British monarchs were still sending emissaries to get trade concessions from the Mughals.) The Portuguese Jesuits in Goa were keen to convert Akbar and a famous compendium of the era praises Akbar for the beauty of his soul. Now Akbar loved European painting and prized the illustrated Bible. When he received religious paintings as gifts he and his son, Jahangir, gave these to their artists to copy – which is how western art became an element in Mughal painting.

There is a painting at the Victoria & Albert Museum – *Deposition from the Cross*, dated 1598 – which shows what happened in this cross-cultural exchange. When you look at it, at first it's a descent from the cross, with Christ being brought down: but if you look more closely, it's both Golgotha and the Last Judgement at one and the same time, with angels sounding the trumpets and the earth giving up the dead. Can you imagine anything more incompatible to a Christian? But to the Indian artists, it didn't matter. They simply put together these motifs because they were visually fascinating. They found the western 'technology' of representation more interesting than the Christian subject matter. This way of making pictures was something very interesting to Mughal artists, and they adopted it, but within their own cultural terms, and they never felt that they were inferior to western culture in doing this. Indeed, Mughal art is actually a mixture of Indian, Persian and European elements. Would you then say it's a hybrid form that is inferior to art from other traditions? Nobody ever says that and why should they? But when you introduce the question of colonial power, then mixture or purity really becomes a judgemental issue.

We saw before that Archer was obsessed with influence and perhaps the artists' real concerns have always been secondary to a historiography that seeks to order art into a hierarchy. As I see it, when an artist from a colonised nation adapts a metropolitan art form, he engages in a purposeful activity that involves making conscious choices. Now I agree there is an overarching cultural hegemony in the colonial context, but we need to differentiate the responses that arise within it, for I strongly believe that artists have the ability to choose and are not passive. Agency is a very important issue, and the colonial artist's agency is erased in Archer's account. I agree with Michael Baxandall who questions this obsession with stylistic influence that misses the role of the artist as an historical actor, who makes an intentional selection from a range of sources.[7]

KM: This is fascinating because your contrast between the 16th-century Mughal empire and the 19th-century British empire suggests that the crossing of cultural frontiers was not always associated with a vertical dichotomy of self and other. Also, you suggest that colonial artists in India faced a distinctly modern predicament because the distaste for hybridity and the demand for authenticity didn't just come from the European art historians, but also from cultural nationalists who wanted something that would break away from academic art, and which wouldn't be tainted with colonialism.

PM: Yes, and I think this is where I differ from Edward Said (who was a good friend and we all miss his engaging presence). I have a lot in common with post-colonial studies – on the question of the canon, for instance – but my own approach is more historically grounded. We are all constrained by our disciplinary boundaries. Said came from English literature and he saw little difference between the 18th and 20th centuries and the previous periods as far as orientalism was concerned. This is no criticism for he was able to propose a powerful theoretical framework for reading colonial discourses that has proven its fecundity. But I feel the need to address the historical dimension. Even though medieval Europe demonised Islam, it was not from a position of strength but from a prejudice born of fear and religious bigotry. For me, the real core period of colonialism is the 19th and 20th centuries, the fruits of which we global children of the 21st century are reaping. All peoples have stereotyped the other but such prejudice is not always a product of unequal power relations. What makes the last three centuries a hegemonic culture is the added equations of power and ideology. As the non-West is brought to its knees by force, an attendant ideology of difference based on 'race', hierarchy and evolution, seeks to maintain western cultural dominance.

In the 18th century, several things happened that radically changed European perceptions of themselves and of the other. Foremost was the idea of progress. Until the 18th century, history was seen as a continuous decline from a mythical golden age when all cultural values were traced back to the ancient Greeks. The Enlightenment overthrew this reverence for antiquity, proclaiming that 18th-century Europe was better than all previous periods and all contemporary societies, and that its superiority rested on its rationality and the ability to control nature. This was enshrined in Hegel's notion of history as the endless progress of the spirit through time. As a result, Europeans began to think of their own

identity somewhat differently. In the 18th century, when the British won their first battles in India, they were living much like Indians and they didn't see themselves as culturally superior. By the 19th century, enormous material successes, sustained by a thrusting teleology, gave birth to the concept of backward, irrational, unchanging orientals. Interestingly, the French *philosophes* of the Enlightenment blamed institutions and climate for non-western backwardness but not 'race'. However, by the time we get to the French writer Gobineau in the mid-19th century, theories of 'race', evolution and hierarchy had integrated with earlier notions of progress to propose an imperial ideology based on an immutable racial hierarchy.

There's no doubt Said made scholars aware of the way that knowledge is constructed to represent and to control the other, which has led to some very important art historical works, especially by feminists. But I think we also need to probe the hidden assumptions of art history that was the legacy of Vasari and later evolutionist thought, a task I have been engaged in since the 1970s. Let me give you an example. Reams and reams are written about the decadence of Hindu art, but we may ask, what exactly is decadence in art? As I have shown, far from being an objective category, decadence is a description of an art that doesn't conform to Winckelmann's ideal of noble simplicity and quiet grandeur, which he identified with Greek art.

Actually, one of the things we might also address here is – why are literary and artistic canons treated so differently? In 19th-century Europe, there were competing literary canons and it was accepted that the English literary canon was not the same as the German one or the French one. Thus Europeans had no problem in being deeply affected by Rabindranath Tagore's poems. Yet when it came to art, the Victorians judged Mughal miniatures as inferior to history painting, which was the epitome of European superiority. Could it be because the visual language was held to be universal whereas texts based on language couldn't make similar claims?

KM: Did notions of 'race', hierarchy and evolution play a part in colonial art education in India? I'm intrigued by what you have written on the role of Ernest Binfield Havell because it seems that in the 1890s he encouraged the creation of a nationalist outlook, and his belief in an 'indigenous' style went against the grain of academic art.

PM: The story of Indian art schools, set up in the 1850s, reveals some fascinating colonial contradictions. The so-called industrial arts, particularly textiles, were dying in India; and they were dying, I would say, because India became the market for cheap mass-produced Manchester textiles. But the situation was diagnosed by the colonial regime as the inability of Indian artisans to compete in the world market because of their ignorance of 'the science of art', which could be rectified by art school training. This was framed as a 'civilising mission' of the British empire –'We cannot repay the debt to India, we've got so much raw material, so many markets there, and we have benefited from India, so how can we repay them?' Only, of course, by 'civilising' them. Yet the Great Exhibition of 1851 had revealed a crisis in British design, which could only be tackled by studying Indian design. As policy framers admitted, 'We cannot even teach the Indian artisan taste; it's impeccable.

All we can teach is scientific drawing.' The irony was that Indian artisans couldn't afford to go to art school whereas boys from English-educated backgrounds joined art schools with alacrity to learn western academic art. That was the end of Raj reform of the crafts.

The reason for such failure is that the admiration for Indian decorative arts by its great champions, like George Birdwood, was tempered by the conviction that Indian culture couldn't rise above decorative arts in world art. So the imperial art policy never resolved the contradiction between 'nurturing' Indian decorative arts while continuing to advocate naturalism. Havell saw through this anomaly, and replaced academic training with what he called the Indian method of drawing and painting, with the help of the founder of the Bengal School, Abanindranath Tagore. Havell also created the first great collection of Mughal art for the art school in Calcutta. He never gave up the idea that nature was important, but his criticism of naturalism was taken up by the nationalist artists who argued that, 'We must do flat, two-dimensional art, decorative art, which is spiritual.' The Bengal School considered the imitation of objects in Renaissance art as gross materialism, whereas Indian art dealt with the world beyond appearances. This was a nationalist interpretation of pre-colonial art, with echoes of Plato. Since you can never really recover the past, we are continuously reinventing it.

KM: Was this indicative of a dialectic between colonialism and nationalism in India?

PM: I think you have raised an important point here if I follow you correctly. Rather than really producing 'traditional' art, the nationalist 'invention' highlighted the tensions between the naturalist outlook in colonial art and the search for the pre-colonial indigenous 'decorative' art. While working on art and national identity in India,[8] I was struck by an interesting fact: if you take the Mexican muralists, their construction of nationhood rested on a historicist representation of Aztec culture, and some of it was also based on American Indian decorative motifs. But in terms of style, Rivera's work belongs within expressionism, as well as early Italian frescos. But in India and Japan, in the early 20th century, as nationalists began to resist western cultural dominance – although Japan was never colonised – they still had to come to terms with it. Some Japanese artists tried to go back to an earlier, indigenous style, *nihonga*, as a marker of identity. Okakura is the key figure in Japan at this time, absolutely resisting the equation of modernisation and westernisation.

KM: Perhaps we could turn to modernism in India, and how the non-West responds to modern art.

PM: Before I take up modern art in India, I would like to distinguish between modernity as a broad historical phenomenon and modernism as a form of discourse, as a literary and artistic cultural movement. Modernity is linked with the Industrial Revolution, which transformed our perceptions of the world. In fact, what was happening in the West also, gradually, happened in other parts of the world. The question then becomes: when was globalisation? What does globalisation actually mean? Let me give my own view on this.

In some ways, the world has always been global. Many complex maritime trade routes linked East and West before modernity, all the way from China right into Europe. I was surprised

Abanindranath Tagore,
Bharat Mata (*Mother India*),
1905

to learn that Chinese porcelain had a market in Africa, even as Gujarati merchants sold textiles in Europe through the Egyptian Mamelukes, and Bengali merchants traded with the US during the 18th century. The change in the 19th century, which we know as modernity, brought far-flung lands closer by steam vessels, electricity, the telegraph, newspapers – all of which were part of a widespread transport and information revolution. You have the rise of large cosmopolitan cities, like Calcutta, the second city of the British empire. More Europeans came to India in the wake of the empire, and a smaller number of Indians travelled abroad.

Take the case of the charismatic Rabindranath Tagore, the poet: he travelled perhaps over a dozen times all over the world and was one of most celebrated cosmopolitans in the inter-war years (c.1913–38). His book of poems, *Gitanjali*, won the Nobel Prize in 1913, the first for a non-European, and established his world reputation. He wrote an enormous amount in his own language, and was judged by whatever was translated, which was a very limited part, but it struck a universal chord. He was known in South America, Spain, France, and in China and Japan in addition to the English-speaking world. There is a touching letter from the mother of the wonderful English poet Wilfred Owen, who died in World War I, to Tagore. Before he took leave of his mother to return to the battlefield, Owen was moved enough to quote the Indian poet who, if I recall correctly, says, 'When I go from hence, let this be my parting word.' Tagore was a household name in Germany, and his admirers included Albert Einstein.[9]

So here is truly a world figure, and he saw himself very much as a cosmopolitan.

Now Rabindranath was fiercely critical of a narrow nationalism, and while criticising the West he also accepted the universals of western thought. He fervently believed that one had to build bridges across the world through friendship which, in an age of tremendous national conflicts, meant that his view of nationalism and universalism was not always popular. Indeed he gave a famous lecture denouncing the aggressive West and Japan, which didn't endear him to these countries. He may have seemed irrelevant in the aftermath of the Holocaust and thus faded away from Anglo-Saxon memory, but in the post-colonial 21st century one can appreciate his fears about jingoism. Another figure from this period was the multilingual sociologist Benoy Sarkar, who published in several European languages. He travelled far and wide and knew the West extensively.

I am developing this idea in my forthcoming book – the notion of the 'virtual cosmopolitan' who was a native of the peripheries, but who intellectually engaged with the knowledge system of the metropolis – and I am also thinking here of the response of the colonised to the window opened to the West.[10] This was not simply a case of westernisation imposed by the colonial powers but also of a revolution in communication in which languages such as English, French and Spanish acted as a lingua franca. If we take the Bengali intellectuals, and Tagore was one of them, there you have a whole élite who are proficient in their own language, and who had no lack of confidence in tackling the whole world of the intellect, while, of course, they were aware of being colonised. Many of these intellectuals travelled to the West mentally, critically engaging with western thought, to the extent of embracing continental philosophy and

contradicting English ideas and systems of thought associated with the British. So that is an interesting window, and that's how the non-West responded to modernism.

Virtual cosmopolitanism had its impact on the diffusion and transformation of modernism outside the West. Looking comparatively at art, modernity and nationalism in Japan, Mexico and India between 1860 and 1940, what's interesting is that there emerges a shared language of modernism right across the world, disseminated by the cosmopolitan élite in the peripheries. Such ideas are transmitted through key European languages that connected with different spheres of influence – such as English in India, Spanish in Latin America, and mostly German in Japan. So one could posit an international imagined community who are engaged with this concept of modernism, and you have the creation of an informal global network among artists, writers and intellectuals who don't even know one another, but who debate shared ideas. Once you widen the picture of modernism by thinking about the global dimension, you go beyond simple colonial power relations.

The first article on cubism found in Bengali, for instance, was in 1914, and was written by Sukumar Roy, who was the father of the film director Satyajit Ray. As a supporter of illusionist art, he didn't approve of modernism, because he equated modernism with the Bengal School, both movements being against naturalism. He said cubism was a distortion of natural objects, even though he accepted that it wanted to be freed of the academic tradition. I would call Sukumar Roy a virtual cosmopolitan, because of his intellectual cosmopolitanism (I believe he was in England only once). He was very much engaged with the West, and yet deeply involved with Indian culture. Intellectuals were discussing modernist issues, and you might be territorial and say, 'Oh, it's British', or, 'It's French. It's not Indian'. On the other hand, even if intellectuals like Roy didn't visit Europe but stayed in Calcutta, we have to ask: did something in their cultural context actually allow for the reception of certain modernist ideas, and for their transformations?

KM: In relation to Calcutta as a cosmopolitan city, providing an opening for two-way intellectual traffic between India and the West, would you say that India had certain sociological preconditions that enabled the fine arts to be associated with modernity's break from tradition? Were the artists associated with nationalism seeking to address an audience beyond the educated classes? Even if it was a construction, did the indigenous emphasis of the 'Swadeshi' doctrine, which sought to encourage interest in the indigenous culture of India's pre-colonial past, lead to a change in iconography along the lines of Rivera's interest in the indigenous Indian cultures of Latin America?

PM: Let me take your three-part question one by one. Even though introduced by the Raj, the western institutions, namely art schools, art societies, art exhibitions, art journalism and the new public patronage, all overturned the pre-colonial system of private, tied patronage and the artist's personal apprenticeship to a master. The Benjaminian aura of a work of art and the artist as a 'genius' gave a new status to Indian artists. These larger forces of modernity would have come regardless of colonial intervention. This was a 'no-turning-back' break with tradition. On the level of the people, nothing hit them with a greater force than the new 'life-like' pictures

created with mechanical reproduction. Because of all this, tradition could be 'invented' but never fully recovered. Therefore the nationalist art of the Bengal School was only a part of the larger process of modernity.

As to your second question, if the nationalist artists addressed an audience beyond the élite, I would point out that Ravi Varma's much-reviled oleographs were meant for the non-literate poor people. Nationalist art can be understood by Benedict Anderson's idea of the nation as an imagined community, held together by print technology and possibly by a lingua franca like English, in other words a community formed by the literate minority. Now although 'subaltern' historians have argued that the Indian nationalist movement was primarily a transfer of power from the British ruling class to the Indian élite, that's not entirely true. For instance, when Gandhi came upon the scene, he brought the peasants into the political orbit for the first time, simply by going out there to the so-called backward areas of India, across east and west. Even so, the majority of the spokespeople would be the élite. Perhaps the case of Russia offers a comparison, where the party and the élite did actually speak for the masses. The idea of communism was shared as a source of inspiration in Russia, whereas in India the core idea for the nationalists had to do with the creation of a new cultural self. As the peasants and the tribals, the 'subalterns', came into focus in the 1920s, artists turned to the village and folk art as subjects, creating a form of romantic primitivism. Some of the most moving works relating to the people were produced by Sunayani Devi, Amrita Sher-Gil and Jamini Roy.

Now as to the third question, about the change of iconography, I would say that the Bengal School created a new iconography that synthesised history, mythology and a Pan-Asian amalgam of styles. In the modernist period, two of the most striking iconographies were created by Sher-Gil and Jamini Roy. But there were significant differences with Mexico here. In Mexico, the revolution demanded propaganda art such as posters, prints and broadsheets. In the Indian context you did have prints of nationalist heroes, who often became martyrs after their execution but, generally speaking, art as a means for the construction of cultural identity was on a small scale except in the case of murals, especially at Tagore's university in Santiniketan. But there again, among artists associated with Santiniketan, it was the élite representation of the 'innocent' tribals or the 'simple villagers'.

The idea of the cultural self, as it developed in Indian nationalism in this period, was thus associated much more with the literate élite and I would define the leading forces of the nationalist movement in this way because they were not always necessarily wealthy. They formed an élite because they dealt with certain ideas and it was their knowledge and learning that distinguished them from the masses.

KM: How did such developments affect the choices that individual artists made? For example, how would you situate the style and subject matter found in Abinandranath Tagore's depiction of 'Mother India' in *Bharat Mata* (1905)?

PM: In Abanindranath's vision of 'Mother India', the creation of an indigenous style became the first priority, for his subject-matter was a historicist interpretation of the Indian past through epics and mythology, much like Ravi Varma. *Bharat Mata* is an ascetic modelled on

Bengali élite women. But Abanindranath's style itself reveals certain contradictions within the Swadeshi ideology of art. Swadeshi doctrine proclaimed cultural self-sufficiency in parallel with economic self-sufficiency and contrasted the flat decorative art of India as spiritual, as opposed to materialist European art since the Renaissance. In contrast to A.K. Coomaraswamy and other ideologues who tended to exclude Muslim contributions to the emerging nation,[11] Abanindranath refused to deny the Muslim heritage and hence he wanted to go back to Mughal art. His first major historical painting, *The Last Moments of the Emperor Shah Jahan* (1903), brings out the pathos of the death of Shah Jahan, who built the Taj Mahal.

This was an invented tradition because Mughal art never depicts the emotions, while *The Last Moments of Emperor Shah Jahan* is 'infused with melancholy', as he put it, as it was created after the artist had lost his little daughter. But Abanindranath did not rest there. Imbued with Pan-Asian ideas, he sought out elective affinities with Japan. Pan-Asianism, led by Rabindranath Tagore, the charismatic Bengali monk, Swami Vivekananda, and the Japanese art critic, Okakura, asserted that all Asia was one, unified by its spiritual resistance to western materialism. Okakura's pupil, Taikan, who was the major exponent of the *nihonga* style in Japanese art, came to stay with Abinandranath and learned to do Mughal painting – a very interesting case of cross-fertilisation. Abanindranath himself was deeply influenced by *morotai*, a Japanese wash technique that creates a hazy atmospheric effect. Abanindranath thus named his work 'oriental art', which is why I have called Indian nationalist art of the Bengal School, orientalism, with a small 'o' to distinguish it from Saidian Orientalism.

KM: Could you expand on how modernism in India made its appearance within this nationalist framework?

PM: This first nationalist art movement, the Bengal School, began to lose steam by the 1920s, as it faced hostility from different quarters. When Gandhi came on the scene in 1921, he wanted the people to boycott British institutions, and making art simply didn't have the same force as it did in earlier periods now that the political situation was changing so rapidly. Another factor is that even amongst artists themselves, historicism began to be questioned strongly by everybody, including Abanindranath Tagore, who writes in a rather elegiac mood, at the end of this period, that 'When we embarked on the nationalist art movement, we had great hopes for it. Alas, what went wrong?' And finally, the advent of modernism rang the death knell for the orientalism of the Bengal School of nationalist art.

KM: The tensions of art and politics involved in this interplay between modernism and nationalism really underline your earlier point that 'primitivism' was enormously important as a catalyst for a counter-modern outlook.

PM: Exactly. Modernism had a very important role to play in the anti-colonial period and that's because modernism was seen to be subversive – it was attacking the foundations of naturalism, which were very much part of the dominant culture, as well as colonialism. If you look at colonial art anywhere, I suspect you'll find the dominance of academic art. So in different ways, modernists around the globe were challenging the values of western art.

Of all the different aspects of modernism in art, perhaps none has been more influential than primitivism. Now in the popular imagination, 'primitivism' suggests something like Gauguin's desertion of sophisticated Paris for the simplicity of Tahitian life. It's a romantic longing of a complex society for the simplicity of pre-modern existence. This is a global phenomenon today, if you think of tourism, but historically speaking, it takes us back to a fundamental crisis of the industrial age when the problem of modernity was blamed on the Enlightenment.

Basically the term 'primitivism' indicates, for me, a counter-modern rather than an anti-modern tendency, because it is really the twin sister of modernity, its alter ego; it's within it, and yet continuously questioning it. The 'primitive' has tried to be the conscience of modernity, tempering its progressivism, even though it involved representations of the non-West as the West's primitive other. The contradictions of primitivism were commented on, a year or so before his death, by Edward Said, who described primitivism as the age-old anti-type of Europe, the dark night out of which urban rationality developed, the other side of the coin of modernity. The second contradiction consisted in the fact that artists were creating this notion of the primitive as frozen in time, whilst they were in the midst of tremendous upheaval.

KM: If primitivism was a phenomenon of the modern West, how did it affect Indian artists?

PM: From the perspective of the colonised, the very ambiguities of primitivism provided a powerful tool for challenging the values and assumptions of modern urban industrial civilisation, that is, the West. I think of Mahatma Gandhi, in this sense, as the most profound primitivist critic of western capitalism. He fashioned the philosophy of non-violent resistance, and the self-sufficiency of village life in India, as symbolised by the humble spinning wheel – one could say he 'invented' the Indian peasant – out of elements associated with the discourse of primitivism.

In my view, primitivism is a complex umbrella term whose meaning changes as the context changes, and its very richness made it a useful critical tool for questioning western values. The ambivalent relationship between modernity, modernism and the primitive allowed Indian artists to put forward anti-colonial strategies and thus fashion their national identity, which they would not be able to do with academic naturalism. As I said before, in the period under discussion, you also have the first-generation of European expressionists whose search for alternative certainties led them to Indian thought. The Bengal School was aware of these so-called dissident groups of the West and felt close to their anti-materialist outlook although their own work couldn't renounce naturalism altogether. This was achieved by the new groups of painters who broke off from academic art through their radical primitivism, whose work I examine in my new book. In the 1920s, as oriental art declined, for the nationalist artists the site of the nation shifted from the 'past' to the 'local' – this was part of the emerging debate on the global and the local. Folk art began to be appreciated and the nationalists turned to the Santals, one of the so-called tribal peoples of eastern India, as representing an innocence lost during the colonial era. Such romantic primitivism led to artists depicting idealised dark-skinned Santal women as standing for a pure timeless

innocence, an image in fact created by colonial anthropology. There are some fascinating contradictions here because while the rebellious Santals were suppressed by the colonial administration, colonial anthropologists helped create this myth of timeless 'noble savages', whose existence was essentialised out of society and history.

One of the first changes was seen at Tagore's university, set in rural Santiniketan, which sought to inculcate a love of the environment and reject the urban civilisation of colonialism. The important figure here was Nandalal Bose, an influential teacher who encouraged interest in rural village art and idealised the Santals living in close proximity. His disciple, Ramkinkar Baij, was one of the most powerful sculptors of pre-independence India, who made heroic sculptures of Santal life by using unconventional media like cement and concrete in the 1940s.

But primitivism was not confined to rural Bengal. The new awareness of folk art threw up a genuinely naïve artist, Sunayani Devi, Tagore's niece. Although she came from a very wealthy élite family, she was a truly naïve artist, and although she was not a villager, her rediscovery of simple village art introduced a new genre of painting. Nationalist critics wrote about her simplicity and purity as epitomising the soul of India that was village-centred. Sunayani took up painting in her mid-thirties by watching her famous brother Abanindranath at work. Her themes were drawn from Hindu religious mythology, and her imagery, she believed, was found in her dreams. Her personal untutored style impressed Kramrisch who published on her in German journals.

However, the three key primitivist figures were Rabindranath Tagore, Amrita Sher-Gil, and Jamini Roy – who helped to define modern art in India prior to independence in 1947. Tagore was very critical of Hindu nationalism and was a universalist. For him, primitive art underpinned his strong links with the western expressionists. In his late years, he found that literature couldn't express his growing interest in the unconscious, which only painting could. His poetry was governed by strict literary canons, and was very Olympian, whereas the paintings brought out the strange, ambiguous and dark aspects of his psyche; they are totally non-representational. In dredging up his unconscious, the images of masks and animals that appear in his paintings, often inspired by American Indian and Oceanic art, produced very powerful expressionist works. He explained his work as the outcome of his desire to return to childhood in order to draw without illusionist sophistication.

Jamini Roy, on the other hand, went back to a utopian vision of a pure, robust and simple village art – whose formal purity was thoroughly modernist. He rejected the grand narrative of historicism, locating the nation in the locality instead and especially in village art. He had started his career by idealising the Santals, but this did not satisfy him. What made him unique among Indian artists was his systematic construction of a communitarian primitivism. Roy had started with mass-produced Kalighat paintings, but he then rejected them as too urban, and turned to village scrolls (these are called *pat* in Bengali) as a model for his work. For Jamini Roy, urban culture was corrupt; he wanted to go back to the communal ethos of village life, not just in subject matter but also in the mode of production he chose for his paintings. He was inspired by Tolstoy's ideas about art and social commitment, seeking to erase the 'aura' of his works. Critics

Jamini Roy,
Jashoda and Krishna, c.1940

complained that he was just debasing painting, saying, 'Look, he lets his children sign his paintings. He sells them at a cheap price and he sometimes signs other people's works.' I initially thought of a parallel with William Morris, and his vision of a socialist utopia for the arts and crafts, but despite the parallels in terms of rejecting urban capitalist contexts, Roy really went into this communitarian social ideal in a distinctively Indian way, and that informs how I see his primitivism in a very wide sense. While writing on Roy I was amazed to discover remarkable parallels between his ideas and those of German expressionists who were moving towards an idea of non-individualist art that sought to restore the function of art in a community. Carl Einstein, who was an important critic in the German expressionist circle, approached primitivism as such a social communal ideal. What makes these parallels riveting is that neither of them could have known of each other.

Amrita Sher-Gil's beauty, her privileged background, her precocious talent and her tragic death at age twenty-eight made her an icon in Indian art. The first professional woman painter of India, her representation of Indian village people as melancholy and alienated was a mirror image of her fractured and divided self. Daughter of an Indian father and Hungarian mother, brought up in a cosmopolitan atmosphere and trained in Paris, her ambivalent sexuality made her much more of a 'post-modern' personality – the intellectual as a restless outsider. One is reminded of Kafka's mental makeup as an 'internal' outsider. But the main point is that once you take account of all these aspects in their specific contexts in India, you can understand the complexity of primitivism as a central phenomenon of both modernism and modernity.

KM: By way of an ending, I'd like to ask, on a more personal note, what it was like when you taught 'Empires and Images' at the University of Sussex in the mid-1970s, which was one of the very first MA courses on race and representation in the UK, and what it was like when you carried out the research for *Much Maligned Monsters*, which was published in 1977, before Said's *Orientalism*. What support was there for work that was so ahead of its time?

PM: Looking back, I feel fortunate to have arrived in London, the metropolis of the British empire, soon after decolonisation, when colonial institutions were still intact. I had enrolled at SOAS in London, the intellectual powerhouse of orientalism, in 1962. I remember the condescension with which *Asia and Western Dominance* by K.M. Pannikar, the most perceptive critic of colonialism before Said, was treated. But perhaps an intellectual weapon to challenge colonial hegemony was yet to be born. I then heard E.H. Gombrich lecturing on Hegel, and for me who read history at the university and had been influenced in India by Marx's teleology, it was amazing to hear someone challenge the western 'progressivist' paradigm, and when I read his *Art and Illusion*, it was a revelation. He was the first art historian to argue that you didn't reproduce nature in painting but represented it by means of stylistic conventions and these changing conventions have to be looked at historically. Gombrich was in many ways the most important art historian of the last sixty or seventy years, but his constantly questioning approach, challenging even his own assumptions, was often misunderstood. I found that while he was convinced, on the one hand, that European art and civilisation were superior

to other traditions, he would, on the other hand, undermine it by arguing that there were no absolute standards in art. I see this as a kind of separation between his heart and his brain. I found this to be most attractive.

When I finished my history degree in 1965, I wanted to give up academic work and be an artist and with this in mind applied to various art schools, but I failed to be funded. It was then that I became his student. Gombrich is criticised for having only concentrated on western art and male artists, but he always asked himself why he found it difficult to accommodate Indian art within his own classical scholarship – and he paid me an unusual compliment in having the confidence that, with my own understanding of both western and eastern worlds, I would be well placed to solve this puzzle. Gombrich had an open mind and gave me a lot of freedom – some of the most intellectually exciting periods in my life were meeting him fortnightly for supervisions. The lesson I learnt from him was that it was more important to ask questions than to find final answers. Also, importantly, he didn't insist that I use his work for my research; rather he suggested what I felt was a more conventional approach, namely, a study of Indian collections in the West, which I dutifully started. But he must have been surprised when my first chapter in *Much Maligned Monsters* (the most theoretical) used his idea of the cultural mindset as it affects our representations of the new and the other, and the formation of stereotypes. It is a measure of his openness that although he knew we had different views on politics, my work in art history, which is more political and very different from that of Gombrich, could only have been possible by working with someone like him.

KM: What was your personal experience of the rise of post-colonial and post-modern studies during this time?

PM: When we moved to Cambridge in 1965 it was the period of Enoch Powell's raw racism and in that political climate Gombrich's ideas had been like a breath of fresh air. Today it's probably a commonplace to think of the role of representation in colonial discourse, which was a line of enquiry I began to develop indirectly, through Gombrich's work. In the late 1970s these ideas began to converge to create the 'post-colonial' moment. Said's now famous *Orientalism* came out about six months after *Much Maligned Monsters*. *Orientalism* was not given that much notice initially, although I remember it annoyed some of my friends at SOAS. I also happened to be at the Institute for Advanced Study in Princeton in 1981 where Bernard Lewis was a fellow. As you know, a bitter personal feud arose between Said and Lewis after Lewis had organised a conference seeking to show that power relations were not the only aspect of western representations of the Orient. My own interests naturally led me to find out what Said was like and I went to meet him at Columbia University. I remember that meeting with some affection, as we didn't meet very often. During the 1980s, *Orientalism* created a tremendous snowballing effect in the debates on post-colonialism.

KM: How would you describe your own development as a historian of colonial representations?

PM: In 1974, my fellowship at Clare Hall in Cambridge came to an end and I joined Sussex

University where I had an opportunity to develop my ideas on colonial representations and racism. As Sussex itself was very interdisciplinary I had several colleagues with similar interests. Brian Street, who wrote a book called *The Savage in Literature*, was an anthropologist who joined me to offer the course on western representations of Asia and Africa.[12] It was here I gradually developed the distinction between representations, stereotypes and racism. But by the late 1970s I began to realise that the other side of the colonial coin, as it were, was the Indian artist's response to the introduction of western art during the colonial period. As an artist I had been deeply involved with modern art in India and I had introduced a series of lectures on Indian art, including modern Indian art, at Cambridge in 1968. In fact it was my wife Swasti who suggested that I document the history of modern art in India since no one had worked on it before. Gradually I began to see this as a problem of the canon leading to resistance, and so I began to explore nationalist resistance and the question of identity as an aspect of colonial representation, and this interaction continues in my work.

But let me go back to what you asked me initially about visual culture. I reviewed John Mackenzie's valuable scholarly book on orientalism.[13] While he makes some thoughtful points, I found a limitation in Mackenzie's insistence on the historical 'truth' and his reluctance to see history as a text and a discourse. I pointed out that many questions about truth and history that were shaped by 19th-century positivism – the Hegelian idea of the continuous march of history – are still unresolved. The famous historian Geoffrey Elton once said that if we have better history today it's because we have a lot of facts at our disposal.

Nothing can be further from the truth than this assertion of historical 'truth'.

Now the dominance of western epistemology is to be found even in Marx who, as we know, provided one of the most powerful weapons of resistance to the dispossessed, which includes the Third World. But Marx was so teleologically oriented that his work is always framed by this idea of western progress. In order to challenge colonial culture, you needed to get to 'unpack' its intellectual foundations, you need to question the very epistemic framework held together by concepts of progress. For my work on art and nationalism I found Gramsci's idea of hegemony to be more nuanced, especially his insight that the dominant groups don't always need to use force to win popular consent, which I have tried to examine in India's history. Hence, I would say that post-colonial studies and visual culture have been very important because for the first time they challenged the Enlightenment project with a critical apparatus that has shown that what is regarded as neutral rationality is value-laden and dependent on western assumptions. This attack at the very roots of Enlightenment rationality has given a special kind of confidence to feminist studies, to studies of colonialism, and so on, and that's been very important, because it was through the study of texts, representations and discourses you could actually challenge the idea that there is a universal canon, or that there is a universal rationality. When there was a whole range of scholars who continuously challenged our assumptions by saying, 'No, there is no such natural order of things, this is all part of a discourse', this was the decisive shift that loosened the grip of positivism. Whereas historians always saw things as facts, it was different discourses that constituted the

phenomena they set out to examine. This enormous shift in our approach to knowledge was something which post-colonial studies has certainly given us, and I hope I've made some contribution to this as a historian of ideas who does not necessarily work from a post-structuralist standpoint. Having said that, the only thing that I worry about in post-colonial studies is that, because it's so wedded to texts, it sometimes doesn't come to grips with the actual problem of inequality, and I do believe in distributive justice, and I also believe there is such a thing as oppression. In my paper on 'The Hottentot Venus' I not only talked about representation and text, but I stressed the suffering caused to the young woman, Saartije Baartman, the putative Hottentot Venus herself, which is an extremely tragic story.[14] When I gave the paper at Said's centre at Columbia University in New York a few years ago, Said was moved to say that it greatly troubled him. I do feel that textual analysis must be combined with an 'old-fashioned' political engagement; otherwise it all becomes a bit bloodless. Terry Eagleton has recently criticized post-colonial studies for its lack of political commitment, but I find some of his criticisms are exaggerated.[15] While we mustn't let go of the actual achievements of post-colonial studies, we need to be aware that there are limitations.

My own feeling, for whatever its worth, is that the way forward is to retain what has been achieved but to also selectively choose aspects of earlier empirical work that may enable us to maintain a solid research foundation. One shouldn't be at the expense of the other. Above all, whatever we might think of the current state of play, I do feel quite strongly that non-western art and artists must not be made into a mere adjunct of western scholarship. We need to think of them as artists and art forms in their own right whose life and work experiences are worth recording, and we must try to see how their stories can be framed within that kind of conceptual framework as well.

NOTES

1. Partha Mitter, *Much Maligned Monsters: History of European Reactions to Indian Art*, Oxford: Oxford University Press, 1977.

2. See Partha Mitter, *Art and Nationalism in Colonial India 1850–1922*, Cambridge: Cambridge University Press, 1994.

3. W.G. Archer, *India and Modern Art*, London: George Allen & Unwin, 1959.

4. John Clark, *Modernity in Asian Art*, Canberra: Wild Peony, 1993, 1–17.

5. W. Kandinsky, *On the Spiritual in Art*, second edn, Munich 1912, K.C. Lindsay and P. Vergo eds, *Complete Writings*, vol. 1, Boston: G.K. Hall, 1982, 173.

6. John Golding, *Paths to the Absolute*, Princeton: Princeton University Press, 2000. Sixten Ringbom, 'Art in the "Epoch of the Great Spiritual": Occult Elements in the Early Theory of Abstract Painting', *Journal of the Warburg and Courtauld Institutes*, XXIX, 1966, 386–418.

7. Michael Baxandall, *Patterns of Intention*, Berkeley: University of California Press, 1985.

8. In 2001, I received Arts and Humanities Research Board (UK) funding, in collaboration with Oriana Baddeley and Toshio Watanabe, to run workshops on Modernity, Art and National Identity: Japan, India and Mexico, 1860s–1940s, as a joint University of Sussex and London Institute project. There are around twenty-five participants and the outcome will be published as a volume of essays. The project arose out of my interest in exploring the different artistic responses to western hegemony.

9. See M. Kaempchen, *Rabindranath Tagore and Germany*, Calcutta: Max Mueller Bhavan, Goethe Institute, 1991.

10. Partha Mitter, *A Different Modernism: Indian Artists in the Late Colonial Era,* London: Reaktion Books, 2005 (in preparation) .

11. A.K. Coomaraswamy, *Rajput Painting*, 2 vols., London: Oxford University Press, 1916, for instance, which is seen as a Hindu style as opposed to the Mughal, but also in general his writings do not acknowledge any presence of Muslims in Indian history and culture.

12. Brian Street, *The Savage in Literature: representations of "primitive" society in English fiction, 1858–1920*, London: Routledge, 1975.

13. Partha Mitter, review of John MacKenzie, *Orientalism: History, Theory and the Arts*, Manchester: Manchester University Press, 1995, in *Times Higher Education Supplement*, n 1203, 24 November 1995, 22.

14. Partha Mitter, 'The Hottentot Venus and Western Man', in L. Hallam and B. Street eds, *Communicating Otherness*, London: Routledge, 2000, 35–50.

15. Terry Eagleton, *After Theory*, London: Allan Lane, 2003.

WHITE WALLS, WHITE SKINS: COSMOPOLITANISM AND COLONIALISM IN INTER-WAR MODERNIST ARCHITECTURE

PAUL OVERY

In this essay I want to examine ways in which issues of race, colonialism and orientalism impinged upon modernist architecture between the two world wars. Over the last two decades a number of commentators have paid specific attention to individual modernist projects from this period, such as the house designed for Josephine Baker in Paris by Adolf Loos in 1927 and Le Corbusier's schemes for the redevelopment of the city of Algiers between 1931 and the early 1940s. Both of these were 'paper' or 'fantasy' projects – although Le Corbusier probably persuaded himself that his Algiers project was capable of being carried through.[1] Both projects were highly individual, eccentric and atypical of inter-war modernism. Here I examine examples of the modernist architecture of the 1920s and 1930s that were both realised and exemplary. I focus in particular on the Weissenhofsiedlung model-housing exhibition shown in Stuttgart in the summer of 1927, although I shall also refer to other examples from the period.

Loos's house for Josephine Baker was an elderly white male architect's fantasy design for a young, fashionable, exoticised and eroticised African American entertainer, clearly located within the cult of 'negrophilia' in Paris of the 1920s. Le Corbusier's plans for Algiers were an aggrandising colonial project for the modernisation of the European quarters of the city and the regularisation and control of the Arab city. These were essentially a modernist re-interpretation of French colonial policies and city planning of the time, mediated through Le Corbusier's architectural obsessions and his own particular exoticised and eroticised version of orientalism. The Weissenhofsiedlung on the other hand was intended to be a permanent demonstration of the possibilities of modernist housing types, which could be built using modern methods of construction – an exemplary international display of the new *Wohnkultur* (or culture of dwelling) that would serve to disseminate modernist ideas about architecture and design.

Exhibited in the summer of 1927 as a series of model houses and apartment buildings that were later rented out to individual tenants, the Weissenhofsiedlung had been conceived two years earlier in 1925 as an international exhibition by members of the German Werkbund – the organisation set up in 1904 to promote cooperation between German art and industry. Jointly sponsored by the Werkbund and the city of Stuttgart, it was originally intended as a direct response to the Paris Arts Décoratifs exhibition of 1925, to which German architects and designers had deliberately been invited too late to participate. It was also a response to the critics of the Paris exhibition, who had argued that this ought to have been a display of modern housing which could be inhabited after the period of the exhibition – rather than a glorification of French luxury production within an international context.

The Weissenhofsiedlung was the only permanent feature of a series of manifestations and displays with the overall title of 'Die Wohnung' (The Dwelling) organised under the 'artistic directorship' of Mies van der Rohe, which included a number of temporary exhibitions devoted to furniture design, the interior, and new building and furnishing materials. The estate consisted of twenty-seven single-family detached, semi-detached and terrace houses, and two apartment blocks – amounting to fifty-three individual dwellings in all. Although initially conceived with the intention of providing models for working-class social housing, as executed the

Weissenhofsiedlung from
'Schönblick' restaurant
tower, Stuttgart, 1931

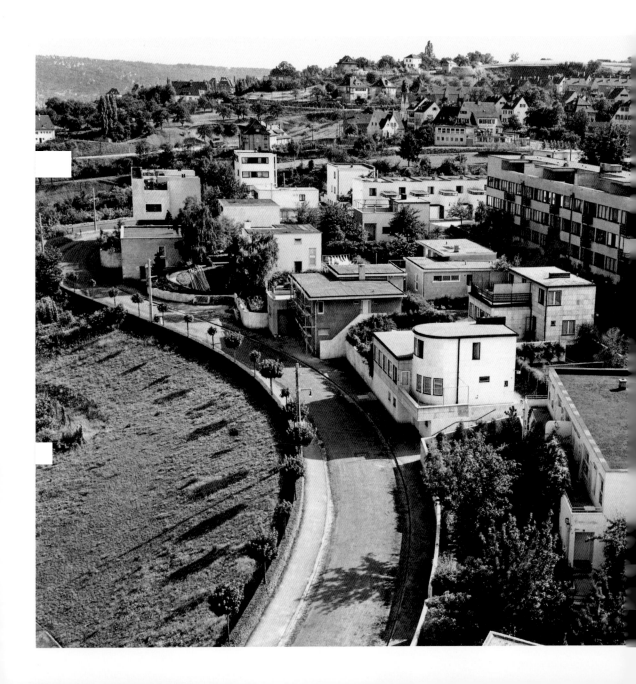

Siedlung was a series of modernist housing types ranging from detached houses aimed at the professional middle class (Le Corbusier, Hans Poelzig) to row houses designed for the lower-middle classes or better paid artisans (J.J.P. Oud, Mart Stam).[2] Although the architects and designers were drawn from only five different countries – all European, and three German-speaking – the Weissenhofsiedlung received international publicity (mainly in professional architecture, design, housing and construction periodicals) and has often been seen as the first major institutionalisation of International Modernist or International Style architecture. It was visited by Henry-Russell Hitchcock and Philip Johnson who included photographs of housing for the estate by Le Corbusier, Oud and Mies van der Rohe in the influential exhibition they organised at the Museum of Modern Art, New York, *Modern Architecture: International Exhibition*, and in their even more influential book published to accompany the exhibition, *The International Style*. It was also visited by Alfred Barr who had overseen the MoMA exhibition in 1932, and who spent three months in Stuttgart the following year on a 'sabbatical' from his post as director of the recently founded museum.[3]

Although a certain type of modernist architecture has been characterised (both at the time, and retrospectively) as 'international', attempts to define modernism in terms that would be universally applicable and which would transcend national boundaries often overlapped or coexisted with attempts to define modernism in national terms in the years between the world wars. Nationalism and internationalism have been closely intertwined in cultural formation and production during the 20th century. In some European countries newly independent after

J.J.P. Oud, *Five Row
(Terrace) Houses at the
Weissenhofsiedlung,
Stuttgart*, 1927, rear view

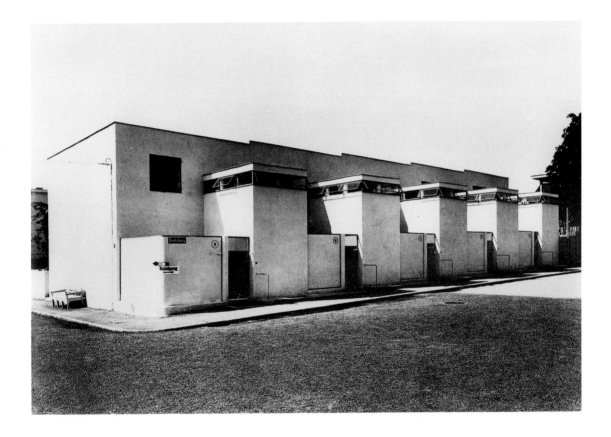

World War I, such as Czechoslovakia, national identity was promoted through ideas and practices in architecture, design and fine art which elsewhere have been identified with International Modernism. On the other hand some critics have seen internationalism in the visual arts as a kind of cultural imperialism, an attempt to impose the ideas and practices of a dominant nation on other parts of the world under the guise of universalism. At the time this was perceived not as we might see it today, as the imposition of a dominant architectural style on the then colonised or emergent nations of the world, but as an attempt by one or two powerful nations such as Germany and the USA to foist the style on the countries of western and central Europe. Certain contemporary critics (particularly in France) regarded the promotion of an internationalising modernism in the late 1920s and early 1930s as an attempt to impose a hegemonic German-inspired modernism upon European national visual cultures. This was also sometimes perceived as an attempt by (largely German) modernist architects and designers to infiltrate 'American' ideas and practices into European architecture and design under the guise of 'internationalism'.

Leftist critics of the period were also suspicious of the depoliticised use of the terms 'international' and 'internationalism' adopted in institutionalising projects such as MoMA and Hitchcock and Johnson's *The International Style*. Earlier attempts had been made in the 1920s in Germany, The Netherlands, and some central European countries such as Czechoslovakia and Hungary, to introduce the notion of the 'Modernist International' – based more directly on the workers' (or communist, or socialist) Internationals – in place of the more apolitical term 'International Modernism'. In his book on Walter Benjamin, the French critic Pierre Missac has argued that the use of the word 'international' in the context of terms such as International Modernism and the International Style risks a 'confusion between bourgeois cosmopolitanism and the workers' internationals'.[4] However when Marx used the term cosmopolitanism with reference to the bourgeoisie, this was arguably in a positive (or at least a neutral) sense.[5] In the 1920s the Marxist architect Hannes Meyer, who succeeded Walter Gropius as director of the Bauhaus, used the term specifically in reference to the international qualities of modernism. In 1926, Meyer declared, adopting a tone familiar from the manifestos of the Futurists and the earlier writings of Le Corbusier, that 'Constructive form is not peculiar to any country; it is cosmopolitan and the expression of an international philosophy of building'.[6]

> Large blocks of flats, sleeping cars, yachts and transatlantic liners undermine the local concept of the 'homeland'. The fatherland goes into decline. We learn Esperanto. We become cosmopolitan.[7]

That might sound like a description of the lifestyle of the wealthy upper class of the period, the class who benefited from an easy access to modern technology in the 1920s. But like other commentators on modernity of his generation, Meyer believed the travel and communications technology that was only accessible to the rich in the 1920s would soon be available to many more people. He argued this was already beginning to make an impact on a large part of the population of developed countries:

Because of the standardisation of his needs as regards housing, food and mental sustenance, the semi-nomad of our modern productive system has the benefit of freedom of movement, economies, simplification and relaxation, all of which are vitally important to him.[8]

Cosmopolitanism and nomadism were ideas that were contested and appropriated by opposing factions during this period. Cosmopolitanism was frequently employed in an anti-Semitic context in both Nazi Germany, and Stalinist Russia, while nomadism (here used positively by Meyer) was also employed disparagingly by Nazi propagandists like Paul Schulze-Naumberg to denigrate 'rootless' cosmopolitan left-wing – and by implication, Jewish – intellectuals.

In the early 1930s the Baedeker guide described the Weissenhofsiedlung as 'an interesting colony of ultra-modern flat-roofed houses with wide windows, large verandas and roof gardens'.[9] These features were remarked on by both hostile and sympathetic commentators, and characterised many modernist buildings of the 1920s and 1930 – which is perhaps why the Weissenhofsiedlung has so often been seen as the moment when modernist architecture first became institutionalised. Such features related to contemporary preoccupations with health and hygiene and the physical and social benefits of light, air, space and openness, but also (as contemporary architects and critics acknowledged) appeared to have much in common with southern European or north African vernacular architecture. Observation of the orientalist aspects of the Weissenhof architecture was not confined to the assaults

of right-wing or proto-Nazi critics, although these have since become notorious.

Modernist architecture was frequently attacked in specifically racist terms in the 1920s and 1930s. The supposedly satirical picture postcard of the Weissenhofsiedlung with figures of Arabs and camels crudely montaged on to a photograph of a panoramic view of the estate first appeared in the early 1930s and (hardly surprisingly) was still available at the end of the decade.[10] But when the model-housing exhibition first opened in Stuttgart in the summer of 1927, its detractors were already referring to it as 'little Jerusalem'. Paul Bonatz, a Stuttgart-based architect who had not been invited to participate at Weissenhof – and who was to remain and work in Germany during the Nazi period, although he never became a virulent Nazi apologist like Schulze-Naumberg – had dismissed Mies van der Rohe's overall plan for the Siedlung in 1926 as an 'assemblage of flat cubes' which 'swarms up the slope in a succession of horizontal terracing, looking more like a suburb of Jerusalem than dwellings in Stuttgart'.[11] Although Bonatz may not have been an active National Socialist, his racist remarks of 1927 opened the way for the more venomous propaganda that followed in a few years time. A year before the Nazi takeover in Germany a writer in a national building trade journal in 1932 sneered that 'the good-natured Swabian people' of the Stuttgart region had rejected the Weissenhofsiedlung as 'oriental imitations', 'Little Jerusalem', and 'collective anthills of vicious central African termites'.[12]

On a Stuttgart map of 1928 the area immediately to the west of Weissenhof is marked with the old name 'Aegypten' (Egypt) – perhaps originally a site occupied by Roma who were often referred to as 'Egyptians' in European

countries, as in the English corruption 'gypsy'. A little further to the north are areas marked 'Im Juden' and 'Judenhof', presumably land formerly owned or occupied by Jews.[13] Even before the *Siedlung* was built, this was identified as a landscape of the other, a site of alterity and (perhaps) expropriation. Although Weissenhof refers to the name of previous tenants (the brothers Weiss, who ran a bakery) its 'white' associations further served to provoke racialist jibes: a 'white' architecture that evoked the middle-eastern or north African dwellings of the 'non-white'. Recent architectural historians have argued that the name of the estate (albeit unconnected) helped to associate the idea of modernist architecture of the period with white and whiteness.[14]

The Weissenhofsiedlung was held in a relatively conservative part of Germany in a city with a medieval centre (predominately black-and-white vernacular architecture, destroyed during World War II) where the modernity of the *Siedlung* contrasted with the traditional buildings around it. Sited in a pleasant hilly suburb where the flat-roofs, sun terraces, balconies and verandas made a particularly dramatic impact due to the uneven terrain and differences in level, this added to the impression of a mediterranean or north African hill town. Nonetheless the attacks from traditionalist and right-wing critics were paralleled in the reception of other modernist estates in Europe at this time, although often this was the response of those who lived close to such estates, rather than that of professional critics. Parts of the famous New Frankfurt project of social housing designed by architects working under the city architect Ernst May between 1925 and 1930 were nicknamed 'new Morocco'. Le Corbusier's social housing of

1925–26, at Pessac on the outskirts of Bordeaux, was referred to locally as 'the oriental region' or 'the casbah',[15] while similar racist nicknames were given to J.J.P. Oud's housing block at Hook of Holland of the same period. More surprisingly, such characterisations were extended by respected professional critics to exclusive and luxurious modernists developments such as those by Robert Mallet-Stevens in the prosperous Paris suburb of Auteuil, and to artists' studios on the Left Bank designed by André Lurçat and Auguste Perret. These were compared to the orientalising 'Arab quarters' built for the Paris Exposition Universelle of 1900, although such comparisons seem more intended as comments on the fashionable and exotic qualities of such 'moderne' or modernist designs, rather than as overt racialist slurs (although they may well have had racialist undertones – many of the occupants of these apartments and studios would have been Jewish).[16]

One of the most frequently remarked characteristics of inter-war modernist architecture was the dazzling whiteness of its painted concrete – or more often plaster – walls. This perception was not always accurate because often the walls of modernist buildings were not actually white but painted in pastel or light-hued colours or shades of grey or off-white (as were many of the Weissenhof houses and apartments). These appeared as white in the high-quality high-contrast black-and-white photography employed to represent architecture at the time. However it is no coincidence that what has sometimes been termed 'white' modernism was produced at the time when European colonialism was at its zenith – although on the verge of imminent collapse. Such buildings also exhibited features other than

'Arab Village'
(photomontage of the
Weissenhofsiedlung with
Arabs in traditional dress,
camels and lions), Stuttgart,
late 1930s

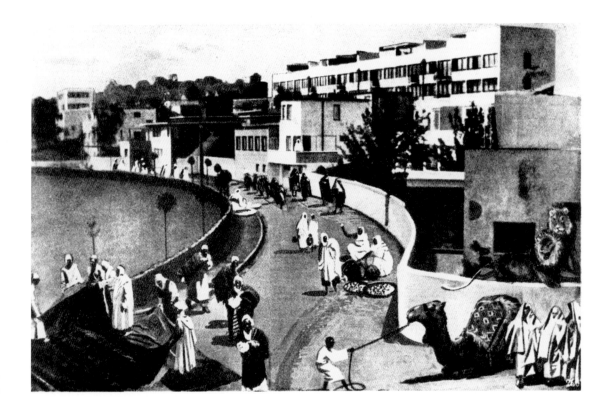

white walls that were represented as 'colonial', 'oriental', 'middle-eastern', or 'north African'. These included roof gardens, sun terraces, balconies, verandas, pilotis (reinforced-concrete columns) – all of which featured prominently at the Weissenhofsiedlung, and in many other examples of modernist housing of the period.[17]

The allusions to middle-eastern or north African vernacular architecture presumed by the racist innuendoes and attacks quoted earlier were not just figments of the overheated imaginations of right-wing and proto-Nazi commentators at the time. This was also an important – and in many ways problematic – aspect of the modernist architecture of the period. Modernist architects knowingly adopted many of what they deemed to be characteristic features of middle-eastern or north African buildings. These can be seen in housing designs of the mid- to late-1920s by Le Corbusier, Gropius, Oud and other modernist architects and were particularly in evidence at Weissenhof, which included housing designed by these architects. Such features can be seen as a response to contemporary ideas about health, hygiene, fresh air and openness, which were a particular obsession at the time – and of modernists in particular. But such picturesque and orientalist qualities can also be seen as a strategy: a unifying and suturing of the abrasive surfaces of modern methods of construction beneath an homogenous overall coat of whitewash, masking modernity by means of formal features that alluded to mediterranean or north African vernaculars – a strategy similar to the adoption of 'primitivist' elements in early modernist painting and sculpture. The 'orientalist' aspect of the Weissenhofsiedlung served to mask or to *veil* its message of

technological modernity in what remained essentially a traditional and conservative European society, although most traditionalist and right-wing critics saw through this and condemned both the 'orientalist' and 'mechanistic' qualities of the project.

Adolf Loos had employed similar strategies in the middle-class villas he designed in Vienna shortly before and shortly after World War I, as had Le Corbusier who gave a 'classical' or 'mediterranean' appearance to his luxurious 'machine-like' Parisian villas of the 1920s. (As Nancy Troy argues in *Couture Culture*, 'oriental' and 'classical' were not necessarily opposed concepts but were often conflated or intertwined at this time.)[18] The classical, mediterranean, or middle-eastern effects of smooth rendered walls, pergolas, roof gardens, terraces and cantilevered balconies served to disguise the technological or rationalising basis of modernist designs, suggesting a 'timeless' quality that counteracted the rawness of the new and disruptive signifiers of modernity. However although this may have been to some extent successful in reassuring the upper-class clients of Le Corbusier's villas in exclusive Parisian suburbs or those of Loos in the prosperous outer suburbs of Vienna, when applied to attempts to create middle- or lower-middle class housing types – as at Weissenhof – such strategies elicited overtly racist reactions.

The orientalist aspects of Le Corbusier's early career are well documented. As a young architect in Paris in 1909 he was employed in the architectural office of one of the major early promoters of reinforced-concrete construction, Auguste Perret, who had many commissions in French colonial north Africa. Although he did not visit north Africa at the time, Le Corbusier worked on the Catholic Cathedral of Oran in

Algeria, for which Perret Fréres were the contractors. After a spell in the office of Peter Behrens in Berlin, he undertook his 'Voyage to the Orient' in 1910–1911 – a kind of 'gap year' (actually six months) in his early career, during which he travelled through southern Europe and the Balkans to Istanbul.[19] Many modernist architects of this generation would have been familiar with southern European or north African vernacular architecture, either from photographs or from direct experience, often of a similar kind to that of Le Corbusier. In the early 20th century, it was not uncommon for young architects or architectural students (and not only the wealthy) to take the equivalent of the 18th-century 'Grand Tour'. When the Russian artist-designer El Lissitzky was an engineering student in Darmstadt in Germany before World War I he *walked* to Italy, as did many other students of the period. This modern version of the Grand Tour was often extended to north Africa or the Middle East. Established architects also sometimes travelled to the mediterranean, the Middle East or north Africa for a variety of reasons. Adolf Loos visited Biskra in Algeria in 1910 while looking for marble to clad the façade of his Michaelerhaus in Vienna, and again in 1911 to accompany his long-term companion, the young English dancer Bessie Bruce (who suffered from tuberculosis), on a 'winter cure'. These trips seem to have furnished Loos with ideas about incorporating flat roofs and terraces into his housing designs that can be seen in the stepped terraces of some of his villas of the immediately pre-1914 period, such as the Scheu House (1912–13).

An admiration for middle-eastern vernacular architecture was common among 'progressive' architectural circles in Europe in the early years of the 20th century. Before World War I, the 'enlightened' industrialist and leading member of the German Werkbund, Karl Ernst Osthaus, commissioned a garden suburb for the north German town of Hagen, set on a hill like a mediterranean or middle-eastern town. 'How much Europe can learn in this respect from the Islamic Orient', Osthaus wrote. 'I don't remember ever having had a stronger impression of domestic peace [*Wohnfrieden*] than in those little alleys, removed from the world and enclosed in high white houses and walls'.[20] The romanticisation or 'orientalising' of the mediterranean littoral (which had a long tradition in German-speaking countries, as in France and England) also came in for criticism from liberal or left-wing critics in contemporary reviews of the Weissenhofsiedlung – a criticism which was of course different in kind to that of the proto-Nazi right wing. The leftist Swiss architect Hans Schmidt complained that many of the Weissenhof houses were unsuitable as designs for lower-middle class or working-class housing types for a northern or central Europe climate – which was what they were supposed to be according to the exhibition brief – but would be more appropriate as holiday homes in southern Europe.[21] Walter Riezler commented in the Werkbund magazine *Die Form* on the impracticality in Germany of Le Corbusier's semi-detached houses at Weissenhof with their roof gardens occupying the whole of the roof area and double-height living rooms lit by enormous windows which would overheat in summer and be extremely cold in winter.[22]

Shortly after this Le Corbusier became preoccupied with the idea of the universal benefits of air conditioning, the 'supreme attraction' of which, according to Tim Benton, was the 'universalism of the solution' that

seemed to offer 'a means of designing the same building, with the same equipment, for any climate in the world'.[23] Le Corbusier described his utopian dream as 'a single building type for every country and every climate, the building with controlled ventilation [*respiration exacte*: literally, "controlled breathing"]':

> The building in Russia, Paris, Suez or Buenos Aires, the ocean liner crossing the equator, will be hermetically sealed. In winter warmed, in summer cooled, which means that pure controlled air at 18°C circulates inside at all times. The building is hermetic! No dust can enter, nor flies or mosquitoes. No sound![24]

Le Corbusier put his ideas into practice, incorporating sealed-glass façades in his building for the Armée de Salut in Paris (1930–32) and the Centrosoyuz building in Moscow (1928–33), roasting the inhabitants of the Salvation Army hostel in summer and freezing the users of the Moscow building in winter. The hermetically-sealed south-facing glass wall of the Salvation Army hostel 'proved disastrous in summer due to thermal gain'[25] and Le Corbusier was forced by the Paris Préfecture to allow the installation of opening windows, while the glazing in the Centrosoyuz was drastically reduced.[26]

Much more than the wide windows and enormous *pannes de verre* of which Le Corbusier and certain other – but not all – modernists were so fond, the white wall has been seen as the main symbolic signifier of modernist architecture.[27] Associated both with hospitals and sanatoriums and the white interiors of modern art galleries, white has remained closely linked to modernism and modernity. Particularly identified with modernist architecture in its so-called international phase of the late 1920s and early 1930s, it also has strong roots in modern painting and sculpture: from Whistler's *Symphony in White* through Malevich's *White on White* to the works of late 20th-century artists such as Piero Manzoni, Robert Ryman, Agnes Martin and Rachel Whiteread.[28] However, the symbolic aspect of the white walls transcends the actuality. The high definition black-and-white photography of the period, employed to document and promote modernist architecture between the wars in magazines, books and exhibitions, rendered the pale pinks, blues or yellows in which many of the walls of modernist buildings of the period were actually painted as a dazzling bleached white surface. This was similar to the way in which the skin colour of Europeans and those of European origin were rendered as white by black-and-white photography, or the black-and-white cinematography of the period. The white wall is both the emblem of modernity and the displaced surface on to which is projected the whiteness of the European – who is not 'really' white but pink or light hued, like the walls of many modernist houses.

The cult of the white or near-white wall, and of mediterranean and middle-eastern sun roofs, terraces, verandas and balconies, among modernist architects appears at the point in the early 20th century when the vogue for sunbathing was at its height. This was something upper- and middle-class Europeans had studiously avoided up until this time. In the 19th century, a pale complexion was associated not only with racial purity but also with social class, differentiating the upper classes from those who had to do manual labour in the open air. But in the 1920s wealthy and fashionable Europeans began

Rachel Whiteread,
House, 1993

to cultivate the tanned sunburned skin of the working-class mediterranean peasant. They began to visit the Riviera in the summer rather than the winter, which had been considered 'the season' in the 19th century. At about the same time, it became fashionable to commission a white-painted modernist villa, displacing 'whiteness' from their now fashionably sunburned skin on to the whiteness of the white wall.

In his book, *White*, the film historian, Richard Dyer, argues that the mediums of still and of ciné photography (predominantly black-and-white in their early days) were particularly attuned to privilege representation of the white skin and to disadvantage the black.[29] Dyer maintains that the 'norms' established for black-and-white ciné photography early in the history of the cinema 'naturally' privileged white skin. Through the standards set up for film stock, lighting, aperture width, exposure time and development procedures, the early professional practitioners of cinematography 'took the white face as the norm, to the disadvantage of black faces'.[30] Somewhat disingenuously, Dyer claims there is nothing particularly sinister or deliberately discriminatory about this – merely that white people are accustomed unthinkingly to accept themselves as the human mean: 'Refinements in the chemistry of film stocks, in camera design and development methods, all took the human face as the touchstone for getting things right, and inventors simply took their own white faces and the ones they were working with as the norm.' When colour was introduced the aim became to achieve 'the right pinkness to convey whiteness', although the norms were established in the era of black-and-white photography.[31] It is no coincidence that one of the early 'great epics' of the black-and-white silent film era was

D.W. Griffith's *The Birth of a Nation*, a racist *tour de force* that glorifies the Ku Klux Klan – who not only *are* 'white', but who dressed up and masked themselves in white robes.

The black-and-white still photography of the time privileged white (or off-white, or light-toned) walls as well as white skins. It would be difficult to imagine an architecture so well suited to representation and reproduction by black-and-white photography as that of the 'international' phase of modernism between the wars, with its white or light-hued tones, large areas of glass and precise geometric lines. In the era of black-and-white architectural photography the white or light-coloured wall (rendered white by the reproductive process) was a complex signifier. Originally owing its popularity among modern architects to its association with cleanliness, hygiene, health and purity, the white wall also carries with it a large quantity of more complicated symbolic luggage. Colonialist and racist implications are a crucial element in this, although to maintain that the white wall was only a racist or colonialist signifier would be a crude oversimplification. Nevertheless racism and colonialism are often evoked unwittingly and ambiguously, and sometimes perhaps more knowingly.

Like flat roofs, white walls have been seen as among the most distinguishing characteristics of the modernist house, and in so far as both appear to erase reference to the specific locality of the building such features have been identified as 'international'. Flat roofs, white walls, roof gardens, sun terraces and verandas were construed as both 'alien', 'oriental' (or middle-eastern) and international (in a negative sense, i.e. as anti-national) by hostile critics – and as international (in a positive sense) and utopian by

the advocates of modernism. Beside obvious references to hygiene and cleanliness, the white walls and flat roofs typical of modernist buildings of the period also evoked only slightly veiled references to sexuality and the eroticised body.

Hygiene and cleanliness were themselves closely linked to notions of modern sexuality. Flat roofs or roof terraces were intended for sunbathing or (in the absence of sun in northern Europe) the taking of *Luftbäder* or 'air baths' that exposed the naked body to the fresh air, or for gymnastic exercises – all of which by implication were taken in the nude or the near nude. Even if such features were used infrequently due to their impracticality in northern climates, they nonetheless evoked associations of sun and water, of mediterranean warmth and sensuality, if not outright sexuality.[32] With its apparent 'nudity' or 'nakedness', the white wall evoked the nude body seen (or photographed) against it. So powerful was this association that the white wall seen or photographed in architectural publications *without* a human figure against it had a powerful metonymic ability to evoke the absent naked figure. By its very purity/nakedness the white wall evoked a strong 'modern' (i.e. uninhibited) sexuality. Such an evocation of sexuality was not specifically regional but southern, utopian, nostalgic. It served to sever sexuality from conventional notions of marriage, courtship and family, projecting it into a world of rootless 'cosmopolitanism' and 'internationalism' where the received morality encouraged the separation of sexuality from generation and childbearing.

As well as associations of cleanliness and hygiene, sunlight, fresh air, openness and sexuality, white and whiteness also alluded to death. One of the key building types of early modernism was the tuberculosis sanatorium, and although the white walls of the sanatorium signified hygiene and cleanliness, and the open air and sunlight associated with the particular treatment for tuberculosis that the sanatorium of the period provided (and the snow-bound mountainous regions where they were often situated), the white walls of sanatoriums also signified death – as is clearly conveyed in Thomas Mann's great sanatorium novel *The Magic Mountain (Der Zauberberg*, 1924). Tuberculosis had been known in the 19th century as 'the White Death' because of the pale complexion of those who suffered from the disease, but also 'because of its long association with childhood, innocence and even holiness'.[33] In his study of tuberculosis as a cultural phenomenon, *The White Death*, Thomas Dormandy has argued that this identification with holiness, innocence, childhood and death did not conflict with 'the deeply ingrained notion' that the disease was also associated with febrile sexual desire and sexual activity.[34]

However, it is always necessary to situate ideas about whiteness and the use of white by early 20th-century modernist artists, architects and designers within the historical context of an era when European colonial power was at its zenith, its imminent collapse already envisaged by some while steadfastly ignored by others. A preoccupation with health, hygiene and cleanliness emerged at a time when throughout the world the dominant white races were differentiating themselves by social and cultural means from people of colour. Until the mid-19th century, intermarriage between the colonisers and the colonised had been quite common, particularly in British India. But during the second half of the 19th century the dominant colonising white races began to separate themselves much more distinctly from those whom they had

colonised. Racial differentiation (and racial tensions) often centred round hygienic matters such as toilet habits or ways of preparing food. Hygiene became a means of separating one race or one class from another, or of differentiating sub-groups within a class system. 'Apartheid meant firstly sorting out toilet arrangements', as Sarat Maharaj has argued:

All imperial forces quickly got down to building toilets, sewers, water closets, drains, gutters, cesspools – vast hydraulic pipe-systems that mirrored the colonial power network. An in-gathering, containing, tribute and tax-collecting business.

Meanwhile, Maharaj adds, the 'conquered natives went about messing all over the show, streams, rivers, the sea' constituting 'an incontinent, disrupting, anarchic force'.[35]

Conclusion

White-walled modernist buildings (which included sanatoriums or hospitals) evoked hygiene and health and hence the cleanliness that was represented as distinguishing the European from the non-European. Their whiteness evoked the white skin and the implicit cleanliness and orderliness of white civilisation. Yet through the conjunction of white walls with flat roofs, sun terraces and roof gardens such buildings also alluded to the vernacular architecture of the mediterranean and north Africa – areas not normally associated with the obsession with hygiene and cleanliness of western and northern Europe, but which evoked notions of otherness that were implicit in architectural tours to north Africa and the Middle East and the upper-class cultivation of the sun-tanned skin of the mediterranean peasant.

Right-wing and proto-Nazi critics attacked such aspects of the Stuttgart Weissenhofsiedlung and similar modernist developments, couching their criticism in the language of racial abuse and innuendo. At the same time, such elements were an important part of the modernist project, not merely the representations of its antagonists. They were employed to mask or veil the obsession with technology and new methods of construction that were an important aspect of modernist thinking, and also to attract potential customers and clients by allusions to southern climates and the vernacular architecture of the mediterranean littoral. They were signifiers of the preoccupations of the period with hygiene, health, fresh air and sunshine, which were not confined to modernists. The white walls of modernist buildings in the inter-war period defined the obsessions of Europeans with such issues – while paradoxically evoking the vernacular architecture of those against whom they defined themselves in and through such obsessions.

I wish to acknowledge the support of the Middlesex University School of Arts research committee and my colleagues in the Art, Philosophy and Visual Culture academic group in the writing of this essay and the paper on which it was based, and to thank Tag Gronberg for a number of helpful suggestions in the revision of the text.

NOTES

1. For Loos's Josephine Baker project, see Paul Groenendijk and Piet Vollard, *Adolf Loos: House for Josephine Baker*, Rotterdam: 010 Publishers, 1985; Beatriz Colomina, *Privacy and Publicity: Modern Architecture as Mass Media*, Cambridge, Mass. and London: MIT Press, 1994, 260ff, 279ff; Karen Burns, 'A House for Josephine Baker', in Gülsum Baydar Nalbantegui and Wong Chong Thai eds, *Postcolonial Space(s)*, New York: Princeton Architectural Press, 1997; Kim Tanzer, 'Baker's Loos and Loos's Loss: Architecting the Body', *Center*, vol. 9, 1995. For Le Corbusier's Algiers project see Manfredo Tafuri, *Architecture and Utopia: Design and Capitalist Development*, Cambridge, Mass. and London: The MIT Press, 1979, chapter 6, 'The crisis of Utopia: Le Corbusier at Algiers', 125–49; Mary McLeod, 'Le Corbusier and Algiers', *Oppositions*, nos. 19–20, Winter–Spring, 1980; Zeynep Çelik, 'Le Corbusier, Orientalism, Colonialism', *Assemblage*, no. 17, April 1992.
2. For the Weissenhofsiedlung see Karin Kirsch, *The Weissenhofsiedlung: Experimental Housing for the Deutscher Werkbund*, 1927, New York: Rizzoli, 1989; Richard Pommer and Christian F. Otto, *Weissenhof 1927 and the Modern Movement in Architecture*, Chicago and London: Chicago University Press, 1991.
3. Barr discussed the Weissenhofsiedlung in an article written in 1933 while he was staying in Stuttgart, but not published until twelve years later. (See Alfred H. Barr Jr, 'Art in the Third Reich – Preview, 1933', *Magazine of Art*, October, 1945, reprinted in Alfred H. Barr Jr, *Defining Modern Art: Selected Writings of Alfred H. Barr Jr*, New York: Abrams, 1986.).
4. Pierre Missac, *Walter Benjamin's Passages*, Cambridge, Mass. and London: The MIT Press, 1995, 151.
5. In the well-known passage on 'bourgeois cosmopolitanism' in *The Communist Manifesto*, Marx argued that 'market forces' were driving capitalism to yet more international quests and conquests:

> The need of a constantly expanding market for its products chases the bourgeoisie over the whole surface of the globe. It must nestle everywhere, settle everywhere, establish connections everywhere. The bourgeoisie has through its exploitation of the world market given a cosmopolitan character to production and consumption in every country (...).

(Karl Marx and Friedrich Engels, *The Communist Manifesto* (1848), Harmondsworth: Penguin Books, 80–85.) Although the authorship was credited to Marx and Engels jointly at the time of publication, the manifesto is now generally thought to have been written solely by Marx.
6. Hannes Meyer, 'Die neue Welt', *Das Werk*, no. 7, 1926 (special issue on European modernism edited by Meyer) reprinted in German and translated into English in Claude Schnaidt, *Hannes Meyer: Bauten Projekte und Schriften/ Buildings, projects and writings*, London: Tiranti, 1965, 93.
7. Schnaidt, 1965, 91.
8. Schnaidt, 1965, 93.
9. Quoted in Barr (1933), 1945, in Barr, 1986, 172.
10. Barr wrote in his 1933 article that 'a cleverly faked postcard of the Weissenhof appeared showing camels and Arabs wandering through the white-walled flat-roofed houses of "Stuttgart's Moroccan Village"'.' (Barr, 1945, in Barr, 1986, 173.) John Willett recalled a friend who was a student at the Architectural Association in London bringing back one of these postcards after visiting Weissenhof in the summer of the Munich crisis in 1938, so presumably they were still on sale at that time in Stuttgart. (John Willett, *The New Sobriety 1917–1933: Art and Politics in the Weimar Period*, London: Thames and Hudson, 1978, 9.).
11. *Schwäbischer Merkur*, 5 May 1926, quoted in Kirsch, 1989, 36.
12. *Die Deutsche Bauhütte: Zeitschrift der deutscher Architektenshaft*, 27 April 1932, quoted in Kirsch, 1989, 200.
13. Reproduced in Kirsch, 1989, 32.
14. 'Since *weiss* also means white, the name of the Werkbund settlement is peculiarly, if fortuitously, appropriate.' (Helen Searing, 'Case Study Houses: In the Grand Modern Tradition', in Elizabeth A.T. Smith ed., *Blueprints for Modern Living: History and Legacy of the Case Study Houses*, Cambridge, Mass. and London: The MIT Press, 1989, 127, n 50.) However late 20th-century historians of the Weissenhofsiedlung have been at pains to emphasise that the estate was not painted exclusively white. (See Kirsch, 1989 and Pommer and Otto, 1991.).
15. William Curtis, *Le Corbusier/English Architecture 1930s*, Milton Keynes: Open University Press, 1975, 25.
16. P. Morton Shand, 'M. Robert Mallet-Stevens', *The Architect's Journal*, vol. LXIV, 5 October 1927, 449; Charles Imbert, 'Le quartier artiste de Montsouris, la cité Seurat, 101 rue la Tombe Issoire (Paris)', *L'Architecture*, vol. 40, no. 4, 1927, 110; Howard Robertson 'The Rue Mallet-Stevens, Paris: Rob. Mallet-Stevens, Architect', *The Architect & Building News*, 20 January 1928, reprinted in Howard Robertson and F.R. Yerbury, *Travels in Modern Architecture*, London: AA Publications, 1989, 53.
17. Towards the end of the 19th century the French authorities in Algiers adopted a 'Muslim style' in place of the 'Parisian style' used for early colonial developments in the cities of Algeria. A Muslim style was also adopted in Morocco after the country had come under French rule in 1907, during the governorship of Maréchal Lyautey. The French colonial 'Muslim style' in north Africa melded seamlessly into

modernist or *moderne* styles in the years between the wars, and such buildings styles proliferated in north African cities, particularly in Algiers and Casablanca. (See Jean-Louis Cohen and Monique Eleb, *Casablanca. Colonial Myths & Architectural Venues*, New York: The Monacelli Press, 2002.).

18. Nancy J. Troy, *Couture Culture: A Study in Modern Art and Fashion*, Cambridge, Mass. and London: The MIT Press, 2003, passim.

19. Parts of Le Corbusier's account of his voyage appeared in local Swiss journals at the time but the complete memoir was not published until after his death. See the edited French version: Le Corbusier, *Le Voyage d'Orient*, Paris: Forces Vives, 1966 and the complete English translation: Le Corbusier (Charles-Edouard Jeanneret), *Journey to the East*, Cambridge, Mass. and London: The MIT Press, 1989.

20. Quoted in Pommer and Otto, 1991, 40.

21. Hans Schmidt, 'Die Wohnung', *Das Werk*, Basel, vol. XIV, 1927, abridged translation in Charlotte Benton ed., *Documents: A collection of source material on the Modern Movement*, Milton Keynes: Open University, 1975, 20.

22. Walter Riezler, 'Die Wohnung', *Die Form*, 1927, abridged translation in Benton, 1975, 19.

23. Tim Benton, in *Le Corbusier: Architect of the Century*, exh. cat., London: Hayward Gallery/Arts Council of Great Britain, 1987, 169.

24. Le Corbusier, *Précisions sur un état présent de l'Architecture et de l'urbanisme*, Paris: Crès & Cie, 1930, my translation. (See also Le Corbusier, *Precisions On the Present State of Architecture and City Planning*, Cambridge, Mass. and London: The MIT Press, 1991, 64 and 66.).

25. Benton in *Le Corbusier*, 1987, 170.

26. Tim Benton, 'Cité de Refuge, Paris', in *Le Corbusier*, 1987, 177-78.

27. For example by the architectural historian Mark Wigley, whose main concern is the relationship of architecture to fashion and reform dress – although he does also briefly touch on issues of race and colonialism. (Mark Wigley, *White Walls, Designer Dresses: The Fashioning of Modern Architecture*, Cambridge, Mass. and London: The MIT Press, 1995.).

28. For white and the modern art gallery see Brian O'Doherty, *Inside the White Cube: The Ideology of the Gallery Space*, Santa Monica: Lapis Press, 1986.

29. Richard Dyer, *White*, London and New York: Routledge, 1997.

30. The quotation is from an article by Dyer that appeared at the time of the publication of the book. (Richard Dyer, 'Is the camera racist?', *The Guardian*, 18 July 1997, 13.).

31. Ibid.

32. Alan Powers has argued that:

> The veiled erotic aspect of the modern house may be hard to demonstrate, but the propaganda against it reveals more than the writing promoting it. Opponents regularly assumed that the house-owners were nudists, and some of them were. Even if they were not, the flat roofs for sunbathing celebrated the body in a suggestive way.

(Alan Powers, 'A Zebra at Villa Savoye: interpreting the Modern House', in *The Journal of the Twentieth Century Society*, no. 2, 1996, 'Twentieth Century Architecture 2: The Modern House Revisited', 22.).

33. Thomas Dormandy, *The White Death: A History of Tuberculosis*, London and Rio Grande: Hambledon Press, 1999, xiv. Patients had a pale complexion because they suffered from anaemia. For the association of whiteness with death see also Dyer, 1997, chapter 6, 'White death', 207-23.

34. Dormandy, 1999, xiv and passim.

35. Sarat Maharaj, 'Up Hearthead for Apartheid: The Peace Committee commends both Award Winners', in *Hygiene: Writers and Artists Come Clean and Talk Dirty*, exh. cat., Birmingham: Ikon Gallery, 1994, 14-15.

SURREALISM FACED WITH CULTURAL DIFFERENCE

MICHAEL RICHARDSON

In a recent essay, the writer Annie Le Brun focuses on the ideology of *créolité* as an example of the dangers of extolling cultural diversity and multiculturalism. She is scathing in her view that what it represents is the counterpoint, or the corroboration, of attitudes that lead to fundamentalism and ethnic cleansing:

> Because in the end is not this *créolité* the very example of a recourse to an aesthetic which... exalts the diversity of the world, in order to be better able to ignore the fact that its shattered state results first of all in population displacements, the expropriation of entire peoples, in ethnic cleansing... [in people] who rebel less and less? And they rebel less and less because they have been rendered nameless, in every sense of the word...[1]

Créolité, she argues, is, 'constructed from a broad falsification of language, resulting in concealing the totalitarianism, racism and flunkeyism which constitute it'.[2] These are serious charges that may at first seem wildly exaggerated, but they deserve to be taken seriously. Le Brun's intervention came about, she tells us, by her outrage at what she saw as the opportunist way in which the advocates of *créolité* renounced the heritage of revolt epitomised by the example of Aimé Césaire. This caused her to reflect not simply on the specific principles of *créolité*, but upon the extent to which it reflected wider ideologies of cultural diversity in today's world.[3] It is, according to her argument, the very statement of cultural diversity that casts people adrift, denying their cultural specificity and so making them nameless. *Créolité*, she asserts, is a 'fashionable ideology, more exactly a particularly successful example of one of those new cultural products in which multiculturalism, métissage and quest for identity paradoxically serve to accelerate a process of indifferentiation, installing each day a little more denial into ways of existing and thinking.'[4] Le Brun's critique is implicitly made from a surrealist perspective (by way of a defence of Césaire) and provides us with a useful starting point for thinking more broadly about the surrealist attitude towards cultural identity and cultural difference, both from a historical perspective and in terms of how it ties in with current debates.

Créolité is a doctrine principally associated with three Martiniquan writers, Jean Bernabé, Patrick Chamoiseau and Raphaël Confiant, whose manifesto, *In Praise of Créolité* (*Éloge de la créolité*), published in 1989, created some waves.[5] Drawing to a large extent upon the work of Edouard Glissant (although doing so in such a way that may be said to vulgarise and even invert the sense of this writer's work),[6] the manifesto extols Caribbean culture as fundamentally mixed, the history of the region having allowed different ethnic cultures to be brought together in a new, open synthesis. This may seem incontrovertible; it is what the authors advocate from this starting point that raises difficulties. Were they simply making a statement of fact, there would be little to take exception to, but in praising *créolité* in the way they do, and making it an article of faith, Bernabé, Chamoiseau and Confiant are excluding anything that refuses to participate in this mingling. Thus their notion of *créolité* turns into an ideologically directed essentialism, and for this reason may also be seen to subvert Glissant's poetics of relation. Indeed, far from being inclusive of different cultural configurations, Annie Le Brun shows that its

emphasis upon cultural mingling and against any form of cultural specificity (other, of course, than *créolité*) even leads its proponents into making racist and sexist statements (she cites examples of anti-mulatto, anti-Semitic and anti-female statements in its literature).

Even without taking later statements into account, *In Praise of Créolité* itself is already a document imbued with theoretical confusion and vagueness. We don't need to go further than the opening paragraph to find evidence of this: 'Neither Europeans, nor Africans, nor Asians, we announce that we are Creoles. For us this will be an internal attitude, or more accurately: a vigilance, or, better still, a kind of mental envelope within which our world will be built in full consciousness of the world.'[7] The troubling thing about this statement is that, if one were to replace the word 'Creoles' with 'English', one could think this was a statement introducing a new right-wing racist party. It is mystificatory, even contradictory: by defining themselves as 'Creoles' in a way that makes them different from Europeans, Africans or Asians, the advocates of *créolité* are already explicitly constituting themselves in terms of an essence, the very thing they claim to be opposing. The intent, one presumes, is the opposite of a fascist affirmation, since it strives to celebrate the diversity of elements within this 'essence', while a fascist statement would refuse to accept the diversity that constituted the notion of 'Englishness' in the first place. Nevertheless, these positions are parallel in their theoretical confusion. Fascism over-determines the name; doctrines of diversity, which are forced to use a name for something that should – if they were consistent – be impossible to name, mystify it.

This is what Annie Le Brun means, I believe, when she speaks of a falsification of language: from the very beginning, this manifesto excludes anyone who considers themselves to be European, African or Asian. *In Praise of Créolité* reduces cultural identity to an amalgam of different elements that denies legitimacy to any idea or reality that refuses this mingling. As in other ideologies of cultural diversity and multiculturalism, what we see here is a reduction of culture to the form of a lifeless hybridity. *Créolité* is a notion defined within the specific context of Francophone Martinique, but I think Le Brun is right to see such reductionism as symptomatic of ideologies of diversity in general, as much as it may seem at first perverse to perceive a totalitarian germ in ideas which seem manifestly to extol tolerance and moderation.

Here it is interesting to note that one of the first statements of legitimation of a position from which notions of cultural diversity have developed was in fact made *against* surrealism. This is what Cuban novelist Alejo Carpentier advanced in the 1940s as the idea of the 'marvellous real', which later became one of the foundation stones for what later came to be reified as 'magic realism', which in turn came to be used to characterise Latin American fiction in general before transmuting into an international literary genre belonging nowhere in specific but providing ideologies of cultural diversity with one of their most characteristic forms of expression.

In his essay of 1947 Carpentier simultaneously distorts and reifies surrealism as an aspect of European decadence in order to contrast it with the vibrancy of Latin America, where the marvellous is 'real' and does not need to be fabricated. He writes, for instance, discussing Masson's and Lam's work of the early 1940s that:

when André Masson wanted to draw the jungle of the island of Martinique, with its incredible tangle of plants and the obscene promiscuity of certain of its fruits, the prodigious truth of the subject devoured the painter, leaving him all but impotent before the blank paper. And it was left to a painter from America, the Cuban Wifredo Lam, to show us the magic of tropical vegetation, the unbridled Creation of Forms of our nature – with all its metamorphoses and symbioses – in monumental canvases of an expressiveness unique in contemporary painting.[8]

If one can agree on Lam's originality, I cannot see how this can be so at the expense of Masson. Masson's paintings and drawings inspired by Martinique are major works, beautiful in their expressiveness, and to regard them as expressions of impotence seems, to say the least, excessive. Masson's works may represent a European response to the alien quality of the landscape he encountered, but how could one expect anything else? Certainly the idea that the difference in perception between Masson and Lam was one of genetic or cultural heritage (which seems to be implied in Carpentier's statement), meaning that Masson was qualitatively excluded from the sense of awareness Lam had, seems absurd. Lam's work is the result of a unique experience - his own – even if he could not have had that experience had he not been born in the Americas. He may have a special importance as the first painter to break the dependence that Latin American artists had hitherto shown towards European models and, in that sense, Lam revealed a specificity of American experience born of a communication between different cultural realities. This does not, however, mean that his work is determined by his cultural background. Nor does it make European representations of America redundant. Moreover, is it really the case that Lam's work 'shows us the magic of tropical vegetation'? Isn't this reductionist of Lam's achievement, making it a form of heightened realism and expression, whereas Lam's real originality was more accurately assessed by the surrealist writer Pierre Mabille as lying in a sensibility - drawn from the Caribbean - that is incompatible with (and brings into question) a Eurocentric view of the world?[9]

Carpentier's interpretation of Lam's work seems to lie in his own disillusion and rejection of surrealism for its failure to be what he wanted it to be; that is, a heightened realism, a super-realism, and so this prevented him from seeing surrealism for the critique of the notion of realism and the interrogation of the nature of reality that it is. Although Carpentier's view is not one that explicitly celebrates diversity – indeed, he seems consciously to be asserting an essentialist Latin American identity – his sense of a specific Latin American identity is founded in a unique sense of the hybridity and mingling of forms that he sees as being characteristic of the notion of 'our America' and which distinguishes Latin America from the USA, which in comparison remains (despite its own cultural diversity) a Eurocentred, homogeneous society. 'Our America', in Carpentier's formulation, becomes qualitatively different because it welcomes - or at least is inseparable from - the very different (i.e. native American and African, as well as European) cultural elements that constitute it. This celebration of hybridity as the harbinger of a different sense of cultural belonging and being in the world seems directly linked to modern theories of multiculturalism. Yet, like the theorists of créolité, Carpentier wants to celebrate cultural

Agustin Cárdenas,
*Mon ombre après minuit:
L'être lunaire*, 1988

multiplicity, but he does so in such a way that it excludes any element that does not fit the image of multiplicity his notion sets up.

Against this, Annie Le Brun is instructive in the basis upon which she defends Césaire's negritude against the attacks made against it by the proponents of *créolité*. Rather than seeing the essential feature of Césaire's negritude as an assertion of African identity, she argues that it lies in a primary negation that is founded by revolt: it was a refusal of European dominance. The rehabilitation of African culture it anticipated was a secondary aspect, inseparable from this essential negation. She accuses the proponents of diversity of renouncing such negation, instituting what she calls 'a catastrophic separation of being from itself'.[10] The same fault we might note in Carpentier's eulogy to Lam's painting, the value of which in terms of the evolution of art in Latin America lies surely in the fact that it negates the practice of previous Latin American art, rather than, as Carpentier asserts, that it represents a reality of Latin America from which a European like Masson was excluded. A double continuity thus seems to be revealed here: a continuity both of surrealist forms of critique and in the forms assumed by ideological statements of cultural hybridity. From this perspective, and given the hegemonic function which the notion of magic realism has served in Latin America over the past decades, we might say that it was Carpentier more than the surrealists who sought to 'invoke the marvellous at any cost', a point I shall return to.

This seems to be a crucial point with respect to contemporary understandings of what is involved in celebrating cultural hybridity. Today most ideologies of cultural diversity begin with a positive: that cultural mingling is inherently good.

In doing so, however, they establish an exclusion: whatever does not accept such diversity is bad. In addition, such ideologies displace the morality of encounter to an abstract sphere so that it becomes no more than a matter of determining levels of tolerance and understanding. This may seem all well and good, but the inevitable consequence of such an attitude is that it makes identity both contingent and abstract. Furthermore, this attitude towards cultural difference does not accept anything that lies outside the frame of reference within which the criteria for this 'tolerance' and 'understanding' are established. This raises the spectre that haunts all theories of relativism: how to deal with what is regarded as unacceptable within the established frame of reference.

Surrealism has always rejected a relativist framework and a philosophy of tolerance. Its watchword here is 'No freedom for the enemies of freedom!'. In invoking this maxim in an early surrealist text, Louis Aragon was well aware of its Hegelian implications:

> The word, although dishonoured in your public pediments, has remained in your mouths even as you would wildly proclaim having banished it from your heart. Thus denied, freedom finally exists. It emerges from the night into which incessant causality has cast it enriched and completely enveloped by the notion of determination. What, then, resolves the contradictions of freedom? What is perfectly free and at the same time determined and necessary? What could draw its necessity from the principle of freedom? Such a being, which submits itself to the development of the idea, whose will is identical with its becoming, and can imagine nothing but the fact that, identifying itself with the idea, it would go beyond itself. Such is the moral being as I conceive at its most extreme point, which desires nothing but what must be, and which, free in its existence, necessarily becomes the development of this free being. In this way, freedom appears as the true foundation of morality, and its definition implies the very necessity of freedom. Within freedom there can be no element which turns against the idea of freedom. One is not free to act against it, to act, that is, in an immoral way.[11]

This statement, which establishes the philosophical ground for surrealism to be seen as fundamentally a 'moral consciousness', could almost stand as a condemnation, *avant la lettre*, both of ideologies of diversity and the demagogic abuse of the notion of 'freedom' by political leaders. Aragon's definition of freedom chimes with Le Brun's critique of *créolité,* and suggests a consistency of surrealist standpoint over seventy years when he writes, 'O moderates of all kinds, how can you cling to this vague morality, in this haze which so delights you? I can't decide what to admire more, your impartiality or your stupidity. Morality and freedom are in your vocabulary. But one would try in vain to get definitions out of you. The only morality is the morality of Terror; the only freedom an implacable despotic freedom: the world is like a woman in my arms.'[12]

Surrealism is unique among intellectual movements in the modern age because of its international appeal, and more specifically for the fact that as it spread internationally, surrealism generally changed its focus of concern to engage with local conditions.

In great part, surrealism in different cultural contexts from the 1930s onwards did not simply emerge from French surrealism; it did not, that is, germinate from a single root. Far from being followers of André Breton, surrealists in places like Belgium, Czechoslovakia, Romania, Egypt and Japan sought to chart their own relation to surrealism in a way that, while giving due recognition to Breton, never acknowledged deference towards his views.[13]

In general, adherence to surrealism appears not to have involved a change of attitude; it had nothing of a religious conversion about it. Rather it represented a confirmation of what writers and artists had already been looking for either individually or collectively. Even Breton always insisted that he was not the voice of surrealism: his perception of it was a partial manifestation of a much vaster latent sensibility. As surrealism crossed cultural boundaries it was not a matter of the transmission of a message from one place to another. Or at least, in so far as a 'message' was received, it was one that acted as an invocation to engage with the specific cultural reality to be found in that environment, to find ways in which surrealism responded to the social and cultural situation to be found there. In its internationalist attitude, surrealism also endorsed a universal ethic, something that is another factor that sets it against notions of cultural relativism. Benjamin Péret's assertion that 'thought is ONE and indivisible' is perhaps the clearest statement of this. At the same time, the surrealists showed a notable responsiveness to the difficulties of cultural translation. Breton, for instance, was, at least given the age in which he lived, remarkably alert to the dangers of reifying otherness. Luis Buñuel gives a revealing example of this sensitivity:

When [Breton] returned from visiting Trotsky in Mexico City, I asked him what the great man was like: 'He's got a dog he absolutely adores', Breton replied. 'One day the dog was standing next to Trotsky and staring at him, and Trotsky said to me, "He's got a human look, wouldn't you say?" Can you imagine how someone like Trotsky could possibly say such a stupid thing?' Breton demanded. 'A dog doesn't have a human look! A dog has a dog's look!'[14]

Buñuel reports that Breton was genuinely angry when he recounted this, and it seems to be characteristic of a surrealist attitude to respect the otherness contained within different entities. Indeed, this surrealist view of the encounter between different cultural realities seems to be defined by the title of one of Breton's books: it is not a matter of adaptation but of establishing the basis upon which vessels are able to communicate. This suggests a certain poetics of relation, although it is one that takes a different path to that put forward by Edouard Glissant.

It is in the Caribbean that surrealism has made one of its significant interventions, something I have looked into in its generality elsewhere.[15] Certainly, it is as a process of communicating vessels that the relation between surrealism and the Caribbean must be understood; it is a question neither of surrealism 'in' the Caribbean nor of 'Caribbean surrealism', but rather about what happened when surrealism and the Caribbean came into interrelation. It is thus the story of an encounter that forged a dynamic by which surrealism and the Caribbean were reciprocally energised. For those artists from the Caribbean drawn to it, surrealism certainly did not offer a closed template from which to draw

inspiration, but provided a point of convergence and interaction, within which they could attain and extend their freedom of expression.

Other than Lam, the artists who came from the Caribbean to surrealism have been little studied and, in briefly looking at their work, I hope to be able to give a concrete form to the problem existing between cultural heritage and belonging in order to bring out more clearly the critique of cultural diversity that seems to be implicit in surrealism (and is made explicit by Le Brun's critique of créolité). These four artists – Agustin Cárdenas, Jorge Camacho, Ivan Tovar and Hervé Télémaque – share the fact that, beyond their involvement with surrealism and that they were all born in the Caribbean, they have been voluntary exiles, all of them having lived for most of their lives in France.[16]

Born in Cuba in 1927, Agustin Cárdenas trained as a sculptor in Cuba, but went to live in Paris in 1955. He spent forty years in France, before returning to Cuba, where he died in 2001. Cárdenas founds his sculpture in the notion of encounter, an encounter that is fundamentally between himself and the world. It is at the same time a human encounter with forms (bronze, wood, marble) whilst also representing the result of an encounter between cultures. But all of these encounters are effected through personal enactment. The sculptures of Cárdenas give an organic form to the action of passing through: all here is door and we are faced with a paradox of sculptures giving form to a state of absence. The vibrancy of these forms is contained in the way in which they seek out hidden correspondences between beings and things by engaging with the elements within them that are receptive, precisely, to the possibilities of encounter, creating form from the fact of being

absent. There is a richness of cultural experience in the work of Cárdenas that comes from his openness to a range of different cultural influences. Cárdenas works through these influences – which he transforms into part of his personal universe – without a need to define himself as belonging principally to one or the other.

Like Cárdenas, Jorge Camacho has spent most of his life in Paris. Born in Havana in 1934, he is a self-taught artist whose proclaimed influences were of Klee, Miró, Tanguy, De Chirico, José Luis Cuevas and Lam. Moving to Paris in 1958 he made contact with the surrealists, participating in the International Surrealist exhibition in Paris (EROS) in 1959–60, and he became an active member of the Paris Surrealist Group in 1961.

Camacho's work is a meditation on death; it subsists in the tension between the life force and the impulsion towards indistinction that Freud called the 'death drive', that simultaneous pull towards death and to the state that preceded life. This is a world of Sadian violence, where life forces seek their consummation in a realm in which everything is in process of becoming, but never assumes a concrete form. Flows of energy, forever regenerating, firing up and extinguishing, passing from one reality to another, seek out or give force to a will to experience the eternal in the moment, to cleanse themselves of the limitations of a material existence. Camacho, who studied alchemy under the hermetic philosopher René Alleau, is well aware of the possibilities of transformation present within the structures of existence and that make a nonsense of any material reductionism.

Ivan Tovar was born in 1942 in San Francisco de Macoris in the Dominican Republic. Since 1963 he has lived in Paris and was particularly close to

Jorge Camacho,
Behique (I), 1998

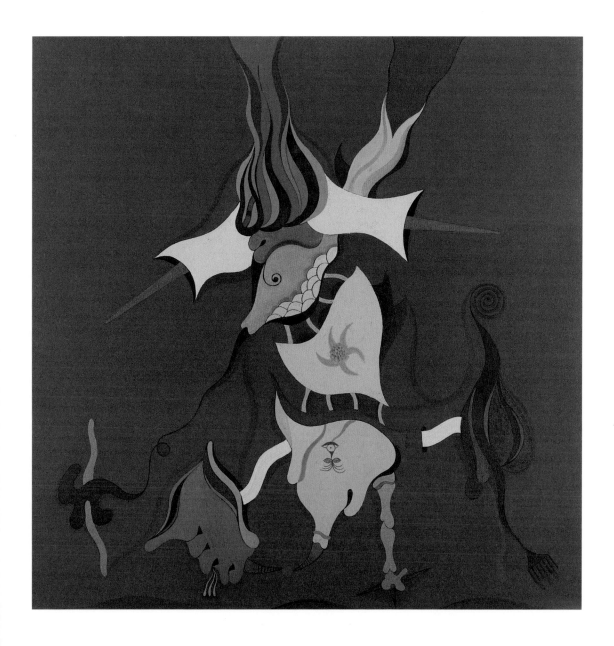

Ivan Tovar,
Le clé de l'amour, 1978

Cárdenas. Tovar's work seems to be about the nature of forms. Influenced by Tanguy above all, one imagines, his painting evokes scenes of convulsion that have been strangely arrested, perhaps by the process of having been brought into representation by the artist's brush. There is indeed a sculptural purity in Tovar's paintings; forms seem petrified or immobilised on the point of transformation. A drama is enacted which is not human, but extra-human, but which, through its extension, comments on the human drama.

Hervé Télémaque, born at Port-au-Prince, Haiti in 1937, went to study in New York when he was twenty, before moving to Paris in 1960, where he has lived ever since. Télémaque's theme is the puzzle of consumption. Everyday objects are subjected to an interrogation that opens them up to unexpected encounters that divorce them from their function, enacting their integrity in a way that allows them to choose to make their own links independent of their position in a system of exploitative relationships. This is the revenge of the object so integral to the surrealist critique of the everyday world. In Télémaque's work, the unity of the consumer's world is broken up, articles of consumption are fragmented into images that hold secret meetings on their own terms. We know how much advertising has learned from the imagery of early surrealist artists; here the compliment is returned as images are torn out of advertising and returned to their own integrality, so mentally disrupting the association one makes between the product and the image that is formed of it.

In discussing these four artists, I have emphasised, in an overly condensed way, some central themes of their work. These themes are disparate and there may appear at first to be little that links these artists despite their common geographical origins and intellectual trajectories (as well as the fact that they are all friends). Should one be surprised by this, or any more surprised than by the very different thematic concerns of the Catalan surrealists Joan Miró, Salvador Dalí and Remedios Varo? Or indeed by the fact that there is little in artistic terms to link André Masson and Marcel Duchamp or Yves Tanguy and Clovis Trouille, despite the fact that they were all French and all participated in surrealism?

There is a tendency to assume a correspondence between geographical place of origin and artistic trajectory when it is a matter of non-western artists, something it would never occur to us to seek out when we are concerned with European artists. Yet, it is difficult to see any way at all in which the work of these four artists is explained by the fact that they come from the Caribbean, even though their experience of their respective Caribbean islands was doubtless formative and it is unlikely that this experience has not found expression in their art. If one has knowledge of the cultural traditions of Cuba, Haiti or the Dominican Republic one can doubtless trace the incidence of the debt of the artists to these traditions, something that would provide an enrichment of one's experience of their work, just as knowledge of Spanish traditions enriches one's appreciation of Picasso's achievement. Lacking knowledge of those traditions does not, however, diminish the understanding we can gain from viewing their work. This does not mean that artists belong to a universal, cosmopolitan community that can be understood in its own terms and that they can thus be divorced from their cultural background. Whether or not one has a specific knowledge of Picasso's Spanish heritage, one would

Hervé Télémaque, *Bannière*
(Les noms du père), 1998

fundamentally misunderstand his work if one thought he was an English artist. In the same way that it is mistaken to identify artists principally with their cultural background, it is equally mistaken to divorce them from it.

Appreciation of any artwork is an act of communication and, like any form of communication, it occurs by means of an identification that links the viewer with the object being contemplated. Identifying Cárdenas as a Caribbean artist through his own sense of solidarity with him, Edouard Glissant has written of a visit he paid to the Cuban sculptor:

> Being introduced to the household, the language barrier, the difficulty of establishing the link. But also, this immediate sense of welcome. An unaffected tranquillity, like relatives who meet once a year. The lacework of sunlight across the room. And beneath our quiet efforts to communicate, the companionable silence to which we would have liked to surrender. Cárdenas is familiar with this silence. We see that it takes the forms that make it visible. He protects himself from it, perhaps, but he especially allows it to enrich his work and sometimes to infect us. It is the punctuation of discourse. It is the quintessential landscape. Perhaps I took it with me when I left this house, in which we so naturally discovered ourselves to be from the same land and the same race. Land of converging cultures, race of many ideas. Outside, the sun banged away at its drum, and Cuba was a shimmer of palm trees.[17]

This encounter between Cuban sculptor and Martiniquan writer, conducted in this silence

(a silence that presumably was not founded in the lack of a common language at a manifest level, since, having lived for more than thirty years in France, one imagines that Cárdenas must have been fluent in French), reveals the simultaneous imminence and distance involved in all communication across cultures (which is to say all communication). Glissant's interest in the work of Cárdenas emerges both from a sense of cultural identification (both of them being from the Caribbean) and from a personal relationship. Yet he recognises that this still leaves a gap, which can only be bridged by means of what he calls 'this companionable silence'. This notion touches the heart of what characterises the work of Cárdenas as it places in evidence the association Glissant makes with it.

Surrealism has always perceived itself as not being a thing itself but rather a relation between different cultural realities. Aragon expressed this quality most felicitously: 'surrealism is nothing but a relation between the spirit and what it will never attain'. The way this relation, which is always underwritten by universalism, is understood must fit uneasily – if it fits at all – with any notion of cultural diversity or multiculturalism having its basis in an arbitrary meshing of hybrid elements.

Here we can look back to the beginnings of modernism, and Baudelaire's response to the Chinese art he witnessed at the Universal Exhibition in Paris in 1855. Baudelaire wrote that, 'it is a sample of universal beauty; but for it to be understood it is necessary for the spectator or the critic to work in himself a transformation that is somewhat mysterious...'.[18] Baudelaire is looking at the problem of cultural difference from a quite different angle to the way it is usually approached. He is asserting that although

universality is contained within the phenomena, it is not immediately apparent and may even elude us because, he seems to be implying, our perceptions are culturally conditioned and this inevitably closes our eyes – if it doesn't blind us altogether – to other ways of perceiving. It is nevertheless the responsibility of the spectator to look for this universal, a process by which one should learn 'to participate in the setting which has given birth to this singular flowering'. Chinese painting therefore is not primarily 'Chinese painting', but is part of a universal canvas taking a particular form in China that needs to be deciphered if its universal significance is to be appreciated. However, this deciphering does not occur through an effort of will but precisely through the spectator's transformation: in order to appreciate the universal, the European spectator must become – at least in a provisional sense in terms of one's relationship to the work of art – Chinese, something that is impossible to achieve. However, it is from the will to achieve it, that a genuine cultural communication can take place. With this comment, Baudelaire was thus articulating a key issue for the appreciation of art across cultural divides.

A century and a half later, when we have far greater access to different cultural traditions than Baudelaire could have imagined possible, the idea of 'universal beauty' is controversial. Nevertheless, the encouragement given to diversity and a broadening of horizons, especially by ideologies of multiculturalism, implies that some standard of aesthetic judgement is being applied across cultural boundaries, even if this is not acknowledged, or is simply being reduced to the level of a subjective question of taste (and no doubt this phenomenon could usefully be analysed from the sort of perspective that Pierre Bourdieu has established for consideration of the notion of taste).[19] In the contemporary context, however, this is occurring without the slightest working through of the transformation in the spectator that Baudelaire perceived as necessary.

In recognising the need for a transformation in the spectator, something that he astutely notes is 'mysterious', Baudelaire brings into question processes of cultural communication in a world of cultural diversity. Indeed, the very notion of transformation becomes difficult, if it is not impossible, in a world today in which we are presented with such a mass of information that, instead of transforming ourselves in order to understand, we must first look for clues to help us assimilate and make sense of any cultural product we are presented with. This makes it difficult for us to create an intimate relationship with what we are observing; instead simply to be able to cope with the mass of information we are presented with, we tend to skate over the surface and perhaps inevitably this process tends to incline us to deny both universalism and cultural specificity, inserting instead an ideology of cultural mixing that values appreciation of difference as a mode de vie above understanding of the deeper import of the work in question. Difference, that is, becomes a lifestyle choice in which one is encouraged to mix and match different cultural experiences according to one's own personal inclinations. In addition, the fact that the media have a vested interest in maintaining control of the flows of information also encourages a diversification of knowledge beyond the bounds of what may be absorbed in anything but an immediate way. There is not one story, only many interpretations. This view assumes that there are no barriers to

appreciation of art across cultures, but it also means that there is no common ground for cultural understanding. Thus the predominant formula of diversity reinforces and legitimises a sense of separation. We are told to respect difference, but the implication is that we can never grasp or comprehend it. The spectator is thus encouraged simply to add each new cultural experience to their roster of experiences. The mysterious transformation that Baudelaire saw as being the key to universal understanding is thereby immobilised. The universal is not overcome, but cancelled, since what is universal is precisely what is different.

In surrealism, Baudelaire's demand for an engagement of the psyche with the object of contemplation finds a focal point in the notion of the marvellous. We have seen that the surrealist concept of the marvellous was disparaged by Carpentier for being an imaginary construction of European decadence. He would replace it with the notion of the 'real marvellous' having its foundation in American reality. The idea came to him during a journey to Haiti when he,

> breathed the atmosphere created by Henri Christophe, a monarch of incredible exploits, far more astonishing than all the cruel kings invented by the surrealists, so fond of tyrannies of the imaginary variety although they never had to endure them in reality. At every step I encountered the marvellous in the real. But I also thought that the presence and prevalence of this marvellous reality was not a privilege unique to Haiti, but the patrimony of the whole of America, where there has yet to be drawn up, for example, a complete list of cosmogonies.[20]

We might contrast this celebration of the 'marvellous real' aspects of Haiti, created by a tyrant who was killed by the people he had oppressed (Carpentier praises Christophe for making real the imaginary prisons of Piranesi!), with André Breton's measured appreciation of Haitian singularity, made in his speeches in Haiti in 1945:

> The map of the world, in 1945, is such that it still acknowledges, in relation to the past, the contrast between the poverty of some and the well-being of others, at least in the material realm... Faced with the justice we seek, rigorously the same for all, I know that no nation has a better foundation to raise an overwhelming indictment of practical indifference and more or less disguised exploitation than Haiti. The grandeur of its past and its struggles, which must make it a target for the rest of the world, is very far from having acquired for it the indispensable aid its exceptional energy and vitality authorise it to claim.[21]

Contrary to Carpentier's characterisation, the marvellous in surrealism is not a state for which the surrealists were athirst, but an analytical category that stands at a point of convergence between the real and the imaginary. Far from it being the surrealists who longed to create the marvellous at any cost, it is difficult not to conclude that it was Carpentier who was desperate to make the marvellous the very condition of life. For the surrealists, the marvellous had a critical function that was never allowed to be fixed in one mode, and it was certainly never reduced to the sort of formulaic quality that magic realism was later to become.

As the critic J. Michael Dash has said:

> The surrealists' insistence on the irreducible strangeness of things and their capacity to constitute the subject's consciousness is central to this literature [Caribbean writing in the 1950s], which is about the dynamics of situated opacities. The constant and restless negotiation of dense, specific, resistant space is central to the idea of a poetics of creolization, which is not about hybrid syntheses, but about inventing routes between zones of irreducible difference.[22]

The 'creolization' Dash is referring to here is very different from the later ideology of *créolité* criticised by Le Brun. In surrealism, the universal and particular are held in dialectical relation and it is through their interplay that specific cultural forms take shape and are transformed. In looking at the surrealist artists whose origins are to be found in the Caribbean, it should be made clear that it cannot be a question of a Caribbean surrealism. Such an assumption had already been definitively rejected by the early surrealists when they made it clear that there could be no surrealist painting because surrealism is not a thing that can be conceptualised, but an activity that extends – or contracts – in accordance with the objective conditions in which it takes place. There can thus be no 'Caribbean surrealism' for the same reason. Just as there is only, as the title of Breton's book *Surrealism and Painting* made clear, a relationship between surrealism and painting, it should be obvious that there can at most only be a relationship between surrealism and the Caribbean.[23] It is in this relation that the interplay between universal and particular is played out.

In making her critique of the notion of *créolité*, Annie Le Brun was drawing upon a long and consistent surrealist assertion that freedom is not relative, but constituted through actions that divest it of all of those elements that deny freedom, a freedom in which there can be, as Aragon said 'no element which turns against the idea of freedom'. Such an understanding of freedom involves a transformation, or a transmutation, of both the self and of society, a task succinctly expressed by the surrealist insistence that Marx's call for 'the transformation of the world' needs to be placed alongside Rimbaud's demand to 'change life'.

Surrealist universalism is not monolithic. In surrealism, the universal is conceived in a multiplicity of forms. Within this relation, specific cultural identities are constantly being formed as part of a complex mosaic that makes up any human being. For it should go without saying that all cultural traditions are hybrid, bringing together disparate elements to form an unstable whole, one that necessarily disintegrates under close analysis. It does not necessarily follow, however, as advocates of diversity assume, that this whole is nonexistent or that it lacks cohesion or is infinitely mutable. The harlequin's robe may be motley and variegated, but it is held together by more than a random selection of disparate elements.

On the other hand, arguments in support of cultural diversity tend to open up the way to a reduction of cultural reality to a superficial appreciation of the form of artistic endeavour at the expense of recognition of the depth of cultural experience that lies at the heart of the work created. While contemporary ideologies of diversity are keen to avoid making artistic and intellectual judgements, they tend to create

barriers and ghettos. At the heart of many of the ideas that encourage the appreciation of different voices and interpretations is a sense of impenetrable difference. In the process, human understanding becomes opaque, reinforcing fragmentation and division. In such a context, is the sort of transformation in the spectator that Baudelaire called for still possible?

For Annie Le Brun, drawing on surrealist tradition, such an outcome involves an intolerable resignation. For her, as for surrealism in general, a spirit of negation, a refusal to accept any given as given, is a fundamental principle not to be surrendered under any circumstances. Founded in a will of transformation, surrealism is profoundly out of step with contemporary ideologies of diversity and celebrations of difference, even though it shares with them an aspiration towards communication across cultural differences and singularities.

NOTES

1. Annie Le Brun, 'Un Créolité cousu de fils blancs' (A Créolité Sewn with White Thread), *GradHiva*, issue no. 24, Paris, 1998, 30. This essay is both a précis and a development of arguments she had already put forward in a book, Annie Le Brun, *Statue cou coupé*, Paris: Jean-Michel Place, 1996.
2. Le Brun, 1998, ibid., 30–31.
3. For a parallel, although more generous, critique of creoleness in the context of the Anglophone Caribbean, see Wilson Harris, 'Creoleness: The Crossroads of a Civilisation?', in Andrew Bundy ed., *The Unfinished Genesis of the Imagination: Selected Essays of Wilson Harris*, London: Routledge, 1999.
4. Le Brun, 22.
5. Jean Bernabé, Patrick Chamoiseau and Raphaël Confiant, *Éloge de la créolité,* Paris: Gallimard, 1989.
6. Edouard Glissant, *Caribbean Discourse* (translated by J. Michael Dash), Charlottesville: University Press of Virginia, 1989.
7. Bernabé, Chamoiseau and Confiant, 1989, op. cit., 1.
8. Alejo Carpentier, *El reino de este mundo*, Madrid: Seix Barral, 1969, 9.
9. See Mabille, 'The Jungle: on the importance assumed by art criticism in the contemporary age', in Michael Richardson ed., *Refusal of the Shadow: Surrealism and the Caribbean* (translated by Michael Richardson and Krzysztof Fijalkowski), London: Verso, 1996.
10. Le Brun, 1998, op. cit., 22. Whatever failings one might see in negritude as a political attitude that was later reified into a justification for neo-colonialist assertion of the interests of the black bourgeoisie, there seems little doubt that Le Brun is right to see its essential movement as lying in such negation, which is the point at which it joins surrealism. See also Aimé Césaire, *Discourse on Colonialism* (translated by Joan Pinkham), New York: Monthly Review Press, 1972, and René Ménil, *Tracées*, Paris: Robert Laffont, 1981.
11. Louis Aragon, 'Libre à vous', *La Révolution surréaliste*, issue no. 2, Paris, 1925, 23.
12. Ibid., 23.
13. Here one might mention in particular, among many others, Paul Nougé in Belgium, Karol Teige and Vratislav Effenberger in Czechoslovakia, Gherasim Luca in Romania, Georges Henein in Egypt and Shuzo Tanizaki in Japan, all of whom developed their own philosophies of surrealism in ways that differed from, even if they were compatible with, the views of Breton.
14. Luis Buñuel, *My Last Breath,* London: Jonathan Cape, 1985, 113.
15. See Michael Richardson ed., *Refusal of the Shadow: Surrealism and the Caribbean* (translated by Michael Richardson and Krzysztof Fijalkowski), London: Verso, 1996.

16. For some further information about these artists and examples of their work see José Pierre, *L'Univers Surréaliste,* Paris: Somogi, 1983; José Pierre, *L'Aventure Surréaliste autour d'André Breton*, Paris: Filipacci, 1986; Adam Biro and René Passeron eds, *Dictionnaire général du surréalisme et de ses environs*, Fribourg, Suisse: Office du livre, 1982; Gérard Durozoi, *Histoire du mouvement surréaliste,* Paris: Hazan, 1997; Vincent Bounoure, *Les Anneaux de Maldoror et autres chapitres d'un traité des contraires*, Paris: L'Écart absolu, 1999.
17. Glissant, op. cit., 241.
18. Charles Baudelaire, 'Exposition Universelle de 1855', in *Oeuvres complètes*, Tome II, Paris: Gallimard, 1970, 576.
19. See Pierre Bourdieu, *Distinction: a social critique of the judgement of taste*, London and New York: Routledge, 1986.
20. Carpentier, op. cit., 12.
21. André Breton, *Oeuvres completes*, Tome III, Paris: Gallimard, 1999, 150.
22. J. Michael Dash, 'Caraïbe Fantôme: The Play of Difference in the Francophone Caribbean', *Yale French Studies*, no. 103, 2003.
23. André Breton, *Surrealism and Painting* (translated by Simon Watson Taylor), New York: Icon Editions, 1972.

THE POST-MODERN MODERNISM OF WIFREDO LAM
LOWERY STOKES SIMS

I believe that the Black soul, if there can be such a thing, belongs in Modernism.[1]

The Black Artist in Modern Art

'Modernism', historian Jeffrey Stewart once observed, 'is a tricky word when used in association with the Harlem Renaissance'.[2] If we consider that the Harlem Renaissance (*c.*1919–29) marked the moment of first significant emergence of artists of colour – and specifically African American artists – within the modernist movement in the last century, then we would do well to heed Stewart's caveat. In order to discuss the situation of African, African American and Caribbean artists within modernism on an equal footing with their European or Euro-American peers, it is necessary to get past the more narrow definition of modernism – described by Stewart as 'the rebellious artistic and literary movements of the late 19th- and early 20th-century Europeans and white Americans'.[3] Whereas modernists are usually cast as having a 'sense of alienation from the rise of the corporate industrialized state',[4] for black artists modernism affirmed the notion that a modern individual could be an agent of change or transformation. Whereas for white artists modernism 'was reflected in the breakdown of the representational and the familiar in literature and art',[5] for black artists that rupture represented a potential revolution in self-definition and self-image as they assumed the role of proactive rather than reactive agents in contemporary society. The fact is, therefore, that black artists created a modernism that is, in the words of art historian, Helen Shannon, 'not always congruent with canonical histories of European and American modernism'.[6]

This did not mean, however, that the situation for black artists globally was straightforward. Inevitably they would have been enmeshed in strategies of assimilation that were dictated by their colonised circumstances as they fought their way to personal sovereignty and expression. 'Primitivism' – the engagement of the 'tribal' by modern artists[7] – blocked their recognition within the chronological imperative of modernism. Emerging from the colonisation of Africa, Asia and the Americas by Europe as of the 15th century, the phenomenon of primitivism marked the appropriation of the ancestral arts of black artists to the purposes of modern art,[8] which dictated that primogeniture and recognition would be conferred on which artists did what first, and which individuals were the agents of 'industrialization, urbanization, secularization and commodification and technological innovation'.[9] Primitivism also engendered the vocabulary for the discourse that maintained, even supported, the power relationships of colonialism: the 'center' versus the 'periphery', 'intellectual' versus 'emotional', 'objective' versus 'subjective', 'technological' versus 'manual', 'conscious' versus 'unconscious', and 'individual' versus 'communal'.[10] So while this convergence of cultures affirmed the importance of world art to modernity it would also inevitably raise the question, if 'modern' art could not exist without the 'primitive', can the 'primitive' also be 'modern'? The subordinate social and political positioning of tribal creators in the history of modernism would hold so long as they were un-named ('anonymous'), the work they created deemed 'communal' and their work assigned a lesser value than that of their white counterparts.

As if to expressly answer this question, one artist of African, Spanish and Chinese descent

from Cuba entered the lexicons of modern art history. Wifredo (originally Wilfredo) Oscar de la Concepcíon Lam y Castilla (1902–82) was the first artist of colour to make an impact on the international art scene, and did so in the 1920s and 30s during the full fluorescence of primitivism. During his sixty-year career (1922–82), Lam was to pave the way for contemporary artists of African, Asian, Pacific and Native American descent in the international art world. His arrival in Paris in the late 1930s effectively precipitated the first crisis of modernism by introducing the 'primitive' into 'primitivism'. He confronted European modernists with a real human entity both conversant in his traditional culture and trained in modernist conventions.

It might be said, in fact, that Lam was at the vanguard of new modernism noted in the early 1950s by Jean Paul Sartre, who wrote that having 'accepted primitive art into itself' European culture was being 'colonised in reverse', as 'Third World artists were themselves entering [European] culture and ... effecting a more complete Africanisation of western art'.[11] This Africanisation was initiated at the beginning of the 20th century in the encounter of French artists such as Paul Gauguin, André Derain, Pablo Picasso and Georges Braque with Pacific and African sculpture in the magasins and museums of Paris. Sartre's comments remind us of the inexorable inversion of European colonisation that was marked by global trends in the post-World War II era such as migrations of populations from former colonies to the centres of world economic, social and political power. Reinforcing the sense of reparation, even retribution in the reversal of cultural imperatives described by Sartre, Lam once cast his art as an

'art of decolonisation', calling on all artists like himself to 'sever all ties with the colonial culture'.[12]

Lam encapsulated this 'Africanisation' of European cultures in a small drawing executed in 1943 in which he depicted a woman – who is clearly European – looking at herself in a mirror. What she sees is her reflection as a figure with a face that resembles an African mask. The woman resembles Lam's second wife Helena Holzer; the reflection represents a version of Lam's avatar of female power – the *femme cheval* or horse-headed woman.[13] The *femme cheval* became the thematic cornerstone of Lam's work, which is characterised by its unique synthesis of European modernist vocabularies – specifically cubism (with its engagement of African forms) and surrealism (with its engagement of non-empirical phenomena) – with motifs and symbols of African religions, which had survived in Cuba.

The Primitive Challenges Primitivism

Wifredo Lam's outstanding achievement within modern art, John Yau observes, was the fact that he reversed the relegation of appropriated forms from African art to being mere 'reductive artefacts to be absorbed into western perceptual systems'. He 'reintegrated' them 'within nature', where they could reclaim 'their original and rightful place'[14] as well as their symbolic content (within the context of traditional tribal art), which had been defused through the process of appropriation in the theoretical and conceptual rubrics of the modernist movement. However, during his peregrinations within the modernist scene, Lam faced many challenges in establishing himself as more than a cultural curiosity and winning recognition as a viable

artistic force in his own right. As an African-Chinese Cuban he was quickly subsumed within the romantic characterisations of the 'primitive' that emanated from 18th-century notions of the 'noble savage', and he was additionally marginalised to an extent as an 'authentic' specimen of 'primitive' wisdom, described variously as 'magician', 'master of the fantastic', 'avatar of the jungle', and 'shaman'.

According to Michael Leja, Lam elicited 'a different sort of response from New York critics' in spite of the 'thematic and formal continuities with the early New York School'.[15] The fact of Lam's ethnicity, Leja notes, caused his work to be 'subsumed into notions of the stereotypical "primitive" that could be glimpsed in Tarzan movies of the period and the more sensationalized and patronizing concepts of the "primitive" that were routine in Hollywood depictions'.[16] Lam's condition as both an insider and outsider is clearly illustrated in the diagram of the modern art 'tree' published by painter Ad Reinhardt in P.M. magazine in 1946.[17] Reinhardt grouped together artists of different modernist tendencies on branches off the trunk of modern art. Lam's name can be found in the proximity of artists whose work manifests a 'magical', 'sur-real' quality – Yves Tanguy, Pavel Tchelitchew, Kurt Seligmann and Louis O. Guglielmi – whose names are written on leaves bunched together on the same branch. Lam's name, on the other hand, is seen on a leaf on the same branch but all by itself. As James Clifford so cogently demonstrated, the challenge for individuals who would be forces of decolonisation within the colonial system was daunting and frustrating. They both had to assert their more subjective and 'authentic' status in relationship to interpretations of their cultures and they also had to challenge presumptions

that their proximity to those cultures deflected their ability for analytical or 'objective' approaches to those cultures.[18]

Undoubtedly because he grew up in Cuba in a culture that was marked by African survivals, Lam's own apprenticeship to modernism during his fifteen-year residence in Spain (1923–38) focused successively on the Africanising aspects of the cubistic work of Henri Matisse and Pablo Picasso. He became familiar with their work first through magazines brought back from Paris to Spain by friends and then had a catalytic encounter with Picasso's work in the 1936 exhibition that toured Spain in support of the Nationalist cause.[19] This work provided structural paradigms through which Lam launched his signature style during the 1940s when he returned to Cuba after the German occupation of France. In this period, Lam's style is characterised by an exploration of Afro-Cuban religious and cultural elements through the sieve of European modernism and arcane symbolism. Less anecdotal than most images of Afro-Cuban culture that were prevalent in the work of his Cuban contemporaries, Lam's hybrids of human, plant and animal elements, in the words of art historian Giulio Blanc, '[interpret] the spirit of magic and pantheism underlying the Afro-Cuban world-view'.[20] Lam's work may thus be said to have paralleled syncretistic survival strategies devised by Africans in the Americas, such as masking or encoding in Santería (Lucumí) and Vodun which allowed African slaves to camouflage their practices of ancestral rituals under the cover of accepting European and Catholic values and practices.[21]

The way to do this was not a given. In the early 1940s Lam had to grapple with finding a way to mediate the vocabulary of European modernism

and traditional Afro-Cuban content, while finding the most effective stylistic and technical means to reintegrate form and content. The presentation of a female figure – the aforementioned *femme cheval* – became the central motif in his work, set in a specifically Caribbean locale or landscape, and featuring Africanising and hybrid forms. He devised seemingly endless variations on the shamanistic *femme cheval*. While most of them were literally endowed with horse-like heads, others had heads of a more helmet-like character, prognathic noses, 'sausage' lips and Egyptian-esque prosthetic beards from which a fall of hair flowed. Decorative elements function like ritual tattoos on their bodies: floral motifs based on Matisse, trefoil designs, arched patterns radiating from a central axis, and a circle-within-a-diamond shape motif. Female breasts mimic hanging tropical fruits – such as papaya; chins morph into male sexual members; limbs approximate cane stalks; and a repetition of forms suggests motion or at least a fugitive state of being.

These elements are evident in compositions such as *Déesee avec feuillage* (1942) where Lam opens up transitional space between figure and background, allowing a progressive 'invasion' of one by the other so that they become enmeshed. Episodes of drawing and painting alternate with one another in a dynamic way, and the focus of the pictorial energy retreats from the edges of the compositions and is concentrated in the centre of the canvas or sheet of paper. On the one hand this work presents a dense, disorienting tropical forest environment; on the other it encapsulates the key modernist concerns around perspective space versus a-formal, 'allover' space. The intensity of that spatial impenetrability and the fusion between plant and human becomes so seamless through the mid-1940s that the pretensions of the human ego are set aside for a complete surrender to an all-encompassing force that is not unlike the Romantic sublime in feeling and certainly signifies the surrender of Lucumí devotees to the will of the orisha. Through this infusion of Afro-Cuban motifs into the landscape, Lam was effectively continuing the practice of positioning the Cuban landscape as 'the foremost indicator of the kind of nationalistic production' that had been the practice in Cuban art during the colonial period.[22] This interest in the distinctive landscape of the Americas had also been a potent strategy in declaring a unique North American identity in art in the USA and Canada in the 19th and early 20th centuries.

Landscape as Metaphor

Landscape was the focus of Suzanne Garrigues Daniel in her 1983 dissertation on Lam's work between 1941 and 1945. Using Fernando Ortiz's 1940 publication *Cuban Counterpoint: Tobacco and Sugar* as a paradigm, Garrigues Daniel notes that the vegetation in Lam's work can be imbued with encoded political nuances. This approach is all the more intriguing given the comparable use of calligraphic elements and natural subject matter as tacit political commentary in traditional Chinese painting (thus fuelling speculation about the influence of Lam's Chinese father Lam Yam on his work).[23] As Garrigues Daniel writes, 'Given these racial, economic, political and historical associations', tobacco is associated with 'liberty' and the national and political hegemony of Cuba,[24] while sugar cane 'in addition to being a symbol of femaleness, fertility and carnality is, on a socio-politico-historical level, also a symbol of slavery, exploitation, colonialism and capitalism'.[25]

Wifredo Lam,
Déesee avec feuillage, 1942

Wifredo Lam,
The Jungle, 1943

Lam himself encouraged a more metaphorical and less literal comprehension of his work. He pointed out that the title of *The Jungle* 'has nothing to do with the real countryside of Cuba, where there is no jungle but woods, hills and open country, and the background of the picture is a sugar cane plantation'.[26] This painting 'was intended to communicate a psychic state' rather than a geographical phenomenon.[27] Lam's observations caution us about primitivist generalisations that often accompany popular notions of the generic 'tropics' where the distinct biological and botanical natures of 'forest', 'rain forest' and 'jungle' are undifferentiated. In *The Jungle* Lam referenced the metaphorical meaning that 'the tropics' conjures in the western imagination: it evokes 'a place of threats, of aggressions, of perils known or unknown'.[28] That psychic state, however, also provides insight into the psychological and cultural relationship of African Cubans to their new homelands in the New World. New York-based Yoruba priest and philosopher John Mason observed that Africans – specifically the Yoruba newly arrived in Cuba – were reticent about claiming a proprietary relationship with the land due to 'their status as slaves'.[29] The Siboney and Arawak had already 'filled the roles of primary land clearers and inhabitants', and 'ownership and social authority rested in the hands of white plantation owners'.[30] Therefore, Mason concludes that since 'the basis of all that is authoritative and original emanates from the lands and its first inhabitants', and since the Africans were 'barred from the ability to claim title to the land', they 'settled on the use of words and actions that taught them why and how they could define themselves in a hostile world…. The people became like the land'.[31] The arena for those words and actions was the dense vegetation of the Cuban countryside known variously as 'el monte' and in Lam's titles as 'la selva', 'la maleza', or 'la brousse'.[32] Paintings by Lam such as *The Jungle* and other compositions of the 1940s, including *Omi Obini*, *Mofumbe [ce qui importe]*, and *Malembo*, all represent the forces of the African cosmos manifest in the realm of the Cuban countryside, and demonstrate how the theme of the landscape and its bush persisted in Lam's work throughout his career.

As Lam explored the incorporation of themes related to Afro-Cuban religions in his work between 1941 and 1946, he brought various painterly techniques to this task, which were integral to and enhanced the thematic aspect of his work. In compositions done in 1941 and 1942, Lam reduced his palette to closely valued contrasts of pale yellows, salmons, and greens (and then in the late 1940s to beiges, browns, black and whites). Often working on brown Kraft paper, he applied the paint sparsely, defining form with a variety of linear elements – some prominent, others so scant they can barely be seen. The 'under colour' of the brown paper emerges through the paint scumbled on top of it; the colour of the figure incorporates that of the ground while the lines defining the figure are occasionally over-painted and obscured. Such techniques convey a sense of the space within the painting as ephemeral and ethereal. Furthermore the use of a 'pointillist' stippling technique, where objects are white voids within the surrounding ambiance, effectively conveys the visual experience of the brilliant, reflective light of the Caribbean.

New York and Europe: Alternate Contexts

Although he was working in Cuba during the 1940s, Lam's artistic development during the 1940s paralleled those among the burgeoning movement that came to be known as abstract expressionism in New York City. His exploration of Afro-Cuban myth in the guise of multi-species hybrids literally embodies the search for 'new hybrids for old myths' [33] on the part of artists such as Mark Rothko, Barnett Newman, Adolph Gottlieb and Jackson Pollock. This new imagery was suffused in mythic and totemic allusions and couched in a morphology that married surrealist improvisation with cubist structure,[34] by breaking up form through techniques such as automatism, the cadavre exquise, and liberating colour as a purely descriptive element in painting. These formal approaches were promulgated in the New York art world by the French artist André Masson and Chilean painter Roberto Matta, who shared with their American counterparts their expertise in the technical aspects of surrealist picture making and the interest in spontaneous paint application through dripping and splattering.[35]

As I have noted at the beginning of this essay, however, despite commonalities with the North American artists, Lam's artistic sensibility was very different from the aggressive, rough-hewn, raw, immediate, and unpremeditated gestural aspects of abstract expressionism in New York that were to become familiar characteristics of the new 'American' spirit in art. Lam's work, in contrast, evoked qualities of 'finish' – in terms of both finesse and completion – and even 'elegance' and 'beauty', which would ultimately come to be dismissed in the New York scene as remnants of European traditions in art. During this period artists in the USA were particularly preoccupied with supplanting such traditions in their work.[36] Lam's work did however, for a period of time, share stylistic and morphological character with that of Arshile Gorky. The monochromatic dripping and thinly painted, open surfaces of compositions such as Lam's Oya and Hermes (1945) may be favourably compared to paintings such as Gorky's Water of the Flowery Mill (1944).[37]

Whatever congruencies that existed between Lam's work and his New York contemporaries were affirmed in a review published in the August 1946 issue of Newsweek magazine which heralded Lam, Adolph Gottlieb and Robert Motherwell as 'some of America's own young abstractionists who think they have found the long-waited "new direction" in art'. The unidentified reviewer distinguished the work of the younger Americans from that of the surrealists in that 'they do not paint dreams, nor do they paint in literal representational styles'. Rather, they utilise 'the surrealists's method of free association to evolve shapes, images, and ideas out of the subconscious'.[38] The review anointed Motherwell as an example of an artist who typifies what the reviewer called a new 'imaginative abstraction' or 'surrealistic formalism'.[39] Lam was described as filling 'his canvases with strange winged creatures and voodoo gods which suggest rather than represent the mysteries of the jungles in his native Cuba'. Gottlieb's paintings 'look something like ancient hieroglyphics'. Gottlieb is quoted as saying that he uses 'rough rectangles' in his work instead of perspective in order to 'kill space'.[40] The fact that Newsweek dubbed Lam as one of 'America's own abstractionists' is noteworthy given the sharply demarcated national lines which have been enforced in the international art world since the 1950s.[41]

Wifredo Lam, *Oya [Divinité
de l'air et de la mort/ Idolos]*,
1944

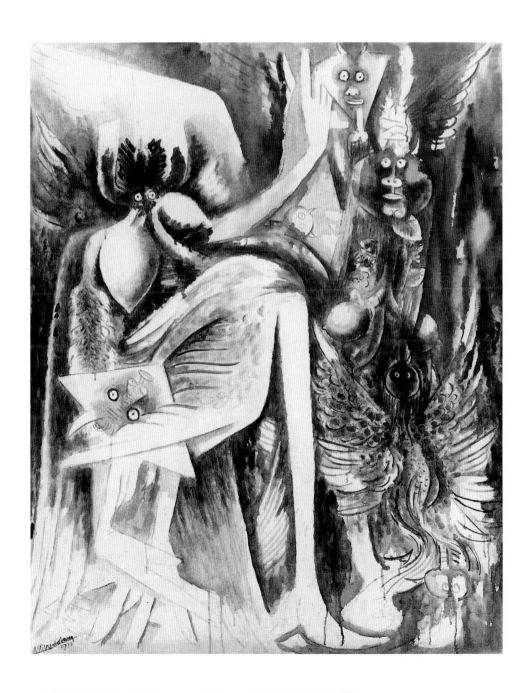

If the American art world after 1948 was more ambivalent about Lam's work within the post-war period,[42] in Europe his work was exhibited in England, France, Italy, Sweden, then Czechoslovakia, Belgium, The Netherlands and Spain. His development toward a hieratic, ceremonial style with flat shapes that evoked a certain ritual protocol, appealed to a post-war generation in Europe that was seeking a more in-depth psychic dimension to primordial manifestations of the cycles of terror and rebirth that were much in evidence after World War II. This factor explains, in particular, the interest in Lam on the part of the CoBrA artists (whose group hailed from Copenhagen, Brussels and Amsterdam under the energetic leadership of Asger Jorn and Cornelis van Beverloo, known as Corneille) especially when the totemic forms in his work became more and more 'pure signs'[43] in his work of the 1950s onwards. For critic and art historian Henri-Claude Clousseau, the viability of Lam's 'écriture' is evoked by the pure line of compulsive, obsessive art-making associated with traditional and folk art, the art of children, and the art of the mentally disabled.[44] Critic and art historian Jacques Leenhardt fosters the view of Lam's work as revolutionising the role of drawing in painting. Charles Merewether takes this further by fostering a reading of Lam's work within the Afro-Cuban cultural context that compares elements of drawing and tracing in his totemic figures as a means to achieve a reconfiguration of empirical reality that is synonymous with divination drawings made by santeros or priests of the Lucumí religion during ritual observances. Lam's work draws some of its power from this genre by means of his deft draughtsmanship and Merewether perceives it as sharing the quality of divination drawings, which 'embodied and transmitted sacred knowledge and historical memory of Afro-Cuban culture'.[45]

A New Model for Art History

Writing in 1992 about Lam, critic and art historian Gerardo Mosquera suggested that his life and career provided models for 'a new orientation of the various discourses [around art history]' that would position the nexus of power and proactivity as 'taking place from the periphery towards the center.'[46] According to Mosquera, through this approach 'the periphery is ceasing to be a reservoir of traditions, and is moving towards a poly-focal, multi-ethical decentralisation of "international" culture combined with a strengthening of local development.'[47] Mosquera's proposal for redefining and reorienting the power positions between European and non-European cultures in the definition of vanguardism, progress and cultural propriety acknowledged the fact that by the 1990s, the century-long infatuation of European culture with traditional, tribal cultures in Africa, the Americas, Asia and the Pacific, meant that these non-western cultures were 'no longer "ethnic" and [had] become internationalised as intrinsic components of a world shaped by the development of the West'.[48]

This shift in interpretation, Mosquera suggests, effectively breaks 'away from the dualism [of "western" versus "non-western"] and recognises the hybridisations, complexities and "inauthenticities" inherent in the post-colonial dynamics through an awareness of the cultural action of the periphery in contemporary processes from modernism to post-modernism'.[49] Mosquera reminds us that despite some fanciful

reconstructive image-making by vanguard leaders like the surrealist magus André Breton, Lam was never the primitive artist, and although of African and Chinese (as well as Spanish) heritage, he studied art at venerable institutions such as the San Alejandro Academy in Havana and the Prado Museum in Madrid, and was a rather highly westernised member of an underdeveloped nation in the post-colonial context. Lam's work should therefore be recognised as neither primitive nor traditional, but, as Mosquera puts it, an example of 'the non-traditional artistic production of the Third World' that reveals 'a... point of true synthesis between avant-garde and "primitivism" – the possible embryo of a future line of development of art as a result of the eruption of the confines of contemporary culture'.[50]

By the 1990s this synthesis would characterise numerous post-modern tendencies in the international art world. Issues such as identity, ethnicity, gender and societal context began to influence the study of Lam's career. I would suggest, however, despite Mosquera's persuasive argument, that a simple deconstruction of Eurocentrist art history is not an adequate means by which to reconstruct Lam's artistic identity on the 20th-century art world stage. We must keep in mind the artist's own determination to establish his place in the context of modernism, while at the same time confronting the fact that to reduce his work to its context would diminish his stature as a modernist pioneer. The challenge, therefore, is to confront the hierarchical constructs of art historiography that correlate with the economic, political, and social hierarchies of world power.

One strategy is to interrogate the definition of modernism and challenge the overly linear genealogy that characterises the canon of 20th-century art history. Art historian Ann Gibson notes the view proposed by Linda Hutcheon, who hypothesised that post-modernism emerged from the oppositional avant-garde of Brecht and Duchamp, on the one hand, and purist formalism on the other.[51] As Gibson notes, Peter Wollen's concept of 'two avant-gardes', provided for a contrast of terms, one of which 'practiced the disjunction that cubism opened between signified and signifier', which made it 'possible, and indeed, necessary, for avant-garde art to appear to be indifferent to political and social issues'.[52] The second avant-garde, according to Gibson, 'interrogated the codes of realism and perception. But unlike the hiding, ignoring, or rejection of certain subject matter demanded by formalism, the aesthetic employed by artists of the second avant-garde permitted the use of abstraction (often along with elements of the mimetic realism) in order to better enable the artist to express his or her view of the subject matter'.[53]

If we consider the career of Lam with that of his African American contemporaries Norman Lewis and Romare Bearden – who were also emerging on the New York art scene in the 1940s – we might also think about 'two waves' of primitivism. Lam, Lewis and Bearden would then signal a transition from the first wave – the European avant-garde's appropriation around 1900 of motifs from the arts of Africa, Native America, the Pacific region, and Pre-Columbian countries – to the second wave in which black artists whose ancestors came from those lands combined modernist styles with motifs from the traditional artists in a way that reflected their more profound and authentic understanding of the meaning that these forms had for their ancestors.[54] In that sense then,

Lam, Lewis and Bearden could be said to have heralded the new ideas of post-modernism some three decades before the international art establishment codified this theoretical world-view.[55]

In the final analysis, I have to return to my initial scepticism about becoming embroiled in an existing critical and art-historical paradigm in an attempt to legitimise the art of African, Native, Asian, Latin, and Latino American artists. Engaging the paradigm of 'modernism' or, more specifically 'modernist primitivism', embroils one in an argument about chronological priority, not to mention arguments about objectivity (centre) over subjectivity (periphery), that also inevitably arise in discussing 'Second Wave' or 'New Wave' primitivism. The 'New World' sobriquet does, however, provide a situation for recalibrating the criteria around issues of authenticity and cross-cultural dialogue put forward by Gerardo Mosquera. Mosquera's proposal for a new art history is given a further concrete methodology by African art historian, Ikem Stanley Okoye, who proposes a parallel notion of various histories to accommodate the ability of all cultures to change and permutate and to reflect more precisely the condition of the 'primitive'.[56]

In his 1996 essay, 'Tribe and Art History', Okoye proposes that in reconsidering the issue of primogeniture in modern art that scholars might consider a hypothetical object produced by an African artist working in Africa the same year as Picasso working in Paris produced *Les Demoiselles d'Avignon*. Within a set number of conditions, such an object by that African artist working in Africa should be considered as much a part of the discourse on the genesis of modernism. He writes:

[t]he idea of modernist sculpture *as such* was as likely invented in Africa (southeastern Nigeria) as in western Europe (France), then a ritual object (anyanwu) created among the Igbo peoples of southeastern Nigeria would have a place next to *Les Demoiselles*.[57]

The fact that this object would include non-traditional elements such as 'a large number of bottles of Schnapps'[58] arranged so that the artist could take advantage of 'the brilliance... produced in the tropical intensities of light and shadow'[59] suggests an affinity with vanguard artistic strategies (such as dadaism). Ordinarily, however, this object would not be included in any exhibition of early 20th-century modern sculpture,[60] its exclusion based solely on notions of traditional African art as creativity emanating from an anonymous, communal activity rather than an individualist, personality-based one.

As an African, Okoye's approach confronts western pretensions at primogeniture more directly than Mosquera, whose experience as a Cuban positions hybridity as a factor that would blur the distinctions between the polarities of western primitivism. Okoye's hypothesis therefore attains cogency in light of current trends in African art history which foreground the contributions and recognition within African contexts of individual artists and their workshops.[61] This would situate formerly 'anonymous' African artists on a par with their European contemporaries and allow them to claim a role in the development of modern art at a time when various forces and trends were transforming their traditional way of life. The exchange between 'primitive' and 'western' cultures would thus be mutual, as the African American artist Robert Colescott once noted,

with Picasso starting with, 'European art... abstracted through African art', and the African artist beginning with 'Africanism' and moving 'toward European art'.[62] As well as the revisionist, and more inclusive, surveys of the modernist terrain by scholars like Mosquera, Gibson, Craven, and to a certain extent Leja, Okoye's viewpoint will reorient our view of the assumed hegemonic relationship between the centre and the periphery by jettisoning the dichotomies of 'centre' and 'periphery', while preserving the richness offered by 'ethnic' notions of culture. The resulting 'open-ended exchange' would not only account for how 'objects in society accrete the meaning that they do' but also avoids the 'insertion of a covert hegemony' in the writing of history and institutes what Okoye describes as R. Radhakrishnan's version of Mosquera's 'heterogeneity'.[63]

In the context of these various methods of reorienting art history, Lam would be more than a follower. He would garner recognition for having reconciled, in the context of the period in which he matured as an artist, the dichotomous relationships that were perceived to exist among form and content, tradition and the future, figure and abstraction. Lam would gain recognition for finding in the reconciliation of these opposites an alternative to materialistic cultural values through the celebration of nature. That Lam's position has continued to be relevant to contemporary life is indicated by the endurance of this point of view over the last thirty years. The reconciliation of dichotomies was a central principle in the social and political liberation movements of the 1960s and such values returned in the 1980s and 1990s in the wake of a revived awareness of the consequences of societal excesses in terms of both natural resources and human potential.

Lam was indeed ahead of his time. For it has been only in the last two decades that the gods of the Lucumí have travelled beyond the borders of Cuba and are finding recognition and new adherents even in the USA, one of the most overtly technological societies in the world. This explains the renewed interest in Lam's work, which has begun to transcend differences of nationality and 'race'. My discussion has attempted to broaden and enrich the conventional view of Lam's career and indicate areas that need further investigation. As I have tried to demonstrate, in his person and eventually in his signature style, Lam posed questions about 'authenticity' within the context of modernist and later post-modernist practice. As such he demonstrated that artists of colour who navigated issues of assimilation and acculturation could at the same time manifest a distinct and integral relationship with their ancestral cultures within the rubrics of modernism or post-modernism and thus function as intermediaries between the old world of the formal avant-garde and the new world of iconographic modernism, from primitivist to ancestralist. When these achievements are fully recognised, with a greater comprehension of the exact nature of Lam's contribution, Lam and artists of colour who have followed comparable paths will be judged by criteria generated from their own centres rather than on the margins of modernism.

NOTES

1. Frank Bowling and Frank Thomson, 'A Conversation Between Two Painters', *Art International: The Art Spectrum*, Vol. XX, 9–10 (October–November, 1976), 65.

2. Jeffrey C. Stewart, 'Paul Robeson and the Problem of Modernism', in *Rhapsodies in Black: Art of the Harlem Renaissance*, essays by David A. Bailey, Richard J. Powell, Simon Callow, Andrea D. Barnwell, Jeffrey C. Stewart, Paul Gilroy, Martina Attille, Henry Louis Gates Jr, Berkeley, Los Angeles and London: University of California Press and London: Hayward Gallery, 1997, 92.

3. Ibid.

4. Ibid.

5. Ibid.

6. Helen Shannon, unpublished exhibition prospectus for the exhibition *Challenge of the Modern: African American Artists, 1925–1945*, Fall, 2001. This exhibition was shown at The Studio Museum in Harlem, 23 January – 4 March, 2003.

7. See William Rubin, *'Primitivism' in Twentieth Century Art: Affinity of the Tribal and the Modern*, exh. cat., New York: The Museum of Modern Art, 1984.

8. Along with Pre-Columbian art, Pacific art and the art of certain marginalised artistic communities such as the self-taught, children and the mentally and physically challenged.

9. Stewart, op. cit., 92.

10. See Lowery Stokes Sims, *Wifredo Lam and the International Vanguard, 1923–1982*, Austin: University of Texas Press, 2002, 2.

11. Sartre quoted in Robert Linsley, 'Wifredo Lam: Painter of Negritude', *Art History*, 2, no. 4 (December 1988), 553.

12. Lam quoted in Gerardo Mosquera, 'Mi pintura es un acto de descolonización: Entrevista con Wifredo Lam', *Bohemia* 92, no. 25 (20 June 1980), 10–13.

13. The *femme cheval* literally represents a possessed devotee in the Afro-Cuban religion of Lucumí, known in popular parlance as the *caballo* or horse of the orisha, or Afro-Cuban deity – who 'rides' the devotee during possession who may be said to effect a shamanistic transformation in the midst of a ritual event.

14. Yau, 'Please Wait by the Cloakroom', *Arts Magazine*, 63 (December 1988), 59. This strategy countered what the surrealist apostate Georges Bataille described in 1930 as the 'sanitisation' of those tribal art forms by modernism. See Georges Bataille, 'L'Esprit moderne et le jeu des transposition', *Documents*, 8 (1930), 49–52.

15. Michael Leja, *Reframing Abstract Expressionism: Subjectivity and Painting in the 1940s*, New Haven and London: Yale University Press, 1993, 102.

16. Ibid., 102–103.

17. This diagram is reproduced in David Anfam, *Abstract Expressionism*, London: Thames and Hudson, 1990, 23.

18. James Clifford, *The Predicament of Culture: Twentieth Century Ethnography, Literature and Art*, Cambridge MA and London: Harvard University Press, 1988.

19. Sims, op. cit., 18–19.

20. Giulio Blanc and Gerardo Mosquera, 'Cuba', in Edward J. Sullivan ed., *Latin American Art in the Twentieth Century*, London: Phaidon, 1996, 85.

21. See for example Roger Bastide, *The African Religions of Brazil: Toward a Sociology of the Interpenetration of Civilizations*, trans. by Helen Sebba, Baltimore: John Hopkins University Press, 1978.

22. Rocío Aranda-Alvarez, 'New World Primitivism in Harlem and Havana: Constructing Modern Identities in the Americas, 1924–1945', PhD dissertation, City University of New York, 2001, 143.

23. This aspect of Chinese painting was the subject of the exhibition *Loyalty and Dissent in Traditional Chinese Calligraphy and Painting* organised by The Metropolitan Museum of Art, New York (20 March – 9 September 1990).

24. See Suzanne Garrigues Daniel, 'The Early Works of Wifredo Lam: 1941–45', PhD dissertation, University of Maryland, 1983 (Ann Arbor, MI: UMI Research Press, 1991), 88–90.

25. Ibid., 90.

26. Lam quoted in Max-Pol Fouchet, *Wifredo Lam*, Barcelona: Ediciones Polígrafa, S.A., 1976. Reprinted Paris: Editions Cercle d'art, 1989, 198.

27. Ibid.

28. Ibid.

29. John Mason, *Four New World Yorùbá Rituals*, Brooklyn, N.Y.: Yorùbá Theological Archministry, 1985, 5.

30. Ibid.

31. Ibid.

32. See Lydia Cabrera, *El monte*, Miami, 1975.

33. Irving Sandler, *The Triumph of American Painting: A History of Abstract Expressionism*, New York: Praeger, 1979, 67.

34. See Robert Carleton Hobbs and Gail Levin, *Abstract Expressionism: The Formative Years*, exh. cat., Ithaca: Herbert F. Johnson Museum, Cornell University and Whitney Museum of American Art, New York, 1978, 18–19.

35. See Sidney Simon, 'Concerning the Beginnings of the New York School: 1939–1943: An Interview with Robert Motherwell conducted by Sidney Simon', *Art International*, 11, no. 6 (Summer 1967), 17–23.

36. See William Rubin's discussion of the surrealist legacy in American art in *Dada, Surrealism and Their Heritage*, exh. cat., New York: Museum of Modern Art, 1968. Irving Sandler confirmed such ideas in a conversation we had at the Studio Museum in Harlem on 1 May 1998, in conjunction with the exhibition *Norman Lewis: Black Paintings, 1946–1977*.

37. See Sims, 'Wifredo Lam and Robert Matta: Surrealism in the New World', in Terry Ann R. Neff ed, *In the Mind's Eye: Dada and Surrealism*, exh. cat., Chicago: Museum of Contemporary Art, Abbeville Press, New York, 1985, 94. In the 1950s, however, the trajectory of stylistic developments in American art diverged into two tendencies in the New York School – the gestural painterliness of Pollock and de Kooning and the colour fields of Barnett Newman and Mark Rothko. As these last two artists would eventually be recognised for predicting developments in American art in the later 1950s and 60s, Valerie Fletcher would assert that in his thinning of colour and soaking into the canvas, Lam – like Gorky – preceded the New York School and Washington Color School. See Valerie Fletcher, *Crosscurrents of Modernism: Four Latin American Pioneers: Diego Rivera, Joaquín Torres-García, Wifredo Lam, Matta*, exh. cat., Washington, DC: Hirshhorn Museum and Sculpture Garden in association with Smithsonian Institution Press, 1992, 175.
38. 'A Way to Kill Space', *Newsweek*, 28 (12 August 1946), 106.
39. Ibid.
40. Ibid, 107. The emphasis on glyph-like shapes, forms that 'suggest rather than represent', and the perception of the 'premonition of danger' echo the primordial condition that the abstract expressionists were evoking in their own work, which Mark Rothko described as 'of the Earth, the Damned and the Recreated', Rothko quoted in Irving Sandler, op. cit., 67.
41. Forty years later Paul Schimmel would find 'counterparts' to Lam's work in Gottlieb's but again distinguishes Lam's work from other artistic developments in the 1940s by noting that the 'other worldly beings' that he created were not merely 'formal devices but a manifestation of his Chinese-Cuban-African heritage'. See Paul Schimmel, *The Interpretive Link: Abstract Expressionism into Abstract Expressionism*, exh. cat., Newport Beach, CA: Newport Harbor Art Museum, 1986, 22.
42. Pierre Mabille, 'The Ritual Painting of Wifredo Lam', *Magazine of Art*, 42 (May 1949), 188.
43. Ibid.
44. Clousseau, 'L'origine et l'écart', in *Paris-Paris: Créations en France 1937–1957*, exh. cat., Paris: Centre de Georges Pompidou, 1981.
45. Merewether, 'At the Crossroads of Modernism: A Limnal Terrain', Charles Merewether et al., *Wifredo Lam: A Retrospective of Works on Paper*, exh. cat., New York: Americas Society, 1992, 20.
46. Ibid.
47. Ibid.
48. Ibid.
49. Ibid.
50. Ibid., 173–75.

51. Ann Gibson, The African American Aesthetic and Postmodernism', in David Driskell ed., *African American Visual Aesthetics: A Postmodernist View*, Washington, DC and London: Smithsonian Institution Press, 1995, 85.
52. Ibid., 86–87.
53. Ibid., 88.
54. Lowery Stokes Sims, 'African American Artists and Postmodernism: Reconsidering the Careers of Wifredo Lam, Romare Bearden, Norman Lewis, and Robert Colescott', in David Driskell, op. cit., 103–104.
55. Ibid., 104.
56. Ikem Stanley Okoye, 'Tribe and Art History', *Art Bulletin*, 78, no. 4 (December 1996), 610–15.
57. Ibid., 610.
58. Ibid., 614–15.
59. Ibid.
60. Ibid., 614.
61. See, for example, *Master Hand: Individuality and Creativity among Yoruba Sculptors*, exh. brochure, New York: Metropolitan Museum of Art, 1997; and Z.S. Strother, *Inventing Masks: Agency and History in the Art of the Central Pende*, Chicago and London: University of Chicago Press, 1998.
62. Quoted in *Robert Colescott: A Retrospective, 1975–1986*, exh. cat., essays by Lowery S. Sims and Mitchell D. Kahan, San Jose: San Jose Museum of Art, 1987, 8.
63. Okoye, 'Tribe and Art History', 615.

COSMOPOLITAN
MODERNISMS

NORMAN LEWIS: 'HOW TO GET BLACK'

ANN EDEN GIBSON

A number of visually coherent series can be identified among the paintings of Norman Lewis. More often than not, the artist developed his ideas in groups of paintings and drawings that have common stylistic characteristics, and frequently, consistent subject matter as well. These series are not completely separate. Four discussed below, for instance – the Traces, the Geometrics, the Entities, and at least the early Tenements – can also be seen as sub-categories of a larger series of post-war abstraction, since the visual characteristics that separate them are cross-cut by shared subject matter and themes. Moreover, in all of these series from 1946 to 1977, Lewis painted many canvases whose dominant tone is black.*

The colour black fascinated Lewis: in its interplay with other colours, in its relation to luminosity, and in its efficiency in referring to a broad range of social and subjective topics. He claimed, though, that his interest in black was purely formal. In 1973 Lewis said of *Blending* (1946) that it was '...a black picture. It has no social connotation to me. I wanted to see if I could get out of black the suggestion of other nuances of color, using it in such as way as to arouse other colors', adding a few sentences later, 'This was my becoming... using colour in such a way that it could become other things'.[1]

Black has always been a complicated 'colour'. In Newtonian terms, black is the absence of light, and therefore of colour. In terms of paint, though, black is supposed to be what you get when you mix all the colours together. In the actual practice of painting, it is hard to get a really deep or rich black by mixing, say, red and green, even if you put in orange and blue, yellow and purple. To get a deep black one must start with pigments already black – ivory black and lamp black, for instance, mixing them with binders, or buy a tube or can of already mixed black paint. You could say that black contains in itself everything else and nothing at all. These contradictions, provocatively parallel to the social situation of African-descended people in colonial situations, led artists like Norman Lewis – despite his apparent disavowals – as well as philosophers like Jean-Paul Sartre, the poets of Negritude, and writers like Toni Morrison, to understand blackness as a figure for the coexistence of apparently contradictory qualities and concepts.

Taking the figural qualities of blackness as a principal theme, this essay revisits the 'black' paintings that appear throughout Norman Lewis's career as they 'become other things' and explores the complex relationships between the artist's African American identity and the historical phenomenon of abstract expressionism in post-war painting. While there is one early 1970s series that Lewis actually called his 'Black Paintings', the recurrence of the colour 'black' across his *oeuvre* as a whole has attracted scholarly attention. Before her contribution to the 1998 exhibition that I co-curated with Jorges Daniel Veneciano at the Studio Museum in Harlem, Lowery Sims had proposed an earlier exhibition in 1982. Noting that, like Clyfford Still, Lewis was 'fond of combining blacks of various textures and finishes in the same composition, thus revealing the potential for spatial complexity of this seemingly straightforward and "limited" color', Sims observed that his use of the colour black 'also allowed him to make pertinent political and social associations in a powerful way'.[2] In her essay for an exhibition of Norman Lewis's black paintings in 1985, Kellie Jones similarly described 'his use of the color black both as a dominant compositional element in his

abstract paintings and as a social comment'.[3] The numerous ways in which blackness in the 20th century conveys a wide range of metaphorical and metonymic associations can be understood, I suggest, once we read Lewis's paintings in the context of the author's and his viewers' experiences and convictions.

According to the painter, his conscious interest in the colour black had begun at least by 1946, the date of such early paintings as *Three in Spades*. 'I think it started with some rhododendrons', said Lewis, 'you know – rhododendrons, which I painted. I used just black – to convey the form – and I liked that and I went on to try to do other things. Just manipulating the paint was exciting to me'.[4] One must remember that Lewis came to aesthetic maturity in the era of abstract expressionism's evasion of language – the increasing reluctance of its major painters and critics to submit their work to literary or narrative interpretation or, for that matter, to use titles whose metaphorical implications would supplement their images.[5] Although Lewis later said that black had 'no social connotation' for him, the topics he depicted in black or very dark paintings, especially the Civil Rights series – done during a time whose events caused Lewis to look most critically at the relation between the colour black and his subject matter – suggest at the very least that he found the colour useful for referring not only to nature (i.e. plants, sky, sea), but to subject matter whose social and political implications involved the 'black' community's struggle for freedom.

If we pay attention only to his words, however, Lewis, seems to avoid metaphor, since his statements stress the *metonymic* connections that simply match black as a colour to whatever it imbues (the process of drawing, and darkness of night and of rhododendron leaves). In practice, though, he implies *metaphoric* connections not only via form (the 'stitching' in *Every Atom Glows*, for instance, as a metaphor for the molecular structure that holds the universe together), but also in his titles (*Three in Spades*; *Birmingham*; *Night Vision*). Lewis's conscious awareness that there was more in his black paintings than he usually chose to admit was perhaps more like the generation that *followed* his than it was like his own contemporaries, the abstract expressionists. Robert Rauschenberg, for instance, said of his black paintings of 1951–53 that he was 'interested in getting complexity without revealing much'.[6] Perhaps the best example of this evasive attitude is Frank Stella, who said of his paintings in 1966, that 'only what can be seen there *is* there', effectively cancelling out for the next decade scholarly speculation on the implication of his titles.[7]

Lewis's conviction that painting politically and painting well were divergent pursuits is not unfamiliar in 20th-century art, especially after mid-century, when as a principle it became enshrined in criticism, catalogues and textbooks. After the mid-1940s, like many ambitious and intellectual painters in New York, Lewis did not want to continue in the style of social realism associated with Diego Rivera and Thomas Hart Benton, or even to participate in the more abstracted realism of painters like Jacob Lawrence, whose works still referred to identifiable groups of people, often in historically specific situations. Born in Bermuda in 1909, Lewis grew up in Harlem, becoming aware of painters like Aaron Douglas and Joseph Delaney when he began working with Cooper Union graduate sculptor Augusta Savage at the Savage Studio of Arts and Crafts at 163 West 143rd St.[8]

Norman W. Lewis,
*Every Atom Glows: Electrons
in Luminous Vibration*, 1951

'The younger painters like Jake, Romy, myself, we did a lot of listening', he recalled.[9] By 1934 they were frequenting the studios of painter Charles Alston, dancer Ad Bates, and sculptor Henry Bannarn that housed the '306' Group at 306 West 141st St, as were Countee Cullen, Ralph Ellison, Claude McKay, Orson Welles, Charles White, John Wilson, Richard Wright and the young Robert Blackburn.

Lewis began moving between black and white worlds when he was accepted in the Federal Art Program of the Works Project Administration some time between 1933 and 1935.[10] He met Adolph Gottlieb, Jackson Pollock and David Smith on the WPA.[11] 'After the Artists' Congress[12] the artists still used to see each other at places like the Cedar Bar on 8th St… I used to see Rothko, Barney Newman and a lot of the other artists – Clyff Still, Rothko, and Reinhardt, we used to meet on 53rd St at 6th Ave. Out of this came… Abstract Expressionism which I think was something beautiful. And I mention this, because they got together and talked about art like musicians talk about music'.[13] Lewis was also close to Hale Woodruff and Charles Alston in those years.[14] By 1946 Lewis wrote that he was concerned with 'the limitations which come under the names "African Idiom", "Negro Idiom", or "Social Painting".' He wanted 'greater freedom for the individual to be publicly first an artist (assuming merit) and incidentally, a Negro', he continued. 'The excellence of his work will be the most effective blow against stereotype', declared Lewis, adding that 'This concept treats art not as reproduction or as convenient but entirely secondary medium for propaganda but as the production of experiences which combine intellectual and emotional activities in a way that may conceivably add not only to the pleasure of

the viewer and the satisfaction of the artist, but to a universal knowledge of aesthetics and the creative faculty which I feel exists for one form of expression or another in all men'.[15] Like other abstract expressionists, he rose to the challenge of wringing from line and colour a metaphorical potential, but one whose impact was, he hoped, impervious to verbal translation. Its payoff was to be meaning on a universal scale.

Lewis got to know fellow teacher Ad Reinhardt when the two taught together at the Thomas Jefferson School for Social Science in New York from 1944 to 1949.[16] 'There were artists out of the WPA like de Kooning and Ad Reinhardt who were really very close to me. Ad painted black on black, if you remember, but hell, he also did the best, most intelligent satirical drawings.'[17] During the later 1940s these two notably critical and politically active painters developed similar views about the ineffectiveness of protest painting.

Reinhardt's extensive contact with Lewis in the late 1940s, as Lewis was beginning to do black paintings, suggests at the least that Lewis had in Reinhardt a kindred spirit, and at the most that Reinhardt's understanding of the metaphorical uses of black was spurred by Lewis, whose black series began about a decade before Reinhardt's.[18] Like Lewis, Reinhardt had strong leftist convictions and, like Lewis, he believed that his art and his politics operated in separate spheres.[19]

While both artists maintained a focus on black over these years, Lewis used the techniques he developed to articulate the suggestive potential of black paint to evoke forms and ideas barely seen (or not seen at all), expanding rather than contracting his medium's compositional and thematic potential. Black, and the dark tones it produced when mixed in large proportions with other colours, became metaphors for the

experience of light and darkness in nature. But they also served as a *métier* in which Lewis described the ironies that flickered on many levels between the compulsory binaries of black and white in diasporic life in America and Europe.[20]

In *Black Skin, White Masks*, Frantz Fanon argued that Antillean Negroes disguised – even from themselves – their blackness in white masks. For Fanon, to be unable to recognise one's own blackness (or whiteness) is to exist in what seems to be a system of fixed terms. In such a system, each word in paired opposites like blackness and whiteness, or dark and light, acts as metaphor for either absence or presence; such sets of binaries thus serve as terms in which each guarantees the existence of the other.[21] Now, *Black Skin, White Masks* wasn't translated into English until 1967. I am not using the book as a source for Lewis; rather, I am using Fanon as a witness from Lewis's generation whom the psychology of race relations similarly disturbed. Like Fanon, Lewis understood the absurdity of such a situation. But for Lewis, blackness has many forms, has its own luminosity, and exists in a dynamic, rather than a static – and negative – relation to paler and brighter colours.

A statement by the painter Raymond Saunders, parts of which were published in *Art Magazine* in 1967, helps to shed light on Lewis's stance.[22] Whereas the tone of some of Saunders' observations is more confrontational than those offered up for public consumption by Lewis, their substance is reminiscent of the older artist's position. Saunders, for instance, writes that 'the american [sic] black artist is in a unique position to express certain aspects of the current american scene, both negative and positive, but if he restricts himself to these alone, he may risk becoming a mere cypher, a walking protest, a politically prescribed stereotype, negating his own mystery, and allowing himself to be shuffled off into an arid overall mystique'. On the next page, however, he writes, 'in america, black is bound to black not so much by color or racial characteristics, as by shared experience, social and cultural'. The very ambiguity at first reading of Saunder's phrase, 'black is bound to black', is instructive in regard to the double role played by black in Lewis's paintings: it is initially unclear whether 'black' refers to people, negativity *per se*, pigment, the absence of light, or some combination. As the passages from Saunders suggest, both metaphor and metonymy are important to poetic thinking – even if Lewis himself seemed unwilling to admit the metaphoric and metonymic tasks performed by blackness in his images and titles.

Traces

Beginning with the earliest series – the Traces – one notes that Lewis's 'black' paintings are seldom entirely black. Other colours including white flicker in and out, suggesting a multiplicity of events and objects enfolded by darker tones. In the Traces series these flickers often look like records of past movement indexically preserved in an extended blur or lines of light, like stop-action photographs. Frequently Lewis named his works, but sometimes he didn't. The title of *Metropolitan Crowd* suggests that the trajectories may be records in light of the movement of figures through space, like Marcel Duchamp's *Nude Descending a Staircase*, or imagined paths of walkers such as those in Alberto Giacometti's *City Squares*, where humans pass over one another's trails without coming into contact. But compared to Giacometti's more

Norman W. Lewis,
Metropolitan Crowd, 1946

representational figures, Lewis's metropolites in *Metropolitan Crowd* are represented more by the traces of their movements than by descriptive lineaments or even abstractions of their bodies. The fact that these figures are caught as trails of light at night records not only Lewis's awareness of the work of painters Paul Klee and Mark Tobey (they both showed at the Willard Gallery in the 1940s), whose paintings of lights on Broadway were much appreciated in those years, but also Lewis's own famously nocturnal habits.[23]

Lewis was said to be 'allergic' to the sun and he was frequently up at late hours. Letters to friends dated with the time and day were often penned or typed at 2:00 or 3:00 in the morning.[24] When asked if Norman Lewis's night paintings had detectably Jungian or psychoanalytic overtones (as did Jackson Pollock's for instance), psychologist Joan Murray Weissman, who lived with him during her graduate student years from 1945 to 1952, said, 'No, he just liked night, especially night time with lights. I think it had more to do with growing up in Harlem than anything more... He really loved night; he loved going out at night, and he loved walking at night, and he loved the sky with stars in it, and he loved lights. He was a night kind of guy.' [25]

Geometrics

The Geometrics are the brightest of the black series in terms of featuring colours that are highly luminescent. But these colours are caught in black frameworks that frequently echo the lattices of analytic cubism, Concrete Art (Theo van Doesberg's name for the geometric abstraction of De Stijl), and the Blue Four, founded by Wassily Kandinsky, Paul Klee and Lyonel Feininger, Lewis's gallery-mate at the Willard Gallery and the artist to whom he was closest in the Willard stable.[26] The Geometrics share a number of characteristics in which Lewis continues his earlier interests in couples, street scenes and jazz ensembles, abstracting them all with both surrealist automatism and the more geometric methods of cubism and constructivism.[27] The Geometrics are the most abstractly angular of these, but many still reveal a figural origin. *Untitled* (1946) for instance, with its anthropomorphic verticals, some with 'feet' or 'legs' and some that could be heads, and the more abstract *Four in Spade* (1947) for instance, are reminiscent of the earlier and more recognisable sources of paintings such as *Musicians* (1945).[28]

Entities

The abstract 'figures' in the Entities series, which includes groups like *Jazz Musicians* (1948), are more biomorphic and more vertically oriented than the Traces. This anthropomorphises them: abstract as they are, they still seem like people. In some, such as *Pussy Willows* (1948) and *Untitled* (1950), the figures are fused together so that they share the all-over quality of the more friezelike Geometrics. *Untitled* (1950), for instance, looks like the façade of a tall building. But in others, such as *Artic (sic) Night* (c.1949), the figures are distinct. Besides displaying a more organic character than the Traces or the Geometrics, many of the Entities are distinguished by a glow that suggests an interior energy. The glow that Lewis created by a modulation of the paint from low to high tonal values makes light appear to emanate *from* the figures, not merely to flicker around them, sometimes extending beyond their edges to form an aura of the kind one may see in

abstractions by Kandinsky, Klee and Feininger, but more finely graduated than theirs, and therefore even more suggestive of light. This, plus the vertical orientation of the figures, suggests that these groups are imbued with life and consciousness.

Structures

The term Structures could serve as an umbrella for nearly all of Lewis's abstractions from the mid-1940s through the mid-1950s, since they demonstrate the artist's tendency in these years to build his images part by part. The Structures, however, consist of a specific modular procedure seen in *Every Atom Glows: Electrons in Luminous Vibration* (1951) and *Moonglow* (1947) that stitches his forms together, cell by cell, or atom by atom.

Lewis developed this stitching technique not in order to represent atoms or trees, or indeed any particular subject, but because he had an insight. 'You suddenly become aware after years of painting that that rectangle or square is composed of shapes', he stated. 'If you arrange those shapes in any interesting fashion that might be visually stimulating, it doesn't have to be a form you know... you don't even know at the moment what you've done. In retrospect you say, *Gee, I did that!* You feel excited... and that's how it happened with me... *Especially if the canvas was in black* [emphasis mine]', Lewis said.[29] 'That was a whole other thing of seeing if I could use blacks with a brushstroke that was from light to dark or jet black – but in between that, just using it lighter on the canvas – like the one you saw in Utica [i.e. *Blending* – at the Munson-Proctor Museum] was again that kind of thing, to see what could come out of it'.[30]

The title of *Every Atom Glows: Electrons in Luminous Vibration*, however, makes it clear that Lewis understood this and related techniques, especially in black, as analogous to the building blocks of the universe. He was also quite concerned, as were nearly all Americans, with the promise of atomic power, but even more about the possibility of the destruction of the human race by the technology that produced the bombings of Hiroshima and Nagasaki. Joan Weissman recalls that *Every Atom* was about the bomb and the cold war, and also about Lewis's ambivalent admiration of Albert Einstein: 'We all loved Einstein. But we had a lot of trouble loving him and knowing he had discovered the thing that could cause this destruction.'[31]

Tenements

Following the use of the word as a title for *Tenement* (1948),[32] this series of city buildings involves scenes from what he saw from his own window. In addition, he was given to walking at night in the city, which gave him another perspective. *Tenement* suggests the former origin most clearly, in part because the bright rectangles we read as windows do not diminish in size nor slant in perspective towards either the top or the bottom; their orientation thus suggests a view that is itself somewhat aerial rather than from the very top or ground level. It must also be remembered, though, that the late 1940s and early 1950s were the years in which the modernist dictum that the flatness of the canvas must not be violated, or 'holed through', came to be accepted as a condition of avant-garde status.[33] Do the Tenements present such an avant-garde surface, or do they diagram its disintegration?

Socially, Lewis's situation presented a similarly ambiguous picture. He appeared in the photograph of the 'Artist's Sessions at Studio 35 (1950)', – one of the most important gatherings of the mid-century avant-garde in New York – and these were 'people I knew very well', he told painter Vivian Browne. The photograph was reproduced in the magazine *Modern Artists in America,* edited by painters Robert Motherwell and Ad Reinhardt and Museum of Modern Art librarian Bernard Karpel. Lewis remembered that the artists in the photo were selected by their galleries.[34] 'It wasn't a promiscuous conversation', he told Browne, 'because you had ample time to think about it; as one person finished the one next to him talked. You were given like five minutes to sum up something that probably took your whole life to learn. But at least things were recorded that I think were very important. And you found out that your frustration wasn't yours alone; you found that others experienced the same difficulty.'

Lewis's following responses to Browne's questions demonstrated his determination to maintain that his singularity as a black artist at this important gathering was due to his contributions as an artist, despite the fact that even though these artists knew him and his work, they had not reached out to him:

> 'But you were the only black face in there. How'd that happen?', asked Browne.
> 'Well, maybe I brought something to what I was doing', answered Lewis.
> 'But you also knew those people', prodded Browne.
> 'But if you know artists, I don't think a feeling of camaraderie really exists', responded Lewis, 'It's too much dog eat dog'.[35]

None of the buildings in the Tenement series seem actually solid. The bricks and girders fade into darkness, and what shows is the light that streams from individual dwellings or places of business. In his copy of Frank Lloyd Wright's *Kindergarten Chats* Lewis underlined Sullivan's statement that he wanted to show his pupil 'how the people of a city portray themselves in mass'.[36] Perhaps similarly motivated, Lewis's Tenements look less like structures of concrete and steel than like human conglomerates, with the same light pouring from their interstices that emanated from the Entities.

Rituals

The earliest known Ritual painting is *Congregation* (1950), and the latest is *Playtime* (1966). These canvases are distinguished by what Lewis explained as the presence, in mass, of his 'little figures' – graphic and increasingly abstract representations of humans as they 'attach themselves... in groups'.[37] Lewis stated that what first aroused his interest in these little figures (which he had compared a few months earlier to Breughel's)[38] was noticing 'how people follow each other'. In later years, Lewis noted, he became more involved with 'what you can do with paint', creating 'a movement across a canvas... almost like a ballet', as in *Evening Rendezvous* (1962) and *Carnivale I* (1957), a painting about processions he had seen in Italy.[39] 'It got to the point', he said, 'where I'd make more masses and show the individual as opposed to the mob – security – and the individual stands alone... Occasionally somebody will follow... those who dare to seek out something different.' 'In the later ones', Lewis noted, 'the masses became just a blob against a smaller blob'.[40]

Bonfire seems an example of this, but the blurring of individuals and groups can be seen in a number of paintings and drawings with 'little figures' that occur in other series too, such as *America the Beautiful* in the Civil Rights series.

Like the earlier Entities, whose characteristics meld into the Geometrics on one side and the Tenements on the other, the Ritual series shares a major characteristic – trails and clumps of abstracted figures – with the Civil Rights series. Looking even further back, one can see that the discrete abstracted figures of all of these series are developments of Lewis's early preoccupation with people on the streets.[41]

The artworks that can be designated as Ritual and those assigned to the Civil Rights series differ principally in the connection of the latter to the historic events of the Black Freedom Struggle. All of these series, though, may be said to depict certain kinds of rituals. As Stephen Polcari has remarked in regard to paintings by Mark Rothko with titles such as *Ritual*, *Ceremonial* and *Totem*, this was an era that psychologised ritual.[42] Ralph Ellison was no exception and Lewis's interest in group psychology can be seen as falling under the conceptual mantle of Ellison's understanding of 'ritual'. For Ellison, who was discussing Faulkner and Hemingway, 'ritual' was one of the functions of the stereotypical representations of others, including Negroes, made by whites. In psychoanalytic terms, Ellison saw stereotypes as 'projected aspects of an internal symbolic process through which, like a primitive tribesman dancing himself into the group frenzy necessary for battle, the white American prepares himself emotionally to perform a social role'.[43]

One wonders, however, if Lewis might have looked askance at Ellison's unproblematised example of a 'primitive tribesman'. Did he consider the potential application of the structure of projection too broad, or, on the other hand, as the similarities in the Ritual and Civil Rights series suggest, did he see it as applicable not only to the Ku Klux Klan's activities but to Civil Rights rallies and his own participation in picketing as well? [44] In any event, all of these activities are clearly involved with 'ritual' in both Ellison's description and in the double-edged terms of what Victor Turner was to call the anti-structural uses of ritual: the generating of *communitas*, a sense of oneness among all members of society regardless of their position in it.[45] But rituals that reduce intragroup aggression by producing *communitas* may do so for various reasons. In this sense, both the Ritual and the Civil Rights series portray gatherings whose purposes might be read as either positive or negative depending on how one interprets the activity represented.

What are the objectives of the 'rituals' of the earliest paintings in this series, *Congregation* and *Ritual* (both 1950), and of the later *Bonfire* and *Ritual* (both 1962)? Does *Bonfire* refer to church and home burnings of African American communities in the south, or is it a gathering held in good fellowship? Is *Ritual* a Klan rally or African Americans gathered around a picnic fire in celebration of a holiday or defiant solidarity at the embers of a burned church? In other words, are some of the Rituals positive, as the title of *Playtime* at first suggests? Or are they darkly ironic? Are Lewis's many representations of musicians – most of them not black paintings – also part of the Ritual series? The fact that such disparate interpretations may be attached to Lewis's use of black, but also to his images in other colours, suggests the doubled vision of which diasporic subjectivity is capable: the realisation that what means one thing in the

old location may have a completely opposite or unrelated implication in the new.

Dark Vistas

If the 'little figures', begun in the 1940s, culminated in the magisterial treatments of the Civil Rights Movement, intimations of the dusky mists that constitute the major characteristic of the Dark Vista series were also evident in Lewis's work before mid-century.

In their broadest implications, the Dark Vistas record the very tissue of Lewis's perceptive relationships with objects and situations in the world. His understanding of the metaphorical work that mysteriously rendered ethers could perform may have begun in the early 1950s as he fished in the waters off the north shore of Long Island. Lewis recalled that 'it was foggy, and the sky and water catalyzed so that you could not see the point where they fell together. Fog, this ethereal filter, fascinated me. It became the dominant undertone in much of my painting then'.[46] In its ability to obscure structure, as well as differences of colour and tone, fog is related to Ralph Ellison's trope of invisibility; but whereas invisible things are not seen at all, objects in fog are selectively obscured – some aspects show, others do not, and some appear, but with a difference. The fact that Lewis chose the more nuanced degrees of visibility suggested by fog, rather than a more binary treatment of visible/invisible, is evident in his adaptation of black as a metaphor for separation and absence – for 'invisibility' as it was described by Ralph Ellison. For this reason, the novelist Richard Wright (like Ellison, a friend of Lewis)[47] offers a more powerful entry into the world of visual metaphor in Lewis's Dark Vistas, in which blackness obscures but also embodies and reveals. Scholar Charles T. Davis believed that Wright gave to blackness a shape and dimension that writers before him had glimpsed less distinctly:

> Wright made blackness a metaphysical state [with *Native Son* (1940) and *Black Boy* (1945)], a condition of alienation so profound that old values no longer applied… Blackness was no longer a set of stereotypes concerned with the old plantation, nor was it the primitive self with roots in Africa, the South, or the West Indies, which the Harlem Renaissance had discovered; Blackness was the disturbing, complicated, ambiguous creation of contemporary civilization.[48]

Although most of the paintings in the Dark Vistas series suggest a misty origin in Long Island fog, they are sometimes articulated by sharper forms such as the black marks in *Night Vision* (1950) and *Orpheus* (1954). In most of these, the dominant impression is one of an obscuring darkness. You could say that in this series Lewis actually succeeded in painting invisibility, the absence to which authors such as Ellison and Morrison have gestured. But Lewis saw the action of darkness not as simply ending in negativity, not as the opposite of presence, but as the visual manifestation of situations full of unseen presences coming into being.

Lewis's realisation of the double potential of black – to enfold in obscurity and to usher from absence to presence, to limn both good and evil – suggests that Lewis fully understood the contingent nature of signification, its poignant but fruitful dependence on audience for the amplification or muffling of an artist's intention.

In the Civil Rights series as a whole, the artist makes this point so clearly – and so early – that the implications of these paintings for art history, and for a structural understanding of the relation of the Black freedom struggle to the forces mobilised to contain it, are only now coming to be understood.

Civil Rights

Lewis knew that the reputations of his most eminent abstract expressionist colleagues had been built on their pursuit of universality, which was understood to exclude social comment; and he was, besides, genuinely fascinated by the 'funny things that happen when you paint'. In his copy of *Possibilities* Lewis had circled the following sentence from the statement of editorial intent written by Harold Rosenberg and Robert Motherwell: 'Political commitment in our times means logically – no art, no literature. A great many people, however, find it possible to hang around in the space between art and political action.' [49]

In 1960 Lewis painted *Alabama* and *Post Mortem*. In the context of our knowledge about Lewis and with the more specific *Post Mortem* beside it, the jostling brushstrokes in *Alabama*'s centre suggest both white-gowned marchers with the peaked hoods of the Klan and a conflagration whose sparks ascend skyward. Without its title, and our knowledge that the painter was a politically concerned African American, though, the painting might read, like earlier black and white abstract expressionism did, as a more generalised meditation on contrasts. In *Post Mortem* the peaked hoods of the Klan and their crosses are clearly visible; the rest of the Civil Rights series explores this range

of associations in paintings that can be seen as meditations on the possibility of achieving the universal *through* difference; of communicating to others without losing the specificity of one's own deepest concerns. One could call this a universalist accomplishment, although David Craven suggests that in Lewis's case it might be better called 'multicultural' or 'international'. [50]

In 1963, the year that he, Romare Bearden, and Hale Woodruff founded Spiral, an organisation with fourteen members dedicated to considering the place of black artists in the struggle for Civil Rights, Lewis painted *Klu* (sic) *Klux*. [51] Like *Totem*, *Post Mortem* and *America the Beautiful* (all painted in or around 1960), *Klu Klux* was composed of white strokes on a black ground. Spiral's first exhibition was in the spring of 1964. 'It was the height of King's involvement in the South', recalled Lewis, 'and we wondered what the hell to do.' [52] That year he completed *Processional* (which was in the Spiral show) and *Journey to the End*. In 1967 he added another *Alabama* that amplifies the perspective of *Processional* by folding the advancing plane of marchers so that they appear to approach the viewer. Jeanne Siegel's view in 1966 that, 'Perhaps the most deeply affected [by the Civil Rights struggle] was the talented and sensitive Norman Lewis', was based on her observation of the change in his work. 'His subject, tiny forms in clusters that suggest migrations of people or birds in space, hasn't changed, but what was delicate and diffuse became sharpened, in a painting like *Procession* [sic], into a definable object with direction and power.' [53]

Lewis maintained, however, the stance he had taken in 1946: 'the statement you try to make', he told a reporter, 'is universal'. [54] How could Lewis claim this as a goal at the same time

Norman W. Lewis,
Alabama, 1960

Norman W. Lewis,
Alabama, 1967

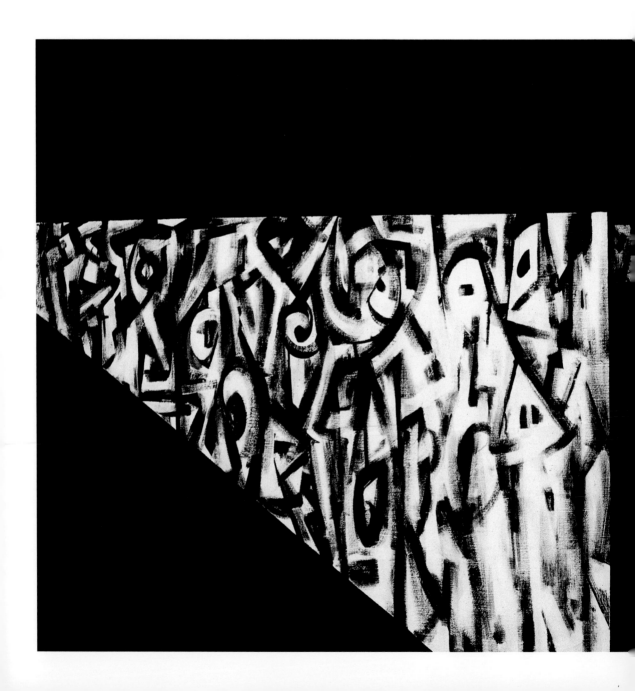

that he was making work that would have seemed to many Americans to be strongly partisan? He powerfully exploited the most basic relationships of light to dark and of figure to ground with bravura strokes. In using an idiom of modernist abstraction to invoke the events of the Black Freedom Movement,[55] Lewis was exploring a basic fact of human life, with the only life available to him: a western life in the middle decades of the 20th century as it was lived by an intellectual African American man from a working class background.[56] His strategic use of darkness, of black, to structure in various ways the abstractions he engaged, located that self – its goings, its appearances, or its absences – at the heart of American abstraction.

Du Bois presciently remarked that the problem of the colour line was *the* problem of the twentieth century, and Ellison had already written by 1946 that Negroes identified themselves with a broader version of American ideals than did whites. Why? Because the ideals of black Americans spring, in part, 'from an American experience which most white men not only have not had, but one with which they are reluctant to identify themselves even when presented in forms of the imagination'.[57] Lewis's determined use of his own specificity in his continuing search for the universal is most evident in the Civil Rights series – where it is thematised by his use of black as the matrix out of which the white forms materialise and is also the means of articulating them. In this sense, his Civil Rights series as a whole provides a persuasive visual and positive response to Ellison's conviction that to stereotype or ignore Negroes, or indeed any group, was to stereotype and ignore one's own humanity.[58] Lewis's insistence that his Civil Rights subject matter

could be represented abstractly is a demonstration of his refusal to understand his blackness as a limitation. Typical of his aesthetic and intellectual generation, he wanted to escape narrow parochialism by learning about and then using in his own work the achievements of other cultures: he loved to read and read widely, and to travel; and he claimed the right to the highest realms of aesthetic accomplishment as he understood them. Only this way, he believed, could he provide experiences for others that had the potential to link them to him *through* their acceptance of his particulars.

Lewis's claim to a universality whites seldom granted him and that blacks (including his own father) considered a 'white man's game' has contributed to his obscurity in the annals of American abstraction. What these estimations of his project neglect is the profound *relativity* at the heart of his project of abstract art. I am thinking that, as Étienne Balibar has pointed out, on a *virtual* level, everyone can see black and white; that is, retinally we receive approximately the same cues, whether we live in China, Africa or the USA. But in Lewis's painting, and most specifically in the black and white paintings of the Civil Rights series, the complexities of the cultural coding of black and white in the cultural imagination of this country (Lewis here uses white – the West's colour for goodness and innocence – for both Klanners and Processional marchers) *make it possible for the same colour to carry directly opposing meanings.*

Yes, these paintings deal with 'universals' in both aesthetic and political terms. But they exacerbate, theatricalise and transport it, distancing us from any reassuring protection that would spare us either from the process of understanding how the same colour could in a single painting stand for two opposed factors (Civil Rights marchers and Ku Klux Klansmen) or, having understood the gesture, shield us from the realisation that the 'universal' is very different than what it has been believed to be so far. Balibar has attempted to revise the aspects of exclusivity that have given the universal a bad name by understanding it not as something that neutralises differences but that intensively seeks to equalise them (i.e. equal freedom, equal dignity). He calls it the 'new globalisation', adding that the translations made in the name of communication from one culture to another always leave some elements out. This mystery creates desire (which is also a function of Lewis's handling of blackness) and maintains the pressure to communicate anew. [59]

No wonder that the colour black was the backbone of Norman Lewis's aesthetic, and that its dynamic relation to white was sharpened in his paintings of the 1960s. As visual metaphor and metonymy of the contextual issues his aesthetic beliefs would not allow him to represent mimetically, blackness was also the signifier of what he maintained was their absence in his work. Although he told Henderson that he couldn't remember why his discovery of the techniques he had used in the Structures series and was still using in the Civil Rights paintings occurred with black paint ('It could have been blue if I had blue, or it could have been red.'), it remains a fact that black was the colour in which the revelation occurred.[60] By the time of the Civil Rights paintings, the colour black was more heavily loaded than ever as metonymy, metaphor and, sometimes, outright denotation of the social issues named above. This did not mean, however, that it did not still carry its traditional authority as the colour in which lines,

and therefore, objects, have most often been drawn, and as the colour on which the construction of space in painting has most often depended. This made it an excellent tool, in Lewis's hands, to accomplish the paradoxical achievement of his Civil Rights paintings: the construction of abstract paintings that stand on their own as formal accomplishments but whose political core is the refusal of African Americans to accept either invisibility or a system in which their difference is perceived as lack.

Conclusion: The Black Paintings

Lewis's continuing determination after 1945 was to produce abstract paintings that resisted narrative interpretation. His lifelong pursuit of black as both medium and message in this context finds rather consistent resonance in a discussion by philosopher Theodor Adorno. A Jew in a Frankfurt University still run by a Nazi faculty, Adorno was struggling as an outsider during the same years as Lewis to defend a modernism that seemed to be slipping into the past in a world whose mainstream saw the problems with which he wrestled as beside the point. Like Lewis, Adorno saw 'blackness with regard to content' in art as 'one of the deepest impulses of abstraction'. 'Radical art today', he wrote 'is synonymous with dark art; its primary color is black.' The philosopher saw contemporary uses of black in art as voluntary impoverishment of means, refusals of 'the injustice committed by all cheerful art, especially by entertainment'. Nevertheless, 'ever since Baudelaire', Adorno noted, 'the dark has also offered sensuous enticement as the antithesis of the fraudulent sensuality of culture's façade . . . [meting out] 'justice, eye for eye, to hedonism'.

Adorno differentiated the difficult allure of this blackness from the attraction of 'affirmative art', that is, pleasing art that confirmed the status quo. For Adorno, black or dark art was dissonant at its heart, like Schoenberg's music, since it could produce pleasure only by overcoming an initial negative response. This pleasure in negation is entirely consistent with Lewis's pursuit of the difficulties of black painting.[61]

This is not the time to forget that for Lewis, whatever blackness was, it was always also, as it is for all Americans, an 'Africanism' in the sense that Toni Morrison has defined it as: 'the denotative and connotative blackness that African peoples have come to signify'. Could he, did he ever, forget that because of this, 'through the simple expedient of demonizing and reifying the range of color on a palette, American Africanism makes it possible to say and not say, to inscribe and erase, to escape and engage, to act out and act on, to historicize and render timeless'?[62] That black, in other words, was always doing more than one thing, and often opposite things, at the same time?

Lewis's late large-scale paintings, which he referred to simply as 'the black paintings', especially examples such as No. 2 (1973) are his most unrelenting meditations in black. Typically, they were inspired by a visual experience. Norman Lewis and his wife, Ouida Lewis, travelled to Greece in 1973 and the canvases that resulted were based on a view of a mountain from his hotel room that he drew every day. 'Actually, I saw the contour of that mountain change, just from the sun', Lewis recalled. 'At night the damn thing disappeared but I knew it was out there.' The question, he recalled when he was back in his New York studio, was 'what the hell can I do with this form at night?'.[63]

While the circumstances of the origins of a work of art supply important historical anchors for its meanings, they leave many questions open. Why, for instance, did Lewis so stubbornly determine that, faced with this powerful but invisible presence, he must paint what to many would be exactly the wrong object: not the mountain in sunlight (one thinks of Cézanne's views of *Mount Sainte-Victoire*), but the mountain *when it was nearly impossible to see*? In an interview less than two months earlier in 1973, Lewis was talking about the kinds of assistance artists could get on the WPA project, emphasising that 'if you were that curious, and that dedicated to what you wanted to get, you got assistance'. The example he chose, not only in the light of the black paintings he was working on in his studio, but also in the longer perspective of his lifelong dedication to exploring the relation of darkness and vision, is significant: 'It's like wanting to know, how do you get black?', he said. 'How do you fire black? You don't take black to get black [in ceramics].' [64] The first thing that came to Lewis's mind in terms of what one would want to know, was 'how to get black'. In all of its beauty, complexity and hardship, this is the problem with which Lewis hoped to imbue American painting, and through it, American life.

** This chapter develops themes and approaches first explored in Ann Gibson, 'Black is a Color: Norman Lewis and Modernism in New York', in* Norman Lewis: Black Paintings 1946–1977, *exh. cat., New York: The Studio Museum in Harlem, 1998, 11–30.*

NOTES

1. Norman Lewis quoted in Romare Bearden and Harry Henderson, *A History of African-American Artists From 1792 to the Present*, New York: Pantheon Books, 1993, 321. Parts of this quotation are from Henderson's original unpublished interviews with Norman Lewis, 10 October 1973, New York.
2. Lowery Sims, 'Norman Lewis: the Black Paintings, 1944–1977', unpublished exhibition proposal, March 1982, 2.
3. Kellie Jones, *Norman Lewis 1901–1979*, Newark, New Jersey: Robeson Center Gallery, 1985, 2.
4. Harry Henderson, second unpublished interview with Norman Lewis, 17 October 1973, New York.
5. See Ann Gibson, 'Abstract Expressionism's Evasion of Language', *Art Journal*, 47, Fall 1988, 208–14; on the role of titles in abstract expressionist paintings see John Welchman, *Invisible Colors: A Visual History of Titles*, New Haven: Yale University Press, 1997, 269.
6. Robert Rauschenberg quoted in Calvin Tomkins, *Off the Wall: Robert Rauschenberg and the Art World of Our Time*, Garden City, N.Y.: Doubleday, 1980, 72.
7. Frank Stella quoted in 'Questions to Stella and Judd', an interview with Bruce Glaser, in *ArtNews*, 65, September 1966, 58–59.
8. Kellie Jones, 'Norman Lewis Chronology', in *Norman Lewis, From the Harlem Renaissance to Abstraction*, New York: Kenkeleba Gallery, 1989, 58.
9. Norman Lewis interviewed by Vivian Browne, 23 August 1973. Untranscribed tape in the Hatch-Billops Archive, New York.
10. Kellie Jones, 'Norman Lewis Chronology', in *Norman Lewis*, 1989, 58, and Lewis, Interview with Billops, Hatch and Vivian Browne, 1973.
11. Norman Lewis, interview with Billops, Hatch and Browne, 29 August 1974, untranscribed tape, Hatch-Billops Archive, New York.
12. The American Artists' Congress existed from 1935–42 with about 900 members at its peak in 1939. It sponsored exhibitions, lobbied for artists' rights, jobs and economic security. See Matthew Baigell and Julia Williams eds, 'The American Artists' Congress, Its Context and History', in *Artists Against War and Fascism, Papers of the First American Artists' Congress*, New Brunswick, N.J., 1986, 2–44.
13. Lewis to Browne, 1973. Joan Murray Weissman remembered that 'Ad [Reinhardt] was there all the time'. Barnett Newman visited them sometimes, as did David Smith and Dorothy Dehner. Adolph Gottlieb came up (to W. 125th St) on occasion. 'Rothko', she said, 'we met other places'. Telephone interview, 5 October 1991.
14. 'Hale was real close to Norm', remembered Joan Murray Weissman, 'he came up; and Spinky did too; he was there a lot'. Interview, 5 October 1991.

15. Norman Lewis, 'Thesis, 1946', in *Norman Lewis, From the Harlem Renaissance to Abstraction*, 63. Lewis related to more than one interviewer how much he enjoyed and benefited from his friendships with abstract expressionists whose fame, however, increased when his did not. Susan Stedman, widow of painter William Majors, a fellow Spiral member, noted that there was a private/public distinction in relations between white and black artists. The artists were forthcoming in the studio, but not nearly so ready to share business and social arrangements. Interview, 13 December 1988, New York.
16. Kellie Jones, 'Norman Lewis Chronology', in *Norman Lewis*, 1989, 58–62; for Lewis's departure see Bearden and Henderson, *A History of African American Artists*, New York: Pantheon Books, 322.
17. Norman Lewis in 'An Interview with Norman Lewis', Joan Rubin, *Lofty Times*, Holiday issue, 1977, 22. My thanks to Thomas Lawson for sending me this article.
18. In November to December 1956, Lewis wrote, 'Monday Ad had his opening, it was a very good exhibition, good paintings'. Letter in the collection of Jean Lagunoff, Sarasota, Florida.
19. Ad Reinhardt, *Art as Art, The Selected Writings of Ad Reinhardt*, Barbara Rose ed., Berkeley: The University of California Press, 1975, 94–98.
20. Kellie Jones, 1985; Curtia James, 'Norman Lewis: Pathfinder', in *American Visions*, 4, June 1989, 21. I use the term 'compulsory' binarities to suggest the social construction (and therefore the artificiality of the opposition) after the argument proposed in Adrienne Rich's 'Compulsory Heterosexuality and Lesbian Existence', in Ann Snitow, Christine Stansell and Sharon Thompson eds, *Powers of Desire*, New York: Monthly Review Press, 1983, 177–205.
21. See Francoise Verges, 'Creole Skin, Black Mask: Fanon and Disavowal', *Critical Inquiry*, 23, Spring 1997, 591.
22. Raymond Saunders, 'Black is a Color', *Art Magazine*, June 1967; this article contained parts of a larger unpaginated and undated manuscript in the collection of the Whitney Museum of American Art.
23. Gallerist Marian Willard's enthusiasm for modern painting was inspired by Paul Klee, as related by her daughter, Miani Johnson, telephone interview, 14 November 1997.
24. His keeping of late hours was noted by his widow, Ouida Lewis, telephone interview, 17 October 1997. Norman Lewis's letters to Jean Lagunoff (private collection), for instance, were often written at night.
25. Joan Weissman, interview with the author, 26 June 1987, New York, and telephone interview, 3 June 1988.

26. Lewis relished conversations with Feininger, whose experience of the European avant-garde included first-hand knowledge of early cubism (he was painting in Paris from 1906–08), and close associations with the Blue Rider and the Bauhaus (he taught there from 1919 until 1933). Ouida Lewis said that 'Norman was involved with Tobey and Feininger both of whom were interested in small figures. People always cite Tobey, but it was Feininger to whom Norman was really close.' Interview with the author, 8 June 1987.

27. 'Did working abstractly come like a lightning blow?', Vivian Browne asked Lewis. 'No, change comes slowly', he answered. 'My enlightenment came from the books and pictures that I saw. It was something that I knew nothing about, and hence this aroused my curiosity. I was terribly involved with Van Gogh, Matisse; Modigliani used a lot of African art, you know. Picasso, Braque – they were saying something I was completely ignorant of; and slowly I began to see the whole cubist thing. This opened up so many more doors for me.' Billops, Hatch and Browne, interview with Lewis, 23 August 1973.

28. *Musicians* is reproduced in *Norman Lewis*, 1989, 31.

29. Bearden and Henderson, *A History of African-American Artists*, 317; Ouida Lewis, interview with the author, New York, 2 August, 1987; Lewis, letter to Jean Lagunoff dated 'Tuesday [Nov./Dec. 1956], one-fifteen am.' Collection Jean Lagunoff, Sarasota, Florida.

30. Bearden and Henderson, *A History of African-American Artists*, 321; Norman Lewis to Harry Henderson, 17 October 1973.

31. Weissman, interview, 8 June 1987.

32. Lewis's *Metropolis* was also called *Tenement* (see Henderson and Bearden, 322) until the painting was relined in 1993 and gallerist Bill Hodges saw that the artist had written the word 'Metropolis' on the back of the work on a part of the canvas previously under the frame. Telephone interview with Bill Hodges, 14 November 1997.

33. Clement Greenberg, 'Toward a Newer Laocöon' [1940], in John O'Brian ed., *Clement Greenberg: the Collected Essays and Criticisms*, vol. 1, Chicago: University of Chicago Press, 1986, 34.

34. Not all artists, evidently, were invited through gallery connections, however. Louise Bourgeois remembers that she was at the Artists' Sessions at Barr's invitation. Louise Bourgeois, interview with the author, New York City, 24 February 1987.

35. Norman Lewis, interview with Billops, Hatch and Browne, 23 August 1973.

36. Louis Sulllivan, *Kindergarten Chats and Other Writings*, New York: Wittenborn, Schultz, Inc., 1947, 109. Collection of Tarin Fuller.

37. Lewis, interview with Henderson, 17 October 1973.

38. Lewis, interview with Billops, Hatch and Browne, 23 August 1973.

39. Ouida Lewis, telephone interview, 17 October 1997.

40. Lewis, interview with Henderson, 17 October 1973.

41. See, for instance, Lewis's *Untitled* (1944), reproduced in *Norman Lewis*, 1989, 17.

42. Stephen Polcari, *Abstract Expressionism and the Modern Experience*, Cambridge: Cambridge University Press, 1991, 129–30.

43. Ralph Ellison, 'Twentieth-Century Fiction and the Black Mask of Humanity', 1946, published in *Confluence*, December 1953, *Shadow and Act*, New York: Signet, 1966, 45.

44. Lewis evidently did not agree with everything Ellison wrote. 'We had a lot of philosophical trouble with Ralph Ellison', recalled Lewis's widow, Ouida Lewis, adding 'Norman knew him very well.' Interview, 8 June 1987, New York City.

45. Victor Turner, *The Ritual Process: Structure and Anti-Structure*, Ithaca: Cornell University Press, 1969.

46. Lewis in an interview with Harry Henderson, quoted in Bearden and Henderson, *A History of African-American Artists From 1792 to the Present*, op. cit., 322.

47. 'I knew Richard Wright very well', said Lewis. 'He used to come to the [Harlem Community] Art Center.' [Lewis was there from 1935 to 1937 and again in 1939]. Billops, Hatch and Browne, interview, 29 August 1974.

48. Charles E. Davis, *Black is the Color of the Cosmos, Essays on Afro-American Literature and Culture, 1942–1981*, Henry Louis Gates Jr ed., Washington, DC: Howard University Press, 1989, 19–20.

49. Norman Lewis's copy of Harold Rosenburg, 'Three Stages', *Possibilities*, 1, Winter 1947/48, 1, Collection of Tarin Fuller.

50. For Lewis's political activity as evidence of the depth of his commitment to the Black freedom struggle and a discussion of the nature of his 'universality' in the light of this goal, see David Craven, 'Norman Lewis as Political Activist and Post-Colonial Artist', in *Norman Lewis Black Paintings 1946–1977*, New York: The Studio Museum in Harlem, curated by Ann Gibson and Daniel Veneciano, 1998, 51–60. For more on the possibility of a universalism that does not drown cultural difference see Ann Gibson, 'Universality and Difference in Women's Abstract Painting: Krasner, Ryan, Sekula, Piper and Streat', *The Yale Journal of Criticism*, 8, Spring 1995, 103–32.

51. Jeanne Siegel, 'Why Spiral?', *ArtNews*, 65, 5 September 1966, 48.

52. Lewis, interview with Billops, Hatch and V. Smith, 23 August 1973.

53. Siegel, 'Why Spiral?', 51, 67.

54. Norman Lewis in Kimmis Hendrick, 'West Coast Report, Artist in Society', *Christian Science Monitor*, 20 January 1964.
55. Dr Vincent Harding, 'Long Time Coming: Reflections on the Black Freedom Movement, 1955–1972', in *Tradition and Conflict, Images of a Turbulent Decade 1963–1973*, curated by Mary Schmidt Campbell, New York: The Studio Museum in Harlem, 1985, 17–43.
56. Lewis was largely self-taught and said, 'All the books here were my education. I taught myself how to paint, observing what has been achieved., Lewis to Esther Rolick, 15 December 1970, untranscribed tape, Archives of American Art, Smithsonian Institute, Washington, DC. His widow, Ouida Lewis, observed that he had at one time 'all of Hegel, all of Marx, all of Engels', in addition to the many art books in his library, interview 22 November 1988. A listing of Lewis's art books, catalogued in 1950 by Joan Murray Weissman, appears in *Norman Lewis: From the Harlem Renaissance to Abstraction*, 67–70.
57. Ralph Ellison, 'Twentieth Century Fiction and the Black Mask of Humanity', in *Shadow and Act*, 43.
58. Ellison, 'Twentieth Century Fiction', especially 60.
59. Étienne Balibar, 'Critical Reflections', *Artforum*, 36, November 1997, 101, 130.
60. Norman Lewis quoted in Harry Henderson, 'Norman Lewis, The Making of a Black Abstract Expressionist, His Achievements and His Neglect', *International Review of African American Art*, 13: 3, 1966, 62.
61. Theodor Adorno, 'Black as an Ideal' in 'Situation', 39–41, in Gretel Adorno and Rolf Tiedmann eds, *Aesthetic Theory*, trans. Robert Hullot-Kentor, Minneapolis: University of Minnesota Press [1970], 1977. My thanks to Dan Monk for this reference.
62. Toni Morrison, *Playing in the Dark*, Cambridge: Harvard University Press, 1992, 6–7.
63. Lewis, interview with Billops, Hatch and Browne, 23 August 1973.
64. Ibid.

ROMARE BEARDEN, 1964: COLLAGE AS KUNSTWOLLEN
KOBENA MERCER

This could be for immigrants to or people trying to establish themself in a world they dont belong

Romare Bearden enjoys the distinction of being an African American artist who is often included in surveys of American art since 1945: but does 'inclusion' guarantee that the work itself enjoys a deep interpretive understanding? Although rarely shown in Britain or Europe, his *Photomontage Projections* form an extraordinary body of work which is widely appreciated in the USA, where it enjoys popular recognition as well as being the subject of large-scale retrospectives at leading institutions such as the Whitney Museum of American Art and the National Gallery of Art in Washington, DC.[1] Taking a look at the art historical scholarship on Bearden, however, reveals an emphasis on narrative subject-matter and the artist's biography which, although indispensable, tends to overshadow our understanding of the importance of Bearden's decision to make collage his primary mode of artistic expression from 1964 onwards.

Composed of paper rectangles and photographic fragments, the *Photomontage Projections* feature dynamic groups of expressive figures in a post-cubist pictorial space that evokes the turbulent changes in African American life throughout the 20th century. Considered as history painting, Bearden's mural-like collages encapsulate his unique synthesis of influences from high modernism and the black vernacular, and disclose an understanding of African American identity as something that has itself been 'collaged' by the vicissitudes of modern history. Writing in 1968, novelist Ralph Ellison got to the heart of the matter when he observed:

> Bearden's meaning is identical with method. His combination of technique is in itself eloquent of the sharp breaks, leaps in consciousness, distortions, paradoxes, reversals, telescoping of time, and surreal blending of styles, values, hopes and dreams which characterize much of Negro American history.[2]

Taking Ellison's insights as a starting point, I argue that the choices that led Bearden to collage in 1964 are doubly significant. On the one hand, because it enabled a resolution of problems in realism and abstraction he had grappled with from the outset of his career, the shift to collage can be seen as the fulfilment of Bearden's artistic intention – his individual 'will-to-form'. Bearden himself spoke of 'arriving at the space' when asked about his overall approach to the *Photomontage Projections*[3]: the fact that collage and montage became his principal working methods, up to his death in 1988, further testifies to their importance in providing a resolution to a struggle over questions of representation that had been initiated in the 1930s.

On the other hand, far from being a merely personal achievement, Bearden's arrival at montage and collage can be seen to 'personify' a historical breakthrough that answered a deeper structural dilemma that generations of black American artists had faced. Bearden wrote about his artistic concerns throughout his career. His 1934 article, 'The Negro Artist and Modern Art', expressed dissatisfaction with the romantic idea of Africa that had underpinned the Harlem Renaissance, as well as his awareness of the pitfalls of protest art in the social realism of the Depression era. Bearden co-authored a major art historical encyclopaedia, *A History of African American Artists*, posthumously published in 1993, as well as a book with fellow artist Carl Holty, *The Painter's Mind: A Study of the Relations of Structure and Space in Painting* (1969);

but the key text that reveals his intellectual acumen on issues of art and politics was a 1946 essay in the short-lived avant-garde journal, *Critique*, entitled 'The Negro Artist's Dilemma'.[4] Identifying the conflicting expectations and demands that restricted the options available to minority artists in a segregated society, Bearden addressed the complex knot of 'race', racism and representation whose ideological dominance had placed black artists on the margins of modernism. Did collage open a way out of this dilemma? Once seen in the light of his own analytical reflections on art, Bearden's breakthrough moment has wide-ranging implications.

Considering various claims that have been made for collage and montage at certain moments in the 20th century – the papier colle of Picasso and Matisse, dada and surrealism, pop and post-modernism – I suggest that Bearden's breakthrough was indicative of a historic shift in African American culture at large. While it would be misleading to attribute the assemblage art, for instance, of artists such as Betye Saar and David Hammons in the 1960s, to Bearden's influence alone, it is nonetheless compelling to think of the formal dynamics of collage as especially relevant to the hyphenated character of diaspora identities historically shaped by the unequal interaction of African and European elements. Let me put it like this: in semiotic terms, the formal principle of collage and montage lies in the purposive selection of signifying elements, found or taken from disparate sources, that are combined in unexpected juxtapositions to create something new that exists as an independent form in its own right. Put in this way, such words not only echo Ellison's insights into the *Photomontage Projections*, but sound as though

they were articulating an anti-essentialist understanding of black identity. Such an understanding would accept that, in a century that saw gradual shifts in the symbolic power of the proper name – from Negro, through Coloured, to Black – what Bearden's art bears witness to, as he cuts into the signifying chains of 'race' and representation, is the dialectical flux of historical becoming. In Stuart Hall's words, 'Far from being eternally fixed in some essentialised past… which is waiting to be found, and which, when found, will secure ourselves into eternity, identities are the names we give to the different ways we are positioned by, and position ourselves within, the narratives of the past.'[5]

Re-viewing Bearden in light of debates which have changed commonplace ways of understanding identity, I suggest that it is precisely the formal agency of 'the cut' in his *Photomontage Projections*, often marked by a paper tear, that demands close attention if we are to understand the emotions that play a part in responses to these powerful works. The piercing inscription of 'the punctum', as Roland Barthes called it,[6] plays a significant role in the disturbing and disorienting effects produced in Bearden's collage practice (which thus addresses, from an oblique angle, the changing relationship between painting and photography as a distinctly modernist problem). This essay explores such issues by tracing the development of Bearden's style from the 1930s to the 1960s.

'The Negro Artist's Dilemma': Style as Problem Solving

Born in 1911 in Mecklenburg County, North Carolina, Bearden attended high school in Pittsburgh after his family relocated to New York

in the 1920s. Following his freshman year at Lincoln University and then Boston University, he transferred to New York University in 1932 and graduated in Mathematics in 1936. Enrolled at the Art Students League in New York, where he studied with expatriate artist George Grosz for eighteen months until 1937, Bearden published political cartoons in weekly newspapers, such as the *Baltimore Afro-American*, and *Opportunity*, the journal of the Urban League. He was employed as a caseworker with the City Welfare Department from 1938 onwards, and it was in the harsh urban environment of Harlem during the Depression that Bearden entered into the debates that revolved around 'the social responsibility of the artist'.

The concern to create a closer rapport between intellectuals and the masses was paramount for numerous artistic movements during the 1930s. The Popular Front platform announced at the 1935 Communist International sought to fuse art and politics in the language of class struggle, and the period also witnessed increased state patronage of the arts in the West, in the form of the Federal Arts Project, which was active from 1939 to 1941 as part of the Works Progress Administration set up by President Roosevelt's government. In 1934 Bearden had attended the inaugural meeting of the Harlem Artist's Guild, which campaigned for the inclusion of African American artists in the FAP programme. As a result, the development of a local FAP initiative at 306 West 141st Street, led to the formation of an artist's group in 1935 that became known as the 306 group. Named after the studio of sculptor Henry Bannarn and painter Charles Alston, the group included the painters Jacob Lawrence (1917–97) and Norman Lewis (1909–79) and provided Bearden with the

context for his first exhibition in May 1940. Ineligible for WPA support on account of his caseworker income, Bearden rented a studio on 125th Street, and while enlisted at the 1st HQ of the 15th Regiment New York City during wartime, he retained a studio in the basement of Harlem's legendary Apollo theatre.

From the outset, Bearden's work reflected a modernist commitment in which the everyday life of ordinary black Americans was embraced as his primary subject, while his stylistic choices demonstrated an equal commitment to the expressive possibilities of modernist painting that went beyond the naturalistic conventions of mere depiction. *Rite of Spring* (1940), for example, is set in the rural milieu of working-class life in the American South. Bearden's portrayal of a boss handing a termination notice to a despondent mother foregrounds the black factory owner's massive face and exaggerated hands. The anti-naturalistic emphasis of Bearden's expressive distortions suggests the influence of Mexican muralists such as Jose Orozco as well as his mentor George Grosz. While *Folk Musicians* (1941–42) and *Cotton Workers* (1942) identified themes from the 'folk' or vernacular culture of the American South that Bearden consistently returned to, his articles of 1934 and 1946 elucidate how he positioned himself in the debates of the time, which often polarised social responsibility and artistic freedom as mutually exclusive choices.

Acknowledging the achievement of the 1920s generation, which lay in the hard-won acceptance of black life as legitimate subject matter, he was sharply critical in 'The Negro Artist and Modern Art' (1934), of what he saw as 'the timidity of the Negro artist'.[7] He regarded the aspiration towards academic naturalism among

(Top to bottom)
Romare Bearden,
Rite of Spring,
Cotton Workers, and
The Visitation, 1940

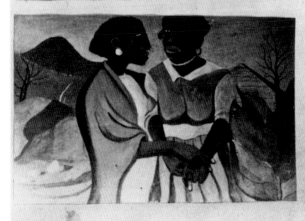

earlier generations of black artists as a symptom of distorted self-perception. Arguing that, 'the post-Impressionists, the Cubists, the Futurists, and hosts of other movements [...] are commendable in the fact that they substituted for mere photographic realism, a search for inner truths', he advocated a forward-looking stance that encouraged stylistic experimentation.[8] In rejecting the goal of neutral verisimilitude that underpins naturalism, Bearden asserted that, 'the Negro artist [...] must not be content with merely recording a scene as a machine. He must enter wholeheartedly into the situation he wishes to convey.'[9] This view gave precedence to an artist's expressive standpoint over the practice of depiction that produces documentary realism. However, rather than an outright anti-realism, the essay reveals the inner workings of what we could call the 'vernacular realism' pursued in Bearden's gouaches of the 1940s, in which the expressive distortions that characterise his figurative vocabulary sought to convey an experiential feeling or subjective disposition towards the scenes he depicted.

To the extent that 'vernacular realism' highlights the expressive qualities of an artist's relationship to the realities referred to in the depicted scene, Bearden's position was closely aligned with such contemporaries as Elizabeth Catlett (b. 1915), Charles White (1918–79) and John Biggers (b. 1924), who also chose the rural South as the setting for narrative scenes of adversity and survival. Whilst an earlier 'vernacular realism' had been adopted by such Harlem Renaissance painters as Archibold Motley and William Henry Johnson, the shift in subject matter from urban nightlife to rural hardship was indicative of the broader changes of the inter-war period. Such shifts were in keeping with trends whereby the WPA encouraged painters and photographers to depict the 'folkways' of rural life, which for many black artists of the period thus displaced the Pan-African iconography of the 1920s. In this regard, Bearden's decisive break with the outlook of his preceding generation was voiced in his scepticism towards the highly simplified notions of Africa that had circulated in previous debates. Writing in an unpublished letter in 1942, he voiced his doubts that, 'to try and carry on in America where African sculpture left off would be to start on a false basis – the gap of the years, the environment, and ideology, is too great.'[10]

Turning to 'The Negro Artist's Dilemma' (1946) we can see how Bearden gradually developed a wide-ranging critique of the politics of 'race' and representation out of his analysis of unresolved problems facing black artists of the 1920s and 1930s. Outspoken in his views on American art institutions, the burden of his criticism was directed towards what he saw as the double standard that characterised the reception of African American artists. Between 1926 and 1933, the philanthropic activities of the Harmon Foundation played a major role in providing access to exhibition opportunities. The Foundation's administrator, Mary Beattie Brody, encouraged numerous practising artists to participate in the programme of annual awards for 'Distinguished Achievement among Negroes'.[11] Although the resulting exhibitions attracted popular audiences, Bearden was unequivocal in his view that:

[...] the attitude of the Foundation towards Negro artists was patronising: it firmly established the pattern of segregated exhibits [and] it fostered artificial and

arbitrary standards, stemming from sociological rather than aesthetic interest in the exhibitor's works.[12]

His unease with the policy of segregated exhibitions was not only indicative of the qualified optimism of the immediate post-World War II period, with regards to the incipient integration of minority artists within the New York art world, but also a clear indication of a critically cosmopolitan outlook, which rejected the inward-looking emphasis of ethnic separatism. Between 1944 and 1947, following a solo exhibition in 1945 at Caresse Crosby's G Place Gallery in Washington, DC, Bearden was represented by the Samuel Kootz Gallery on East 57th Street. Kootz was among a new generation of East Coast gallerists who featured African American artists on their books. Jacob Lawrence, for instance, held six solo exhibitions at Edith Halpert's Downtown Gallery in New York between 1941 and 1953; William Henry Johnson had shows at the Wakefield Galleries in 1943 and 1944 during Betty Parson's tenure; and Norman Lewis was represented by Marian Willard from 1946 to 1964. Such partial inclusion in the art market was short-lived, but it was important because it shows that black American artists encountered a revolving door in negotiating access to an art world environment where segregation was mostly accepted as a social norm.

Institutional double standards generated one set of constraints in the structural dilemma Bearden identified, but far more insidious were the gamut of value-laden assumptions that placed prescriptive demands on minority artists. Starting with a historical review of black subjects in 19th-century American painting, the insight

that, 'it is the privilege of the oppressor to depict the oppressed',[13] reveals Bearden's keen awareness of the importance of images in shaping social attitudes towards 'race'. In this historical context, a struggle for access to the means of representation, and to the arts as a specialised profession, placed African American artists at odds with the canonical freedom of expression taken for granted by other modernists whose identities were not marked by 'race'. Observing that, 'The Negro, aside from his folk expressions, is a latecomer to the visual arts',[14] Bearden sympathised with the late 19th-century achievements of Henry Ossawa Tanner, and with the collective breakthrough of the 1920s generation, but as he surveyed the discourses surrounding the reception of African American artists in the 1930s and 1940s, he pinpointed the conflicting pressures arising from three competing definitions of what black culture is or should be. 'I have observed three major concepts that constantly reappear', he writes:

1. The Negro should continue, or at least simulate, the traditions of African art.
2. The Negro should attempt a unique nationalistic, social expression, closely akin in feeling to jazz music and the spirituals. (One critic stated in reviewing a group of Negro artists: "We can say this of it: the farther removed the Negro is from copying the white man's style or subject matter, the better he is.")
3. The Negro's art should be a visual and trenchant reflection of his political and social aspirations, especially as it would focus attention on the exigency of his existence.[15]

At one level, each emphasis can be grasped as an attempt to name what is distinctive to African American culture and identity – its African origins, its musical expressions, its political aspirations for freedom – and in this sense parallels could be found in the critical debates on artistic freedom and social responsibility in African American literature. What distinguished the reception context for visual artists, however, was the marked imbalance whereby these competing definitions of cultural or ethnic distinctiveness came up against the implicit demand for conformity on the part of liberal-conservative institutions such as the Harmon Foundation.

Although the values espoused by newly-expanding American institutions of modern art in the period, such as the Museum of Modern Art, New York, (which gave Jacob Lawrence his first solo exhibition in 1943), adhered to the high modernist doctrine of originality, complexity and authenticity in artistic production, the more conservative criteria of the public patronage provided by the WPA in the 1930s, or institutions such as the New York Public Library system in the 1920s, entailed the implicit demand that minority artists should demonstrate competence and mastery of the rules of academic art. It was this underlying double bind that lay at the heart of 'the Negro artist's dilemma'.

As 'latecomers to the visual arts', African American artists faced conflicting expectations from different audiences and institutions. Against a historical background of institutional racism, the few artists able to gain access to validated careers were obliged to 'answer' the prevalent assumption that, apparently without an autonomous visual tradition of their own, African American artists should master the conventions of western naturalism in order to be recognised as artists as such. Conversely, however, with the advent of modernism in the early 20th century, work produced under such segregated conditions was widely perceived as 'peculiarly backward'.[16] Where modernist criteria demanded individual distinctiveness in artistic production, the valorisation of what was held to be 'different' about African American culture – which developed at the point where high modernist primitivism came into contact with Pan-Africanism in the 1920s – was directed to a *collective* cultural phenomenon. Rather than the freely-chosen responsibilities adopted by avant-garde artists or movements that sought to join art and politics in a broad challenge to modern life, black artists were subjected to a discursive formation of art and politics in which they were expected to produce art that would be 'representative' of African American cultural identity, even though there was no artistic consensus as to what made such an identity distinctive.

Within the 1946 essay, the gist of Bearden's response to the discursive construction of black cultural difference is to reject an either/or logic that perceives each of the three facets of African American identity to be mutually exclusive. Instead of finding essential traits, Bearden states that, 'the work of the Negro artists reflects all the artistic trends of the time'. Because, 'there is no single characteristic that would stamp their individual works', it follows that, 'there seems little reason for the continuation of all-Negro shows'.[17] Debates about the justification for separate exhibitions, like those on the social responsibility of the artist, have reappeared throughout the 20th century, but Bearden was the first to describe the structural predicament that arises when the social relations of 'race' over

determine the freedom of choice available to black artists in western societies. One might call this the black artist's 'burden of representation' in that each of the three 'shoulds' underlines the highly circumscribed conditions under which the African American struggle for artistic and political freedom was shaped.

In what follows I offer a fresh approach to the *Photomontage Projections* by tracing Bearden's relationship to these three facets of African American cultural identity. While this reveals an anti-essentialist understanding of identity that aligns his visual modernism with the anti-realism of Ralph Ellison's classic novel, *Invisible Man* (1952), I also want to suggest an affinity with the philosophy of culture voiced by the critic Alain Locke. To the extent that these figures form a lineage in African American modernism that has consistently offered an alternative to nationalist, separatist and ethnicist strands, we can glimpse a critically cosmopolitan counter-tradition that flows from the condition of 'double consciousness' that differentiates diaspora life.

Spiral and Cut: Repeating, Remembering and Working Through

Taking the view that, 'it would be highly artificial for the Negro artist to attempt a resurrection of African culture in America',[18] Bearden voiced a reply to the 'ancestralist' paradigm advocated by Alain Locke in the 1920s. In 'The Legacy of the Ancestral Arts', Locke had urged artists to take equal inspiration from the tribal artefacts that were part of their 'aboriginal endowment' and the plastic experiments carried out in primitivist modernism so as to create a new synthesis that would be distinctly African American.[19] By the 1940s, the ancestralist option had fallen out of

favour (or rather had migrated to the Caribbean modernism of Wifredo Lam in Cuba, and the Haitian rituals explored by writer Zora Neale Hurston and dancer Katherine Dunham) and Locke modified his earlier stance. He now placed more emphasis on the composite aspect of African American life as an 'amalgamation' of disparate elements. Interestingly, this was also Bearden's term when he defended his critical distance from Afrocentrism by stating:

> ... whatever creations the Negro has fashioned in this country have been in relation to his American environment. Culture is not a biologically inherited phenomenon. [...] However disinherited, the Negro is part of the amalgam of American life.[20]

The philosophy of culture common to Locke and Bearden thus rejected 'race' as an essential category of human identity fixed by laws of nature. It was for this reason that Bearden said: 'The critic asks that the Negro artist stay away from the white man's art, but the true artist feels that there is only one art – and it belongs to all mankind [...] Examine the art forms of any culture and one becomes aware of the patterns that link it to other cultures and peoples.'[21] For his part, Locke argued for a similar approach in the remarkable text, 'Who or What is Negro?' (1942), in which he questioned 'the logical predicament... arising from our over-simplified conceptions of culture'. 'Neither national nor racial cultural elements are so distinctive as to be mutually exclusive', he stated: 'It is the general composite character of culture which is disregarded by such over-simplifications.'[22] Declaring that, 'To be "Negro" in the cultural sense, then, is [...] to be distinctively composite', Locke concluded:

Strictly speaking, we should consistently cite this composite character in our culture with hyphenated descriptions, but more practically we stress the dominant flavour of the blend. It is only in this same limited sense that anything is legitimately styled 'Negro'; actually, it is Afro- or Negro-American, *a hybrid product of Negro reaction to American cultural forms and patterns.*[23]

In so far as Locke plays theory to Bearden's practice, as it were, one might say that this 'patterns of culture' approach was part of a broader bridge between white and black artists and intellectuals in 1940s America. Bearden's inclusion at Samuel Kootz, alongside Robert Motherwell, William Baziotes, Carl Holty and Byron Brown, as well as his long-standing friendship with Stuart Davis, was part and parcel of an integrationist moment in liberal-left circles. Bearden was prolific during this period, when he worked in watercolours and oils. *He is Arisen* (1945), from *The Passion of Christ* series exhibited in that year, was purchased by MoMA, and the Whitney Annual Exhibitions of 1945 and 1947 also featured his work to wide acclaim.

In his choice of biblical narrative, namely scenes of crucifixion and resurrection central to the black Protestant church, Bearden's subject matter reflected a search for material that would reconcile the perceived particularity of vernacular culture with the universalist claims arrogated by the ascendant ideology of high modernism. In this respect, his 1946 series inspired by García Lorca's *Lament for the Death of a Bullfighter*, and another series based on *Gargantua and Pantagruel* by Rabelais, are telling choices, for the 'folk' culture of Old World peasantry resonates with the vernacular realism of the 1940s generation of African American artists, and aligns with Bearden's passion for Goya's *Disasters of War* (1824). In his highly selective engagement with the European canon, Bearden immersed himself in a questioning relationship to the history of western art. Citing Goya's articulation of art and politics as his exemplar against the pitfalls of protest art, the 1946 essay sheds light on the importance Bearden placed on the expressive and non-mimetic dimension of style in shaping the viewer's response to the scenes of historical tragedy chosen from literary and biblical sources. Dissatisfied with the medium of oils, on account of the issue of brushwork or facture, Bearden's prismatic watercolours emphasised his increasingly loose expressive line in this period.

As the figurative expressionism he practiced between 1944 and 1947 displaced the geometric shapes of earlier vernacular scenes, by the time Bearden contributed *Blues Has Got Me* (1946) to a group show at Kootz entitled *Homage to Jazz*, the tide had turned on the short-lived moment of cross-cultural integration. What happened next reveals the limitations of the view that black American artists simply faced an either/or dilemma of inclusion or exclusion. In 1946 Samuel Kootz had organised a touring exhibition with official sponsorship from the US Information Service that travelled to Gallerie Maeght in Paris in 1948. Originally entitled, *Advancing American Art*, it had sought to demonstrate America's lead in the onward march of modernist innovation. But when it arrived in Paris, the exhibition was derided as retardataire rather than avant-garde on account of the figurative rather than abstract expressionists it showcased (including Bearden). The change of title to *Introduction to Modern American Painting* did

not forestall the perception that action painting had rendered any traces of mimesis as anathema to the 'purity' of expression now championed as the goal of modernist painting. Kootz closed his gallery in July 1948 and, when he re-opened in September 1949, his new roster of artists included Willem de Kooning, Mark Rothko and Jackson Pollock. Like Brown and Holty, Bearden had been dropped, not because of his ethnicity, but because his figurative expressionism was fundamentally at odds with the emerging dominance of abstract expressionism.

Ann Gibson has brought to light the contradictory relationship between African American artists and abstract expressionism.[24] From Piet Mondrian's *Broadway Boogie Woogie* (1942) to Franz Kline's *Dahlia* (1959), the improvisational qualities of bebop jazz were highly esteemed by European and American modernists as a source of expressive power that painters sought to emulate. In Pollock's action painting, the all-over drip technique called the figure-ground relationship into question along the lines of call-and-response, or antiphony, in bebop performance, in which no single instrument dominates the field. Norman Lewis's *Jazz Musicians* (1948) and Charles Alston's *Blues Singer I* (1952) shared this source of inspiration, but the presence of representational elements in their work was seen to stop short of the high modernist tenet that, 'expressive brushwork was an authentic index of an artist's emotional honesty'.[25] Artists who held back from 'pure' painterly abstraction were thus held to practice a stylistic centrism that prevented their acceptance in the avant-garde circles of the New York School.

As a result of being dropped by his gallery, Bearden took a nine-month study leave in Paris under the GI Bill (he enrolled to study with Gaston Bachelard, but felt unsure about his spoken French). On returning to New York in 1952 he experienced a malaise that persisted for over a decade. The small-scale abstract paintings he produced during the 1950s feature little of the expressive dynamism associated with Bearden's stylistic signature. His later reflections on the wilderness years are highly revealing:

> For me, the trouble is the word 'abstract.' [...] A lot of these painters painted with jazz sounds filling their studios. *Now I was lost in this.* [...] At my studio in the Apollo I found the music more interesting, and although I couldn't see any painterly equivalent at the time, I did try some experiments with Holty in the use of color – that it sometimes broke open the picture for me – that it seemed to run away and not stay on the canvas. So I began to work in bigger chords of color... Then, just as the color was getting away from me, so did painting as a whole. Like the surveyor in Kafka's Castle, it always seemed to elude me.[26]

The revealing allusion to Kafka's dystopian modernism suggests not that Bearden was alienated from jazz, but that he felt 'lost' within the ideological double bind whereby the discursive formation of abstract expressionism readily accepted the expressive 'difference' of black jazz musicians, but disparaged the stylistic variations of black painters. As Judith Wilson shows in her study of abstract paintings by Hale Woodruff (1900–80), African American artists were 'blanked out' of the equations that posited teleological 'purity' as the ultimate high modernist goal.[27] Whereas the earlier dominance of various figurative realisms had created 'the

Negro artist's dilemma' as a quandary shaped by competing claims for representational content, the anti-mimetic notion of expressive 'purity' that reigned during the heyday of abstraction also over-determined the context-of-choice for minority artists by rendering any trace of mimetic signification as absolutely 'other' to the now dominant value of total artistic freedom.

Following his marriage in 1954, and two solo exhibitions in 1955, Bearden conducted quiet experiments in papier colle at his Canal Street studio, but what 'broke open' the stasis for him was the formation of the Spiral group in 1963, which was the catalyst for the shift into collage. Dr Martin Luther King's vision of social justice at the Peoples March on Washington led union leader A. Phillip Randolph to ask how artists might respond to the burgeoning Civil Rights movement.[28] At its first meeting at Bearden's Canal Street loft on 5th July 1963, Spiral brought together younger artists, such as Reginald Gammon (b. 1921), Richard Mayhew (b. 1934) and Emma Amos (b. 1938), with members of the 1930s generation who had participated in the 306 group, such as Alston and Lewis. Seeking to enjoin political commitment and artistic freedom without reducing one to the other, the group's discussions echoed earlier debates about the social responsibility of the artist, albeit in the radically altered political context of the 1960s. 'As a symbol for the group, we chose spiral', said Woodruff, '[...] because, from a starting point, it moves outwards embracing all directions, yet constantly upward'.[29]

Having leased a gallery on Christopher Street with a view to an exhibition that would pay homage to Civil Rights activists slain in the South – which was to have been entitled, *Missisippi 1964* – members were wary of the potential misreading of their initiative as mere documentary or protest. In the ensuing debate, an alternative premise was adopted in which it was proposed that all contributions would be restricted to a monochrome palette. Hence, during its brief existence from 1963 to 1965, Spiral staged *Black and White*, its first and only group exhibition. Working towards this goal, Amos recalls that Bearden arrived one evening with 'an enormous picture file, all cut out in shapes and stuffed in a bag. He brought it to the Spiral meeting place at Christopher Street and spread it out on the floor, suggesting that we make a collaborative piece.'[30] Although Amos and Mayhew joined in, with a view to making a mural along the lines of *Guernica*, the idea for a collective collage proved unworkable and was thus dropped.

Spiral's group exhibition featured *Processional* (1965) by Norman Lewis, an abstract work whose emphatic dialogical evoked the era's optimism in 'progressive' social movements, but Spiral's failure to produce a collective collage had, paradoxically, provided Bearden with the conditions for his own individual breakthrough. Working on 8 x 11 inch masonite boards, on which he assembled images torn from magazines such as *Life* and *Ebony*, he took up Gammons' suggestion to enlarge the initial papier colle to a much larger scale of 3 x 4 or 6 x 8 feet by means of a photo-mechanical process that would create a continuous monochrome surface in keeping with the exhibition's black-and-white premise. Forming the basis of his first museum retrospective at the Corcoran Gallery in 1965, the twenty-one *Photomontage Projections* were greeted by Bearden's colleague Ernest Crichlow with the words, 'Romie, it looks like you've come home'.[31]

Romare Bearden,
The Prevalence of Ritual:
Baptism, 1964

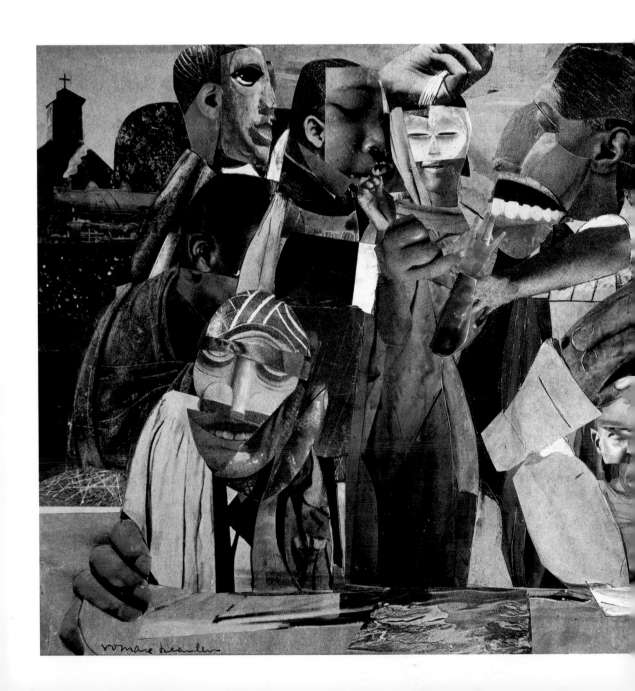

On the one hand, where the narrative contents of the *Photomontage Projections* evoke the momentous historical transitions of modern Black America – 'A lot of the life I knew in certain rural Negro communities is passing, and I set down some of my impressions of that life', said Bearden [32] – many commentators have underlined the importance of Bearden's theme of memory as a connecting thread that elates the past to present and creates a 'homecoming' – a deeper historical consciousness – in the series as a whole.[33] On the other hand, however, while many writers have acknowledged the intertextual patterns whereby Bearden revisited motifs from his earlier works, few apart from Ellison have given close attention to the dialectical process of semiotic transformation generated by Bearden's compositional use of differential repetition. Produced in serial clusters, the *Photomontage Projections* feature patterns of generative repetition whereby certain key motifs – train, guitar, window – constantly roam between urban and rural scenes of depiction. Individual works from the *Prevalence of Ritual* series, such as *Walls of Jericho* or *Baptism*, revisit the biblical stories Bearden explored in the 1940s, while works such as *Watching the Good Trains Go By* or *The Street*, cut across the narrative spaces of rural past and urban present to suggest a zigzag shape for African American history.

Travelling across this pictorial space, the 'mask-faced Harlemites and tenant farmers' [34] who form the protagonists of Bearden's scenes are literally torn out of one context and re-assembled in another. 'A harsh beauty [...] asserts itself out of the horrible fragmentation which Bearden's subjects and their environment have undergone', says Ellison,[35] whose account lays bare the critical relationship that the collages

Romare Bearden,
The Dove, 1964

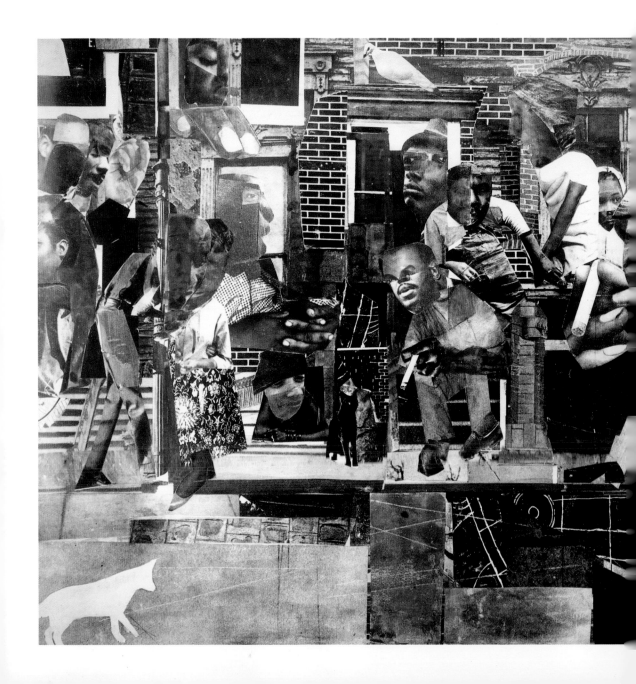

have towards their source materials. Ellison's account remains one of the most insightful readings of the *Photomontage Projections* because, where attention focuses on narrative content and finds an unambiguous affirmation of black history and cultural identity, Ellison stresses the critical moment of negation involved in Bearden's dialectical relationship to the regimes of representation from which his source materials are derived. 'Suggesting some of the possibilities which commonplace materials could be forced to undergo a creative metamorphosis when manipulated by [...] non-representational techniques',[36] Ellison also observes the synthetic moment of re-assemblage whereby the photographic fragments that Bearden pulled out of antithetical sources are cancelled out and yet legibly preserved in his artistic re-articulation of signifying elements.

In this respect, the most important aspect of Bearden's collage practice lies in his treatment of photographic materials. Looking at the iconography of the street, and at the construction of faces and hands in his figurative vocabulary, we can see how the dialectical interplay between the photograph as found object and the compositional forms of modernist *mise-en-scène* infuse the *Photomontage Projections* with surplus energy. Whereas the photographic depiction of the inner city ghetto had been saturated with connotations of poverty and despair, pictures such as *The Dove* or *Pittsburgh Memory* construct a metropolitan space in which countervailing qualities of community and conviviality also crowd into the scene. As Ellison puts it, teeming figures sit cheek-by-jowl, 'as signs and symbols of a humanity that has struggled to survive the fragmentizing effects of American social processes'.[37] When Ellison goes on to say that,

'faces which draw on the abstract character of African sculpture for their composition are made to focus our attention on the far from abstract reality of a people',[38] he offers a diagram of Bearden's unique resolution to the deep-seated problem of primitivism in the history of modernism.

As fragments of Ife, Dan and other African masks are cut and mixed to give form to the faces of his protagonists, we glimpse the critical differentiation that Bearden generated out of his handling of the pictorial technology of collage. Quoting photographs of carved tribal sculptures, Bearden's choices indicated a subject-position and a mode of address that was self-consciously twice removed from an authentic African origin. In this sense, the masks that recur in his construction of faces refer not to Africa as it actually is, but to an imagined 'Africa' always already thrust into quotation marks by the violent catastrophe of a diaspora's inaugural separation from its historical origins. By virtue of such distancing acts of quotation, Bearden's masks acknowledge 'Africa' as a signifier constantly subjected to antagonistic efforts of representation. The stereophonic space of cross-cultural 'dialogue' that arises between Euro-American modernism and Black Atlantic diaspora culture thus also comes to reveal Bearden's equally critical relationship to Picasso, and his place at the centre of the canon created by institutional modernism.

Bearden's oblique allusions to Picasso perform a critical return journey to (the problem of) primitivism that casts the issue of cross-cultural borrowing in a different light. In *Three Folk Musicians* (1967), Bearden revisited his 1941–42 gouache, *Folk Musicians*, in such a way as to reveal his intertexual dialogue with the trio seen in Picasso's *Masked Musicians* (1921).

The masked harlequin in Picasso's painting is significant because in the Rabelaisian tropes of the European carnival tradition, this figure mocks official authority and his patchwork clothes amount to an emblem of the various 'folk' cultures of the carnivalesque and the grotesque that were subordinated to the classical tradition.[39] As the harlequin is translated by Bearden into an itinerant Delta bluesman, his code-switching suggests cross-cultural correspondences with the figure of Esu-Elegba, the Yoruba deity found at a place of crossroads, who also 'returns' in the trickster figures found in folk tales of the African diaspora. In *Conjur Woman* (see front cover), the woman's face bears the ghostly traces of one of the *Demoiselles D'Avignon* (1907), even as Bearden's portrait holds a mirror to the syncretic belief systems, such as the venerated High John the Conqueror, found in rural African American faith healing practices.[40]

The critic Albert Murray foregrounds such dialogic qualities in Bearden's art and sees parallels with call-and-response patterns in blues and jazz composition.[41] While Bearden himself was fascinated by the role of the delayed interval in jazz syncopation, the musical analogy, however, has the frustrating effect of assuming rather than explaining the formal moves and choices that activate similar improvisational qualities in Bearden's pictorial space. The critical understanding of the formal agency of the stylistic choices found in Bearden's signifying practice is further thwarted by the hierarchy of differential attention to literary and visual texts in African American studies. In the sense that this engenders what critic Michele Wallace called 'the problem of the visual in Afro-American culture', I conclude with some reflections on unresolved issues in writing the art histories of

Black culture is about an approach to life

the black diaspora and suggest that closer attention to Bearden's intertextual repetition opens the possibility of finding a way out.

Conclusion

According to Wallace, the persistent 'invisibility' of black artists across modernism and post-modernism finds an explanation in unconscious mechanisms of denial that repudiate the interdependent relationships of cross-cultural borrowing. Whereas 'mutual influence and intertextuality is acknowledged' in literary history, she argues that in the visual arts, 'the exchange is disavowed and no-one admits to having learned anything from anyone else'.[42] Her trenchant conclusion that, 'Euro-American Postmodernism emerges as the lily white pure blooded offspring of […] Modernism and Post-structuralism', is matched by her equal insistence that, 'the Black Aesthetic emerges as the unambivalent, uncompromised link-up between Africa and the New World in which Euro-American influences are superfluous and negligible'.[43]

By the late 1960s, with the rise of the Black Arts Movement, Bearden's late modernist, humanist and pluralist positions, like that of his Spiral cohorts, had become overshadowed by the ascendant discourses of cultural nationalism and ethnic separatism. In a context where a didactic rhetoric of militant populism was led by such playwrights as Amiri Baraka, Larry Neal and Ron Karenga, who espoused what critic Addison Gayle called 'the black aesthetic',[44] artist's groups such as AfriCobra in Chicago, and the Black Emergency Cultural Coalition, formed by Benny Andrews in New York, tended to fuse art and politics into campaigning activities, such as the boycott of the controversial

Harlem on My Mind (1968) exhibition at the Metropolitan Museum in New York.

As if to confirm the view that those who do not understand the past are condemned to repeat it, such tendencies on the part of the Black Arts Movement would seem to confirm Wallace's insight that the politics of black essentialism merely repeated the exclusionary logic of Eurocentrism by inverting it into Afrocentrism. By virtue of retaining the binary code of either/or reasoning, any notion of cross-cultural syncretism or hybridity was repudiated as 'other' to an essentialist conception of African American cultural identity. Although critics such as Murray offered an alternative voice, like Ellison he was dismissed as a conservative integrationist. The deeper paradox of the period, however, was that the Black Arts Movement's demand for identifiably black content in the visual arts itself merely repeated the three prescriptive 'shoulds' that Bearden had dealt with in 1946. Taking the chronology of Bearden's career as broadly accompanying the major paradigm shifts in 20th-century art – from high modernism, through late modernism, to post-modernism – one might stand back to observe the discrepant time line that characterises the historical formation of African American art as a kind of 'minority modernism'. On the one hand, negotiating the double binds of 'race' in a white-majority society, black artists were often expected to create art that would be 'representative' of their cultural identity as a whole. On the other hand, when similar expectations were reinforced on the part of the Black Arts Movement, the 'burden of representation' pushed black artists even further away from the freely-chosen articulation of art and politics found in the historical formation of the Euro-American avant-garde.

what am I trying to do in my collage

While the contextual history of the mirror-like relationship of minoritarian and majoritarian essentialisms explains the persistent blind spot that pushed 20th-century black artists into a persistent condition of invisibility, as Wallace suggests, one could also observe that it was not until the 1980s that the dual meanings of 'representation', as both a practice of depiction (in art) and a practice of delegation (in politics), were opened up by the critique of essentialist models of identity. In this non-linear and lop-sided chronology, the view that identities are socially constructed in struggles over the relations of representation, as Hall puts it,[45] could be understood as a line of inquiry that Bearden had begun to investigate in his collages of the 1960s.

To the extent that 'the problem of the visual' recapitulates 'the Negro artist's dilemma', the structural predicament of minority modernism is further reproduced in contemporary African American scholarship. Bearden's intertexual repetition bears all the hallmarks of 'signifyin' in Henry Louis Gates' account of the way African American novelists critically modify the master codes of literary production, and the allegorical motif of the crossroads lies at the heart of the literary history put forward by Houston Baker; but visual artists are seldom cited in these studies, perhaps on account of the view that it was primarily in language and music that formerly enslaved subjects were able to express themselves freely.[46] Alternatively, we can understand why Bearden's collages have stood the test of time, and retain contemporary relevance, once the work is read in relation to the concept of 'the cut' put forward by critic James Snead. Questioning the Hegelian model of historical teleology, Snead posited a heuristic contrast of classical and improvisational traditions:

European culture does not allow 'a succession of accidents and surprises' but instead maintains the illusions of progression and control at all costs [...] Black culture, in the 'cut', builds accidents into its coverage, almost as if to control their unpredictability. [...] this magic of the 'cut' attempts to confront accident and rupture not by covering them over but by making room for them inside the system itself.[47]

Like the caesura in poetry, or the syncope in music, the 'cut' is a formal interval in which structural conventions are de-centred by the agency of controlled negativity. Dub offers a further example in which acoustic spaces are opened by subtracting the voice or melody from a song in such a way as to reveal the agency of the elements that have gone missing. Or as Bearden himself put it, discussing Attic figures on ancient Greek vases: 'Its the spacing of what you leave out that makes what is *in* there'.[48] Where Snead saw an affinity between the aesthetics of the 'cut' and Freud's notion of repetition compulsion, it is tempting to suggest that it is the historical trauma of diaspora that lies at the root of the improvisational approach to rupture and accident. In any case, Snead offers a revealing contrast between two kinds of repetition, one that blindly repeats the pain of the past, and one that works through the loss so as to produce a memory that allows the subject to separate itself from what it mourns for – which is one way to describe the 'truth content' of the *Photomontage Projections* as a whole.

Lastly, when Snead suggests that, 'in black culture, the thing (the ritual, the dance, the beat) is "there for you to pick it up when you come back to get it"', and adds, 'If there is a goal in

Need to look up

such a culture, it is always deferred',[49] his view offers fresh insight into the generative power of Bearden's intertextual repetition. Snead suggests both the Derridian concept of 'differance' that delays the closure of the signifying chain (hence, the *Photomontage Projections* are open to multiple readings), and the Freudian concept of deferred action. This latter rejoins the psychoanalytic orientation of Wallace's account of an egocentric tendency to repudiate interdependent relationships with others. Once inserted into the ex-centric time lines of African American modernism, deferred action would also help to explain the variant time-scales of different minority experiences of modernity. On the one hand, as 'latecomers to the visual arts' black artists were deemed to be 'peculiarly backward' in their relation to institutional modernism, but, on the other hand, if blackness is syncopated to fall behind the beat, this might not be such a bad place to be – Dada set out to interrogate the classical tradition of pure form by also allowing for rupture, accidents and surprises in its relationship to the found object.

In other words, a cross-cultural perspective can reveal hidden correspondences between black culture and modernism that scramble our received understanding of modern art history. The Janus-like mask that presides over Bearden's *Black Manhattan* (1969) counsels art historians to look both ways. Only with a concept of deferred action can we come to understand why, in 1964, Bearden's collages had less in common with Robert Rauschenberg's flatbed receptacle than they did with Hanna Hoch's Weimar hybrids. Collage practice can be seen to mark modernism's 'big break' from the accumulated realisms, naturalisms and illusionisms of the classical tradition for it identifies the key

moments when various artists called into question the 'truth value' produced by the dominant codes of visual representation in the West. The key to unlocking our deferred historical understanding of mutual cross-cultural influences lies in transforming the concept of 'artistic will' or the 'will-to-form' that underpins the category of 'style' in modernist art historiography.[50] Bearden did much more than merely repeat the interruptive logic of modernist collage: bringing to light the mixture of cultural elements that constitute diaspora identities, he wielded the 'cut' as a generative incision that shows us how, 'the true artist destroys the accepted world by way of revealing the unseen'.[51]

NOTES

1. Surveys featuring Bearden include Daniel Wheeler, *Art Since Mid-Century: 1945 to the Present*, New Jersey: Prentice Hall, 1991, 273 and Lisa Phillips ed., *The American Century, Part II: 1950–2000*, New York: Norton, 1999. Recent retrospectives include Gail Gelburn and Thelma Golden eds, *Romare Bearden in Black and White*, New York: Abrams/Whitney Museum of American Art, 1997 and *The Art of Romare Bearden*, National Gallery of Art, Washington, DC, 2003.

2. Ralph Ellison, 'Introduction', *Romare Bearden: Paintings and Projections*, exh. cat., Albany: The Art Gallery, State University of New York, 1968, reprinted as 'The Art of Romare Bearden', in Ralph Ellison, *Going To the Territory*, New York: Vintage, 1987, 237.

3. Romare Bearden, in Myron Schwartzman, *Romare Bearden: His Life and Art*, New York: Abrams, 1990, 179.

4. Romare Bearden, 'The Negro Artist and Modern Art', *Opportunity*, December 1934, 371–72; Romare Bearden, 'The Negro Artist's Dilemma', *Critique*, November 1946, 16–22; Romare Bearden, 'Rectangular Structure in my Montage paintings', *Leonardo*, 2, January 1969, 11–14; Romare Bearden and Carl Holty, *The Painter's Mind: A Study of the Relations of Structure and Space in Painting*, New York: Crown Press, 1969; Romare Bearden and Harry Henderson, *A History of African American Artists from 1792 to the Present*, New York: Pantheon.

5. Stuart Hall, 'Cultural Identity and Diaspora', in Jonathan Rutherford ed., *Identity: Culture, Community, Difference*, London: Lawrence & Wishart, 1990, 225.

6. Roland Barthes, *Camera Lucida: Reflections on Photography*, London: Jonathan Cape, 1981.

7. Romare Bearden, 1934, op. cit., 371.

8. Ibid.

9. Ibid.

10. Romare Bearden letter to Walter Quirt, 20 January 1942, quoted in Myron Schwartzman, 1990, op. cit., 121.

11. See Gary Reynolds and Beryl Wright eds, *Against the Odds: African American Artists and the Harmon Foundation*, New Jersey: Newark Museum, 1989.

12. Romare Bearden, 1946, op. cit., 19.

13. Ibid., 17.

14. bid., 16.

15. Ibid., 20.

16. Malcolm Vaughn, *New York American* (1927), quoted in Bearden, 1934, op. cit., 372.

17. Bearden, 1946, op. cit., 21.

18. Ibid., 20.

19. Alain Locke, 'The Legacy of the Ancestral Arts', in Locke ed., *The New Negro: An Interpretation*, New York: Albert and Charles Boni, 1925; reprinted Atheneum, 1977, 254–67.

20. Bearden, 1946, op. cit., 20.

21. Ibid.

22. Alain Locke, 'Who or What is "Negro"', *Opportunity*, February and March 1942, reprinted in Jeffrey C. Stewart ed., *The Critical Temper of Alain Locke: A Selection of His Essays on Art and Culture*, New York, Garland Publishing, 1983, 311.

23. Ibid.

24. Ann Gibson, *Abstract Expressionism: Other Politics*, New Haven: Yale, 1997, and Ann Gibson, 'Two Worlds: African American Abstraction in New York at Mid-Century', in Corrine Jennings ed., *The Search for Freedom: African American Abstract Painting 1945–75*, New York: Kenkelaba House, 1991.

25. Gibson, 1997, op. cit., 101.

26. Romare Bearden quoted in Myron Schwartzman 1990, op. cit., 173.

27. Judith Wilson, 'Go Back and Retrieve It: Hale Woodruff, African American Modernist, 1942-70', in *Selected Essays: Art and Artists from the Harlem Renaissance to the 1980s*, Atlanta: National Black Arts Festival, 1988.

28. Gail Gerburd, 1997, op. cit., 18.

29. Hale Woodruff, 'Foreword', to *Spiral*, exh. cat., Long Island University, 1965, quoted in Floyd Coleman, 'The Changing Same: Spiral, the Sixties, and African American Art', in William E. Taylor and Harriet G. Warkel eds, *A Shared Heritage: Art by Four African Americans*, Indianapolis: Indianapolis Museum of Art, 1996, 148–49.

30. Emma Amos quoted in Myron Schwartzman, 1990, op. cit., 210.

31. Ernest Crichlow quoted in Sharon F. Patton, *African American Art*, London and New York: Oxford University Press, 1998, 190.

32. Romare Bearden quoted in Myron Schwartzman, 1990, op. cit., 179.

33. Kinshasha Holman Conwill, Mary Schmidt Campbell and Sharon F. Patton eds, *Memory and Metaphor: The Art of Romare Bearden, 1940 - 1987*, New York: Oxford University Press and Studio Museum in Harlem, 1991.

34. Ellison, 1987, op. cit., 234.

35. Ibid., 236.

36. Ibid., 234.

37. Ibid., 234–35.

38. Ibid., 235.

39. See Mikhail Bahktin, *Rabelais and His World* [1965], Bloomington: Indiana University Press, 1984, and Peter Stallybras and Allon White, *The Politics and Poetics of Transgression*, London: Methuen, 1986.

40. See Theophus H. Smith, *Conjuring Culture: Biblical Formations of Black America*, New York: Oxford University Press, 1995.

41. Albert Murray, 'The Visual Equivalent to Blues Composition', in *The Blue Devils of Nada: A Contemporary American Approach to Aesthetic Statement*, New York: Vintage, 1996, 117– 40; see also Albert Murray, *The Omni-Americans: New Perspectives on Black Experience and American Culture*, New York: Dutton, 1970.

42. Michele Wallace, 'Modernism, Postmodernism, and the Problem of the Visual in Afro-American Culture', in Russell Ferguson, Martha Gever, Trinh T. Minh-ha and Cornel West eds, *Out There: Marginalization and Contemporary Culture*, New York: New Museum, 1990, 45.

43. Ibid., 46.

44. Addison Gayle Jr ed., *The Black Aesthetic*, New York: Doubleday, 1971.

45. See Stuart Hall, 'New Ethnicities', [1988], in David Morely and Kuan-Hsing Chen, *Stuart Hall: Critical Dialogues in Cultural Studies*, London and New York: Routledge, 1996.

46. Henry Louis Gates Jr, *The Signifying Monkey: A Theory of Afro-American Literary Criticism*, New York: Oxford University Press, 1988; Houston A. Baker, *Blues, Ideology and Afro-American Literature: A Vernacular Theory*, Chicago: University of Chicago, 1984.

47. James Snead, 'Repetition as a Figure of Black Culture', in Henry Louis Gates Jr ed., *Black Literature and Literary Theory*, London: Methuen, 1984, 67.

48. Romare Bearden quoted in Myron Schwartzman, 1990, op. cit., 110.

49. James Snead, 1984, op. cit., 67.

50. The history of the concept of 'style' is the key point at which the critique of art history rejoins the cultural study of different modernisms. The concept of the 'kunstwollen' concerns the drive to make art and because it addressed collective subjects, such as nations and 'races', as well as individual artists, it forms a bridge between the archaeology of Eurocentrism and critical enquiry into the aesthetic dimension of cultural difference in the history of modernism. On the 'kunstwollen' concept, see Alois Reigel, *Problems of Style: Foundations for a History of Ornament* [1893], trans. Everlyn Kain, Princeton: Princeton University Press, 1992, and Margaret Iverson, *Alois Reigel: Art History and Theory*, Cambridge: MIT, 1993. On the intellectual journey of the concept of 'style', from 19th-century 'zeitgeist' paradigms to the anti-hierarchical study of non-western materials, see Meyer Schapiro, 'Style' in A.L. Kroeber ed., *Anthropology Today: An Enclyclopedic Inventory*, Chicago: University of Chicago, 1953. The history of the interrelated concepts of 'style' and 'kunstwollen' is examined in Michael Ann Holly, *Panofsky and the Foundations of Art History*, Ithaca: Cornell University Press, 1984, and the political ambiguity of this intellectual history is laid out in Christopher Wood ed., *The Vienna School Reader: Politics and Art Historical Method in the 1930s*, New York: Zone, 2000.

51. Ellison, 1987, op. cit., 234.

C.L.R. JAMES AS A CRITICAL THEORIST OF MODERNIST ART

DAVID CRAVEN

The earliest studies of the post-colonial were by such distinguished thinkers as Anwar Abdel Malek, Samir Amin, and C.L.R. James... And indeed, one of the most interesting developments in post-colonial studies was a re-reading of the canonical cultural works, not to demote or somehow dish dirt on them, but to re-investigate some of their assumptions, going beyond the stifling hold on them of some version of the master-slave binary dialectic. This has certainly been the comparable effect of astoundingly resourceful novels such as Rushdie's *Midnight's Children*, the narratives of C.L.R. James, the poetry of Aimé Césaire and of Derek Walcott... The idea of rethinking and reformulating historical experiences which had once been based on the geographical separation of peoples and cultures is at the heart of a whole spate of scholarly and critical works.

Edward Said, *Orientalism* (1994)[1]

Histories of cultural studies seldom acknowledge how the politically radical and openly interventionist aspirations found in the best of its scholarship are already articulated to black cultural history and theory. These links are rarely seen or accorded any significance. In England, the work of figures like C.L.R. James and Stuart Hall offers a wealth of both symbols and concrete evidence for the practical links between these critical political projects... Modernity might itself be thought to begin in the constitutive relationships with outsiders that both found and temper a self-conscious sense of western civilisation.

Paul Gilroy, *The Black Atlantic* (1993)[2]

Few defining figures of the 20th century are as famous and as unknown as C(yril) L(ionel) R(obert) James (1901–1989). In certain circles he is widely recognised as the author of two legendary texts almost thirty years apart – *Black Jacobins* (1938) and *Beyond a Boundary* (1963). The first book was a groundbreaking study of the revolutionary anti-colonial movement among the slaves in 18th-century Haiti that would itself become a prologue to the national liberation movements throughout the Third World that exploded on the international scene from the 1940s through the 1990s. The second, equally groundbreaking book, was a comprehensive examination of the aesthetic and social dimensions of the sport named 'cricket' that showed how a ruling class sport in the United Kingdom was very much one of the popular classes in former colonies like Trinidad. Yet these two commanding books, plus the fame of James as a political theorist of 'Black Marxism', have sometimes served to eclipse other important studies about various topics by the same author. The Renaissance-like range of C.L.R. James has not been duly acknowledged, owing to how his notable success in a few areas, such as political theory, sociology and political activism, have been circumscribed by what José Ortega y Gasset once called the 'barbarism of specialisation' in modern society.

To date, though, mainstream art history, cultural studies and visual culture have had almost nothing to say about the equally precocious contribution by C.L.R. James to rethinking modernism in the visual arts – aside from the above-noted references by Edward Said and Paul Gilroy, plus a few others by Kobena Mercer and Paul Buhle, as well as Keith Hart and Anna Grimshaw.[3] This neglect of James as a

argument

theorist in the arts is hardly surprising, since most western intellectuals continue to assume in the most ethnocentric manner that writing about theory is a prerogative of European and Euro-American thinkers alone. What Edward Said has rightly noted of the late Michel Foucault could be asserted with equal force about most post-modernists in the western world: '[Foucault] showed no real interest in the relationships his work had to feminist or post-colonialist writers facing problems of exclusion, confinement, and domination. Indeed, his Eurocentrism was almost total, as if "history" itself took place only among a group of French and German thinkers.'[4]

In fact, for many 'post-modernists' and 'post-structuralists' even now, any analysis of art from Asia, Africa, Latin America and the Caribbean must be mediated by western theory alone. It is as if an international division of labour – such as that which exists worldwide within the 'globalisation process' of corporate capitalism – dictates that, while the Third World can produce art and culture, it is the West alone that enjoys monopoly control over the production of theory about art and culture. As such, non-western art functions as a 'raw material', while western theory is seen as a highly processed 'finished good' that emerges from the theoretical transformation of the 'rudimentary resources' mined by the Third World labour force of artists and cultural workers. This was the view unwittingly announced in 1992 by W.J.T. Mitchell even when he stated that his position was exactly the contrary:

> If the balance of *literary* trade has shifted from the First to the Second and Third Worlds, the production of *criticism* has become a central activity of the cultural industries of the imperial centres... they are in the paradoxical position of bringing a rhetoric of decolonisation from the imperial centre... We ought to resist the notion that this relationship merely reflects the traditional economic relations of imperial centres to colonial peripheries.[5]

Yet, this misguided, if well-intentioned 'dependency theory' of how western criticism purportedly 'explains' non-western art in what is posited as a 'theoretical void' in the Third World, *is utterly disallowed by the case of C.L.R. James.* (And there are many others, such as Sergio Ramírez, Paulo Freire, Frantz Fanon, Samir Amin, Rasheed Araeen, Partha Mitter, Chinua Achebe and Nestor García Canclini.)[6] The ignorance demonstrated by Mitchell (and other westerners for whom French post-structuralism almost alone seems to qualify as 'theory or criticism') rudely cancels out any avowals of 'solidarity' with post-colonial leaders and anti-imperial movements. Such a lack of knowledge concerning non-western contributions to critical theory was not acceptable a decade ago, whether one lived in the West or in a post-colonial nation, and it is even less tolerable now.

By reclaiming and consolidating the intervention of C.L.R. James into art theory, as I begin to do here, we will gain new insights into post-colonial modernism's transnational origins, cosmopolitan character and delta-like trajectory. As such, no future discussion of modernism's multinational import will be adequate without the challenging commentary of James about the panoramic nature of certain paradigmatic works by Pablo Picasso and Jackson Pollock in dialogue with non-western artistic practice. Among other things, the art theory of James should open up

new insights into the previously under-recognised discursive significance of Picasso and Pollock to artists from Latin America and the Caribbean. The 'dialogic role' in art history – in opposition to one of mere 'dependency' on the West – played by the artworks of Picasso and Pollock, whether in Cuba, Martinique or Nicaragua will also emerge more emphatically as a consequence of C.L.R. James's broad and left-wing look at the pictorial logic of cosmopolitan modernisms.[7] By reversing analytically the flow of theory from the imperial West to a 'dependent' post-colonial periphery like Trinidad, we can come to appreciate more deeply just how profound the multinational dialogue along theoretical lines about topics like modernism *always has been and no doubt will ever more become*. C.L.R. James and other Third World critical theorists of the 20th century were, of course, relatively few in number compared to those from the West proper, but the legacy of James will no doubt foster an even more transformative dialogic process in the future.

James corresponded about art and politics in the 1950s with his friend, art historian Meyer Schapiro – a relationship never before mentioned in the art historical literature.[8] Similarly, James wrote two remarkable critical essays about the fine arts from the West and he also made many incisive comments about the visual arts in passing within other essays devoted to topics ranging from Caribbean popular music to West Indian cricket. There was one essay published in James's lifetime about Picasso (and Michelangelo, as well as Greek statuary), which appeared in a 1977 volume of his selected writings, while a highly original piece that James wrote in 1980 on Picasso and Pollock remained unpublished in his lifetime. It is this latter essay on

which I will focus in the '*explication du texte*' that follows.[9] In discussing the transnational role of Pollock's all-over paintings, James points out how these images functioned, qua visual language, as generative indexical fields replete with integrative signs for humanity in general, not just westerners in particular. In his arresting, anti-Greenbergian assessment of Pollock's works, James used a fresh philosophical approach based in structural homologies.

Yet, the novel position of James will assume more explanatory clout only if we anchor his critical theory of modernism as embodied in Pollock within the distinctively unorthodox variant of Marxist thought for which James has become well known. Two analytical manoeuvres are in order here. First, we must reconstruct James's concept of art as it surfaced in a couple of key essays – 'The Artist in the Caribbean' (1959) and 'What Is Art?', from *Beyond a Boundary* (1963). In the latter book about the aesthetic dimensions of cricket we will encounter, for example, celebrated passages on batting techniques and performative styles in cricket that help to explain why James so deeply admired the 'action paintings' of Pollock. Second, we will address the original way in which James has used the dialectical method, more in keeping with the 'dialogic' aesthetic of Mikhail Bakhtin, than with any recycling of a Zeitgeist-driven neo-Hegelianism. Along the way, I show how the trans-cultural cosmopolitan modernism of James's theory exists within a larger critical tradition throughout the Americas, one that extends from José Carlos Mariátegui to Adolfo Sánchez Vázquez. It will be clear that there is no dearth of noteworthy critical theory from the Third World and that modernism's cosmopolitan character can best be grasped by learning about

this generally overlooked philosophical tradition from outside the West's mainstream.

The Nature of Art from a Post-colonial Vantage Point

In 1959, James spoke in Jamaica on the campus of the University of the West Indies about how 'an analysis of the artist in the Caribbean properly done was a pointer to the general social and political problems there'.[10] The title of his talk was 'The Artist in the Caribbean' and in it he deftly outlined a multi-point perspective for doing a critique of any artwork. James emphasised how artistic practice is both a form of labour and the extension of a language, so that it simultaneously serves as a mode of cognition that 'adds to the sum of knowledge of the world' and yet also expands our concrete sensory engagement with specific things 'by that economy of means... [that] adds new range and flexibility to the medium'.[11]

On the one hand, James refused to reduce art to a mere reflection of existing society (as did Soviet aesthetics) or to a simple act of 'language speaking itself' without individual agency (as would structuralists like Barthes and the early Foucault). Yet, on the other hand, while emphasising that 'artistic production is essentially individual', James also warned that one should *not* place 'undue emphasis on the great, master artist', since 'the great artist is the product of a long and deeply rooted national tradition'. Moreover, all things are not possible at all times, so that a great artist is most likely to appear 'at a moment of transition in national life with results that are recognised as having significance for the whole civilised world'.[12]

Here, though, we need to distinguish James's crucial emphasis on a popular-based 'national life' from any type of official nationalism. Grounded as it is in languages and media as a precondition for important artworks, the national life is inherently opposed to official nationalism, such as that of the British Colonial Empire, which James rightly saw as undermining any significant art on behalf of humanity per se, in favour of narrow class-based ethnic interests. In this way, James adroitly linked internationalism, not with nationalism, but with national self-determination (whether in the West Indies or Ghana, both of which, in the 1950s, were then in the process of winning it through anti-colonial struggles against Great Britain). Thus, he could conclude of Cézanne – 'who gave a new direction to modern painting' – (as well as of Shakespeare the dramatist and Aimé Césaire the poet) that 'the universal artist is universal because he is above all national'.[13] Accordingly, James concluded:

> A supreme artist exercises an influence on the national consciousness that is incalculable. He is created by it but he himself illuminates and amplifies it, bringing the past up to date and charting the future... Such a writer is a pole of reference in social judgment, a source of inspiration in concept, in language, in technique (not always beneficial), to succeeding generations of artists, intellectuals, journalists, and indirectly to ordinary citizens... The Greeks and the Florentines of the great period understood the direct, the immediate influence of the great artist upon the society in which he lived. But today in particular he is a tremendous force while he lives, and particularly to people like us, with our needs... In the age in which we live and in the present social and political stage of the underdeveloped countries, we cannot leave

these (and other) matters to an empirical growth that took centuries to develop in other countries. We cannot force the growth of the artist. But we can force and accelerate the growth of the conditions in which he can make the best of his gifts.[14]

Along these lines, James could see the greatness of Shakespeare as originating with a dialogical interplay of professional letters and popular culture, involving 'the marriage of native English with the Latin incorporations'. An Englishman of yeoman lineage, Shakespeare was someone 'for whom thought and feeling were always experienced in terms of nature, the physical responses of human beings and the elemental categories of life and labour. This is the basis of his incomparable vividness and facility of expression'.[15] In a related vein, James could praise his contemporary Aimé Césaire for the cosmopolitan, multi-ethnic nature of his dialogical approach to modernist poetry and also for its emancipatory vision on behalf of a post-colonial Caribbean. To quote James: 'The finest piece of writing that to my knowledge had come from the West Indies is a poem which bears the significant title, *Cahier d'un Retour au Pays Natal*. It is the desperate cry of a Europeanised West Indian poet for integration with his own people'.[16]

This set of observations places us in a position to appreciate two of the most innovative and enduring features of C.L.R. James's art theory in relation to reception theory, as well as to popular participation in artistic production. As Kobena Mercer has rightly noted of James, he possessed an elective affinity with the position of Bakhtin and Valentin Volosinov in two key respects. First, James had a subtle sense, as did the two Russian theorists, of the 'multi-accentuality of the

ideological sign' within the production of artistic meaning. Signification itself is thus a site of negotiation and even of contestation. Second, James operated, as did Bakhtin, with a commitment to a 'dialogic principle' in which the possibility of social change is prefigured in collective consciousness by the multiplication of critical dialogues.[17] Similarly, the radically democratic conceptions of both Marxism and socialism that James advocated for several decades found a clear analogue in his emphasis on post-vanguard (and post-Leninist) modes of artistic practice. This feature of James's critical theory in art and culture was noted by Paul Gilroy when, in praising the popular 'practice of antiphony' within African American (and English) culture, he wrote: 'Its best feature is an anti-hierarchical tradition of thought that probably culminates in C.L.R. James's idea that ordinary people do not need an intellectual vanguard to help them speak or to tell them what to say'.[18]

Significantly, James incorporated into his theory both a belief in the notable role of popular dialogue with professional artists and a disbelief in any populist reduction of art to a monologue by the lay public for the arts. The crucial importance of the dialogical interplay of high art and popular culture could not be used legitimately to dumb-down or de-skill the very real and quite worthwhile challenges posed by the mastery of artistic media in the arts, along with the visual languages linked to them and the specific form of highly-skilled labour necessary for realising them. Accordingly, specialised knowledge both of the fine arts and popular culture respectively would be a prerequisite for any fundamental critical engagement with all artwork genuinely worthy of human development. This insight helps us to understand

the highly nuanced and quite technical discussion of the nature of art found in James's excellent contribution to aesthetics proper. After all, James was emphatic (as was Bakhtin in the 1920s) about the centrality of *a type of formalism* to his critical approach: '*it is the question of the medium which at the present time is crucial*... The artist is a human being who uses usually one, sometimes more than one medium of communication with exceptional force and skill'.[19]

How did formalism relate more specifically to James's approach? He himself gave an eloquent answer in 1963 through his celebrated book on cricket, *Beyond a Boundary*, which contained a chapter entitled 'What Is Art?'. In the passages I cite below, James elaborates with uncommon range, not only upon the aesthetic dimension of a sport, but also upon the nature of aesthetics as such:

> Cricket is first and foremost a dramatic spectacle. It belongs with the theatre, ballet, opera, and the dance... [a] major consideration in all dramatic spectacles is the relation between event (or, if you prefer, contingency) and design, episode and continuity, diversity in unity, the battle and campaign, the part and the whole. Here also cricket is structurally perfect... In addition to being a dramatic [art], cricket is also a visual art. This I do not pitch too low at all. The whole issue will be settled here... The aestheticians of painting, especially the modern ones, are the greatest advocates of 'significant form'... the late Mr Bernard Berenson... distinguished two qualities which could be said to constitute the significance of the form in its most emphatic manifestation. The first he called 'tactile values'... This significance in the form gave a higher coefficient of reality to the object represented. Not that such a painting looked more real, made the object more lifelike. That was not Mr Berenson's point. Significant form makes the painting life-enhancing, to the viewer... [Similarly] Mr John Berger of the *New Statesman*... claims that what is really significant in Michelangelo is his bounding line. The abstract artists get rid of the object altogether and represent only the abstract form, the line and relations of line. If I understand Mr Berger aright he claims that all the great representational paintings of the past live and have life only to the degree that their form is significant... The second characteristic of significant form in Mr Berenson's aesthetic is the sense of 'movement'. Mr Berenson discussed the artistic possibilities and limitations of an athletic event, a wrestling match... Now here all of us, cricketers and aestheticians, are on a familiar ground. I submit that cricket does in fact contain genuinely artistic elements, infinitely surpassing those to be found in wrestling matches... I submit finally that without the intervention of any artist the spectator at cricket extracts the significance of tactile values... [and] the purely artistic appeal, the significant form at its most unadulterated is permanently present. It is known, expected, recognised and enjoyed by tens of thousands of spectators. Cricketers call it style. Steel's definition clears away much cumbersome litter about left shoulder forward and straight bat: 'no flourish, but the maximum of power with the minimum of exertion'. If the free-swinging off-drive off the front foot has been challenged by the angular jerk through the covers of the back foot, this

last is not at all alien to the generation which has experienced *Cubism in posters and newspaper advertisements... Each in its own way grasps at a more complete human existence* [my italics].[20]

The concluding observations in James's discourse on art take us back to some central tenets of classical Marxism, then bring us forward to a signal thesis of Mikhail Bakhtin. Indeed, several of the symptomatic points explicated below make clear just how much James's account presupposes many of the fundamental concepts with which Marx and Engels (though not necessarily Soviet-style Marxist-Leninism) situated themselves in relation to art, labour and human nature. A salient trait of James's approach is his deployment of a non-normative formalism, concerning how the major artist 'adds new range and flexibility to the medium', which overturns the normative formalism of Greenberg et al., with its a priori usage of a reductive and essentialised 'medium purity' to which the artist is supposedly limited. The latter is essential for a Eurocentric version of modernism, just as the former put forth by James is significant for a non-Eurocentric discussion of cosmopolitan modernisms. Here again a crucial link with the theoretical vantage of Bakhtin is located in James's implicit distinction between an ideologically informed non-normative formalism and an ahistorical, purportedly non-ideological brand of formalism, one so important for mainstream western theory.[21]

What James then did was to assume that non-normative formalism, ever in a state of historical formation, is a formative social force precisely because of its progressive character as a form of human labour. By expanding what can be humanly sensed by the five senses beyond the crude practical aims and instrumental ends of the status quo, art actually becomes a major means of *re*creating human nature through the creative advances of formalism in the arts. Such a view presupposes a classical Marxist sense of humans being more well-rounded and multidimensional than capitalism would allow – or, to quote James, possessing the potential for a 'more complete human existence'.

In terms that serve as a precondition for James's above-noted discussion of art, the 'humanist' early Marx famously summed up the socially formative role of formal values in the arts:

> Just as music alone awakens in a person the sense of music, and just as the most beautiful music conveys no meaning to the unmusical ear... because the meaning of an object for me goes only so far as my senses go... [so] for this reason the senses of the social person are *other* sense than those of the non-social person. Only through the objectively unfolding richness of humanity's essential being is the richness of subjective *human* sensibility (*a musical ear, an eye for beauty of form* – in short, *senses* capable of human gratifications, senses confirming themselves as essential powers of humanity) either cultivated or brought into being... The forming of the five senses is a labour of the entire world down to the present.[22]

Similarly, just as James emphasised the centrality to art of the 'physical responses of human beings and the elemental categories of life and labour', so both Marx and Engels wrote of art as a natural form of labour, of labour as a shaper of human nature. In *Das Kapital*, for example, Marx observed that 'First of all, labour

is a process between humans and nature. In this process, humanity mediates, regulates, and controls its material interchange with nature by means of its own activity'. Thus, he concluded that 'In acting upon nature outside of itself, and changing it, humanity thus changes its own nature also'.[23] In consolidating this contention of Marx (and subsequently of James), Friedrich Engels wrote of the paramount importance of skilled labour for the arts (as well as for sports or popular culture) and for human development in the broadest sense:

> Labour is the source of all wealth... But it is even infinitely more than this. Labour is the prime basic condition for all human existence, and this to such an extent that, in a sense, we have to say that labour created humans themselves... the hand is not only the organ of labour, it is also the product of labour. Only by labour adaptation to ever new operations, by inheritance of the thus acquired special development of muscles... by the ever-renewed employment of this inherited finesse in new and more complicated operations, has the human hand attained the high degree of perfection that has enabled it to conjure into being the paintings of a Raphael, the statues of a Thorvaldsen, the music of a Paganini.[24]

Revealingly, for James and for Marx or Engels, the ongoing existence of class-based hierarchies, whether in the arts or in society, should never be linked to some populist diatribe that underestimates differences in artistic skills or intellectual advances. Rather, hierarchical social structures, including the arts (as opposed to genuine differences in levels of technical virtuosity within the arts per se) were linked by

James, Marx and Engels to the socially debilitating consequences resulting from the division of labour in the workplace within capitalism – along with the international division of labour in transnational terms still based in the current legacy of colonialism. In their visionary commitment to a 'more human future', Marx and Engels laid the groundwork for what James would then develop so effectively into his art theory. For all three thinkers, the arts would become at once more 'fine' (or subtle) and more popular – but not more populist – when there occurred a supercession of divisive capitalist labour practices through the democratisation of the workplace via *autogestion*.

Such a post-capitalist and post-colonial future predicated on the radical democratisation of society as a whole was discussed by Marx and Engels in a manner that also helps to illuminate James's own insistent concern in art theory with a dialogue in the present between professionals and amateurs, or intellectuals and the popular classes:

> The exclusive concentration of artistic talent in particular individuals, and its suppression in the broad mass of people, which is bound up with this, is a consequence of the division of labour [under capitalism]... In any case, with a communist organisation of society, there disappears the subordination of the artist to local and national narrowness, which arises entirely from division of labour, and also the subordination of the artist to some definite category of art... In a communist society there are no painters, but at most people who, among many other activities, also paint.[25]

Here, though, we must emphasise that the critical theory produced by C.L.R. James did not simply *reproduce* classical Marxist positions – however rich the critical dialogue with the thought of Europeans like Marx and Engels (or Bakhtin, who often identified with western Asian thought, more than European thought). The 'Black Marxism' of James produced something new, for all of its dialogic intercourse with Marxism per se, that both opposed Eurocentrism (that is, the privileging of European thought at the expense of other traditions) and drew upon European philosophy to construct a more cosmopolitan critical theory along post-colonial lines.[26] As Anna Grimshaw and Keith Hart have rightly noted, for example, 'The originality of the *Black Jacobins* derived from James's fusion of Marxism with the colonial struggle of blacks in the New World and Africa. This perspective also informed *A History of Negro Revolt*, a synoptic review of the intimate link between industrial capitalism and black resistance over two centuries'.[27]

Similarly, in opposition to orthodox Marxist-Leninists from the West and the Soviet Bloc or even Communist China, James defined *post-colonial socialism* as 'the extension of democratic principles into the sphere of production'.[28] In sum, then, for James, formal advances in the arts, both fine and popular, were grounded in a radically democratic sense of human wholeness that in turn necessitated a disalienated, self-determining labour process whereby humanity could construct itself through creating artworks, as well as everything else it produced.

What fresh methodological approach would allow these interlocking issues to be grasped in a single set of artworks?

James's summation of his own method as 'dialectical' and 'materialist' not only permits yet another appreciation of his theoretical affinity to Bakhtin's conception of the 'dialogic', but it also allows us to see how he was able to posit a profound, new alternative view for assessing the paintings of Jackson Pollock. James did so by refusing to see Pollock's images as being reducible either to an *art of affirmation*, as did mainstream critics like Clement Greenberg and Michael Fried, or to an *art of negation*, as have critics on the left from John Berger and Peter Fuller to T.J. Clark and Peter Wollen. Instead, James explained how Pollock's artwork was extremely important precisely because of the way it concretely combined the affirmative and the negative into a uniquely generative pictorial image, thus also expanding the communicative resources of the medium itself in a manner replete with extra-aesthetic ramifications.

In his best-known book on his own heterodox methodological approach, *Dialectical Materialism and the Fate of Humanity* (1947), C.L.R. James wrote as follows:

> Over a hundred years ago, Hegel said that the simplest reflection will show the necessity of holding fast the positive in the negative, the presupposition in the result, the affirmation that is contained in every negation, the future that is in the present... [But] Hegel complicated the question [of dialectics] by his search for a closed system embracing all aspects of the universe; this no Marxist ever did... Quite different is the mode of Marxism. It understands its own logical laws [self critically].[29]

Jackson Pollock as Cosmopolitan Modernist

Upon his death in Brixton in 1989, C.L.R. James left unpublished among his papers a five-page essay entitled simply 'Picasso and Jackson Pollock'. He had composed it in 1980 for a letter to a friend in Chicago named Sara Devine, whom he had met as a labour leader and political activist in the USA. James wrote the letter from the West Indies, while he was living in the headquarters of the Oilfield Workers Trade Union in Trinidad – a fact with intriguing implications, given Jackson Pollock's own long-time, left-wing affiliations to the labour movement in the USA. This study appeared posthumously during 1992 in Anna Grimshaw's exemplary compilation entitled *The C.L.R. James Reader*.[30]

The essay, which features an awe-inspiring yet effortless grasp of world culture almost *in toto*, is marked by nimble turns of phrase, elegant incisiveness, and a luminous sense of humanity that make clear why James is one of the most commanding thinkers of the 20th century. Perhaps characteristically, he began the essay with both considerable confidence and a matching sense of humility, so as to lodge a thoughtful set of insights and yet welcome dialogue or debate from the public about them. His essay started as follows:

When I was in Washington some months ago, a friend of mine took me to see some pictures by Jackson Pollock. They interested me. I bought some books and spent a long time over them. I have now come to the conclusion that the paintings of Picasso dominated the first half of the twentieth century and that the painter of the second half is Mr Jackson Pollock. Now this may sound very strange because I am an amateur when it comes to painting, but I have spent many hours on this business... The range I bring to these works is not comprehensive, but rather wide... I have seen the Pollocks at the Museum of Modern Art and I must say that when I left the room where they are and passed *Guernica*, a painting which I have admired and seen any number of times, *Guernica* looked dull to me in comparison with the blazing impact that the Pollocks had just made on me.[31]

These seemingly off-hand, if deeply-felt observations, immediately alert us to how several apparently conventional remarks are anything but that. Rather, these value judgements are actually markers in a discursive field that James himself did much to shape so deeply in the domain of theory. Above all, we need to understand that by the general term 'dominated painting', a standing which James attributed to both Picasso and Pollock, there is no standard agenda to characterise either artist as a Nietzschean-like *Ubermensch* towering above mainstream art within a 'great man theory of history'. Rather, James's use of the term 'dominated' for an artistic medium here signifies something much closer to what Michel Foucault identified as the 'trans-discursive' position of Freud and Marx in modern western thought. In 'What Is an Author?', Foucault wrote: 'Freud is not simply the author of *The Interpretation of Dreams* or of *Wit and the Unconscious*. Marx is not simply the author of 'The Communist Manifesto' or *Das Kapital*. Both Freud and Marx have established a possibility for further discourse.'[32]

And, on this score, James's point is a crucial one. Both Picasso and Pollock do in fact occupy virtually unsurpassed trans-discursive positions within 20th-century cosmopolitan modernisms.

Mural of Picasso's *Guernica*,
Havana, Cuba, 2003

Few if any other artists from the West generated a broader field of discursive interchange than did Picasso as co-inventor of cubism, as originator of the collage, as the first international (and anti-colonial) voice in the dialogic interchange of an Afro-European character, and as the author of *Guernica*, the most well-known protest painting of the 20th century (which even today makes a fragmentary appearance at almost every major demonstration, whether anti-war or anti-fascist, world-wide). As James himself put it so succinctly, 'Picasso and Braque come from Cézanne and African Art… [and] Picasso's high peak is *Guernica*'.[33]

As a stalwart figure in the anti-colonial movement, C.L.R. James knew well the enormous importance for national liberation movements of Picasso's dialogic visual discourse with African and African American, as well as Asian and Latin American artists – from Wifredo Lam of Cuba (whom he mentored) and Aimé Césaire of Martinique (with whom Picasso collaborated on a series of prints) to such contemporary artists as Abdelali Dahrouch of Morocco (who has written of Picasso's cosmopolitan modernism as a significant decolonising antecedent for North African artists), Rasheed Araeen of Pakistan (who has noted how Gauguin and Picasso helped to shift western art away from 'its ethnocentric tradition of Greco-Roman classicism'), Armando Morales of Nicaragua (one of whose prints about anti-Imperialism for the *Saga of Sandino* series is based on *Les Demoiselles d'Avignon*), and José Fuster of Cuba (who emphasises Picasso's ongoing centrality to the anti-colonial visual discourse that remains of paramount importance to the Caribbean).[34] As a result, then, of the counter-hegemonic and transnational discursive field that Picasso helped to generate, thus validating art from Africa qua art on equal dialogic terms with the fine arts of Europe, African culture itself was often afforded greater parity with western culture even before decolonisation had fully succeeded. Such was the message of political theorist Amílcar Cabral from Guinea-Bissau in a 1970 speech entitled 'National Liberation and Culture':

> In spite of colonial domination (and perhaps even because of this domination), Africa was able to impose respect for her cultural values. She even showed herself to be one of the richest of continents in cultural values… in works of art as well as in oral and written traditions… The universal value of African culture is now an incontestable fact.[35]

Something similar could be claimed about the trans-discursive position of Pollock, who, as art critic Robert Hughes once noted, 'was mined and sifted by later artists as though he were a lesser Picasso'.[36] From there, Hughes also went on to observe something else in 1982 of considerable significance for approximating the main premise of James's article about Pollock's interplay of negative and positive forces in his *oeuvre*. About the multi-ethnic basis of Pollock's visual language, Hughes wrote: 'It now seems that Pollock was eager to wind so many elements together, not out of some empty eclecticism… but in the belief that cultural synthesis might redeem us all… Pollock's career was one of the few great models of integrating search that our fragmented culture can offer'.[37]

But, let us return directly to the essay by James and how he developed methodologically the thesis for his above-noted conclusion. To

quote James on this matter: 'There are two fundamental elements that meet. First there is the work of art itself. Secondly, there is the mind you bring to it'.[38] Thus, he showed that he was as concerned with the production of art as with the reception of it – that is, as much with the subject of production (supposedly the main modernist interest) as with the production of the subject (the avowed aim of much post-modernist criticism). By combining a focus on both of these ideological problems, James advanced to a post-colonial understanding of each in relation to the other, rather than being restricted to a constraining preoccupation with one or the other. Similarly, James was quick to question the professional interpretation of artwork, whether by scholars from the West or the Eastern Bloc, even as he did the same for the populist views of the 'ordinary public'. Instead, a new type of critical encounter between the two would be featured in his dialogic approach.

Perhaps not surprisingly, James began his essay with a prefatory excursus in the realm of literary masters, where he was not just 'an amateur', as was supposedly true of his status as a commentator on the visual arts. What he found in the orthodox Shakespeare scholarship, both East and West, was an insistence upon a reading of Shakespeare's *King Lear* as an embodiment of 'total disillusionment with society', as if human nature itself were on trial. In taking issue with this mainstream view, James singled out here – as he did earlier in the above letter to art historian Meyer Schapiro – that elements of resistance to any such total resignation constituted a notable counterweight to this standard tragic reading of the 'human condition'.[39] Conversely, in surveying the literature on Alexander Pushkin, the Russian writer who 'has no equal in European literature',

James discovered the opposite problem, namely, the conventional wisdom that the poem *Bronze Horseman* was an apology for monarchy. Yet, contrary to the received wisdom here, James points out a symptomatic 'negative' passage concerning the repudiation of monarchical power that precludes any placid view of the palace in society.[40]

At this place in his essay, James moved from letters to images. He did so while underscoring that major artworks are neither unreservedly up-beat or resolutely resigned. To recall the related observation of Herbert Marcuse, 'Compared with the often one-dimensional optimism [or pessimism] of propaganda, art is permeated with pessimism, not seldom intertwined with comedy'.[41] With a witticism worthy of the topic, James switched to an analysis of the interplay between the affirmative and negative within the Renaissance paintings by Leonardo da Vinci: 'The lady with the smile has distorted the appreciation of Leonardo. The ordinary public is not aware that in the last twenty years of his life, Leonardo painted a world being overcome'.[42] The opposite is of course the case with Michelangelo, since 'It might seem that his last word as a painter was stated in the *Last Judgement*, the death of civilisation'. Such an easy conclusion is contradicted, however, by the later frescoes in the Cappella Paolina, according to James. In the latter paintings, 'Michelangelo was saying that in young people with some experience there was the possibility of re-building a world in which truth and justice would emerge over destruction'.[43]

He next advanced with equal fluency to addressing 'the painters of our time'. Beginning with the anti-Renaissance pictorial logic of the

Impressionists, who '*went back to nature*', James observed critically how, 'Nature, they thought would give them all that was required, but nature didn't'.[44] His critique found a ready analogy with Georg Lukács' criticism of 'naturalism' for its lack of 'typicality' and its theoretical innocence concerning the manner in which nature is always mediated by a visual language, and unavoidably inflected with subjectivity. A recognition of this naïve approach to nature and language is precisely what permitted the advent of modernism (which James calls 'modern painting') in the work of Cézanne and Picasso, each of whom understood the dual character of modernist art as both mediating agent and as self-critical cultural assessor. It is instructive to note at this point that James's view was more sophisticated than that of, say, Foucault, since for the Trinidad author, art was both about the representation of the means of artistic representation (as claimed by Foucault) and also about the testing of these same means of representation in relation to extra-linguistic forces (something Foucault, following Ferdinand de Saussure, did not succeed in doing, unlike Bakhtin).[45]

The synthesis of nature (meaning the 'elemental categories of life and labour') with a multi-ethnic language forged from European and African traditions is what ultimately led to Picasso's masterful *Guernica*, which James admired perhaps more than any other painting of the 20th century. Yet in this unpublished piece on Picasso and Pollock from 1980, James seemed to amend his earlier view of *Guernica* that appeared in print in 1977.[46] In the first article, James contrasted Picasso's painting with the pedimental sculpture for the Temple of Zeus at Olympia, as well as with Michelangelo's last frescoes at the Vatican. About the sculpture from ancient Greece, James wrote:

[T]he Ancient Greek saw, and we see today, the human fighting with the animal instincts in man. The magnificent figure of Apollo shows that the Greek is very certain that civilisation will win... In the *Guernica*, a contemporary mural, the human is stripped to the elementary need to survive, and, in the presence of the bull, the need to propagate. Everything else is complete confusion, crisis, and catastrophe... all mankind is now subjected to destruction from bombing planes, an imaginative glimpse of the future.[47]

The unease James felt in 1977 for this painting, his admiration for Picasso's anti-fascism and anti-imperialism notwithstanding, returned more noticeably in the 1980 essay. Upon further reflection, James decided that *Guernica* actually attested to a lack of deep faith in any post-imperial and post-colonial world, despite Picasso's own avowed stand on this issue as a socialist. Accordingly, James pitched the problem as follows: 'The decisive questionfrom our investigation is that Picasso could not make up his mind about the human personality... Like all great artists, Picasso was aware of the antagonistic forces in human nature'.[48] In grappling with this question about Picasso, James first noted the bankruptcy of professional art history in confronting these issues. Nevertheless, he then conceded his own, quite different, reservations about the social signification of this well-known painting. His justified critique of the literature then led into a critique of *Guernica*:

[I]n his book on Picasso (1975), Mr [Timothy] Hilton, in a work obviously aimed at putting Picasso in his place (not the place which the world had given him) says of *Guernica* (p. 246): 'Nobody knows what is going on in it'... I have not to answer here. Hundreds of thousands, if not millions, of people know... He made the bull into a fighter against the decay that the picture represents... He went still further and emphasised that procreation could not be defeated. That is in the testicles of the bull... [Thus] In opposition to the decay of society, he places sexuality (pro-creation), militancy, and high civilisation; but he cannot join them. They remain separate in the bull, on the one hand; and the extending arm holding the lamp on the other. It is this with which Pollock lived.[49]

So, at this point of suspension in his narrative, James introduced the post-1947 'all-over' paintings of Pollock. In relation to artworks, James again took up the issue of affirmation and negation interwoven in a compelling way within the same image. Before quoting from James's quite resourceful and incisive analysis of Pollock's 'great paintings of the period 1947', we should recall four key intertextual concepts from his earlier discussions of art that underlie this essay, thus giving it added analytical clout. In summarising the salient attributes of important art, James had written that it involves four common features, two of which help explain the work's 'significant form': namely, a sense of 'tactile values' derived from the material texture of the medium's use and a singular sense of 'movement', such as was invoked by the 'bounding line' of Michelangelo's images. In addition, there are two other concomitant attributes: 'an economy of means' to expand the 'flexibility of the medium' plus its communicative resources and a discursive extension of language through the 'elemental categories of life and labour' that in turn 'adds to the sum knowledge of the world'.[50]

What innovation by Pollock was so notably registered, in James's view, by the 'great paintings of the 1947 period'? Here we should also note that two of the works in this cluster of groundbreaking paintings were given literary titles with crucial links to James's own literary criticism: *Full Fathom Five* (1947) in MoMA, named after a famous passage in Shakespeare's *The Tempest*, and *Blue (Moby Dick)* (c.1943) in Ohara Museum of Art, Kurashiki in Japan, entitled after the celebrated book by Herman Melville that was the subject of a lengthy study by James himself in the 1950s. Refusing to see the works as merely abstract or just figurative, or as non-representational, James wrote of the paintings as oblique intimations of barely emergent things. About these evocative, but not illustrative, paintings, James maintained that, in them, there 'is a combination of the immense diversity of the world and scattered all over it are the beginnings and development of the human personality in the human face'.[51] As such, for Pollock, 'The world is not a chaos. He goes on, the diversity becomes more and more structured and organised, not according to previous organisation, but independently according to the designs which have emerged or are implied in the drippings'.[52]

In pursuing this line of enquiry James wrote of how the suggestive emergence of faces in the 1947 works gave way to the 'clearly discernible walking feet' in the 'classic' 1950 paintings – such as *One* in MoMA and *Autumn Rhythm* in the Met. James observed that in these two magisterial mural-size all-over images:

Jackson Pollock,
Autumn Rhythm (Number 30),
1950

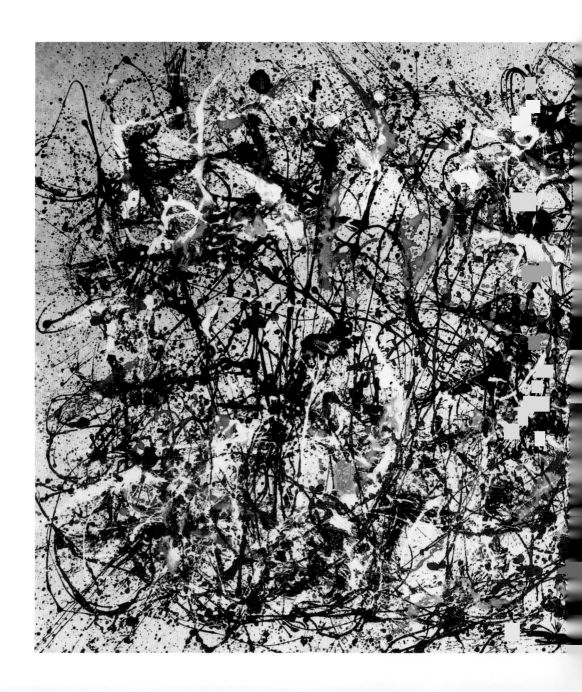

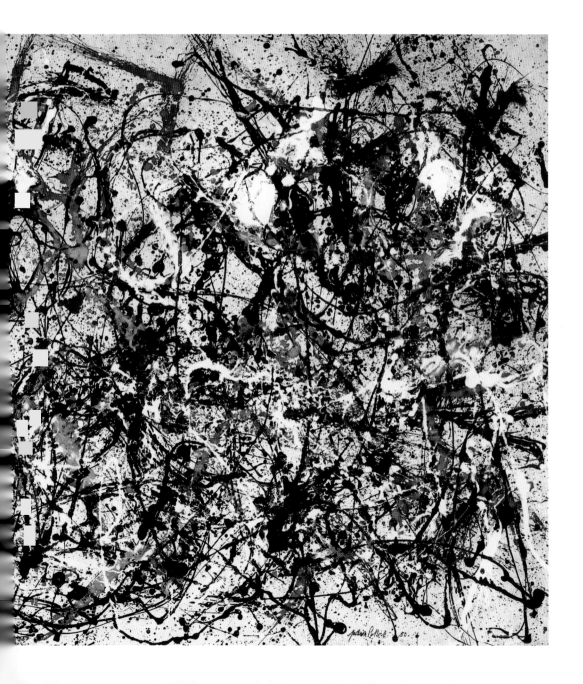

[T]here is the intricacy of design, the emergence of human faces and there is unmistakably the sense of feet walking along. I must say that I am astonished in the critiques I have read, there is insistence on the absence of representation and no statement whatsoever on these walking feet that are so fundamental a part of the structure of the paintings... In all great artists, as Max Raphael has said, there is an excess... the *Head* of 1938 cannot be eliminated from *Ocean Greyness* in 1953.[53]

At this point in the essay, James said that the aim of Pollock was nothing less than 'to tackle in his own way the problems that Picasso was tackling in 1937 or 1938' – when the Spanish painter could not decide about the course of history and of human nature, thus leaving them in a state of abeyance in *Guernica*. For James, though, Pollock was able both to advance beyond the technical impasse created by Picasso's consolidation of his discursive field and also to move past the doubts about humanity plaguing Picasso's work. Such was James's conclusion about the new discursive field in painting inaugurated by Pollock:

What conclusions can be drawn from all this? Dangerous as such conclusions really are, I shall not run away from mine. In the bull of *Guernica*, Picasso having already established the civilisation represented by Greece, could find only procreation and struggle as the future of human society. A Great painter [Pollock] starting there found his way to the infinite diversity and basic, though hitherto unrepresented order in the world. But he insisted that from this structural diversity emerged the human face (not high civilisation, as in *Guernica*); and more than mere sexuality and struggle. He found the beginning of humanity in that men, or rather human beings, walked.[54]

We can conclude here commenting on some of the remarkable observations that have come to the fore in James's unlikely look at the modernist paintings of Pollock. First, James has underscored how through a process of doubling-back, Pollock both advanced the medium of painting and returned to one of the definitive moments in the evolution of humanity, namely, when it first walked upright. Second, James has rightly underscored the indexical nature of the sign in Pollock's artworks, rather than their iconic or symbolic characters, so that we see Pollock's paintings as a field of indexical signs calling attention to the unique form of human pictorial movement that both attests to the concrete form of artistic labour used for the painting and also engulfs the spectator with a sense of pictorial movement indicative of its significant form. Third, James highlighted the bodily engagement of these all-over images – in truth, these works are not 'gestural paintings' but 'body paintings' – so that they are seen as performative in a way analogous to the aesthetic activity observed in a cricket match. And, fourth, these paintings possessed a panoramic quality and cinematic structure that, in 'Popular Art and Cultural Tradition', James said was symptomatic of all major 'modern art'.

Indeed the best way to understand what James admired about Pollock's all-over paintings and also how he implicitly defined cosmopolitan modernism, is simply to quote one of his more moving descriptions of art in contemporary society:

Our world of the 20th century is panoramic.
Contemporary society gives a sense, on
a scale hitherto unknown, of connections,
of cause and effect, of the conditions from
which an event arises, of other events
occurring simultaneously. His [the artist's]
world is one of a constantly increasing
multiplicity of relationships between himself,
immense mechanical constructions and
social organisations of world-wide scope...
Modern content demanded a modern
technique, not vice versa... But no age has
been so conscious of the permeation of
the historical past in the actual present as
our own.[55]

NOTES

1. Edward Said, *Orientalism*, New York: Random House, 1994, revision of 1978 edition, 349–351.

2. Paul Gilroy, *The Black Atlantic: Modernity and Double Consciousness*, London and Cambridge, MA: Harvard University Press, 1993, 6, 17.

3. See, for example, certain passages in Kobena Mercer's *Welcome to the Jungle: Positions in Black Cultural Studies*, London: Routledge, 1994, and the study by Paul Buhle, *C.L.R. James: The Artist as Revolutionary*, London: Verso, 1988, and also the fine introductory essay by Anna Grimshaw and Keith Hart in C.L.R. James, *American Civilization*, Oxford: Blackwell, 1993. As for a recent look at the importance of C.L.R. James to literary studies see Emily Eakin, 'Embracing the Wisdom of a Castaway: The Leftwing critic C.L.R. James', *The New York Times*, 4 August 2001, A15, 17.

4. Edward Said, 'Michel Foucault, 1927 – 1984', in his *Reflections on Exile and Other Essays*, Cambridge, MA: Harvard University Press, 2002, 196.

5. W.J.T. Mitchell, 'Post-Colonial Culture, Post-Imperial Criticism', in Bill Ashcroft et al. eds, *The Post-Colonial Studies Reader*, London: Routledge, 1995, 475–80.

6. For a definitive refutation of W.J.T. Mitchell's 'dependency theory' conceptual framework see Rasheed Araeen, Sean Cubitt and Ziauddin Sardar eds, *The Third Text Reader on Art, Culture, and Theory*, London: Continuum, 2002.

7. See, for example, David Craven, *Abstract Expressionism as Cultural Critique: Dissent During the McCarthy Period*, Cambridge: Cambridge University Press, 1999, 9–32 and David Craven, *Art and Revolution in Latin America, 1910 – 1990*, New Haven: Yale University Press, 2002, 96, 98–99.

8. C.L.R. James, 'My Dear [Meyer] Schapiro', letter of 9 March 1953, in Anna Grimshaw ed., *The C.L.R. James Reader*, Oxford: Basil Blackwell, 1992, 237–40.

9. C.L.R. James, 'Picasso and Jackson Pollock', 1980, in *The C.L.R. James Reader*, 405–10.

10. C.L.R. James, 'The Artist in the Caribbean', 1959, in C.L.R. James, *The Future in the Present: Selected Writings*, Westport, Conn.: Lawrence Hill & Co., 1977, 183.

11. Ibid., 185.

12. Ibid., 185.

13. Ibid., 185.

14. Ibid., 184–85, 187.

15. Ibid., 184.

16. Ibid., 189. For similar praise of Aimé Césaire by a leading European modernist poet, see the remarks of surrealist leader André Breton, who called *Cahier d'un Retour au Pays Natal* 'nothing less than the greatest lyrical monument of this time'.

17. Kobena Mercer, *Welcome to the Jungle: Positions in Black Cultural Studies*, London: Routledge, 1994, 62.

18. Paul Gilroy, *The Black Atlantic*, 79.

19. Ibid., 183. See also Richard Wollheim, *On Formalism and Its Kinds*, Barcelona: Fundacio Antoni Tapies, 1995.

20. C.L.R. James, 'What is Art?', in *The C.L.R. James Reader*, 318–20, 326.

21. M.M. Bakhtin and P.N. Medevedev, *The Formal Method in Literary Scholarship*, 1928, trans. A.J. Wehrle, Baltimore: Johns Hopkins University Press, 1978, 41–53.

22. Karl Marx, *The 1844 Economic and Philosophical Manuscripts*, trans. Martin Milligan, New York: International Publishers, 1964, 140–41.

23. Karl Marx, *Das Kapital*, 1867, reprinted in Lee Baxandall and Stefan Morawski eds, *Marx & Engels on Literature & Art*, St Louis: Telos Press, 1973, 53.

24. Friedrich Engels, 'The Part Played by Labor in the Transition from Ape to Man' 1876, reprinted in ibid., 54–55.

25. Karl Marx and Friedrich Engels, *The German Ideology*, 1847, C.J. Arthur ed., New York: International Publishers, 108–09.

26. See Samir Amin, *L'eurocentrisme: Critique d'une ideologie*, Paris: Anthropos, 1988.

27. Anna Grimshaw and Keith Hart, Introduction, in C.L.R. James, *American Civilization*, Oxford: Basil Blackwell, 1993, 9.

28. Ibid., 20.

29. C.L.R. James, *Dialectical Materialism and the Fate of Humanity*, 1947, in *The C.L.R. James Reader*, 161, 154.

30. C.L.R. James, 'Picasso and Jackson Pollock', in *The C.L.R. James Reader*, 405–10.

31. Ibid., 405, 409–10.

32. Michel Foucault, 'What Is an Author?', 1969, trans. J. Venit, *Partisan Review*, vol. XLII, no. 4, 1975, 611.

33. C.L.R. James, 'Picasso and Jackson Pollock', 407. Because of such things, however, as the use of African art by right-wing artists like Maurice Vlaminck (with political views at odds with those of Picasso), James then says: 'I don't intend to spend any time here on African art and its influence on French painting because, waiting for us there, is a morass of debate and confusion'.

34. Interview with José Fuster by the author, Jaimanitas (a suburb of Havana), Cuba, 7 November 2003. In fact there is a replica of Picasso's *Guernica* – specifically linked with the cause of anti-fascism and anti-imperialism, in downtown Havana on a public billboard prominently seen from one of the main highways. In the course of our conservation, Fuster (after acknowledging the enormous importance of Picasso's trans-cultural paintings for his own painted ceramics) declared: '*El bloqueo actual estadounidense es la Guernica de Cuba*'. On Picasso's anti-colonial visual discourse and its impact on North African artists see, for example, Abdelali Dahrouch, 'The Neglected Side:

Matisse and Eurocentrism', *Third Text*, no. 24, Fall 1993, 13–24.
35. Amílcar Cabral, *Return to the Source: Selected Speeches*, New York: Monthly Review Press, 1973, 50. As for the most important discussion of Picasso's anti-colonial and anti-imperialist politics in relation to his dialogic usage of African Art, see Patricia Leighten, 'The White Peril and *L'Art negre*: Picasso, Primitivism, and Anti-Colonialism', *The Art Bulletin*, vol. LXXII, no. 4, December 1990, 604–30.
36. Robert Hughes, 'Jackson Pollock', in *Nothing If Not Critical*, New York: Penguin Books, 1992, 217.
37. Ibid., 220.
38. C.L.R. James, 'Picasso and Jackson Pollock', 405.
39. Ibid., 406.
40. Ibid.
41. Herbert Marcuse, *The Aesthetic Dimension*, Boston: Beacon Press, 1978, 14.
42. C.L.R. James, 'Picasso and Jackson Pollock', 406.
43. Ibid.
44. Ibid., 407.
45. Terry Eagleton, *Literary Theory*, Minneapolis: University of Minnesota, 1996, 101–02.
46. C.L.R. James, 'The Olympia Statues, Picasso's *Guernica*, and the Frescoes of Michelangelo in the Cappella Paolina', in C.L.R. James, *The Future in the Present*, Westport, Conn.: Lawrence Hill, 1977, 226–34.
47. Ibid., 232.
48. Ibid., 407.
49. Ibid., 408–09.
50. C.L.R. James, 'The Artist in the Caribbean', 184.
51. C.L.R. James, 'Picasso and Jackson Pollock', 409.
52. Ibid.
53. Ibid.
54. Ibid.
55. C.L.R. James, 'Popular Art and the Cultural Tradition', in *The C.L.R. James Reader*, 247–48.

COSMOPOLITAN
MODERNISMS

NEOCONCRETISM AND MINIMALISM: ON FERREIRA GULLAR'S THEORY OF THE NON-OBJECT

MICHAEL ASBURY

This chapter presents the first English translation of Ferreira Gullar's 'Theory of the Non-Object' by Michael Asbury, whose essay offers a comparative study of the aesthetic philosophies of minimalism and neoconcretism. Originally published in the national newspaper Jornal do Brasil *in December 1959, Gullar's text addresses the underlying concerns of the neoconcrete movement that briefly flourished in Brazil in the late 1950s and early 1960s. Gullar's 'Neoconcrete Manifesto', published in March 1959, had articulated a critical reaction to earlier constructivist tendencies and the resulting break with concretism created the context in which the* Jornal do Brasil *opened the pages of its weekend supplement to a new generation of poets and critics. Examining the broad philosophical reflection on modernism that informs Gullar's conception of the 'non-object', Asbury relates the discourse of the neoconcrete movement to the interest in Gestalt psychology and phenomenology that is associated with minimalism in the North American context. As a result of the contrasts and similarities produced in this comparative study, new questions are raised with regards to a consideration of cosmopolitanism at a local level and a critique of provincialism in historical accounts of this important post-war period.*

THEORY OF THE NON-OBJECT [1]
FERREIRA GULLAR

The expression 'non-object' does not intend to describe a negative object nor any other thing that may be opposite to material objects. The non-object is not an anti-object but a special object through which a synthesis of sensorial and mental experiences is intended to take place. It is a *transparent* body in terms of phenomenological knowledge: while being entirely perceptible it leaves no trace. It is a pure appearance.[2] All true works of art are in fact non-objects, if this denomination is now adopted it is to enable an emphasis on the problems of current art from a new angle.[3]

The Death of Painting
This issue requires retrospection. When the impressionist painters, leaving the studio for the outdoors, attempted to apprehend the object immersed in natural luminosity, figurative painting began to die. In Monet's paintings the objects dissolve themselves in colour and the usual appearance of things is pulverised amongst luminous reflections. The fidelity towards the natural world transferred itself from objectivity to impression. With the rupture of the outlines which maintained objects isolated in space, all possibility of controlling the pictorial expression was limited to the internal coherence of the picture.

Later, Maurice Denis would say, 'a picture – before being a battle horse, a female nude or an anecdote – is essentially a flat surface covered by colours arranged in a certain order'. Abstraction was not yet born but figurative painters, such as Denis, already announced it. As far as they[4] were concerned, increasingly the represented object lost its significance and consequently the picture, and similarly the object, gained importance. With cubism the object is brutally removed from its natural condition, it is transformed into cubes, virtually imposing upon it an idealised nature; it was emptied of its essential obscurity, that invincible opaqueness characteristic of the thing. However, the cube being three-dimensional still possesses a nucleus: an *inside* which was necessary to consume – and this was done by the so-called synthetic phase of the movement. Already, not much is left of the object. It was Mondrian and Malevich who would continue the elimination of the object.

The object that is pulverised in the cubist picture is the painted object, the represented object. In short, it is painting that lies dying there, dislocated in search of a new structure, a new form of being, a new significance. Yet in these pictures (synthetic phase, hermetic phase) there are not only dislocated cubes, abstract planes: there are also signs, arabesques, collage, numbers, letters, sand, textiles,

nails, etc. These elements are indicative of the presence of two opposing forces: one which attempts relentlessly to rid itself of all and any contamination with the object; the other is characteristic of the return of the object as sign, for which it is necessary to maintain the space, the pictorial environment born out of the representation of the object. The latter could be associated with the so-called abstract painting, of sign and matter, which persists today in tachisme.

Mondrian belongs to the most revolutionary aspect of cubism, giving it continuity. He understood that the new painting, proposed in those pure planes, requires a radical attitude, a restart. Mondrian wipes clean the canvas, eliminates all vestiges of the object, not only the figure but also the colour, the matter and the space which constituted the representational universe: what is left is the white canvas. On it he will no longer represent the object: it is the space in which the world reaches harmony according to the basic movements of the horizontal and the vertical. With the elimination of the represented object, the canvas – as material presence – becomes the new object of painting. The painter is required to organise the canvas in addition to giving it a transcendence that will distance it from the obscurity of the material object. The fight against the object continues.

The problem Mondrian set himself could not be solved by theory. He attempted to destroy the plane with the use of great black lines which cut the canvas from one edge to the other – indicating that it relates to the external space – yet these lines still oppose themselves to a background and the contradiction between space and object reappears. Thus, the destruction of these lines begins, leading to his last two paintings: *Broadway Boogie Woogie* and *Victory Boogie Woogie*. But the contradiction in fact was not resolved, and if Mondrian had lived a few more years, perhaps he would have returned once more to the white canvas from which he began. Or, he would have left it favouring construction into space, as did Malevich at the end of his parallel development.

The Work of Art and the Object
For the traditional painter, the white canvas was merely the material support on to which he would sketch the suggestion of natural space. Subsequently, this suggested space, this metaphor of the world, would be surrounded by a frame that had as a fundamental function the positioning of the painting into the world. This frame was the mediator between fiction and reality, a bridge and barrier, protecting the picture, the fictitious space, while also facilitating its communication with the external, real, space. Thus when painting radically abandons representation – as in the case of Mondrian, Malevich and his followers – the frame loses its meaning. The erection of a metaphorical space within a well-protected corner of the world no longer being necessary, it is now the case of establishing the work of art within the space of reality, lending to this space, through the apparition of the work – this special object – significance and transcendence.

It is a fact that things occurred with a certain level of sluggishness, equivocations and deviations. These were undoubtedly inevitable and necessary. The use of collage, sand and other elements taken from the real, already signal the necessity to substitute fiction by reality. When the dadaist Kurt Schwitters later builds the Merzbau – made from objects and fragments he found in the streets – it is once again the same intention which has further developed, now freed from the frame, and in real space. At this point it becomes difficult to distinguish the work of art from the real objects. Indicative of this mutual overflow between the work of art and the object is Marcel Duchamp's notorious *blague*, submitted to the Independents' Exhibition in New York in 1917, a fountain-urinal of the kind used in bar toilets. The ready-made technique was adopted by the surrealists. It consists of revealing the object, dislocated from its usual function, thus establishing new relationships between it and the other objects. This process of transfiguration of the object is limited by the fact that it is grounded not so much in the formal qualities of the object but in its connection with the object's quotidian use. Soon that obscurity that is characteristic of the *thing* returns to envelop the *work*, bringing it back to the common level. On this *front*, the artists were defeated by the object.

From this point of view some of today's extravagant paintings pursued by the avant-garde appear in all their clarity or even naïveté. What are the cut canvases of Fontana, exhibited in the V Biennial,[5] if not a retarded attempt to destroy the fictitious pictorial space by means of introducing within it a real cut? What are the pictures by Burri with kapok, wood or iron, if not a return – without the previous violence but transforming them into fine art – to the processes used by the dadaists? The problem lies in the fact that these works only achieve the effect of a first contact, failing to achieve the permanent transcendent condition of a non-object. They are curious, bizarre and extravagant objects – but they are objects.

The path followed by the Russian avant-garde has proved to be more profound. Tatlin's and Rodchenko's counter-reliefs, together with Malevich's suprematist architecture, are indicative of a coherent revolution from the represented space towards real space, from represented forms towards *created* forms.

The same fight against the object can be seen in modern sculpture from cubism onwards. With Vantongerloo (De Stijl) the figure disappears completely; with the Russian constructivists (Tatlin, Pevsner, Gabo), mass is eliminated and the sculpture is divested of its condition of *thing*. Similarly, if non-representational painting is attracted towards the orbit of objects, this force is exerted with far greater intensity amongst non-figurative sculpture. Transformed into object, sculpture rids itself of its most common characteristic: mass. But this is not all. The base – sculpture's equivalent to the painting's frame – is eliminated. Vantongerloo and Moholy-Nagy attempted to create sculptures that would inhabit space without a support. They intended to eliminate weight from sculpture, another fundamental characteristic of the object. What can be thus verified is that while

painting, freed from its representational intentions, tends to abandon the surface to take place in space, thus approaching sculpture, the latter liberates itself from the figure, the base and of its mass, therefore maintaining very little affinity with what traditionally has been denominated as sculpture. In fact, there is more affinity between a counter-relief by Tatlin and a sculpture by Pevsner than between a Maillol and a Rodin or Fidias. The same could be said of a *painting* by Lygia Clark and a *sculpture* by Amílcar de Castro. From which we can conclude that current painting and sculpture are converging towards a common point, distancing themselves from their origins. They become special objects – non-objects – for which the denominations *painting* and *sculpture* perhaps no longer apply.

Primary Formulation

The problem of the frame and base, in painting and sculpture respectively, has never been examined by critics in terms of its significant implications as static. The phenomenon is registered but simply as a curious detail that escapes the problematics raised by the work of art. What had not been realised was that the actual work of art posited new problems and that it attempted to escape (to assure its own survival) the closed circuit of traditional aesthetics. To rupture the frame and to eliminate the base are not in fact merely questions of a technical or physical nature: they pertain to an effort by the artist to liberate himself from the conventional cultural frame, to retrieve that desert, mentioned by Malevich, in which the work of art appears for the first time freed from any signification outside the event of its own apparition. It could be said that all works of art *tend towards* the non-object and that this name is only precisely applicable to those that establish themselves outside the conventional limits of art: works that possess this necessary limitlessness as the fundamental intention behind their appearance.

Putting the question in these terms demonstrates how the tachiste and l'informel experiments in painting and sculpture are conservative and reactionary in nature. The artists of these tendencies continue – although in desperation – to make use of those conventional supports. With them the process is contrary: rather than rupturing the frame so that the work can pour out into the world, they keep the frame, the picture, the conventional space, and put the world (its raw material) within it. They part from the supposition that what is within the frame is the picture, the work of art. It is obvious that with this they also reveal the end of such a convention, but without announcing a future path.

This path could be in the creation of these special objects (non-objects) that are accomplished outside of all artistic conventions and reaffirm art as a primary formulation of the world.

NEOCONCRETISM AND MINIMALISM: COSMOPOLITANISM AT A LOCAL LEVEL AND A CANONICAL PROVINCIALISM

Neoconcretism is one of the key references within the current economy of legitimation of Brazilian contemporary art, and has gained international notoriety while remaining contextually obscure. Its notoriety arises from the fact that it has acquired a quasi-mythical status: that of signalling the national origin of contemporary Brazilian art. Interpretations suggesting such an inaugural role rely on artists associated with neoconcretism such as Hélio Oiticica and Lygia Clark whose participatory work during the 1960s transcended the contemplative nature of previous modernist art. Some contemporaneous critics, most notoriously amongst them Ferreira Gullar,[6] argued that such a move not only questioned art's *raison d'être* but went beyond the domain of the discipline and thus lead to an art historical dead end.[7] Precisely due to such a rupture, Oiticica and Clark have become paradigmatic figures within the discourse surrounding the very character of Brazilian contemporary art.[8] Neoconcretism's obscurity is the result of the fact that only vague and often incorrect information on the movement is articulated in support of this paradigmatic role.

Neoconcretism's profound influence upon subsequent generations of artists is not in question here, yet it would be reductive to describe its complex legacy as a tradition. Despite the fact that it is often cited within the context of the 1960s, the development of the movement is historically placed at the crest of the wave of optimism that spread through Brazil during the late 1940s and 1950s. During this period, constructivist-orientated art, and concrete art in particular, was consolidated in Brazil through influential figures such as the Argentinean critic and curator Romero Brest and the Swiss artist and designer Max Bill.

Although the term *art concret* had been coined by Theo van Doesburg in 1930, in response to the notion of abstraction promoted by Joaquin Torres-Garcia and Michel Seuphor's first *Cercle et Carré* exhibition (at Galerie 23 Rue la Boétie, Paris), concrete art nevertheless only gained widespread international recognition as an aesthetic philosophy in light of the post-war spirit of reconstruction. In Brazil, concretism was very much a product of its time as it accompanied an intense period of industrialisation and urbanisation that highlighted the nation's momentary yet seemingly unlimited faith in modernity.[9]

Architecture, perhaps more so than art, was symbolic of the developmentalist ideology that became hegemonic in this period. It is not coincidental that the constructivist tendencies emerged alongside the inauguration of the museums of modern art in São Paulo and in Rio de Janeiro during the late 1940s,[10] and declined shortly after the inauguration of the new capital Brasilia in 1960 as faith in the industrial development of the nation dissipated with the political and economic crisis brought by the excessively accelerated modernisation of the 1950s. Brazilian concrete art therefore corresponds to the most striking icons that marked the rise and fall of the optimism of the period. The fact that in 1957 the national newspaper *Jornal do Brasil* invited Amílcar de Castro and Reynaldo Jardim, two constructivist artists from Rio de Janeiro, to redevelop its graphic design provides a further indication of the enthusiasm for modernity that characterised the era.[11] As well as a radical change in its visual identity, the newspaper gained a weekend cultural supplement that featured contributions from young avant-garde critics, including Ferreira Gullar. The resulting neoconcrete

Ferreira Gullar, 'Teoria do Não-Objeto', Suplemento Dominical, *Jornal do Brasil*, 19–20 December 1959

movement was in effect established by the newspaper's role in providing Gullar with opportunities to publish both the 'Neoconcrete Manifesto' and the 'Theory of the Non-Object' in March and December 1959.[12]

The first *National Exhibition of Concrete Art* had opened at São Paulo's Museum of Modern Art in 1956 and travelled to Rio in 1957. Despite the disagreements that surrounded the exhibition, which clearly indicated a rift between the São Paulo and Rio-based groups of artists, it was primarily through poetry that the neoconcrete rupture took place. In light of his access to the broadsheet, Gullar had been asked by the São Paulo-based concrete poets Haroldo and Augusto Campos to publish in the *Jornal do Brasil* a text entitled *Da Psicologia da Composição à Matemática da Composição* (From the Psychology of Composition to the Mathematics of Composition), and to include his name amongst its signatories.[13] However, as he could not accept the premises of mathematics as an a priori formula for poetry, Gullar wrote another article instead that was published alongside the *Paulista* text, entitled *Poesia Concreta: Experiência Fenomenológica* (Concrete Poetry: Phenomenological Experience).[14] It was this phenomenological experience rather than the neoconcrete manifesto's initial reaction to the orthodox nature of concrete art's rhetoric that was articulated in the 'Theory of the Non-Object'. No longer directly concerned with establishing parameters of distinction for neoconcretism, Gullar's text centres on the unfolding of the two-dimensional plane within space as a general art historical development.

The implicit linearity in Gullar's positioning of neoconcretism within the wider history of art contrasts sharply with the recent misunderstandings surrounding the relation that the movement possesses with Brazilian art history. Within such discourses, the phenomenological emphasis on the physical space that the work of art occupies is seen as directly related to subsequent experiments such as Oiticica's environmental installations of the 1960s in which both physical and social spaces were emphasised.[15] Oiticica acknowledged his debt to neoconcretism but his references to the popular culture and architecture of the *favelas* (shanty towns) belonged to an altogether different context to that of the aesthetic experimentation of neoconcretism.[16]

Although various artists originally affiliated to the neoconcrete movement maintained their production relatively unchanged throughout their careers, as a united front neoconcretism only lasted approximately three years: between 1959 with the publication of its manifesto and 1961 with Ferreira Gullar's abandonment of avant-garde practice and the demise of the weekend supplement of the *Jornal do Brasil*.[17] This short period nevertheless coincided with a moment of intense political transformation (which will be discussed shortly) that went far beyond the transferral in 1960 of the federal capital from Rio de Janeiro to Brasilia.[18] Such a significant moment would naturally invite historical associations. However, it is only through a careful historiography that the often misleading connections between past and present can be identified. It is perhaps because neoconcretism came to international attention alongside various generations of Brazilian artists during the late 1980s and early 1990s that such connections have been established between the neoconcrete movement, 1960s radicalism, and today's generation of contemporary Brazilian artists.[19]

Such connections are the result of similar processes to those denounced by Benjamin Buchloh with regard to post-pop and minimalist art in the USA during the late 1980s:

> [...] the critic might best define his or her practice, especially in regard to the legacies of pop and minimalism and their successors, as an act of countermemory, one which opposes such facile and falsifying 'rediscoveries' of '60s practice in the present.[20]

Buchloh is provocatively mourning the demise of the art critic as an agent who identifies the quality as well as the progressive tendency within creative production. He argues that the critic's alienation from the ranks of contemporary production has enabled those who stand to benefit the most from such disengagement to establish their own criteria for validation. In Buchloch's view, this legitimating machine is often powered by conjuring historical connections and a sense of aesthetic 'tradition':

> [T]he merger between avant-garde culture and culture industry has initiated among curators and collectors, dealers and artists a new awareness: namely, that management and control, validation and affirmation can just as well be performed from within the ranks of the given institutions and their networks of support, in particular the museum and the market.[21]

Such methods of artistic validation tend to limit themselves to the scope of a national art tradition, while ignoring the contextual distinctions faced by each generation. Buchloh suggests that the art critic, now confined within academia, is restricted to the denunciation of historical simplifications and the investigation of that which lies on the margins of such discourses. Similarly, this essay will discuss neoconcretism and raise certain parallels with discourses on minimalism. However, rather than simply discussing neoconcretism as a possible, albeit obscure, precedent to minimalism, I adopt Buchloh's suggestion of displacing simple linearities and exploring the margins of history as related aspects of a single methodological practice.

Resulting from the difficulty encountered in categorising a work by the artist Lygia Clark,[22] Ferreira Gullar's 'Theory of the Non-Object' introduced issues that informed much of the local 'environmental' and 'participatory' work which followed in Brazilian art, and also anticipated theoretical debates that would emerge in North America during the following decade. While Robert Morris's interest in Gestalt psychology would suggest a proximity with the theoretical repertoire of concrete art, Donald Judd's text 'Specific Objects' and Ferreira Gullar's 'non-object' present surprising similarities.[23] Both share a common philosophical awareness and consequently reach the same conclusion. Judd's realisation in 1965 that 'half or more of the best new work in the last few years has been neither painting nor sculpture'[24] confirms Gullar's conclusion in 1959 that 'current painting and sculpture is converging towards a common point, distancing themselves from their origins. They become special objects – non-objects – for which the denominations *painting* and *sculpture* perhaps no longer apply'. Similarly, Judd's critique of the limitations of the rectangle within which painting operates could be equated with Gullar's observation that painting was in the midst of transcending its frame in the same way in which sculpture was discarding its mass and its

Ferreira Gullar et al.,
'Manifesto Neoconcreto',
Suplemento Dominical,
Jornal do Brasil,
21–22 March 1959

base or pedestal. Gullar and Judd both drew upon a phenomenological approach towards the work of art and its relation to space. In other words, they were equally critical of the emphasis on the surface of painting, and ultimately both Gullar and Judd attempted to transcend a critique that relied upon its inherently two-dimensional nature. To do so required an engagement with the nature of the object (of art) as opposed to the medium.

Such writing emerged as reactions to quite distinct local precedents. Although both Judd's and Gullar's texts are imbued with a sense of history that maintained a teleological bias, it was their understanding of history that kept them apart. To establish a comparison between their respective critical positions is therefore to question the high modernist canon, and in particular its obligatory passage via Clement Greenberg's highly influential views. Hence, with Gullar's 'Theory of the Non-Object' in mind, Hal Foster's description of the contemporary pertinence of minimalism is worth quoting at length:

> Although the experimental surprise of minimalism is difficult to recapture, its conceptual provocation remains, for minimalism breaks with the transcendental space of most modernist art (if not with the immanent space of the dadaist ready-made or the constructivist relief). Not only does minimalism reject the anthropomorphic basis of most traditional sculpture (still residual in the gestures of abstract-expressionist work), but it also refuses the siteless realm of most abstract sculpture. In short, with minimalism sculpture no longer stands apart, on a pedestal or as pure art, but is repositioned among objects and redefined in terms of space. In this

transformation the viewer, refused the safe, sovereign space of formal art, is cast back on the here and now; and rather than scan the surface of a work for a topographical mapping of the properties of its medium, he or she is prompted to explore the perceptual consequences of a particular intervention in a given site. This is the fundamental reorientation that minimalism inaugurates.[25]

While Gullar seemed to be calling for such a re-orientation in 1959, we should observe that his notion of the non-object does not directly suggest a break with the ready-made, as he states that its immanent space is limited by its connection with the object's quotidian use. It is this connection that the non-object's 'perceptual transparency' breaks with, along parallel lines to Foster's interpretation of minimalism.

Foster's claim that 'minimalism is an apogee of modernism, but it is no less a break with it' in effect establishes a relationship between high modernism and contemporary art.[26] Here, too, a parallel could be raised with the art critic Ronaldo Brito who saw neoconcretism as the 'peak and rupture' of the constructivist project in Brazil.[27] Foster's argument regarding minimalism and modernism nevertheless entails some important historiographical speculations:

It is true that, as represented by Edmund Husserl and Ferdinand de Saussure, phenomenology and structural linguistics did emerge with high modernism. Yet neither discourse was current among artists until the 1960s, that is, until the time of minimalism, and when they did re-emerge they were in tension.[28]

Gullar's reading of Merleau-Ponty (an indirect route to Husserl) and Haroldo de Campos' discussion of semiotic categories in relation to concrete art seem to question the decisive character of minimalism in Foster's account.[29] Indeed, similar theoretical tensions can be perceived between the concrete poets' interest in linguistics and Gullar's use of phenomenology. The increased emphasis on the individual's perception, and therefore the presence of a certain theatricality, are indicative of such parallel tensions. In fact, it could be argued that the tension between spatial and linguistic approaches has its origins in the historical avant-garde and particularly with dada and the ready-made. The fact that dada's deferred action upon minimalism cannot be considered as an exclusive historical relationship seems to escape Foster whose linear narrative could be interpreted as a product of his own provincialism.

Buchloh's observation that the activity of art criticism has declined due to the critic's disengagement from the ranks of contemporary production seems to be confirmed by the fact that the primary writing on both minimalist and neoconcrete art emerged from artists and/or poets affiliated to those movements and as such naturally courted controversy. While minimalism was notoriously confronted by Michael Fried's 'art and objecthood',[30] neoconcretism's primary opponents were the concrete artists and the concrete poets of São Paulo. In both contexts, controversies implicitly revolved around the views held by senior critics, namely Clement Greenberg and Mário Pedrosa. However, while it is undeniable that Judd referred to the edges of painting as a direct or literal reference to Greenbergian critique, Gullar's attack on tachisme and l'informel could be interpreted as theoretically similar albeit paradigmatically distinct. All the activity associated with neoconcretism somewhat obscures the fact that if indeed there had been a generalised enthusiasm for constructivism it was clearly in decline by the late 1950s. The most obvious sign of such a shift could be seen in the São Paulo Biennial of 1959 (the year in which Gullar published the 'Theory of the Non-Object'), which had been overwhelmed by 'informal abstraction'. According to Gullar, the 5th Biennial had as much an impact as the first. The difference was that, while in 1951 the impact of novelty was restricted to the Swiss section, in 1959 the entire Biennial was dominated by tachisme. As Gullar remarked: 'Even Mário Pedrosa came back from Japan defending it'.[31]

If Greenberg became representative of that which minimalism rebelled against, Pedrosa's role within the rift that developed between São Paulo's and Rio's constructivist tendencies was far more ambivalent. One of the most frequent citations with regard to the critic's position has been Pedrosa's thesis on Gestalt psychology. The thesis was 'defended' in 1949 as part of Pedrosa's submission to the chair of Art and Aesthetics at the National Faculty of Architecture. Although it circulated amongst intellectual circles,[32] it was however only published in 1979.[33] This informal nature of intellectual exchange was fully encouraged by Pedrosa's generosity and was responsible for Gullar's immersion within the field of art criticism. Pedrosa frequently organised meetings at his home in Rio, and his library was made available in this way to the young poet Ferreira Gullar who gained his art historical and philosophical knowledge through Pedrosa's tutelage.

In light of Pedrosa's interest in Gestalt psychology, subsequent art critics and historians such as Ronaldo Brito considered it to be an exclusive concern of concrete art since it corresponded to the drive for a scientific interpretation of art's function and action upon the world. This close association of concretism and Gestalt theory, as Brito argued, took shape as an autonomous enquiry that could benefit the rest of society:

> A brief analysis of concretist visual production immediately reveals its poles of interest and therefore, to a certain extent, its truth. This production characterised itself by the systematic exploration of serial form, of time, mechanical movement and it defines itself by its strictly ethical-sensorial intentions. That is, it proposed a perceptivist game against representational content – a program of ethical exercises that were, in themselves, 'beautiful' and significant, that meant the explication and invention of new visual syntagms whose interest was their capacity to renew the possibility of communication and their capacity to act as feedbacks, factors of the fight against entropy, to use the terminology of the theory of information. Concrete art is an aesthetic repertory of the optical and sensorial possibilities prescribed by the *Gestalt* theory.[34]

Brito established the chronological development of neoconcretism with respect to concrete art as a process that had exhausted the constructivist project. He posited concretism as the implementation of ideas brought into the country from Zurich and Ulm, while neoconcretism represented their absorption within the local Brazilian context. Moreover, Brito found the phenomenology of Merleau-Ponty, as well as existentialism in general, to be of key importance as Merleau-Ponty's attacks on Gestalt theory were analogous, for Brito, to neoconcretism's reactions against concrete art.

Gullar, for his part, saw the concretist interest in Gestalt psychology as related to the composition of the two-dimensional plane, which, when formed by geometrical arrangements, appeared to the viewer through the foreground/background distinction, while in neoconcretism the work became the foreground and its environment (the world) became its background.[35] Again, despite the fact these debates took place in very different contexts, a remarkably similar proposition to that of Gullar was expressed by Robert Morris:

> While the work must be autonomous in the sense of being a self-contained unit for the formation of the Gestalt, the indivisible and undissolvable whole, the major aesthetic terms are not in but dependent upon this autonomous object and exist as unfixed variables that find their specific definition in the particular space and light and physical viewpoint of the spectator.[36]

For Gullar,[37] neoconcretism did not regard Merleau-Ponty's phenomenology as entirely antagonistic to Gestalt psychology. The relationship between these two analytical approaches was in this sense coherent with that between concretism and neoconcretism, as expressed by Gullar in a column in the *Jornal do Brasil* in 1959, shortly after the first neoconcrete exhibition:

An important point expressed in the neoconcrete manifesto [...] concerns the insufficiency of Gestalt psychology in defining and comprehending, in all its complexity, the phenomenon of the work of art. It is not a question, of course, of negating the validity of the Gestaltian laws within the field of the perceptual experience where the direct method of this psychology really opened new possibilities in which to comprehend formal structures. Gestalt's limitation, according to Maurice Merleau-Ponty ('La Struture du Comportement' and 'La Phenomenology de la Perception') is in the interpretation that the theorists of form give to the experiments and tests that they have carried out, the laws that the experiments permitted being observed within the perceptual field [...] after thorough scrutiny of the concept of form show that Gestalt remains a causalist psychology, which in turn obliges it to give up the concept of 'isomorphism' in order to establish a unity between the external world and the internal one, between the object and the subject. We do not intend in this short note to do more than to draw the attention towards this important aspect of the new attitude – in practice and theory – that the neoconcrete artists adopt faced with constructive-geometric art.[38]

Gullar's critique of the notion of 'wholeness' within concrete art's related theory would therefore suggest a further distinction from Foster's argument that minimalism transcended the dialectics of objectivity versus subjectivity:

For it is precisely such metaphysical dualisms of subject and object that minimalism seeks to overcome in phenomenological experience.[39]

In contrast to such claims, Gullar drew on existential philosophy as well as the phenomenology of Merleau-Ponty in order to articulate the existential complexity within the object-subject relation. As he explained:

Whilst the subject exists for itself, the object, the thing exists in itself. Leaving aside the implications that [Sartre] draws from such a fundamental contradiction, let us stay with the fact that it reaffirms the opacity of the thing that rests on itself and the perplexity of the man who feels exiled amongst them. A nexus of significations and intentions constitutes the human world, in which the opacity of the non-human world persists, exterior to man. The experience of the object without-name is the experience of exile. The fight to overcome the subject-object contradiction is at the core of all human knowledge, of all human experience and particularly of the work of art.[40]

Underlying the distinguishing character of the non-object in relation to other more mundane objects was Gullar's implicit belief in art as an autonomous activity. Such autonomy was posited by his view that ordinary objects – due to their inescapable association with their name and thus with their function or place in the real world – were semantic hybrids. Their own specific form was the only aspect of their being that presented itself to the perceptual field. This is what Gullar meant by his statement that the non-object 'is a *transparent* body in terms of phenomenological knowledge: while being entirely perceptible it leaves no trace. It is a pure appearance'.[41] The non-object, in this manner, possessed an immanent signification associated with its form:

'Experiência Neoconcreta',
Suplemento Dominical,
Jornal do Brasil,
21–22 March 1959

the latter, according to Gullar, represented its pure signification.

Brito had described neoconcretism's insistence on the autonomy of art as a specific field of research (its perceptual purity in Gullar's terms), arguing that it represented an activity comparable to that of an experimental laboratory.[42] It is due to this emphasis on autonomy that the subsequent radical experimentalism during the 1960s of artists such as Lygia Clark and Hélio Oiticica cannot be considered as a continuation of the neoconcrete movement. The transition between the optimistic 1950s and the tumultuous 1960s deeply affected their practice.

With the political crisis brought about by the resignation of the recently elected president Janio Quadros in 1961, a radical shift took place within the cultural landscape of the nation. The unreserved belief in the modern destiny of the nation was swiftly replaced by a period of political and economic instability that would ultimately lead to the military coup in 1964. The aesthetic stance of avant-garde practice became unsustainable for many practitioners as artists and intellectuals saw themselves breaking away from the autonomy of their field and searching to establish relations with the Brazilian people. The legacy of neoconcretism varied from ex-members such as Oiticica, who attempted to articulate Brazilian popular culture with his previous aesthetic experiments, to artists such as Raymundo Collares, who acknowledged constructivist and neoconcrete aesthetics within his experiments that drew on pop art and the visual culture of the streets of Rio de Janeiro.

One of the most radical repercussions entailed by this transition in the arts was its effect on Ferreira Gullar. Approximately two years after publishing the 'Neoconcrete Manifesto' and the 'Theory of the Non-Object', Gullar abandoned the neoconcrete group to become involved with a movement of popular engagement, the CPC (Popular Centres for Culture), associated with the Marxist inclined National Students' Union (UNE).

From 1961, neoconcretism could no longer contain the diverging trajectories of its artists. Central to this dissolution of the neoconcrete movement was its apolitical posture. For Brito, the ideological lucidity of the constructivists' 'abdication of politics', via their emphasis on autonomy, related to the position taken by *concretismo* as a practice within the neutral fields of culture and economics and *neoconcretismo* as a practice within the neutral fields of culture and philosophy.[43]

Brito had thus emphasised the apolitical nature of concrete art by stressing that its interpretation of culture was a non-ideological and autonomous development.[44] As a specialised field of enquiry, it saw itself ideally entering a centralised state programme that would direct its aesthetic production into a meaningful relation with society as a whole. This position was sustainable while the country's *intelligenzia* had been intoxicated by the ideology of developmentalism: a belief that underdevelopment could be overcome through industrialisation, urbanisation, in short, planning. The most extravagant outcome of this line of thought was undoubtedly the new city of Brasilia.

Neoconcretism on the other hand, with its operation strictly restricted to the field of culture was, according to Brito, even less politically orientated.[45] It did not actively seek to inform industrial design, for instance, but preferred to remain strictly within the field of artistic activity:

Characteristically of underdevelopment such a typically Brazilian paradox occurred: a constructive avant-garde that did not guide itself based on a plan of social transformation and that operated in a manner that was almost marginal.[46]

According to Brito, this marginality in relation to society was one of the most significant characteristics of neoconcretism, as it had opened the possibility for a questioning not only of the premises of constructivism but of the nature of art itself.[47] While this argument is similar to that presented by Foster with regard to minimalism, Brito's epistemological differentiation between the two groups – concretism which placed 'man' as social and economic agent, while neoconcretism placed 'man' as a being in the world[48] – is specific to the debates in philosophy and science that influenced the context in which the relationship of art and society was discussed in post-war Brazil.

Acknowledging the retrospective nature of his essay, Brito admitted that neoconcretism – in attempting to escape the technicist nature of concretism – found two solutions contained in humanism: one that represented the peak of the constructivist tradition in Brazil (in which he included the artists Willys de Castro, Franz Weissmann, Hécules Barsotti, Aluísio Carvão and to a certain extent Amílcar de Castro). Such artists engaged in aesthetic research that held the sensibility of the work of art as paramount and sought to preserve its specificity. In the other more disruptive side to neoconcretism, such sensibility was replaced by a dramatisation of the work of art. In the latter category Brito had in mind artists such as Hélio Oiticica, Lygia Clark and Lygia Pape.[49] It would be possible to add to this group Ferreira Gullar himself who, through the production of object-poems, entered into an ambivalent space between written and visual language.

For Brito, neoconcretism thus held two distinct tendencies: a rationalist humanism which tended to inform industrial design in a qualitative manner, while preserving the specificity and aura of the work of art;[50] and another more disruptive tendency that distanced itself from the constructivist tradition through a dramatic transformation of art's function and *raison d'être*.[51] Both tendencies nevertheless maintained a united front against the precepts of concretism, either on account of its technicism (as opposed to the neoconcrete aesthetic sensibility) or, on the other hand, on account of its 'fear for the loss of the specificity (and aura) of the work of art'.[52]

Implicit in Hal Foster's argument that minimalism represented a rupture with modernism is the assumption that Greenbergian high modernism represents the culmination of modernism as a whole. This in fact is the most negative consequence of Foster's argument (its provincial nature[53]) and shows why a parallel discussion of neoconcretism – in the context of the 'peak and rupture' of the less totalising Brazilian constructivist project – seems pertinent. Indeed, considering Foster's key argument in *The Return of the Real* – in which he proposes that the neo-avant-garde brought the disruptive element of the historic avant-garde[54] into the institutional space of the gallery/museum as a form of critique from within – Alex Coles[55] has suggested that this approach seems oddly coherent with Greenberg's maxim that:

The essence of modernism lies, as I see it, in the use of the characteristic method of a discipline to criticise the discipline itself – not in order to subvert it, but to entrench it more firmly in its area of competence... modernism criticises from the inside, through the procedures themselves of that which is being criticised.[56]

Foster states from the outset that his argument stands as a critique of Peter Bürger's *Theory of the Avant-Garde*.[57] He argues that the utopian desire to merge art into the praxis of life (celebrated by Bürger) was replaced by the neo-avant-garde's pragmatic exercise of institutional critique from within. The historic avant-garde in Foster's account acts upon the neo-avant-garde through a process of deferred action while ignoring the heroic utopian idealism of its predecessors. If we are to extend such a logic beyond the association with the inescapably utopian character of Brasilia, and into the context of the relation that contemporary Brazilian art holds with movements such as neoconcretism, it is possible to remark that neoconcretism's apolitical stance together with the belief in the possibility of participating on equal terms within an international community of practitioners has been perversely fulfilled by the current position Brazilian contemporary art holds within the globalised art market.

Neoconcretism's effect upon subsequent art is in fact more complex than a Foster-like deferral would suggest. To a certain extent, one can observe the reversal of the process described by Foster. The radical neoconcrete artists, and particularly Oiticica, transformed the work's phenomenological character, its relation with the viewer, into a participative element that eventually transcended the domain of the institution of art (and some – including Gullar himself – would argue art itself), eventually questioning wider socio-cultural hierarchies. Such a connection with life was inextricably related to the concurrent political transitions of a country suffering from the hangover of the developmentalist dream of planned modernisation.

For today's historians, perhaps the most interesting characteristic of the 'Theory of the Non-Object', and by extension the neoconcrete movement, is precisely its out-of-jointness with respect to the wider history of art. Despite its innovative character and its importance within contemporary Brazilian art, it is this marginality towards mainstream history that maintains it within a strictly national context. Gullar realised this when, following his abandonment of the movement, he wondered whether in an underdeveloped country such as Brazil it is possible to envisage the notion of an avant-garde in a similar manner as is possible in Europe or North America.[58] Such an insight was not the product of a cosmopolitan modernist but that of a man on the eve of six years of political exile.[59] Gullar's subsequent critique of contemporary art practices goes beyond the scope of this study, yet his realisation that Brazilian avant-garde practice escaped canonical narratives of the development of modern art reveals the importance of re-evaluating the different chronologies existent within the wider history of modern art.

NOTES

1. Originally published as 'Teoria do Nao-Objeto' in Suplemento Dominical, *Jornal do Brasil*, 19–20 December 1959.

2. Note on translation. In the original: O não-objeto não é um antiobjeto mas um objeto especial em que se pretende realizada a síntese de experiências sensoriais e mentais: um corpo transparente ao conhecimento fenomenológico, integralmente perceptível, que se dá à percepção sem deixar rastro. Uma pura aparência. Please note also that the phrase that follows is not included in subsequent catalogue editions.

3. Lygia Clark has adopted, through a suggestion of mine, the term non-object as a means of describing her latest work that consist of constructions made directly in space. The meaning of such a term does not restrict itself as a definition of specific works: the sculptures of Amílcar de Castro, Franz Weissmann, recent work by Hélio Oiticica, Aluisio Carvão and Décio Vieira, together with the book-poems by the neoconcrete poets, are also non-objects. (Original 'Theory of the Non-Object' footnote.)

4. Note on translation. In the original: Cada vez mais o objeto representado perdia significação aos seus olhos […]. Here, 'a seus olhos' could refer to either the opinion of Maurice Denis or that of the figurative painters.

5. Note on translation. Reference here is to the 5th São Paulo Biennial.

6. Ferreira Gullar interview with the author, 27 April 2004.

7. Ferreira Gullar's abandonment of the neoconcrete movement and subsequent critique of contemporary practices is discussed later in this study.

8. Ivo Mesquita, reflecting upon the construction of such narratives, has claimed that it is necessary to 'offer alternatives to the sometimes accommodated and monolithic view that all contemporary Brazilian art is indebted to the powerful legacy of Lygia Clark and Hélio Oiticica' adding that it is 'a simplistic view, a seductive key of understanding aimed mainly at foreigners who rely on the oeuvre of these artists to approach Brazil's current art production'. See I. Mesquita, 'Nelson Leirner and Iran do Espírito Santo, Venice, 1999', in *Pavilhão Brasileiro, Bienal de Veneza*, exh. cat., Fundação Bienal de São Paulo, 1999, 38.

9. In this sense, it is possible to view two distinct events in 1951, the first São Paulo Biennial and the Festival of Britain, as part of the same international enthusiasm for modernity.

10. In São Paulo, the Art Museum (MASP) in 1947, and the Museum of Modern Art (MAM-SP) in 1948; in Rio, the Museum of Modern Art (MAM-RJ) in 1949.

11. Aracy Amaral ed., *Projeto Construtivo Brasileiro na Arte (1950 - 1962)*, exh. cat., Rio de Janeiro and São Paulo: Museu de Arte Moderna do Rio de Janeiro. Rio de Janeiro: MEC-FUNARTE and São Paulo: Secretaria da Cultura, Ciência e Tecnologia do Estado de São Paulo, Pinacotéca do Estado, 1977, 23.

12. This was suggested by Reynaldo Jardim. See *Os Neoconcretos*, documentary video, [K. Maciel dir.], Rio de Janeiro: N-IMAGEM, UFRJ, 2000. For an English translation of the neoconcrete manifesto see D. Ades, *Art in Latin America: The Modern Era 1820–1980*, New Haven and London: Yale University Press, 1989, 335. Originally published as 'Manifesto Neoconcreto', Rio de Janeiro: Suplemento Dominical, *Jornal do Brasil*, 22 March 1959.

13. F. Gullar, 'A Tregua, Interview with Ferreira Gullar', in *Cadenos da Literatura Brasileira*: no. 6, Gullar Ferreira, São Paulo: Instituto Moreira Salles, 1998, 35.

14. *Cadenos da Literatura Brasileira*: no. 6, Ferreira Gullar, op. cit., 11.

15. Characteristic of the artist's general ambivalent approach, Oiticica while departing radically from the premises of neoconcretism, was the first to argue this progression within his work. See L. Figueiredo, L. Pape, and W. Salomão eds, *Hélio Oiticica: Aspiro ao Grande Labirinto*, Rio de Janeiro: Rocco, 1986.

16. See H. Oiticica, 'Esquema Geral da Nova Objetividade', in *Nova Objetividade Brasileira*, exh. cat., Museu de Arte Moderna do Rio de Janeiro, 1967. Reprinted and translated in Witte de With et al., *Hélio Oiticica*, retrospective, exh. cat., Witte de With Center for Contemporary Art, 22 February – 26 April 1992; Galerie Nationale du Jeu de Paume, 8 June – 23 August; Fundació Antoni Tàpies, Barcelona, 1 October – 6 December 1992; Fundação Calouste Gulbenkian, Lisboa, 20 January – 20 March 1993; Walker Art Center, Minneapolis, 31 October – 20 February 1994, 110–19.

17. F. Gullar, 'A Tregua, Interview with Ferreira Gullar', in *Cadenos da Literatura Brasileira*: no. 6, Ferreira Gullar, op. cit., 37.

18. Ferreira Gullar has rejected any association that the neoconcrete movement had with modern Brazilian architecture, yet he agreed that both Brasilia and neoconcretism were products of the same political, social and cultural moment. Gullar interview with the author, 27 April 2004.

19. Most notable among which is Gerardo Mosquera's assumption that neoconcretism took place during the late 1960s and that Cildo Meireles's radically politicised work of the late 1960s and early 1970s was produced within the context of that movement. See Interview with Cildo Meireles, in P. Herkenhoff, G. Mosquera and D. Cameron, *Cildo Meireles*, London: Phaidon Press, 1999, 8–35.

20. B. Buchloh, Periodizing Critics, in H. Foster ed., *Discussions in Contemporary Culture*, Dia Art Foundation Number 1, Bay Press Seattle, 1987, 70.

21. Ibid., 68.

22. The (unspecified) work held an ambivalent position with respect to painting, relief and sculpture. Gullar mentioned that while Pedrosa described Clark's new work as a relief, the fact that there was no background plane meant that it could not be described as such. Realising that it was also neither painting nor sculpture, Gullar could only define it as an object, yet, such a definition remained unsatisfactory since it would not distinguish it from other ordinary objects such as the table, chair and so forth. Therefore the only possibility left, was to call it – initially jokingly, Gullar admits – a non-object. Of course, Gullar's own account also described Pedrosa's claim that to call something a non-object would be nonsensical. See F. Gullar, 'A Tregua, Interview with Ferreira Gullar', in *Cadenos da Literatura Brasileira*: no. 6, Ferreira Gullar, op. cit., 36.

23. The similarities that the 'Theory of the Non-Object' holds with Judd's (1965) essay *Specific Objects* have been raised by Ricardo Basbaum in a study on the ambivalent relationship between art and writing, and by Milton Machado in discussing art and its exteriority. See R. Basbaum, *Convergencias e Superposições Entre Texto e Obra de Arte*, Dissertação de Mestrado, Rio de Janeiro: UFRJ, 1996, 13.

24. D. Judd, 'Specific Objects', *Arts Yearbook*, 8, New York, 1965, 74–82. An edited version is reprinted in C. Harrison and P. Wood eds, *Art in Theory: 1900–1990, An Anthology of Changing Ideas*, Oxford: Blackwell, 1992, 809.

25. H. Foster, *The Return of the Real: The Avant-Garde at the End of the Century*, Cambridge, Massachusetts and London, England: MIT Press, 1996, 37–38.

26. Ibid., 42.

27. R. Brito, *Neoconcretismo: Vértice e Ruptura do Projeto Construtivo Brasileiro*, Rio de Janeiro: Marcos Marcondes, 1975. [Latest edition: R. Brito, *Neoconcretismo: Vértice e Ruptura do Projeto Construtivo Brasileiro*, São Paulo: Edições Cosac & Naify, 1999. Page numbers referred to throughout the study are based upon the English translation (of the original 1975 version): *Neoconcretism: Peak and Rupture of the Brazilian Constructivist Project*, in *Neoconcretismo: Vértice e Ruptura do Projeto Construtivo Brasileiro*, Rio de Janeiro: FUNARTE, Série Temas e Debates 4, 1985, 91–114.]

28. H. Foster, *The Return of the Real*, op. cit., 43.

29. Campos is quoted in Gullar's account of the debate. See F. Gullar, 'Debate Sobre a Arte Concreta', Suplemento Dominical, *Jornal do Brasil*, 12 October 1958.

30. M. Fried, 'Art and Objecthood', *Artforum*, Summer, 1967. Edited version reprinted in C. Harrison and P. Wood eds, *Art in Theory: 1900–1990, An Anthology of Changing Ideas*, Oxford: Blackwell, 1992, 822–34.

31. See interview with Gullar, in F. Cocchiarale and A.B. Geiger eds, *Abstracionismo Geométrico e Informal: a vanguarda brasileira nos anos cinquenta*, Instituto Nacional de Artes Plasticas, Rio de Janeiro: FUNARTE, 1987, 90.

32. Lucy Teixeira took a copy of Pedrosa's thesis to the Northeast state of Maranhão where Gullar was able to read it. The young poet was then able to write to Pedrosa – very pretentiously as he recalls – questioning some concepts. See F. Gullar, 'A Tregua, Interview with Ferreira Gullar', op. cit., 38.

33. Interview with Mário Pedrosa, in F. Cocchiarale and A.B. Geiger eds, *Abstracionismo Geométrico e Informal: a vanguarda brasileira nos anos cinquenta*, op. cit., 105.

34. R. Brito, *Neoconcretismo: Vértice e Ruptura do Projeto Construtivo Brasileiro*, Rio de Janeiro: Marcos Marcondes, op. cit., 101.

35. See interview with Ferreira Gullar, in *Os Neoconcretos*, op. cit.

36. R. Morris, 'Notes on Sculpture 1–3', in *Artforum*, vol. 4, no. 6, February 1966, 42–44; vol. 5, no. 2, October 1966, 20–23; vol. 5, no. 10, Summer 1967. Reprinted in edited version in C. Harrison and P. Wood eds, *Art in Theory: 1900–1990*, op. cit., 818.

37. Lygia Pape denied that neoconcrete artists, other than Gullar, had any form of profound knowledge of Merleau-Ponty's theories. See *Os Neoconcretos*, op. cit. F. Gullar 'Os Neoconcretos e a Gestalt', Suplemento Dominical, *Jornal do Brasil*, 15 March 1959.

38. In the original: Um ponto importante do manifesto neoconcreto [...] é o que se refere a insuficiencia da psicologia da Forma (Gestalt Psychology) para definir e compreender em toda a sua complexidade o fenômeno da obra de arte. Não se trata, evidentemente, de negar a validade das leis gestaltianas no campo da experiência perceptiva onde realmente o método direto dessa psicologia abriu novas possibilidades para a compreenção das estruturas formais. A limitação da Gestalt, conforme o afirma e demonstra Maurice Merleau-Ponty ('La Struture du Comportement' e 'La Phenomenology de la Perception') esta na interpretação que os teóricos da forma dão as experiencias e téstes que realisam, ou seja, as leis que as experiencias permitiram objetivar no campo perceptivo [...] depois de um exame minucioso do conceito da forma mostra que a Gestalt é ainda uma psicologia causalista, o que a obriga a lançar mão do conceito de 'isoformismo' para estabelecer a unidade entre o mundo exterior e o mundo interior, entre o sujeito e o objeto. Não pretendemos nesta pequena nota mais do que chamar a atenção para este aspecto importante da nova atitude - prática e teórica - que os artistas neoconcretos tomam em fase da arte construtivo-geométrica.

39. H. Foster, *The Return of the Real*, op. cit., 40.
40. F. Gullar, 'Dialogo Sobre o Não-Objeto', Suplemento Dominical, *Jornal do Brasil*, 26 March 1960. Translated by Hélio Oiticica in a letter to Guy Brett.
41. See 'Theory of the Non-Object' (notes 1 and 2 above).
42. R. Brito, *Neoconcretismo: Vértice e Ruptura do Projeto Construtivo Brasileiro*, op. cit., 107.
43. R. Brito, 'Ideologias Construtivas no Ambiente Cultural Brasileiro', in A. Amaral ed., *Projeto Construtivo Brasileiro na Arte (1950–1962)*, exh. cat., Rio de Janeiro and São Paulo: Museu de Arte Moderna do Rio de Janeiro. Rio de Janeiro: MEC- FUNARTE & São Paulo: Secretaria da Cultura, Ciência e Tecnologia do Estado de São Paulo, Pinacotéca do Estado, 1977, 304.
44. R. Brito, *Neoconcretismo: Vértice e Ruptura do Projeto Construtivo Brasileiro*, op. cit.
45. R. Brito, 'Ideologias Construtivas no Ambiente Cultural Brasileiro', op. cit., 307.
46. Ibid. In the original: Ocorreu então esse paradoxo tão brasileiro e tão próprio do subdesenvolvimento: uma vanguarda construtiva que não se guiava diretamente por nenhum plano de transformação social e que operava de um modo quase marginal.
47. Ibid.
48. Ibid., 305.
49. R. Brito, *Neoconcretismo: Vértice e Ruptura do Projeto Construtivo Brasileiro*, op. cit.
50. Franz Weissmann's comments that he did not see the necessity of adding a 'neo' to concretism seem coherent with this claim. See *Os Neoconcretos*, op. cit.
51. R. Brito, *Neoconcretismo: Vértice e Ruptura do Projeto Construtivo Brasileiro*, op. cit.
52. R. Brito, 'Ideologias Construtivas no Ambiente Cultural Brasileiro', op. cit., 306.
53. Speaking at the Royal College of Art in London, (*Performance and Process in Relation to Judgement and Excess*, lecture series, 24 February 1999), Foster had indeed admitted the provincialism of his position.
54. As outlined in P. Bürger, *The Theory of the Avant-Garde*, translated by M. Shaw [based on the second German edition 1974], University of Minnesota, 1984.
55. A. Coles, 'Rendevous: Walter Benjamin and Clement Greenberg – Programme of the Coming Art', in A. Coles and R. Bentley eds, *de-,dis-,ex*, vol. 1: Excavating Modernism. London: Backless Books and Black Dog Publications, 1996, 62–63.
56. C. Greenberg, 'Modernist Painting' (originally published as a part of the Forum Lectures, *Voice of America*, Washington, DC, 1960), in J. O'Brian, ed., *Clement Greenberg: The Collected Essays and Criticism*, vol. 4, 1993, 85. The passage is quoted in Coles, 1996, 63.
57.. P. Bürger, *The Theory of the Avant-Garde*, translated by M. Shaw [based on the second German edition 1974], University of Minnesota, 1984.
58. F. Gullar, *Vanguarda e subdesenvolvimento*, Civilização Brasileira, Rio de Janeiro, 1969.
59. Following his involvement with left-wing politics through the CPC, he was arrested in 1968, lived in clandestine conditions for a period and eventually left Brazil in 1971, staying in exile (Moscow, Santiago, Lima and Buenos Aires) until 1977.

p. 20
Gavin Jantjes, *Untitled,*
1989
Sand, tissue paper
and acrylic on canvas
© G. Jantjes. Arts Council
Collection, Hayward
Gallery, London

p. 27
Gaganendranath Tagore
(1867–1938), *Cubism,* c.1921
Watercolour on paper,
4 12 x 4 12 inches
Collection of P. & S. Mitter

p. 32
Ravi Varma
(1848–1906), *The Triumph
of Indrajit (from the
epic Ramaya),* 1903
Oil on canvas
Courtesy of Sri
Jayachamarajendra
Art Gallery, Mysore,
Karnataka, India

p. 37
Abanindranath Tagore
(1871–1951), *Bharat Mata
(Mother India),* 1905
Watercolour on paper,
4 12 x 7 12 inches
Courtesy of Rabindra
Bharati Society, Jorasanko,
Kolkata, India

p. 44
Jamini Roy (1887–1972),
Jashoda and Krishna,
c.1940
Gouache on specially
prepared paper
Courtesy of the artist's
family

p. 52
Weissenhofsiedlung from
'Schönblick' restaurant
tower, Stuttgart, 1931
Photograph
(Landesmedienzentrum
Baden-Württemberg/
Robert Bothner)

p. 54
J.J.P. Oud, *Five Row
(Terrace) Houses at the
Weissenhofsiedlung,
Stuttgart,* 1927, rear view
Photograph
Collection of Netherlands
Architecture Institute,
Rotterdam, Archive of
J.J.P. Oud, inv. nr. ph 408
© DACS 2005

p. 58
'Arab Village'
(photomontage of the
Weissenhofsiedlung
with Arabs in traditional
dress, camels and lions),
Stuttgart, late 1930s
Post card
Reprod.: LMZ

p. 62
Rachel Whiteread,
House, 1993
Commissioned and
produced by Artangel, 1993
Photograph © Artangel

p. 72
Agustin Cárdenas,
*Mon ombre après minuit:
L'être lunaire,* 1988
Black and white wood,
95 58 x 30 38 x 4 inches
Image courtesy of André
Cárdenas

p. 76
Jorge Camacho,
Behique (I), 1998
Oil on canvas, 100 x 100 cm
Courtesy of Basilio Muro,
Galeria Muro, Valencia,
Spain

p. 77
Ivan Tovar, *Le clé de
l'amour,* 1978
Oil on canvas, 130 x 97cm
© Ivan Tovar
Courtesy of the artist

p. 79
Hervé Télémaque, *Bannière
(Les noms du père),* 1998
Acrylic on canvas,
159 x 132 cm
© Hervé Télémaque
Image courtesy of the artist

p. 91
Wifredo Lam, *Déesee avec
feuillage [Jungle Goddess/
Goddess with Foliage],*
1942
Gouache on paper,
41 12 x 33 12 inches
(105.4 x 85.1 cm) (framed)
The Metropolitan Museum
of Art, The Pierre and Maria-
Gaetana Matisse Collection,
2002 (2002.456.32)
© ADAGP, Paris and DACS,
London 2005
Photograph © 2002
The Metropolitan Museum
of Art

p. 92
Wifredo Lam,
The Jungle, 1943
Gouache on paper,
mounted on canvas, 7 feet
10 inches x 7 feet 6 12 inches
(239.4 x 229.9 cm)
© ADAGP, Paris and
DACS, London 2005
Digital Image © The
Museum of Modern Art,
NY/Scala, Florence 2005

p. 95
Wifredo Lam, *Oya
[Divinité de l'air et de la
mort/ Idolos],* 1944
Oil on canvas, 160 x 127 cm
© ADAGP, Paris and DACS,
London 2005
Photograph courtesy of
SDO Wifredo Lam

p. 105
Norman W. Lewis, *Every
Atom Glows: Electrons in
Luminous Vibration,* 1951
Oil on canvas,
54 x 35 inches
© Estate of Norman W. Lewis
Private collection of John
Axelrod, Boston, MA, US
Photographed by
Clive Russ

p. 108
Norman W. Lewis,
Metropolitan Crowd, 1946
Oil on canvas,
17 18 x 39 58 inches
© Estate of Norman W. Lewis
Delaware Art Museum,
Louisa du Pont Copeland
Memorial Fund and partial
gift of Ouida
B. Lewis in memory of
Harvey W. Singleton, 1994
DAM # 1994-48

Arranged into three sections, this bibliography provides an orientation into the field of study with regards to cultural difference in the visual arts. The first section features contemporary art writing alongside important contributions from related humanities disciplines; the second foregrounds art historical studies engaged with post-colonial methods and approaches; and the surveys grouped by geographical region, in the third section, include both historical studies and exhibition catalogues.

Cultural Difference and Contemporary Art

Arjun Appadurai, *Modernity at Large: Cultural Dimensions of Globalisation*, Minneapolis: University of Minnesota, 1997

Rasheed Araeen, Sean Cubitt and Ziaddin Sadar eds, *The Third Text Reader on Art, Culture and Theory*, London: Continuum, 2002

Orianna Baddeley and Valerie Fraser eds, *Drawing the Line: Art and Cultural Identity in Contemporary Latin America*, London: Verso, 1989

Homi Bhabha, 'Beyond the Pale: Art in an Age of Multicultural Translation', in Elizabeth Sussman et al. eds, *1993 Biennial Exhibition*, New York: Whitney Museum of American Art/Abrams, 1993

Avtar Brah and Annie Coombes eds, *Hybridity and Its Discontents: Politics, Science, Culture*, London and New York: Routledge, 2000

Centre George Pompidou, Les Cahiers Du Musée National D'Art Moderne, no. 28, *Magiciennes de la Terre*, Paris: Editions du Centre Pompidou, 1989

Katy Deepwell ed., *Art Criticism and Africa*, London: Saffron, 1998

Gina Dent and Michele Wallace eds, *Black Popular Culture*, Seattle: Bay Press, 1992

Documenta and Museum Fredricianum, *Documenta 11 Platform 5: Exhibition*, Kassel: Hatje Cantz Publishers, 2002

Gen Doy, *Black Visual Culture: Modernity and Postmodernity*, London: I.B. Taurus, 1995

Jimmie Durham, *A Certain Lack of Coherence*, London: Kala Press, 1993

Okwui Enwezor ed., *Trade Routes: History and Geography* (2nd Johannesburg Biennale), Johannesburg: Greater Johannesburg Metropolitan Council/Prince Claus Fund, 1997

Russell Ferguson, Martha Gever, Trin T. Minh-ha and Cornel West eds, *Out There: Marginalization and Contemporary Culture*, New York: New Museum, 1990

Jean Fisher ed., *Global Visions: Towards a New Internationalism in the Visual Arts*, London: Kala Press, 1994

Jean Fisher ed., *Reverberations: Tactics of Resistance/Forms of Agency in Transcultural Practices*, Maastricht: Jan van Eyck Akademie, 2000

Jean Fisher, 'The Syncretic Turn: Cross Cultural Practices in the Age of Multiculturalism', in Melina Kalinovska ed., *New Histories*, Boston: Institute for Contemporary Arts, 1995

Jean Fisher, 'Some Thoughts on "Contaminations"', *Third Text*, no. 32, Autumn 1995, 3–7

Jean Fisher, 'The Work Between Us', in Okwui Enwezor eds, *Trade Routes: History and Geography*, Johannesburg: Prince Claus Fund, 1997

Hal Foster, *The Return of the Real: The Avant-Garde at the End of the Century*, Cambridge: MIT Press, 1996

Coco Fusco, *English is Broken Here: Cultural Fusion in America*, New York: The New Press, 1994

Sunil Gupta ed., *Disrupted Borders*, London: Rivers Oram, 1992

Stuart Hall and David A. Bailey eds, 'Critical Decade: Black British Photography in the 80s', *Ten. 8*, vol. 2, no. 3, 1992

Stuart Hall and Jessica Evans eds, *Visual Culture: The Reader*, London: Sage, 2002

Stuart Hall and Sarat Maharaj, *Modernity and Difference* (Annotations 6), London: INIVA, 2001

Stuart Hall and Mark Sealy eds, *Different*, London: Phaidon, 2001

Salah Hassan, *Gendered Visions: The Art of Contemporary Africana Women*, Trenton: Africa World Press, 1997

House of World Cultures, *Dis-Orientation: Contemporary Arab Artists from the Middle East*, Berlin: House of World Cultures, 2003

Wu Hung ed., *Chinese Art at the Crossroads: Between Past and Future, Between East and West*, London and Hong Kong: New Art Media/ INIVA, 2002

Geeta Kapur, *When Was Modernism: Essays on Contemporary Cultural Practice in India*, New Delhi: Tulika, 2000

Ria Lavrisjen ed., *Cultural Diversity in the Arts*, Amsterdam: Royal Tropical Institute, 1993

Ria Lavrisjen ed., *Intercultural Arts Education and Municipal Policy*, Amsterdam: Royal Tropical Institute, 1997

Lucy R. Lippard, *Mixed Blessings: New Art in a Multicultural America*, New York: The New Press, 1990

Fran Lloyd ed., *Displacement and Difference: Contemporary Arab Visual Culture in the Diaspora*, London: Saffron, 2001

Edward Lucie-Smith, *Race, Sex and Gender in Contemporary Art: The Rise of Minority Culture*, New York: Art Books International, 1994

Edward Lucie-Smith, *Art Today*, London: Phaidon, 1999

Thomas MacEvilley, *Art and Otherness: Crisis in Cultural Identity*, New York: McPherson and Co., 1992

Sarat Maharaj, 'The Congo is Flooding the Acropolis', in Kellie Jones and Thomas Sokalowski eds, *Interrogating Identity*, New York: Grey Art Gallery, New York University, 1991

Kobena Mercer, *Welcome to the Jungle: New Positions in Black Cultural Studies*, New York and London: Routledge, 1994

Kobena Mercer, 'Ethnicity and Internationality: New British Art and Diaspora-Based Blackness', *Third Text*, no. 49, Winter 1999, 51–62

Nicholas Mirzoeff, *The Visual Culture Reader* (2nd edn), New York and London: Routledge, 2003

Gerlado Mosquera, 'The Marco Polo Syndrome: Some problems around Art and Eurocentrism', *Third Text*, no. 21, Winter 1992/93, 35–41

Everlyn Nicodemus, 'Meeting Carl Einstein', *Third Text*, no. 23, Summer 1993, 31–38

Everlyn Nicodemus and Kristian Romare, 'Africa, Art Criticism and the Big Commentary', *Third Text*, no. 41, Winter 1997/98, 53–65

Olu Oguibe, *The Culture Game*, Minneapolis: University of Minnesota, 2004

Nikos Papastergiadis, *The Complicities of Culture: Hybridity and 'New Internationalism'*, Manchester: Cornerhouse Communique, no. 4, 1994

Nikos Papastergiadis, *Dialogues in Diaspora*, London: Rivers Oram, 1998

Nikos Papastergiadis, *The Turbulence of Migration*, Cambridge: Polity, 2000

Nikos Papastergiadis ed., *Mixed Belongings and Unspecified Destinations* (Annotations 1), London: INIVA, 1996

Nelly Richard, 'Postmodernism and Periphery', *Third Text*, no. 2, Winter 1987/88, 5–12

Gilane Tawadros and Victoria Clark eds, *Run Through the Jungle: Selected Writings by Eddie Chambers* (Annotations 8), London: INIVA, 2000

Caroline Turner ed., *Tradition and Change: Contemporary Art of Asia and the Pacific*, Queensland: University of Queensland Press, 1993

Michele Wallace, 'Modernism, Post-modernism and the Problem of the Visual in Afro-American Culture', in Ferguson et al. eds, *Out There: Marginalization and Contemporary Culture*, New York: New Museum, 1990

Prina Werbner and Tariq Modood eds, *Debating Cultural Hybridity*, London: Zed, 1997

Alice Yang, *Why Asia? Contemporary Asian and Asian-American Art*, New York: New York University Press, 1998

Post-colonial Studies and the History of Art

Dawn Ades, 'Constructing Histories of Latin American Art', in Charles W. Haxthausen ed., *The Two Histories: The Museum and the University*, Williamstown: Clark Art Institute/Yale University Press, 2002

Aijaz Ahmed, *In Theory: Classes, Nations, Literatures*, London: Verso, 1992

Malleck Allouah, *The Colonial Harlem*, Minneapolis: University of Minnesota, 1985

Anthony Appiah, *In My Father's House: Africa in the Philosophy of Culture*, New York: Oxford University Press, 1992

Petrine Archer-Straw, *Negrophilia: Black Culture and Avant-Garde Paris*, London and New York: Thames and Hudson, 2000

Bill Ashcroft, Gareth Griffiths and Helen Tiffin eds, *The Postcolonial Studies Reader*, London and New York: Routledge, 1995

Orianna Baddeley, 'Her Dress Hangs Here: De-Frocking the Frida Cult', *Oxford Art Journal*, vol. 14, no. 1, 1991, 10–17

Orianna Baddeley, 'Nostalgia for a New World', *Third Text*, no. 21, Winter 1992/93, 29–34

Senake Bandaranayake, 'Ivan Peries (Paintings 1939-69)', *Third Text*, no. 2, Winter 1987/88, 76–92

Tim Barringer and Tom Flynn eds, *Colonialism and the Object: Empire, Material Culture and Museums*, New York and London: Routledge, 1998

Maurice Berger, *How Art Becomes History*, New York: Harper Collins, 1993

Maurice Berger ed., *Modern Art: A Multicultural Reader, 1860–1990*, New York: Harper Collins, 1994

Homi Bhabha, *The Location of Culture*, London and New York: Routledge, 1994

Jody Blake, *Le Tumult Noir: Modernist Art and Popular Entertainment in Jazz Age Paris, 1900–1930*, Pennsylvania: Pennsylvania State University Press, 1999

Jody Blake, 'The Truth About the Colonies, 1931: Art Indigène in Service of the Revolution', *Oxford Art Journal*, vol. 25, no. 1, 2002, 35–58

Albert Boime, *The Art of Exclusion: Representing Blacks in the 19th Century*, London and New York: Thames and Hudson, 1989

Benjamin Buchloh and Jean-Hubert Martin, 'Interview', *Third Text*, no. 6, Spring 1989, 19–27

Ladislas Bugner ed., *The Image of the Black in Western Art* (Volumes I – IV), Cambridge: Harvard University Press, 1989

Nestor Cancilini, *Hybrid Cultures*, Minneapolis: University of Minnesota, 1995

Anna Chave, 'New Encounters with "Les Demoiselles d'Avignon": Gender, Race and the Origins of Cubism', *Art Bulletin*, no. 76, vol. 4, December 1994, 527–44

James Clifford, *The Predicament of Culture*, Cambridge: Harvard University Press, 1988

James Clifford, *Routes: Travel and Translation in the Late 20th Century*, Cambridge: Harvard University Press, 1999

Frances Connelly, *The Sleep of Reason; Primitivism in Modern European Art and Aesthetics 1725–1907*, Pennsylvania: Pennsylvania State University Press, 1995

Annie Coombes, *Reinventing Africa: Museums, material culture and popular imagination in late Victorian and Edwardian England*, New Haven and London: Yale University Press, 1994

David Craven, *Diego Rivera as Epic Modernist*, Boston: G.K. Hall, 1997

David Craven, *Art and Revolution in Latin America, 1910–1990*, New Haven and London: Yale University Press, 2002

David Craven, 'Abstract Expressionism and Third World Art: A Post-Colonial Approach to American Art', *Oxford Art Journal*, vol. 14, no. 1, Spring 1991

David Craven, 'The Latin American Origins of Alternative Modernism', *Third Text*, no. 36, Autumn 1996

David Craven, 'Postcolonial Modernism in the work of Diego Rivera and Jose Carlos Mariategui', *Third Text*, no. 54, Spring 2002

David Craven, 'Art History and the Challenge of Postcolonial Modernism', *Third Text*, no. 60, Autumn 2002

David Dabydeen, *Hogarth's Blacks*, Manchester: Manchester University Press, 1985

Abdelai Dahrouch, 'The Neglected Side: Matisse and Eurocentrism', *Third Text*, no. 24, Autumn 1993, 13–24

David Driskell ed., *African American Visual Aesthetics*, Washington: Smithsonian Institution Press, 1996

Elizabeth Edwards ed., *Anthropology and Photography 1860–1920*, New Haven and London: Yale University Press, 1992

Steve Edwards ed., *Art and Its Histories: A Reader*, London and New Haven: Open University and Yale University Press, 1998

Jack Flam with Miriam Deutsch, *Primitivism and 20th Century Art: A Documentary History*, Berkeley: University of California, 2003

Hal Foster, 'The "Primitive" Unconscious of Modern Art, or White Skins, Black Masks', in *Recodings: Art, Spectacle, Cultural Politics*, Seattle: Bay Press, 1985

Hal Foster, '"Primitive" Scenes', *Critical Inquiry*, no. 20, Autumn 1993

Frances Frascina and Jonathan Harris eds, *Art in Modern Culture: An Anthology of Critical Texts*, London: Open University and Phaidon, 1992

Henry Louis Gates Jr ed., *"Race," Writing and Difference*, London and Chicago: University of Chicago, 1985

Ann Eden Gibson, *Abstract Expressionism: Other Politics*, New Haven and London: Yale University Press, 1997

Ann Eden Gibson, *Norman Lewis: The Black Paintings, 1946–1977*, New York: Studio Museum in Harlem, 1998

Ann Eden Gibson, 'Faith Ringghold and the Avant-Garde', in *Faith Ringghold: Quilts*, New York: New Museum, 1998

Sander Gilman, *Difference and Pathology: Stereotypes of Sexuality, Race and Madness*, Ithaca: Cornell University Press, 1985

Sander Gilman, 'The Figure of the Black in German Aesthetic Theory', *Eighteenth Century Studies*, vol. 6, no. 4, 1975, 373–91

Paul Gilroy, *The Black Atlantic: Modernity and Double Consciousness*, London and Cambridge: Harvard University Press, 1993

Paul Gilroy, 'Art of Darkness', in Paul Gilroy, *Small Acts*, London: Serpents Tail, 1993

Tapati Guha-Thakurta, *The Making of a New 'Indian Art': Art, Aesthetics and Nationalism*, Cambridge: Cambridge University Press, 1992

Sneja Gunew and Fazal Rizvi eds, *Culture, Difference and the Arts*, Sydney: Allen and Unwin, 1994

Stuart Hall, 'The Local and the Global: Globalization and Ethnicity', in Anthony King ed., *Culture, Globalisation and the World System*, Binghampton: State University of New York and Macmillan Education, 1991

Jonathan Harris, *The New Art History: A Critical Introduction*, London: Routledge, 2001

Charles Harrison, Frances Frascina and Gill Perry, *Primitivism, Cubism, Abstraction: The Early 20th Century*, London and New Haven: Open University and Yale, 1993

Susan Hiller ed., *Myths of Primitivism*, London: Routledge, 1991

Hugh Honour, *The Image of the Black in Western Art*, Volume IV, Parts 1 and 2, Cambridge: Harvard University Press, 1989

Osman Jamai, 'E.B. Havell: The Art and Politics of Indianness', *Third Text*, no. 39, Summer 1997, 3–19

Rannjana Khanna, 'Latent Ghosts and The Manifesto: Baya, Breton and Reading for the Future', *Art History*, vol. 26, no. 2, 2003, 238–80

Catherine King ed., *Views of Difference: Different Views of Art*, London and New Haven: Open University and Yale, 1999

Patricia Leighten, 'The White Peril and L'Art negre: Picasso, Primitivism and Anti-colonialism', *Art Bulletin*, vol. 72, no. 4, 1990

Sieglinde Lempke, *Primitivist Modernism: Black Culture and the Origins of Transatlantic Modernism*, New York and London: Oxford University Press, 1998

Reina Lewis, *Gendering Orientalism: Race, Femininity and Representation*, London: Routledge, 1996

Ania Looba, *Colonialism/Postcolonialism*, London: Routledge, 1998

John MacKenzie, *Orientalism: History, Theory and The Arts*, Manchester: Manchester University Press, 1995

Anne McClintock, *Imperial Leather: Race, Gender and Sexuality in the Colonial Conquest*, London and New York: Routledge, 1995

Kobena Mercer, 'Romare Bearden: African American Modernism at Mid-century', in Keith Moxey and Michael Ann Holly eds, *Art History, Aesthetics, Visual Studies*, Williamstown: Clark Art Institute and Yale University Press, 2002

Nicholas Mirozeoff ed., *Diaspora and Visual Culture: Representing Blacks and Jews*, New York and London: Routledge, 2000

Timothy Mitchell, *Colonizing Egypt*, Cambridge: Cambridge University Press, 1988

Partha Mitter, *Much Maligned Monsters: History of European Reactions to Indian Art*, Oxford: Oxford University Press, 1977

Partha Mitter, *Art and Nationalism in Colonial India 1850–1922: Occidental Orientations*, Cambridge: Cambridge University Press, 1994

Linda Nochlin, 'The Imaginary Orient', in Linda Nochlin, *The Politics of Vision: Essays on Nineteenth Century Art and Society*, New York: Harper Collins, 1989

Ikem Stanley Okoye, 'Tribe and Art History', *Art Bulletin*, vol. 79, no. 4, December 1996, 610–15

Kymberly Pinder ed., *Race-ing Art History: Critical Readings in Race and Art History*, New York: Routledge, 2002

Griselda Pollock, *Differencing the Canon: Feminist Desire and the Writing of Art's Histories*, London and New York: Routledge, 1999

Colin Rhodes, *Primitivism and Modern Art*, London and New York: Thames and Hudson, 1994

Michael Richardson, *Refusal of the Shadow: Surrealism and the Caribbean*, London: Verso, 1996

Michael Richardson, 'Enough Said? Reflections on Orientalism', *Anthropology Today*, vol. 6, no. 4, August 1990

Michael Richardson with K. Fijalkowski, 'Years of Long Days: Surrealism in Czechoslavakia', *Third Text* no. 36, Autumn 1996, 15–28

William Rubin, *'Primitivism' in 20th Century Art: Affinities of the Tribal and the Modern*, New York: Museum of Modern Art/Abrams, 1984

Edward Said, *Orientalism*, London and New York: Routledge, 1978

Edward Said, *Culture and Imperialism*, London: Chatto and Windus, 1993

Edward Said, *Freud and the Non-European*, London: Verso/Freud Museum, 2003

Gayatri Spivak, *In Other Worlds: Essays in Cultural Politics*, London and New York: Methuen, 1987

Robert Farris Thompson, *Flash of the Spirit: African and Afro-American Art and Philosophy*, New York: Vintage, 1983

Tzvetan Todorov, *The Conquest of America: The Question of the Other*, New York: Harper and Row, 1985

Maria Torognovic, *Gone Primitive: Savage Intellects: Modern Lives*, Chicago: University of Chicago, 1990

Patrick Williams and Laura Chrisman eds, *Colonial Discourse and Post-Colonial Theory*, Cambridge: Harvester/Wheatsheaf, 1993

Raymond Williams, *The Politics of Modernism*, London: Verso, 1989

Meyda Yegengolu, *Colonial Fantasies: Towards a Feminist Reading of Orientalism*, Cambridge: Cambridge University Press, 1998

Surveys

North America

Janet Catherine Berlo ed., *The Early Years of Native American Art History: The Politics of Scholarship and Collecting*, Seattle and London: University of Washington Press, 1992

Janet C. Berlo and Ruth B. Phillips, *Native North American Art*, London and New York: Oxford University Press, 1998

Sharon Patton, *African American Art*, New York and London: Oxford University Press, 1999

Richard Powell, *Black Art and Cultural History*, New York and London: Thames and Hudson, 2002

Richard Powell and David A. Bailey eds, *Rhapsodies in Black: Art of the Harlem Renaissance*, Berkeley and London: University of California/Hayward Gallery, 1997

W. Jackson Rushing ed., *Native American Art in the Twentieth Century*, New York: Routledge, 1999

The Decade Show, New York: New Museum of Contemporary Art, Museum of Contemporary Hispanic Art, Studio Museum in Harlem, 1990

The Caribbean

Petrine Archer-Straw ed., *Fifty Years – Fifty Artists: 1950–2000 The School of Visual Arts*, Kingston: Ian Randle and Edna Manley College of the Visual and Performing Arts, 2000

Holly Block ed., *Art Cuba: The New Generation*, New York: Abrams, 2001

David Boxer and Veerle Poupeye, *Modern Jamaican Art*, Kingston: Ian Randle and University of West Indies, 1998

Luis Camnitzer, *New Art of Cuba*, Austin: University of Texas, 1994

Juan A. Martinez, *Cuban Art and National Identity: The Vanguardia Painters 1927–1950*, Florida: University Press of Florida, 1994

Veerle Poupeye, *Caribbean Art*, London and New York: Thames and Hudson, 1998

Lowery Stokes Sims, *Wifredo Lam and the International Avant-Garde, 1923–1982*, Austin: University of Texas, 2002

Jose Veigas et al. eds, *Memoria: Cuban Art of the 20th Century*, Los Angeles: California International Arts Foundation, 2002

Ann Walmsley, *The Caribbean Artists Movement, 1966–1972*, London: New Beacon, 1992

Latin America

Dawn Ades ed., *Art in Latin America: The Modern Era, 1820–1980*, New Haven and London: Yale University Press/Hayward Gallery, 1989

Geraldine P. Biller ed., *Latin American Women Artists 1915–1995*, Milwaukee: Milwaukee Art Museum, 1995

Guy Brett, *Transcontinental: Nine Latin American Artists*, London: Verso, 1995

Valerie Fletcher ed., *Crosscurrents of Modernism: Four Latin American Pioneers*, Washington, DC: Smithsonian Institute Press, 1992

Edward Lucie-Smith, *Latin American Art of the 20th Century*, New York and London: Thames and Hudson, 1993

Geraldo Mosquera ed., *Beyond the Fantastic: Contemporary Art Criticism from Latin America*, London and Cambridge: INIVA/MIT Press, 1995

Walso Rasmussen with Fatima Bercht and Elizabeth Ferrer, *Latin American Artists of the Twentieth Century*, New York: Museum of Modern Art/Abrams, 1993

Edward Sullivan ed., *Latin American Art in the Twentieth Century*, London: Phaidon, 1998

Marta Traba, *Art of Latin America 1900–1980*, Washington: Inter-America Development Bank/John Hopkins University Press, 1994

Jane Turner ed., *Encyclopedia of Latin American and Caribbean Art*, London and New York: Macmillan, 2000

Africa

Clementine Deliss ed., *Seven Stories about Modern Art in Africa*, London: Whitechapel Gallery, 1995

Laurie Farrell ed., *Looking Both Ways: Art of the Contemporary African Diaspora*, New York and Ghent: Museum for African Art/Snoeck, 2003

Olu Oguibe and Okwui Enwezor eds, *Reading the Contemporary: African Art from Theory to the Marketplace*, London and Cambridge: INIVA/MIT Press, 1999

Simon Ottenberg ed., *The Nkussa Artists and Nigerian Contemporary Art*, Washington, DC: National Museum of African Art/Smithsonian Institute, 2002

Gilane Tawadros and Sarah Campbell eds, *Fault Lines: Contemporary African Art and Shifting Landscapes*, London: INIVA, 2003

The Arab World

Fatma Ismail Afifi, *Twenty-Nine Artists in the Museum of Egyptian Modern Art*, Cairo: AICA, 1994

Wijdan Ali, *Modern Islamic Art: Development and Continuity*, Florida: University Press of Florida, 1997

Wijdan Ali ed., *Contemporary Art from the Islamic World*, London and Amman: Scorpion/Royal Society of Fine Arts, Jordan, 1989

Barbican Centre, *Lebanon – The Artist's View: 200 Years of Lebanese Art*, London: Barbican Centre, 1989

Liliane Karnouk, *Modern Egyptian Art: The Emergence of a National Style*, Cairo: American University in Cairo, 1998

Salwa Mikdadi Nashashibi ed., *Forces of Change: Artists of the Arab World*, Lafayette and Washington, DC: International Council for Women in the Arts and National Museum of Women in the Arts, 1994

Sherifa Zuhur ed., *Images of Enchantment: Visual and Performing Arts of the Middle East*, Cairo: American University in Cairo, 1998

South Asia

Geeta Kapur, *Contemporary Indian Artists*, New Delhi: Vikas Publishing, 1978

Balraj Khanna and Aziz Kurtha, *Art of Modern India*, London: Thames and Hudson, 1998

Partha Mitter, *Indian Art*, New York and London: Oxford University Press, 2001

Akbar Naqvi, *Image and Identity: Fifty Years of Painting and Sculpture in Pakistan*, Karachi: Oxford University Press, 1998

Shivaji K. Panikkar, Parul Dave Mukherji and Deeptha Achar eds, *Towards a New Art History: Studies in Indian Art*, New Delhi: DK Printworld, 2003

Ratan Parimoo, *Creative Arts in Modern India*, New Delhi: Books and Books, 1995

T.K. Sabapathy ed., *Modernity and Beyond: Themes in Southeast Asian Art*, Singapore: Singapore Art Museum, 1996

Asia Pacific

John Clark, *Modern Asian Art*, Sydney:
Art Asia Pacific/G + B Arts International, 1998

David Clarke, *Hong Kong Art: Culture and
Decolonization*, London: Reaktion, 2001

David Elliot and Kazu Kaido ed., *Reconstructions:
Avant-Garde Art in Japan, 1945-65*, Oxford:
Museum of Modern Art Oxford

Maria Galikowski, *Art and Politics in China,
1949–1984*, Hong Kong: The Chinese University
Press, 1998

Alexandra Munroe ed., *Japanese Art After 1945:
Scream Against the Sky*, Yokohama: Yokohama
Museum of Art/Abrams, 1994

Jochen Noth, Isabel Pohlmann and Kai Reschke
eds, *China Avant-Garde*, Berlin: Editions Braus,
1993

Britain

Rasheed Araeen ed., *The Other Story: Afro-Asian
Artists in Post-War Britain*, London: Hayward
Gallery, 1989

Moira Beauchamp-Byrd and Franklin Sirmans
eds, *Transforming the Crown: African, Asian and
Caribbean Artists in Britain, 1966–1996*, New York:
Caribbean Cultural Center, 1997

Europe

Stephen Mansbach, *Modern Art in Eastern
Europe: from the Baltic to the Balkans
ca. 1890–1939*, Cambridge: Cambridge University
Press, 1999

Michael Asbury
Born in Teresopolis, Rio de Janeiro, the son of
British missionaries, Michael Asbury was
educated in Brazil until the age of 20. He is
currently a Research Fellow in art history at the
University of the Arts, London, working on the
'Transnational Art Identity and Nation' project.
His fellowship was previously associated with
'Modernity and National Identity in Art,
1860s–1940s: Japan, India and Mexico', an
Arts and Humanities Research Board-funded
collaborative research project between the
University of Sussex, Chelsea College of Art
and Design and Camberwell College of Arts. His
research has focused on the work of artists such
as Hélio Oiticica and their articulation of avant-
garde practice and notions of national and
popular culture. Michael has published numerous
articles on 20th-century Brazilian art and design
and has worked on various curatorial projects
including the Rio de Janeiro section of the
inaugural exhibition at Tate Modern, *Century City:
Art and Culture in the Modern Metropolis*. Recent
publications include: 'Tracing Hybrid Strategies in
Brazilian Modern Art', in J. Harris ed., *Critical
Perspectives on Contemporary Painting,* Critical
Forum Series no. 6, Tate Gallery Liverpool and
University of Liverpool Press, 2003, 139–70, and
'Marvellous Perversions', in Z. de Weck ed.,
*Unbound: installations by seven artists from Rio
de Janeiro*, exh. cat., Parasol-Unit, 2004, 24–40.

David Craven
David Craven is Professor of Art History and
Latin American Studies at the University of
New Mexico in Albuquerque. He is author of five
books – among them, *The New Concept of Art
and Popular Culture in Nicaragua Since the
Revolution in 1979* (1989); *Diego Rivera as Epic
Modernist* (1997); and *Art and Revolution in Latin
America, 1910–1990* (2002) – and a co-author of
five exhibition catalogues for major museums
(such as the Tate Gallery (UK), Museo Nacional
Centro de Arte Reina Sofía (Spain) and the
Studio Museum in Harlem (USA)). His articles
and reviews, which number over a hundred, have
been published in the leading journals of fifteen
different countries. In 1991, he won an Excellence
Award for distinguished scholarship and
teaching from the State of New York.

Ann Eden Gibson

Ann Eden Gibson writes on contemporary art and theory and is a Professor in the Art History Department of the University of Delaware in the USA. She is the author of *Issues in Abstract Expressionism, The Artist-Run Periodicals* (UMI Research Press, 1990), and *Abstract Expressionism: Other Politics* (Yale University Press, 1997). She co-curated *Judith Godwin: Style and Grace* (1997) and *Norman Lewis, The Black Paintings, 1945–1977* (1998). She is finishing her book *Seeing Through Theory: Intention, Identity and Agency*, forthcoming from the University of Chicago Press. She has written essays on Richard Anuszkiewicz, Louise Bourgeois, Nannette Carter, Beauford Delaney, Sam Gilliam, Joe Overstreet, Betty Parsons, Faith Ringghold, Alma Thomas and Günter Umberg, and on topics such as 'The African American Aesthetic and Postmodernism', 'Diaspora and Ritual' and 'Asian-American Cross-Cultural Voices' for various exhibition catalogues and periodicals. Her next project is a book-length study of Hale Woodruff.

Kobena Mercer

Kobena Mercer writes and teaches on the visual arts of the black diaspora. He is the author of *Welcome to the Jungle: New Positions in Black Cultural Studies* (1994) and has taught at University of California Santa Cruz and New York University. His monographs include Keith Piper (1997), Isaac Julien (2001) and James VanDer Zee (2002) and he has contributed exhibition catalogue essays to *Adrian Piper: A Retrospective* (1999) and *Fault Lines: Contemporary African Art and Shifting Landscapes* (2003). He is currently Senior Research Fellow in Visual Culture and Media at Middlesex University, London.

Partha Mitter

Partha Mitter is Research Professor in Art History at the University of Sussex and has been Director of the Arts and Humanities Research Board (UK) Project, 'Modernity and National Identity in Art, 1860s–1940s: Japan, India and Mexico'. He has been Fellow of Clare Hall, Cambridge; Mellon Fellow, Institute for Advanced Study, Princeton; Reader of the British Academy; Radhakrishnan Lecturer at Oxford; Scholar at the Getty Research Institute, Los Angeles and Fellow at the Clark Art Institute, Williamstown. At the Clark, he completed his book, *A Different Modernism: Indian Artists in the Late Colonial Era (1922–1947)*, which is a continuation of his work on modernity, art and identity in colonial India. He is the author of *Much Maligned Monsters: History of European Reactions to Indian Art* (1977 and paperback 1992), *Art and Nationalism in Colonial India 1850–1922* (1994) and *Indian Art* (2001). He has also written numerous articles on various aspects of art, modernity and identity.

Paul Overy

Paul Overy's publications include books on Kandinsky, the De Stijl group, and the Romanian sculptor Paul Neagu, exhibition catalogues of Roberto Matta and Rasheed Araeen, and co-authored books on the Rietveld Schröder House, Rietveld furniture, and the work of Norman Foster. He has worked extensively as a critic for newspapers, cultural periodicals and specialist art and design magazines, and has curated a number of exhibitions, including contemporary Hungarian art, Rietveld Furniture and the Schröder House, and the work of the Bauhaus artist and designer Josef Albers. He is Reader in the History and Theory of Modernism at Middlesex University, and is currently completing a book on health, hygiene and modernist architecture.

Michael Richardson

Michael Richardson is currently Visiting Professor at Waseda University in Tokyo. He is principally interested in questions of communication across cultural boundaries and is the author of *The Experience of Culture* (Sage Publications, 2001) and *Georges Bataille* (Routledge, 1994). He has also written many articles on aspects of surrealism and has edited several collections of surrealist writings, including *The Dedalus Book of Surrealism* (Dedalus, 1993–94), *Refusal of the Shadow: Surrealism and the Caribbean* (Verso, 1996) and, with Krzysztof Fijałkowski, *Surrealism Against the Current* (Pluto, 2001). His new book, *Surrealism and Cinema,* is to be published in 2005 by Berg.

Lowery Stokes Sims

Lowery Stokes Sims is Executive Director of The Studio Museum in Harlem. Prior to her appointment in January 2000, she was Curator of Modern Art at The Metropolitan Museum of Art. Sims received her PhD in art history in 1995 from the Graduate School and University Center of the City University of New York. The subject of her dissertation was 'Wifredo Lam and the International Avant-Garde, 1923–1992', which was published by the University of Texas Press (2002). During her tenure at the Metropolitan Museum she organised exhibitions of the work of Ellsworth Kelly, Stuart Davis and Richard Pousette-Dart among others. She has also guest-curated exhibitions internationally, most recently *Curator's Eye: Install, Insite and In the Moment* at the National Gallery, Jamaica. Sims has extensive experience as a lecturer and juror and has written on the work of African American, Latino, Asian and Native American artists.

We would like to thank the series editor
Kobena Mercer for shaping the critical
framework for this first volume in the series
Annotating Art's Histories and all the authors
for their insightful texts and commitment to
this project from its inception. We would also
like to thank the artists, estates and copyright
holders for their permission to reproduce the
images in this volume. Special thanks are due
to John Axelrod, Camillo Gatta, Tarin Fuller,
Maggie Seidel and Sheila Rohan.

We are extremely grateful to
The Getty Foundation for their generous
support without which this series would
not have been possible. We would also like
to thank Middlesex University for their
continuing support of the project. Additional
thanks to Dawn Ades, Adelaide Bannerman,
Jon Bird, Iain Boyd Whyte, Sarah Campbell,
Indie Choudhury, Susan Clark, Roger Conover,
Suzanne Davies, Luciano Figueiredo, Monique
Fowler-Paul, David Hawkins, Glenn Howard,
Uwe Kraus, Keith Moxey, Griselda Pollock,
Lisa Reeve, Adrian Rifkin, Janet Rossi,
Moira Roth, Clive Russ, Linda Schofield
and Shela Sheikh.